Freedom of Clay and Brush through Seven Centuries in Northern China: Tz'u-chou Type Wares, 960-1600 A.D.

Freedom of Clay and Brush through Seven Centuries in Northern China:
Tz'u-chou Type Wares, 960-1600 A.D.

Yutaka Mino
Catalogue with the assistance of Katherine R. Tsiang

Indianapolis Museum of Art

Indiana University Press
Bloomington

INDIANAPOLIS MUSEUM OF ART
November 17, 1980—January 18, 1981

CHINA HOUSE GALLERY, NEW YORK
March 16—May 24, 1981

CLEVELAND MUSEUM OF ART
August 5, 1981 — September 6, 1981

Library of Congress card catalog number: 80-8642

ISBN 0-253-13170-7 cloth

ISBN 0-253-25575-6 paper

Mino, Yutaka.
 Freedom of Clay and Brush through Seven Centuries in Northern China: Tz'u-chuo Type Wares, 960-1600 A.D.
 Issued on the occasion of an exhibition to be held at the Indianapolis Museum of Art Nov. 17, 1980-Jan. 18, 1981, at China House Gallery, New York, Mar. 16-May 24, 1981, and at Denver Art Museum June 27-Aug. 9, 1981.
 Catalogue: p. 26
 Bibliography: p. 260
 1. Tz'u-chou ware—Exhibitions. 2. Pottery, Chinese—Sung-Yüan dynasties, 960-1368—Exhibitions. 3. Pottery, Chinese—Ming-Ch'ing dynasties, 1368-1912—Exhibitions. I. Tsiang, Katherine R. II. Indianapolis Museum of Art. III. China House Gallery. IV. The Denver Art Museum. V. Title.
 NK4166.T95M56 738.3'7 80-8642

On the Cover:
Truncated Mei-p'ing
Group 13
Chin Dynasty, 12th century
See Plate 87

Credits:
Design, Layout: Marcia K. Hadley
Photography: Robert Wallace
Calligraphy: Dr. Fu Shen, Dr. Yutaka Mino
Typography and Composition: Compolith Graphics
Printing: Design Printing Co., Inc.
Paper: Cameo Dull 80# Text
Cover: Quintessence 100# Cover
Type: Baskerville
Production Coordination: Marcia K. Hadley with assistance from
Patty C. O'Friel, Debra (Slott) Sovinski, James N. Fledderjohn
Distributed by: Indiana
University Press, Bloomington,
IN 47405

Acknowledgments

The Art Gallery of Greater Victoria, Canada
 Roger Boulet, Director
The Art Institute of Chicago
 Jack Sewell, Curator of Oriental Art
The Asian Art Museum of San Francisco
 René-Yvon Lefebvre d'Argencé, Director
The British Museum
 Jessica Rawson, Deputy Keeper Oriental Antiquities
The Brooklyn Museum
 Robert Moes, Curator of Oriental Art
Buffalo Museum of Science
 Virginia Cummings, Director
The Cleveland Museum of Art
 Sherman Lee, Director
Mr. and Mrs. Myron S. Falk, Jr., New York
Field Museum of Natural History, Chicago
 Bennett Bronson, Curator, Asiatic Department
Fogg Art Museum, Harvard University
 John Rosenfield, Curator of Oriental Art
 Robert Mowry, Assistant Curator of Oriental Art
Mr. and Mrs. Stanley Herzman, New York
Herbert F. Johnson Museum of Art, Cornell University
 Marty Young, Curator of Oriental Art
Mrs. Josephine Knapp, Washington, D.C.
Kyusei Atami Museum, Japan
 Yoji Yoshioka, Director
Sonia and Joseph Lesser, New York
Los Angeles County Museum of Art
 George Kuwayama, Curator of Oriental Art
Lowe Art Museum, University of Miami
 Brian Dursun, Curator
Dr. Ralph Marcove, New York
Matsuoka Museum of Art, Tokyo, Japan
 Norio Oyama, Acting Director
The Metropolitan Museum of Art
 Wen Fong, Special Consultant, Far Eastern Art
 Suzanne Valenstein, Associate Curator, Far Eastern Art
Montreal Museum of Fine Arts
 Jean Trudel, Director
Museum of Fine Arts, Boston
 Jan Fontein, Director
Museum of Fine Arts, Springfield
 Richard Muhlberger, Director
Museum für Ostasiatische Kunst, Cologne, West Germany
 Roger Goepper, Director
William Rockhill Nelson Gallery-Atkins Museum of Fine Arts, Kansas City
 Ralph Coe, Director
 Marc Wilson, Curator of Oriental Art
Okayama Art Museum, Japan
 Ritsuji Okuma, Director
Philadelphia Museum of Art
 Jean Gordon Lee, Curator of Far Eastern Art
Mrs. Hans Popper, San Francisco
Royal Ontario Museum, Toronto
 Barbara Stephen, Associate Director
Arthur M. Sackler Foundation, New York
 Lois Katz, Curator
The St. Louis Art Museum
 Richard Cleveland, Curator of Oriental Art
Sakamoto Photographic Studio, Tokyo
Seattle Art Museum
 Henry Trubner, Associate Director
Dr. Laurence Sickman, Kansas City
Dr. Paul Singer
Mr. Janos Szekeres, Stamford, Conn.
Professor Yutaka Tazawa, Tokyo
Tokyo National Museum
 Gakuji Hasebe, Curator, Oriental Department
The University of Michigan Museum of Art, Ann Arbor
 Bret Waller, Director
Worcester Art Museum, Massachusetts
 Richard Stuart Teitz, Director
Yale University Art Gallery, New Haven
 Mary Neill, Curator of Oriental Art

Indianapolis Museum of Art

Robert A. Yassin, *Director*
Betty Bartkiewicz, *Supervisor, Financial Office*
Hilary Bassett, *Registrar*
Vanessa Wicker Burkhart, *Associate Registrar*
Pamillia Cavosie, *General Office Assistant*
Sarah Cloar, *Assistant Registrar*
Matthew Cornacchione II, *Controller*
Janet Feemster, *Curatorial Secretary*
Marcia Hadley, *Supervisor, Publication and Graphic Designer*
Albert Louer, *Director of Public Relations*
Isabel Martin, *Executive Secretary*
Dorothy Meyer, *Manager, News Services*
Sherman O'Hara, *Preparator*
Denny Paff, *Carpenter, Preparation*
Elaine Patton, *Manager, News Services*
Martin Radecki, *Conservator*
James Robinson, *Assistant Curator of Oriental Art*
Sam Smith, *Foreman, Preparation*
Robert Wallace, *Photographer*

Lenders:

The Art Gallery of Greater Victoria, Canada
The Art Institute of Chicago
The Asian Art Museum of San Francisco
The British Museum
The Brooklyn Art Museum
Buffalo Museum of Science
The Cleveland Museum of Art
Mr. and Mrs. Myron S. Falk, Jr. New York
Field Museum of Natural History, Chicago
Fogg Art Museum, Harvard University
Mr. and Mrs. Stanley Herzman, New York
Indianapolis Museum of Art
Mrs. Josephine Knapp, Washington, D.C.
Herbert F. Johnson Museum of Art, Cornell University
Sonia and Joseph Lesser, New York
Kyusei Atami Museum, Japan
Los Angeles County Museum of Art
Lowe Art Museum, University of Miami
Dr. Ralph Marcove, New York
Matsuoka Museum of Art, Tokyo, Japan
The Metropolitan Museum of Art, New York
Montreal Museum of Fine Arts, Montreal, Canada
Museum of Fine Arts, Boston
Museum of Fine Arts, Springfield, Mass.
Museum für Ostasiatische Kunst, Cologne
Nelson Gallery-Atkins Museum of Fine Arts, Kansas City
Okayama Art Museum, Okayama, Japan
Philadelphia Museum of Art
Mrs. Hans Popper, San Francisco
Royal Ontario Museum, Toronto, Canada
The St. Louis Art Museum
Arthur M. Sackler Foundation, New York
Seattle Art Museum
Dr. Laurence Sickman, Kansas City
Dr. Paul Singer
Mr. Janos Szekeres, Stamford, Conn.
Professor Yutaka Tazawa
Tokyo National Museum
The University of Michigan Museum of Art, Ann Arbor
Worcester Art Museum, Mass.
Yale University Art Gallery, New Haven, Conn.

This project was funded in part by the National Endowment for the Arts, Washington, D.C., a federal agency, and generous contributions from Mr. and Mrs. Robert A. Borns and children, Indianapolis, Mrs. Pierre F. Goodrich, Indianapolis, and Dr. Ralph C. Marcove, New York City.

Dedicated to the memory of Professor Fujio Koyama who was my mentor

Contents

	Pg. No.
Acknowledgments	*5*
Preface	*8*
Introduction	*9*
I. . . Literary Evidence	*11*
II. . . Dedicatory Stelae	*12*
III. . . Patronage	*13*
IV. . . Classification	*15*
Color Plates	*17*
Catalogue	*26*
Appendices	*244*
A. List of dated materials	*244*
B. Chart of Tz'u-chou type kilns	*250*
C. Map	*252*
Index	*254*
Bibliography	*260*

Chronological Table

Five Dynasties	907-960
Sung Dynasty	960-1279
Northern Sung	960-1127
Southern Sung	1127-1279
Liao (Khitan Tartar Dynasty)	907-1124
Chin (Jurchen Tartar Dynasty)	1115-1234
Yüan Dynasty (Mongol)	1280-1368
Ming Dynasty	1368-1644

Preface

I believe this exhibition to be the first attempt to assemble all the various kinds of wares of Tz'u-chou type. The lack of evidence on Tz'u-chou type wares up until recent times has disguised their importance and the true extent of their production over many centuries at numerous kiln sites in the northern part of China. Archeological activity under the People's Republic has brought to light much valuable historical material and has called for a new and comprehensive study of these wares. It is my hope that the current exhibition and catalogue will provide a new appreciation of these wares to both scholars and the general public alike and will be a useful reference and stimulus to further study and discussion of this important area of Chinese ceramics.

I began collecting material relating to Tz'u-chou type wares over a decade ago, even before it became the topic of my doctoral thesis, and have received help from many people in this work. I am first of all indebted to the late Professor Fujio Koyama who instilled in me some of his great enthusiasm for the study of Chinese ceramics and gave me the initial opportunity to study in North America. I deeply regret that he could not see the result of his inspiration. To Professor Max Loehr at Harvard University, I am forever grateful for teaching me how to conduct serious, scholarly research, both by his example and by his invaluable criticism and advice. I would also like to express my appreciation to Dr. Hsio-yen Shih, Director of the National Gallery

of Canada, for assisting me in numerous ways during the early stages of my career as Curatorial Assistant at the Royal Ontario Museum. In addition, many special thanks go to Mr. and Mrs. Myron S. Falk, who have shown me unlimited kindness and support since I first had the good fortune to meet them in 1971.

It was with a grant from the National Endowment for the Arts that the concrete plans for this exhibition originally were launched. Since then others have come to my assistance in the funding of this ambitious project. For this I would like to convey heartfelt thanks to Mr. and Mrs. Robert A. Borns and their children, and to Mrs. Pierre F. Goodrich, all of Indianapolis; and to Dr. Ralph Marcove of New York. Much credit goes to the Trustees and the Staff of the Indianapolis Museum of Art for providing me the opportunity to organize this exhibition, as well as to Mr. Gordon Washburn and the Art Committee of the China House Gallery and to Mr. Ronald Otsuka, curator of Oriental Art at The Denver Art Museum, for their enthusiastic support and their efforts in arranging for this exhibition to be held at their respective institutions.

Finally I would like to thank my wife Katherine, whose long-term interest and assistance in this project have been an invaluable asset, for her work on the catalogue entries.

Y. M.
August 1980

Introduction

Tz'u-chou type wares have enjoyed one of the longest histories of any of the major ceramic wares of China. They have been produced for more than a millennium from the tenth century to the present day. The name Tz'u-chou ware derives from that of one of the major centers of its production, Tz'u-chou or present day Tz'u-hsien, in southern Hopei Province. It appears in the first edition of the *Ko-ku yao-lun*, printed in 1387, where Tz'u-chou ware is mentioned in a passage comparing it to Ting ware, and it is recorded there to have been manufactured at Tz'u-chou in Chang-te-fu.[1]

Interest in these wares in this century was stimulated by the discovery of the remains of the Sung dwelling site of Chü-lu-hsien, a site known to have been destroyed by floods in 1108.[2] When the Tientsin Museum began its investigation in 1920, much of the material from this important site had already been removed by local residents and antique dealers through whom many objects were sold to foreign collectors and taken out of China.[3] At about this time, R. L. Hobson recognized that the white-slipped wares from Chü-lu-hsien and related ceramic wares were those Tz'u-chou wares to which the Chinese writings referred.[4] Not realizing the extensiveness of their distribution, he assumed them all to be the product of the kilns in Tz'u-chou.

The first excavation of an ancient kiln site that yielded Tz'u-chou type wares was conducted by R. W. Swallow at Chiao-tso in Hsiu-wu-hsien, Honan Province, in 1933.[5] His work was reported by Ovar Karlbeck in an article published in *Ethnos* in 1943.[6] In subsequent years other sites came to light. Ch'en Wan-li's investigations are an important source of information on the early exploration of kiln sites in Hsiu-wu-hsien, in the Anyang area, in Tz'u-hsien and Ting-hsien,[7] and his book, *Sung-tai pei-fang min-chien tz'u-ch'i,* published in 1955, dealing exclusively with Tz'u-chou type and related black wares, is the first work of its kind.[8] In his investigations, Ch'en made the remarkable discovery at several sites of stone stelae inscribed with dedications to a single deity, providing evidence of the close ties between the kilns, an affiliation that was based not only on technical and stylistic exchanges, but also on a sense of spiritual community.[9]

The number of kiln sites excavated in China since 1949 now stands at twenty-one. Most have been discovered within the last twenty-five years. Valuable evidence for establishing the provenance of various types of wares is now available through the reports on these excavations. In recent years Hasebe Gakuji of the Tokyo National Museum has studied Tz'u-chou type wares and classified them according to decorative techniques. The first edition of his *So no Jishuyo* appeared in 1958,[10] and a second, revised, edition in 1974.[11] Jan Wirgin collected examples of Tz'u-chou type wares in his book, *Sung Ceramic Designs,* 1970 and Margaret Medley in hers, *Yüan Porcelain and Stoneware,* 1974.[13] Feng Hsien-ming, at the Palace Museum, Peking, has written extensively on the subject and has been involved in many of the excavations.

Tz'u-chou type wares arose from the tradition of T'ang white stonewares. The early shapes are similar to those of late T'ang wares, and it is often difficult to distinguish between the two at first glance. The techniques of ceramic manufacture and of glazing used by the Tz'u-chou potters can be seen to have had their roots in the T'ang ceramic industry of North China. The production of white wares and the use of three-color lead glazes are evidence of this connection. Whereas the porcelaneous Ting ware, which also arose from the T'ang northern stoneware tradition, became primarily an official ware, Tz'u-chou ware was developed entirely as a popular ware. Kilns producing Tz'u-chou type wares arose as manufacturers of inexpensive white wares for everyday use. Although made of common stoneware clays, the wares were given a smooth white surface by the application of a white slip under the transparent glaze. It is this white slip that is the distinguishing characteristic of Tz'u-chou type wares.[14] Using this white surface, as distinct from both the body and the glaze, the Tz'u-chou potters were able to explore a number of directions in developing the decorative possibilities of their wares. As a result, Tz'u-chou type wares are the most richly varied of all of the major Chinese ceramic wares and can be classified, according to the techniques used in their decoration and the type of pigments and glazes applied to their surfaces, into nineteen groups.

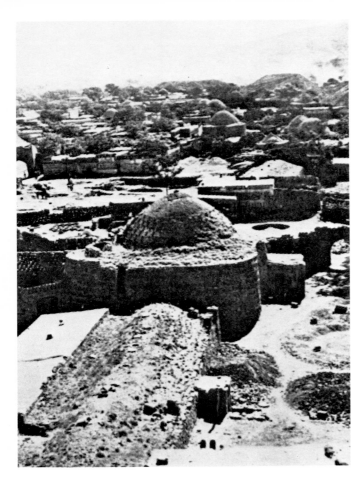

Figure A
View of modern Tz'u-chou kiln site at P'eng-ch'eng in Tz'u-hsien. (photograph taken by late Professor Fujio Koyama in 1941; after Hasebe, *Jishuyo*, p. 91.)

During the tenth century, the bulk of production appears to have been white wares. Kilns in Mi-hsien and Chia-hsien, in Honan Province, are known to have been in operation at the time. In the late tenth and eleventh centuries new techniques of decoration such as deep carving and stamping with a dense fish-roe-like pattern were introduced. These often create bolder effects than are seen on the "classical" Sung wares and can be strikingly beautiful. As the changes in social structure that occurred after the fall of the T'ang Dynasty made possible an increased social mobility, and the establishment of the Sung brought a higher standard of living to greater numbers of common people, there was a growing interest on the part of ordinary people in material goods. The increased demand for more decorative objects spurred the growth of new kilns in the 11th and 12th centuries. The magnificent sgraffiato wares in white and black were a major achievement of this period when kilns were active in Kuan-t'ai, Yeh-tzu-ts'un, Tung-ai-k'ou and Pa-ts'un. Toward the end of the Northern Sung period, underglaze black painted wares were first developed and three-color lead glazes were brought back into use in innovative ways. These latter methods of decoration achieved their fullest expression during the Chin period during which time a continued growth in volume of production is evident from the development of simpler shapes better suited to mass production and more spontaneous and freehand styles of decoration. New techniques were employed in the 13th and 14th centuries, including underglaze painting in brown pigment together

with the black and painting over the glaze in red, green and yellow enamels. Turquoise colored glaze was first introduced from the Middle East during this period. Ho-pi-chi in T'ang-yin-hsien, Honan, was a major kiln center of that time. The continuity of production was not significantly disturbed even with the Mongol succession, though an unfortunate decline in standards of workmanship and taste had begun by then. During the Ming Dynasty the court is known to have patronized the Tz'u-chou kilns to some extent, as large numbers of jars were ordered by the court as wine containers. Ming Dynasty wares are generally of coarse material and have very freely painted decoration. Tz'u-chou type wares with painted decoration have continued to be produced into the 20th century, when, in very recent years, there has been an attempt to revive the styles and techniques of the Sung Dynasty.

The success and longevity of Tz'u-chou type wares can be attributed to their strong popular and domestic economic base. They are wares that did not depend upon official patronage or export revenues, as did many other Chinese ceramic wares, for their existence at any time in their history. Their discovery, in rare cases, among ancient remains in Japan, eastern Java, Sarawak, and the Celebes has led some to believe that they may have been an "export ware." The numbers of Tz'u-chou type wares found abroad, however, are so insignificant that it is highly unlikely that they were ever made expressly for a foreign market.

A full appreciation of the long and continuous development of Tz'u-chou type wares can be gained only by observing their development within a broad historical and archeological context. This exhibition attempts to present such an overview while at the same time examining individual objects. The vast number of wares of Tz'u-chou type that are preserved in collections in Japan, Europe, Canada and the United States can now be studied in the light of the materials recently excavated in China. One hundred and nine selected examples of these wares are assembled in the exhibition and discussed below in the Catalogue section.

Notes
 1. Ts'ao Chao, *Ko-ku yao-lun*, in *I Men Kuang Tu*, 1597 edition, vol. 6, p. 49a.
 2. Anon., "Chü-lu Sung-tai ku-ch'eng fa-chüeh chi-lüeh (Excavation Report from the Sung Dynasty City at Chü-lu)," in *Kuo-li li-shih po-wu-kuan ts'ung k'an*, vol. 1, no. 1 (1926), p. 1.
 3. Li Hsiang-ch'i and Chang Hou-huang, *Chü-lu Sung-ch'i ts'ung-lu*, (Tientsin, 1923), p. 3.
 4. Hobson, *Chinese Pottery and Porcelain*, vol. 1, (London: 1915), pp. 101-108.
 5. Karlbeck, "Notes on the Wares from the Chiao Tso Potteries," *Ethnos*, vol. 8, no. 3 (July-September 1943), p. 82.
 6. *Ibid.*, pp. 81-95.
 7. *Wen Wu*, 1952, no. 2, pp. 56-62.
 8. Ch'en Wan-li, *Sung-tai pei-fang min-chien tz'u-ch'i*, (Peking, 1955).
 9. *Wen Wu*, 1952, no. 2, p. 56.
 10. Hasebe Gakuji, *So no Jishuyo*, in Toji zenshu, vol. 13, (Tokyo, 1958 and 1966 editions).
 11. Hasebe, *Jishuyo*, in Toki taikei, vol. 39, (Tokyo, 1974).
 12. Wirgin, "Sung Ceramic Designs," *Bulletin of the Museum of Far Eastern Antiquities*, no. 42 (1970), pp. 86-124.
 13. Medley, *Yüan Porcelain and Stoneware*, (London: 1974), pp. 105-123.
 14. This definition excludes black-glazed wares, which are considered by some scholars to be of Tz'u-chou type. In order to make a distinction between the wares with white slip and other wares which were also made in North China, however, I have not included them in the present discussion. Black-glazed wares, Chün wares, northern celadon and even *ying-ch'ing* type wares are all known to have been found at the same kilns as Tz'u-chou type wares. Black wares were made also at Ting ware kilns in the same region. To deal with all of these is beyond the scope of this exhibition.

I—Literary Evidence

Traditional Chinese writings on ceramics contain little evidence of the production and distribution of Tz'u-chou wares. Only fragmentary documentation of the vast variety of wares and the extensive area over which they were manufactured can be found. This is in large part due to the fact that it was basically a common ware made for everyday use. Therefore its long history before coming into use by the court in the early Ming Dynasty is unrecorded.

The name "Tz'u-chou ware" has been adopted from traditional sources. Although Tz'u-chou is the name of only one district which produced this type of ware, the term *tz'u-ch'i*, using the character from the name Tz'u-chou rather than the character *tz'u* meaning "high-fired wares," had by Ming times become the generic name for ceramics in China much as "Setomono" in Japan and "china" in the West.[1] It thus seems appropriate to apply the name Tz'u-chou type ware to the group of Tz'u-chou-*related* ceramics manufactured in North China.[2] The term used by Ch'en Wan-li for this large group of wares, *pei-fang min-chien tz'u-ch'i* (northern people's wares) expresses the nature of it.[3] I have chosen, however, to keep the older name, which is already widely known and a good deal less cumbersome.

The earliest literary descriptive evidence of Tz'u-chou ware appears in the *Ko-ku yao-lun* by Ts'ao Chao, published in 1387.[4]

Ancient Tz'u-chou ware.
Fine pieces are similar to Ting ware but lack the "tear drops." They also have incised and impressed patterns. The price of the plain pieces is lower than those of Ting ware. Contemporary pieces are not worth discussing.[5]

In it the product of the Tz'u-chou kilns is regarded as an inferior version of Ting ware. Later writings are confusing because they state that white Tz'u-chou ware is more expensive than Ting, and yet Ting is known as the most highly valued white ware. This seems to have arisen from the misreading of one character that was not clearly printed in a copy of what is believed to be the first edition.[6] The *Ku-yao-ch'i-k'ao* by Liang T'ung-shu, published in the eighteenth century,[7] the *T'ao-shuo* by Chu Yen, published in 1774,[8] the *Yao-ch'i-shuo* by Ch'eng Che, published in 1813,[9] the *Ching-te-chen t'ao-lu* by Lan P'u, published in 1815,[10] and the *Yin-liu-chai shuo-tz'u* by Hsü Chih-heng, published ca. 1914,[11] all have this discrepancy. They also contain passages with the names of places in the Tz'u-chou area where the wares were produced.

By late Ming times the character *tz'u* as in Tz'u-chou had replaced the older character *tz'u* for high-fired ceramics in regular written use. The *Wu-tsa-tsu* compiled by Hsieh Chao-chih and published in the Wan-li period (1573-1619) attributes the use of the character *tz'u* for ceramic wares in general to the large output of the kilns in Tz'u-chou.[12]

Ming texts record that the court ordered large numbers of wine jars of Tz'u-chou type. The *Ming-hui-tien (A Compilation of State Regulations of the Ming Dynasty)* contains a passage saying that during the Hsüan-te period (1426-1435) 51,850 wine containers were ordered from Chün-chou (Honan) and Tz'u-chou (Hopei) each year.[13] In the thirty-second year of the Chia-ching period (1553), also, large numbers of jars were ordered from these two areas.[14] Be-

cause very few jars or vases of the Chün ware type exist today, it may be assumed that the jars from Chün-chou were also of Tz'u-chou type. Margaret Medley has read this text as evidence of the production of numbered Chün ware, but the numbers in this case clearly designate various sizes of wine jars, and not those of flower pots and their bases.[15]

According to the *Shih-hou-chih* of the *Ming Shih (History of the Ming)*, in the early Ming period, the Prince of Chao's household ordered its sacrificial vessels from Tz'u-chou. The palace was situated not far away in Chang-te-fu (modern Anyang.)[16]

The *Tz'u-chou-chih* or *Gazetteer of Tz'u-chou* is another source of information. It records that in the twelfth year of the Hung-chih period (1498), 11,936 *p'ing-t'an* wine jars were paid to the government as tax.[17] The Ying-chien or buildings section of the same text mentions storehouses for official wine jars or *kuan-t'an-ch'ang* in the Tz'u-chou area during the Ming Dynasty. One was located at Shih-ch'iao-tung, Nan-kuan then moved to Liu-li-ts'un and subsequently moved back to the former location. Another official storehouse was in P'eng-ch'eng in Fu-yüan. Each year the ceramic jars made for official use were collected and stored in these warehouses before shipping by river to the capital. These storehouses fell into disuse after the end of the dynasty.[18]

Notes

1. Seto, north of Nagoya in central Honshū, is the biggest center for the production of ceramics in Japan.
2. Approximately twenty-one kiln sites producing Tz'u-chou type ware are now known:
In Hopei, Han-tan-shih (including Yeh-tzu-chen, P'eng-ch'eng-chen, Kuan-t'ai-chen and Tung-ai-k'ou); in Honan, An-yang-shih (Hsi-shan-ying and T'ien-hsi-chen), Hui-hsien (Yen-ts'un, Miao-yüan-kang, Yang-i-tang and Ts'ai-p'o), T'ang-yin-hsien (Ho-pi-chi), Hsiu-wu-hsien (Tang-yang-yü), Mi-hsien (Hsi-kuan and Yao-kou), Teng-feng-hsien (Ch'ü-ho), Yü-hsien (Shen-hou-chen group, Pa-ts'un and Chün-t'ai), Chia-hsien (Hei-hu-tung and Huang-tao), Pao-feng-hsien (Ch'ing-lung-ssu), Lu-shan-hsien (Tuan-tien), Hsin-an-hsien (T'an-tzu-kou and Shih-shu-ling); in Shansi, T'ai-yüan-shih (Meng-chia-ching), Chieh-hsiu-hsien (Hung-shan-chen), Kao-p'ing-hsien (Pa-i-chen), Yang-ch'üan-shih (P'ing-ting); in Shensi, T'ung-ch'uan-shih (Huang-pao-chen); in Shantung, Te-hsien (Te-chou), Tzu-po-shih; in Anhui, Hsiao-hsien (Pai-t'u-chen).
3. Ch'en Wan-li, *Sung-tai pei-fang min-chien tz'u-ch'i*, (Peking: 1955).
4. Ts'ao Chao, *Ko-ku yao-lun*, in I Men Kuang Tu, (1597 ed.), vol. 6, p. 49a.
5. *Ibid.*
6. David, Percival, *Chinese Connoisseurship: The Ko-ku yao-lun (The Essential Criteria of Antiquities)*, (New York: 1971), p. 306.
7. Liang T'ung-shu, *Ku-yao-ch'i-k'ao*, in Mei-shu-ts'ung shu, p. 143 (vol. 1, no. 5).
8. Chu Yen, *T'ao-shuo*, (1913 ed.), vol. 2, p. 10a.
9. Ch'eng Che, *Yao-ch'i-shuo*, in Mei-shu-ts'ung-shu, p.174 (vol. 1, no. 3).
10. Lan P'u, *Ching-te-chen t'ao-lu*, (1815 ed.), vol. 7, p. 13a and b.
11. Hsü Chih-heng, *Yin-lin-chai shuo-tz'u*, in Mei-shu-ts'ung-shu, p. 158 (vol. 3, no.6).
12. Hsieh Chao-chih, *Wu-tsa-tsu*, in Kuo-hsüeh Chen-pen Wen-k'u, vol. 1, (Shanghai, 1935), chüan 12, p. 170.
13. Li Tung-yang comp., *Ta Ming Hui-tien*, (1587 ed.), chüan 194, kung-pu 14, p. 2b.
14. *Ibid.*, p. 3a.
15. Medley, *Yüan Porcelain and Stoneware*, (London, 1974), p. 95.
16. Chang T'ing-yü (1672-1755) comp., *Ming Shih*, (1739 ed.), vol. 82, Shih-huo-chih, 10, p. 868.
17. *Tz'u-chou-chih*, (1700 ed.), chüan 8, Fu-i p. 2a.
18. *Ibid.*, chüan 3, Ying-chien, p. 14a.

II—Dedicatory Stelae

Another type of documentation which has only recently been brought to attention by Ch'en Wan-li, and which is more valuable than that from literary texts as evidence of the early development and spread of Tz'u-chou ware manufacture, is a number of stelae found at or near several kiln sites.[1]

In 1951 Ch'en first discovered a stone stele at Tang-yang-yü in Hsiu-wu-hsien. The inscription was lost in parts, as the stone was being used as part of a wall, but from the decipherable characters it could be read that the stele had been erected originally at a temple built in honor of a deity Te-ying-hou whose given name was Po-lin. The inscription itself was recorded to have been copied from one in Yao-chün (present day Yao-chou), an area in which kilns producing white wares and black wares were active in the T'ang Dynasty. An apprentice had been sent to Yao-chün to make a careful drawing of the stele there.[2] Two dates are inscribed on the stele at Tang-yang-yü: 1100 A.D., the year in which the temple was founded, and 1105, the year in which the stele was erected.[3]

In 1954, after much searching, Ch'en luckily found the original stele.[4] Dedicated to the same legendary figure Po-lin, whose surname had been forgotten, it described him as a man from the south who was traveling through when he discovered suitable clay for pottery-making and set up the first kilns in the area. The Yao-chou stele is dated 1084 A.D.[5] The *Yao-chou-chih* or *Gazetteer of Yao-chou* contains a passage recording that the governor of the district applied for and was granted a title, Te-ying-hou, for the local kiln guardian deity Po-lin during the Hsi-ning reign period (1068-1077). The local people had built a temple and were worshipping Po-lin long before.[6] (See Figure B)

Another stele was discovered on a bridge at Ch'en-chia-ts'un near Ho-pi-chi in T'ang-yin-hsien which is also dedicated to Po-lin. It, too, describes a legendary potter who came into the area and taught people in surrounding villages the art of pottery-making. That stele was re-erected in place of an older one in the thirty-seventh year of the Ch'ien-lung period, 1772.[7]

Yet another stele recording the rebuilding of a temple to Po-ling in the third year of the Hung-chih period (1490) was discovered at the kiln site in Meng-chia-ching, T'ai-yüan in Shansi Province.[8]

Temples or shrines devoted to a similar deity are also recorded in prefectural gazetteers. The *Honan Yü-hsien-chih* (1747 ed.) notes a Po-ling-kung shrine, of unknown origin, that was rebuilt in 1322.[9] The variations in the characters of the name may be attributed to mistakes in copying or to transmission by word of mouth in which characters of a similar sound were substituted. The *Honan Yi-yang-hsien-chih* (1747 ed.) mentions that repairs were made on the Te-ying-hou shrine in the sixth year of the Ch'ung-ning period (1107).[10]

A stele dedicated to a different diety was found at the kiln site producing Tz'u-chou type ware at Hung-shan-chen in Chieh-hsiu-hsien, Shensi Province. It commemorates the building of a temple to Yüan-shen in the first year of the Ta-chung-hsiang-fu period (1008).[11] Two of the donors' names on the stele are Jen T'ao, ceramics tax officer, and Wu Chung, a former ceramics tax officer.[12]

Another type of stele was excavated at a kiln site in Mi-hsien, Honan, which records the restoration of the shrine dedicated to the T'ang dynasty poet Po Chü-i (772-846) and designates him as the god of their kilns. The stele is dated to the first year of the Hsien-feng reign (1851).[13]

Notes
1. *WW*, 1952, no. 2, p. 56.
2. *WW*, 1954, no. 4, p. 44.
3. *Ibid.*
4. *WW*, 1955, no. 4, p. 75.
5. *Ibid.*
6. *Ibid.*, pp. 75-76.
7. *WW*, 1956, no. 7, p. 36.
8. *WW*, 1964, no. 9, p. 46.
9. Sun Kuang-sheng and Shao Ta-yeh, *Yü-hsien-chih,* (1747 ed.), chüan 2, p. 55a.
10. Ch'en I-ching and Hsieh Ying-ch'i, *I-yang-hsien-chih,* (1881 ed.), chüan 5, p. 5a.
11. *WW*, 1958, no. 10, p. 37.
12. *Ibid.*
13. *WW*, 1964, no. 2, pp. 59-60.

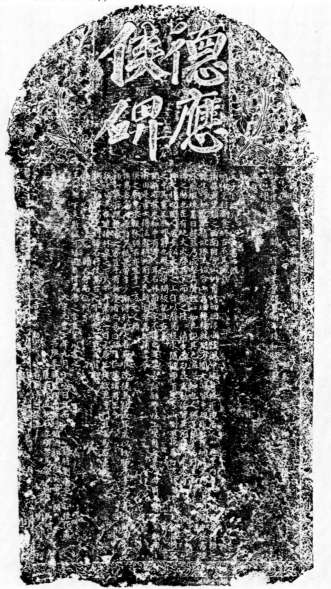

Figure B
Rubbing from the stone stele at Yao-chou (after *Shan-hsi T'ung-ch'uan Yao-chou-yao*, pl. 30)

III—Patronage

Evidence from the site of Chü-lu-hsien shows clearly that Tz'u-chou type ware was in common use from the Northern Sung period. The stele of the Hall of Miao-yen in the Buddhist temple of San-ming-ssu records that in the autumn of the second year of the Ta-kuan reign (1108), the Chang River broke its banks and flooded the city, burying everything but the pagoda and Lohan Hall of the San-ming-ssu in up to twenty feet of mud.[1] The site was rediscovered accidentally in 1918-19 by the local people. In 1920 when wells were being sunk during a drought a great deal more of the site was uncovered. By the time the Tientsin Museum sent a team to investigate the site that same year, much of it had been pillaged and the ceramic wares sold to dealers through whose hands thousands of pieces were sent out of China.[2] The museum was able to acquire a sizeable sampling of the wares by purchasing them from the local people. The report by the Tientsin Museum, published in 1923 under the name *Chü-lu Sung-ch'i ts'ung-lu* or *Catalogue of Sung Artifacts from Chü-lu,* lists objects, including bowls, lobed melon-shaped jars, jars with two handles, pillows, basins, vases and ewers of Tz'u-chou type ware.[3] One pillow bears an ink inscription on the base celebrating a wedding day.[4] Many other pieces had written on the bottom the record of their purchase, the date, and the name of the owner. Of these none are dated later than 1108 A.D., the year of the flood.

In 1921 the National Historical Museum in Peking conducted investigations on the remains of two houses in Chü-lu-hsien, the reports of which were published in the Museum Bulletin. One of the houses excavated belonged to the Wang family and the other to the Tung family. In one, bowls and plates like kitchen wares were found on a wooden table.[6] Such objects are valuable evidence of the types of household wares that must have been in current use.

Another dwelling site at which many Tz'u-chou type wares were found is Ch'ing-ho-hsien which was inhabited in Sung and also later times.[7] This site, however, does not provide any clearly dated material.

The large-scale production of Tz'u-chou wares over several centuries is well evidenced. The factors accounting for its success are less clear. Among these factors, contrary to the reason for the rise of other important wares in China, foreign trade plays a negligible part. The few pieces that have been found outside China probably served as containers for other goods but were not themselves valued. A record mentioning the appointment of a ceramics tax officer in Shansi in the early eleventh century suggests that the ceramics industry in the North was already of substantial size and profitable enough to have been tapped as a source of government income.[8] Aside from supplying an extensive market for household and kitchen wares, it appears to have been stimulated by a large demand on the part of local wine manufacturers for wine containers of many sizes and shapes. The Sung text, *Chiu-ming-chi* by Chang Neng-ch'en, is a compilation of names of famous wines and wine shops.[9] The first part of the work lists shops and brand names. The second part records names of wines and their places of manufacture. Most of these places are in the northern part of China and many in the vicinity of kilns which produced Tz'u-chou type wares. A wine known as Feng-ch'ü fa-chiu was produced in Tz'u-chou, and another called Yin-kuang was produced in Hsiang-chou (modern day Anyang) near Kuan-t'ai.[10] I-ch'eng and Hsiang-kuei wines were made in Huai-chou (modern Pi-yang) west of Tang-yang-yü.[11] Jars inscribed with names of wines or wine shops or with phrases praising the quality of the wine could readily have been ordered by merchants at the local kilns. The *Chiu-hsiao-shih* or *Short History of Wine* by Sung Po-jen of the Yüan Dynasty also records names of wines and their places of manufacture.[12] By the Ming Dynasty the market for wine jars was well-established. The passages in the *Ming-hui-tien* mentioning that the Ming court ordered tens of thousands of such containers in one year is evidence of the volume of this trade.[13]

Kilns producing Tz'u-chou type wares are known to have been located close to coal mines.[14] The shortage of trees in the North brought coal into regular use as a fuel in the Northern Sung period.[15] Coal was used for cooking in the capital of K'ai-feng from this period,[16] and traces of coal ash have been found at kiln sites of Tz'u-chou type wares and also Ting ware of the Sung Dynasty.[17] The other essential materials of clay and running water were also in good supply in the coal mining areas. In northern China, clay was regularly found associated with deposits of coal, and it is observed that fine white clay was always found directly above and below the layer of coal.[18]

The relative importance of all the economic factors in the development of Tz'u-chou wares and how they changed from the early formative stages of the industry to later periods is not readily determined. In examining the production of the wares over the centuries, however, a striking continuity can be observed which seems not to have been affected by political and dynastic changes. It appears that the ownership and operation of kilns was largely free of official interference. Because the market for Tz'u-chou type wares was based on local trade with common people and merchants, the kilns did not rely on court management or patronage for their livelihood.

Notes

1. The stele is dated the third year of the Hsüan-ho reign (1121 A.D.). See Li Hsiang-ch'i and Chang Hou-huang, *Chü*-lu Sung-ch'i ts'ung-lu (Catalogue of Sung Artifacts from Chü-*lu),* (Tientsin, 1923), p. 3a; and Anon., "Chü-lu Sung-tai ku-ch'eng fa-chüeh chi-lüeh (A record of a Sung ancient city excavated at Chü-lu), *Kuo-li li-shih po-wu-kuan ts'ung-k'an (Bulletin of the National Historical Museum),* vol. 1, no. 1 (1926), p. 3.

2. *Kuo-li li-shih po-wo-kuan ts'ung-k'an, op. cit.,* p. 1.

3. Li Hsiang-ch'i and Chang Hou-huang, *op. cit.*

4. *Ibid.,* p. 28b.

5. A list of the dated pieces is given below:
 a) A reddish-brown glazed box (1092), *Ibid.,* p. 3.
 b) Two white glazed basins (1108), *Ibid.,* pp. 1-2.
 c) A reddish-brown glazed bowl (1108), *Ibid.,* pp. 4-5.
 d) A pillow (1108), *Ibid.,* p. 28.

6. *Kuo-li li-shih po-wu-kuan ts'ung-k'an,* vol. 1, no. 1 (1926), p. 1.

7. Palmgren, Nils, *Sung Sherds,* (Stockholm, 1963), pp. 261-266.

8. The stele, found at the Tz'u-chou type kiln site at Hung-shan-chen in Chieh-hsiu-hsien, Shansi Province, is dated 1008 A.D. See *WW,* 1958, no. 10, p. 37.

9. Chang Neng-ch'en, *Chiu-ming-chi,* in *Shuo-fu,* vol. 94, pp. 1-3.

10. *Ibid.,* p. 2a.

11. *Ibid.,* p. 2a and b.

12. Sung Po-jen, *Chiu-hsiao-shih,* in *Shuo-fu,* vol. 94, pp. 1-4.

13. Li Tung-yang, comp., *Ta Ming-hui-tien,* (1587 ed.), chüan 194, kung-pu 14, pp. 2b and 3a.

14. Hou Te-feng, "Ho-pei-sheng Tz'u-hsien nien-t'u kuang ti-chih k'uang-yeh chi yao-yeh" (The clay deposits and porcelain industry of P'eng-ch'eng-chen in Tz'u-hsien), *Ti-chih Hui-pao* (Geological Bulletin), vol. 17 (October 1931), pp. 43-82, Hou Te-feng, "Ho-nan Hsiu-wu-hsien mei-t'ien ti-chih," *Ti-chih Hui-pao,* vol. 15 (December 1930), pp. 13-24, Sun Chien-ch'u, "Ho-nan Yü-hsien Mi-hsien mei-t'ien ti chih" *(Geology of the Yü-hsien and Mi-hsien Coal Fields, Honan Province), Ti-chih Hui-pao,* vol. 24 (September, 1934), pp. 1-32.

15. Miyazaki, Ichisada, "Sō-dai no tetsu to sekitan" (Iron and coal in the Sung Dynasty), *Tohogaku,* no. 13, p. 13.

16. *Ibid.*

17. *WW,* 1964, no. 8, p. 12.

18. Naito, Tadashi, *Ko tōji no kagaku (The Science of Early Ceramics),* (Tokyo, 1972), p. 125.

IV—Classification

The characteristic feature of Tz'u-chou type ware is the white slip applied over the clay body, which is in turn protected by a transparent glaze. Given this white surface as a base, distinct from both the body and the glaze, the Tz'u-chou potters had many directions in which to experiment and develop the decoration of their wares. As a result, wares of Tz'u-chou type are the most richly varied of all of the major Chinese ceramic wares. They can be classified according to the techniques used in their decoration and the types of pigments and glazes applied to their surfaces, into nineteen groups. A brief description of the techniques involved and the types of objects on which they are used is presented here.

1. White with transparent colorless glaze
Pieces in this group are made of the basic materials of most of the Tz'u-chou type wares, a greyish clay body covered with white slip and then transparent colorless glaze. A few examples of this group are carved with lotus petal motifs or other designs before the application of the slip. Plain white Tz'u-chou type ware is made in a variety of shapes, most of which can be identified as relatively early in the general development of this ware: bowls, ewers, *mei-p'ing*, truncated *mei-p'ing*, basins, *tou* (high-footed bowls) and lobed jars. The majority of the ceramics found at Chü-lu-hsien are of this group. (Pls. 1-7)

2. White with green splashes
This group is similar to the one above but has additional splashes of green color in the glaze which blend into it and tend to run down the sides of the vessels. The splashes are usually applied to accent handles and spouts and other parts which have been added on to the basic thrown form. Vessels on which this type of glaze occurs are ewers, long-necked vases with dished mouth, six-spouted jars, and *tou* with molded Buddhist figures around the sides. (Pl. 8)

3. White with deeply carved decoration
The decoration is carved on the unfired leather-hard pieces which have been dressed with white slip. The sharply cut designs of peony blossoms and leaves reveal the clay beneath the slip. The transparent glaze is then applied over the carving. Objects in this group include ewers, long-necked vases with dished mouth, globular jars, and cloud-shaped and rectangular pillows, all exhibiting a high degree of precision in the carving and in the finishing of the shapes of the vessels. The body of nearly all of these objects is grey, showing a light brown color under the glaze.

An additional sub-group of small cups with deeply cut patterns of lines and arcs is also included here. Most of these have a body that displays a rather deep color under the glaze. (Pls. 9-12)

4. White slip inlaid on the body
Objects in this group are incised with fine linear scrolls or stamped with designs on the unfired body. After the application of the white slip, the slip over the designs is scraped off just down to the clay. The slip which has filled in the incised and stamped patterns remains, producing the effect of fine white inlay-work. The object is then covered with transparent colorless glaze. Long-necked vases with dished mouth and cloud-shaped and rectangular pillows make up this small group. (Pls. 13-14)

5. White with incised decoration and stamped fish-roe ground
Examples of this group are covered with white slip and incised with linear designs, the areas around which are stamped with a thin straw-like instrument in a close pattern of small rings, like fish-roe. Earlier examples of this group tend to be more densely stamped, the rings small and set one next to another. Pillows are the most common type of object in this group, occurring in four-lobed, bean-like, rectangular and octagonal shapes with vertical sides. Vessels decorated in this manner include ewers, *mei-p'ing*, six-spouted jars, and incense burners. (Pls. 15-27)

6. White with stamped decoration
In this group, which consists entirely of pillows, the designs are stamped on the white slip under the glaze. Small star-like flowers similar to those on the pillows in the above group are used. More common, however, are larger and more representational designs, including leaves, flowers, floral scrolls, deer, small boys and ducks. The double lines bordering the central patterns are also stamped. The pillows are made in oval, four-lobed and roughly rectangular shapes with tapering sides. (Pls. 28-30)

7. White with incised decoration on combed ground
The background of the main incised motifs is striated by scratching through the slip with a comb-like instrument. Peonies and lotuses are frequently used in the decoration, as is a narrow meander band which serves as a border pattern. Deep bowls, dishes, basins, *mei-p'ing* and leaf-shaped pillows comprise this group of wares. (Pls. 31-35)

8. White with incised and/or combed designs
The principal motifs are incised with a single or multiple-pointed instrument. This small group of objects includes *mei-p'ing*, shallow bowls, and bean-shaped, rectangular and cloud-shaped pillows. (Fig. 75)

9. White sgraffiato designs on the clay body
The outlines of the decoration are incised into the slip, the background areas lightly removed by scraping to expose the clay beneath the slip, and transparent colorless glaze applied over the top. This group is related in technique to Group 3, the deeply carved wares, but the incised designs are more freely executed and do not have the stiffly cut, relief quality of the carved ones. This group is an extensive one, spanning

15

a long period of time and encompassing a variety of wares. Objects bearing this type of decoration include *mei-p'ing, tsun* vases (vases with high flared foot and long, wide everted neck), deep bowls, *kuan*, pear-shaped bottles, and pillows of oval, rectangular and octagonal shapes.

A few pillows are known that have sgraffiato decoration on white slip on the sides and incised designs with fish-roe ground on the top. These will be discussed in Group 5. (Pls. 36-38)

10. *Black slip sgraffiato designs on white slip*

Objects in this group are covered with a layer of black slip on top of the white. Designs are incised on the black slip, which is scraped away to reveal the underlying white slip. Generally the designs are black on a ground of white, but in some examples the ground is reserved black and the main designs scraped white. Combinations of these two treatments may occur on a single piece. This group includes some of the most striking examples of Tz'u-chou type wares. Shapes include *mei-p'ing,* truncated *mei-p'ing, tsun* vases, *kuan*, deep bowls, incense burners, and octagonal, bean-shaped and leaf-shaped pillows. (Pls. 39-43)

11. *White with brown glaze dots*

Examples of this group are decorated with simple patterns of round and tear-drop-shaped dots. They are closely related in shape to the plain white ware of Group 1. The dots are applied on top of the transparent colorless glaze. Vessels decorated in this manner are ewers, vases with long wide neck, deep bowls, rounded jars and lamps. (Pls. 44-45)

12. *Black painting on white slip*

Designs are painted on black under the transparent colorless glaze. The technique of under-glaze painting, which first appeared as early as the Sui Dynasty, was fully mastered and widely used in Tz'u-chou wares from the Northern Sung period on. Its similarity to painting in ink would presumably have expedited the adoption of popular styles and themes of illustration from contemporary painting and also woodblock printing into the ceramic medium. Though materials used in ceramic decoration would not have offered the range of effects possible in ink painting, the potters nevertheless achieved a control of their medium in which both bold and delicate styles of brushwork could be displayed as well as different gradations of pigment. Because of its long and widespread use, large numbers of objects with black painted decoration are known: octagonal pillows (12/A), cloud-shaped pillows (12/B), bean-shaped pillows (12/C), rectangular pillows (12/D), truncated *mei-p'ing* (12/E), deep bowls (12/F), small jars (12/G), *mei-p'ing* (12/H), bottles (12/I), *tsun* vases (12/J), wide-mouthed jars with two handles (12/K), small-mouthed jars (12/L), *kuan* (12/M), large jars (12/N), basins (12/0), and flasks (12/P). In order to facilitate the description of the objects, they have been discussed in separate sections, by shapes and in the order in which they are listed here. (Pls. 46-86)

13. *Painted and incised decoration*

The decoration is painted in black, while the details are then incised through the black pigment into the white slip beneath. Wares decorated in this manner include truncated *mei-p'ing*, deep bowls, leaf-shaped pillows, *tsun* vases with foliated rim, *kuan*, flasks and four-handled jars. (Pls. 87-91)

14. *Black painting with brown accents*

This group is similar to the group with black painting but involves the use of an additional underglaze pigment. The tan or light brown colored pigment is usually used to fill the areas which have been outlined in black. On many of the pillows made in the shape of a recumbent tiger, however, the brown is used as a wash of color over almost the whole body. Other objects with brown and black painting include *kuan*, covered boxes, *mei-p'ing* and pear-shaped bottles. (Pls. 92-93)

15. *Green lead glaze*

Green lead glaze is used over the transparent colorless glaze on pieces with sgraffiato designs or black painting and directly on the white slip on pillows with incised and combed decoration. The glaze is a low-firing lead-fluxed glaze colored by copper oxide fired in an oxidizing atmosphere. When the green glaze is applied over the transparent stoneware glaze, the piece undergoes a second firing. If the green glaze is applied directly on the white slip the piece is fired only once at the lower temperature and is therefore earthenware. Green glazed wares include *mei-p'ing, tsun* vases, *kuan*, and bean-shaped and rectangular pillows. (Pls. 94-97)

16. *Turquoise glaze*

Turquoise glaze is in all cases, applied over the transparent colorless glaze on pieces with black underglaze painting. The coloring agent, as in the green lead glaze described above, is copper oxide, which is an alkaline glaze producing the color turquoise instead of bright green. Vessels comprising this group are *mei-p'ing*, covered boxes, *kuan*, and jars with two loop handles. (Pls. 98-99)

17. *Incised decoration under three-coloured lead glaze*

Incised and sgraffiato designs, and in some cases painted brown spots, on white slip are covered with green, yellow and colorless lead glaze. The glaze is applied directly to the body, filling in the areas marked off by incised lines. This group is comprised primarily of pillows but also includes dishes, pear-shaped bottles and *tsun* vases with foliated mouth rim. (Pls. 100-104)

18. *Enamel overglaze painting*

Designs in red, yellow and green enamels are painted on glazed and pre-fired, plain white pieces. They are then fired again at a lower temperature. The majority of vessels are shallow bowls and dishes, though *kuan* and pear-shaped bottles are also known. (Pls. 105-106)

19. *Incised and impressed designs under yellow-brown glaze*

The brownish colored glaze is applied over white slip into which designs have been impressed or incised. There are two subdivisions of this group. The first is comprised only of ewers with a cross-hatched or dot pattern impressed in the surface by a roulette. The ewers are covered in a yellowish brown glaze stopping short of the foot. The second subgroup has a generally darker brown glaze applied over incised lotuses and other patterns. On some examples the area around the incised patterns is filled with fish-roe or combed lines. Bowls, covered jars, large basins and *mei-p'ing* with conical mouth are among the vessels decorated in this manner. (Pls. 107-109)

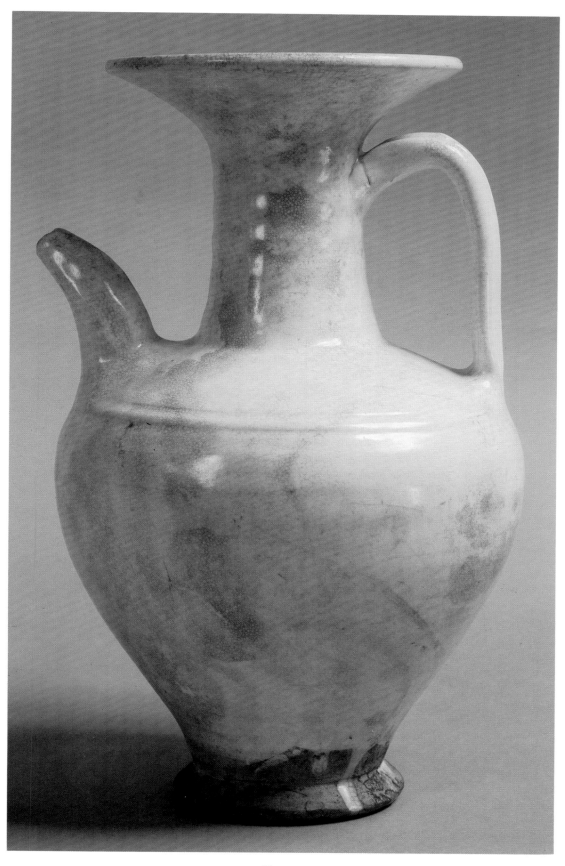

Ewer
Group 1
Northern Sung Dynasty, dated 1105
See Plate 5

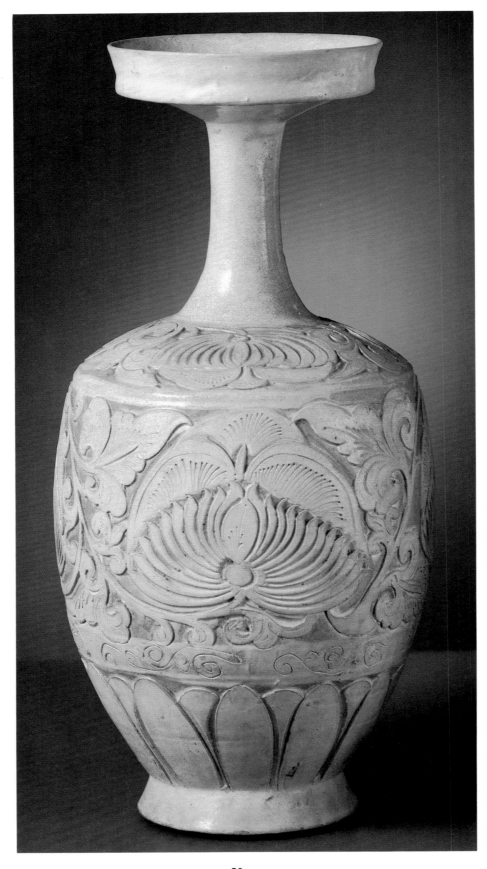

Vase
Group 3
Northern Sung Dynasty, late 10th—early 11th centuries
See Plate 9

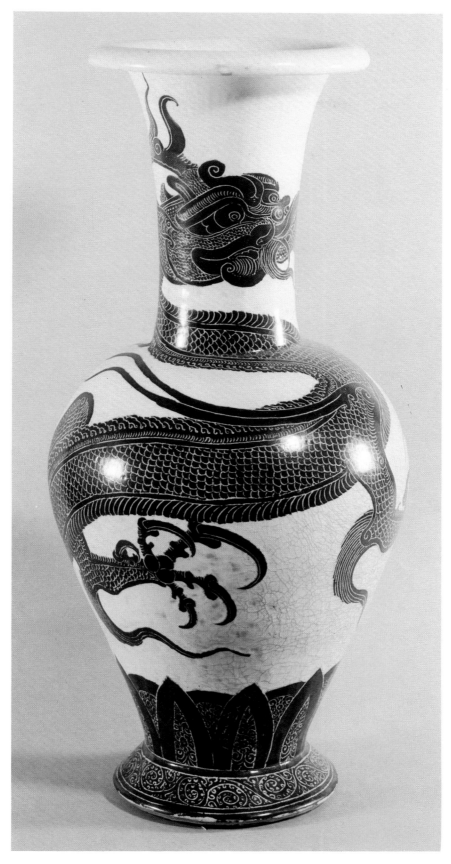

Tsun-shaped Vase
Group 10
Northern Sung Dynasty, 12th century
See Plate 42

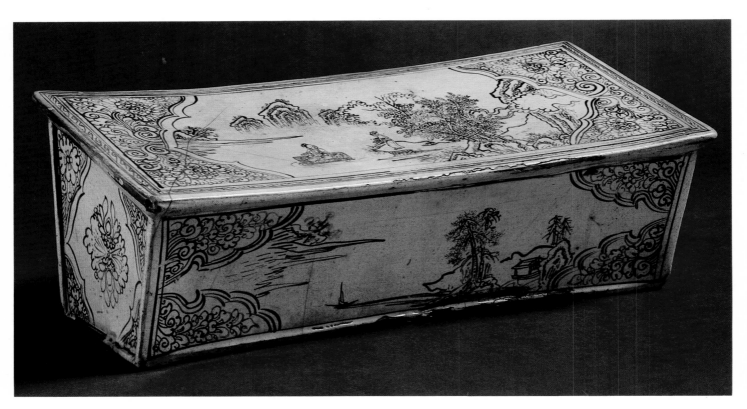

Pillow
Group 12/D
Chin Dynasty, 13th century
See Plate 57

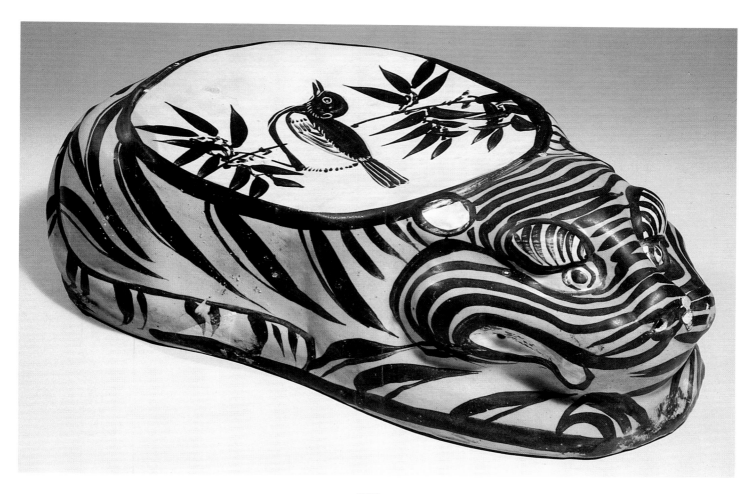

Pillow
Group 14
Chin Dynasty, late 12th century
See Plate 92

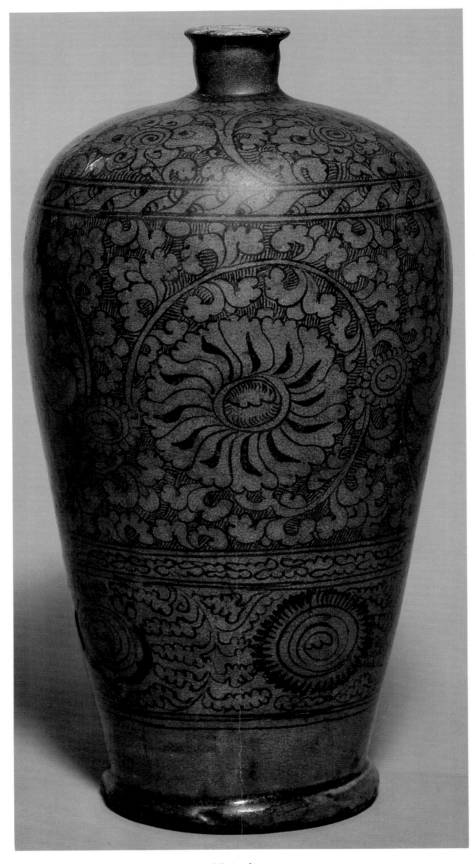

Mei-p'ing
Group 16
Ming Dynasty, 16th century
See Plate 99

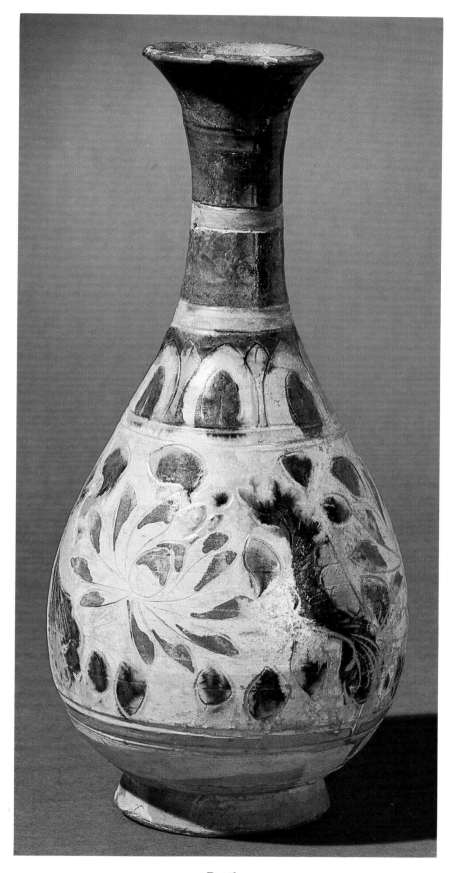

Bottle
Group 17
Chin Dynasty, late 12th—13th centuries
See Plate 101

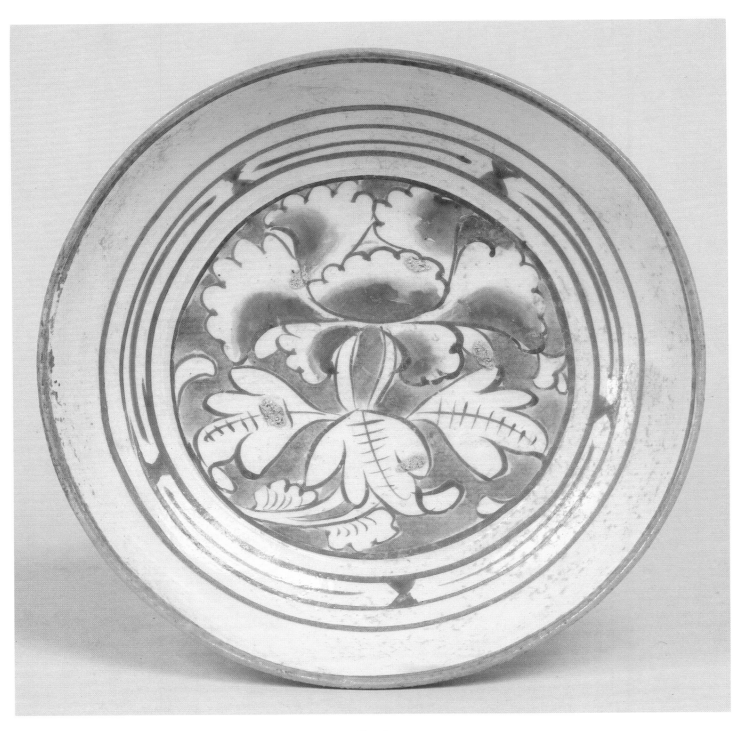

Bowl
Group 18
Chin Dynasty, dated 1201 A.D.
See Plate 105

磁州窯系展覧

Plate 1

Ewer

Group 1
Five Dynasties Period, 10th century
H. 4-3/4 in. (12.1 cm)
W. 2-1/2 in. (6.3 cm.)
Museum of Fine Arts, Springfield, Mass., The Raymond A. Bidwell Collection

Ewer with ovoid body, high shoulder, short trumpet-shaped neck and everted mouth rim; short spout attached at the shoulder opposite a double-strand handle bound with a small cord-like loop at the top; low slightly flaring foot and flat base. Greyish-white stoneware with white slip and transparent glaze stopping just above the foot. No decoration.

Published: *The Raymond A. Bidwell Collection of Chinese Bronzes and Ceramics*, p. 70.

Plain white wares are among the earliest of the Tz'u-chou type wares. Produced from the tenth through the twelfth centuries, they are the basic form of early Tz'u-chou ware and have been found at every kiln site of Tz'u-chou type ware known to have been active during this period. In addition to large numbers of utilitarian bowls, of which there are few in collections outside China, there are several distinct shapes of vessels of plain white ware. One of these is the ewer with small spout and curving handle attached to the neck and shoulder, represented here by the one in the Museum of Fine Arts, Springfield. A ewer that is very similar in shape to this, but has no looped cord at the top of the handle, is in the collection of Dr. Paul Singer. An interesting variation of this type of vessel, in the Bristol City Art Gallery, is a small ewer with its handle in the form of a lion standing on hind legs and peering into the mouth of the ewer. This shape is known, also, in Ting ware of the ninth and early tenth centuries. (*KK*, 1965, no. 8, pl. 5:5.) Another variation, a ewer that has a short spout, nearly cylindrical wide neck and flat ribbon-like handle with vertical striations, can be seen in the Idemitsu Art Gallery, Tokyo. (fig. 1; Koyama, *Chugoku toji*, Pl. 33.) Fragments of similar handles were found among the remains at kiln sites in Teng-feng-hsien, Honan Province. (*WW*, 1964, no. 2, pl. 6:1.)

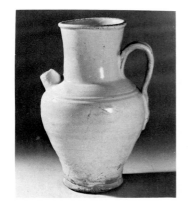

Figure 1

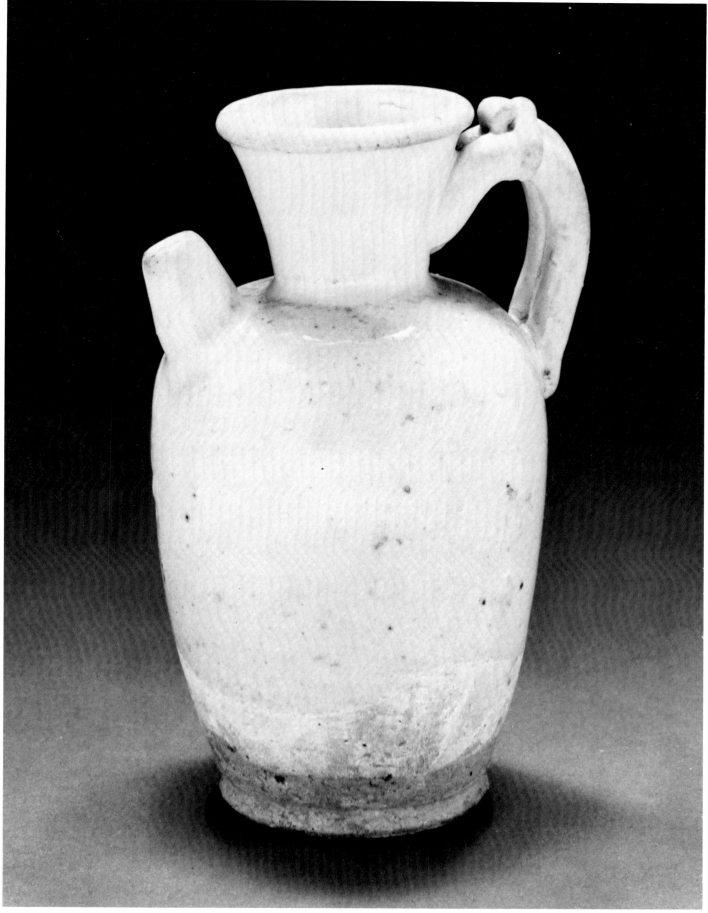

27

Plate 2
Tou, High-footed Bowl
Group 1
Northern Sung Dynasty, 10th century
H. 3 in. (7.7 cm.)
D. 4-13/16 in. (12.2 cm.)
Buffalo Museum of Science

Bowl with nearly flat, everted mouth rim and widely splayed, high foot. Grey stoneware covered with white slip and transparent glaze stopping short of the base. Molded and applied Buddhist figures around the sides of the bowl under the slip and glaze.

Published: Hochstadter, "Early Chinese Ceramics," pl. 42.

Similar vessels, one in the British Museum and one in the Victoria and Albert Museum, have green splashes in the glaze and therefore belong to Group 2. The example in the British Museum has molded lotus petals beneath the Buddhist figures. (The British Museum, Registration no. 19377-1641). The Victoria and Albert Museum *tou* has a thinner, flatter mouth rim and a horizontal flange with foliated edge encircling the lower part of the bowl beneath the molded figures (Victoria and Albert Museum, Registration no. C 283-1910). In addition, the piece has a thick ridge at the base of the bowl where it is joined to the foot.

Tou of shape similar to the Buffalo *tou* but without the molded ornament, were found in excavations at the Yen-ts'un kiln site in Hui-hsien (Fig. 2; *WW*, 1965, no. 11, p. 38, fig. 7:10) and at Ho-pi-chi in T'ang-yin-hsien (*WW*, 1964, no. 8, p. 14, fig. 17: 10). At both sites, the *tou* were found in the lower layers, which the Chinese archeologists have assigned to the late T'ang and Five Dynasties Period.

Figure 2

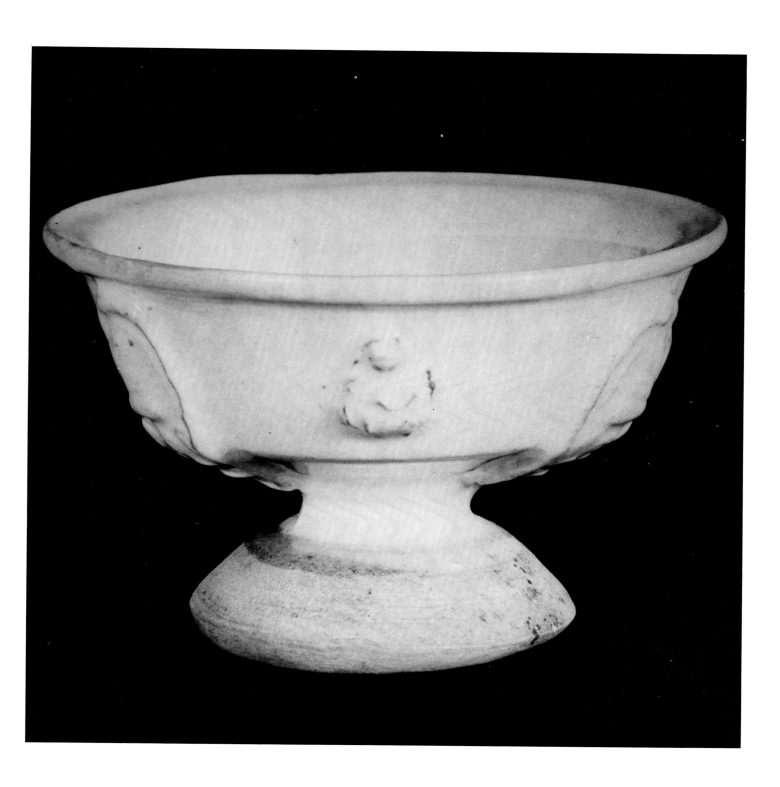

Plate 3
Mei-p'ing[*]
Group 1
Northern Sung Dynasty, 11th century
H. 11-7/8 in. (31.1 cm.)
Tokyo National Museum

Figure 3 Figure 4

Vase with ovoid body, sloping shoulder, small cylindrical neck and flattened mouth rim; recessed, flat base. Pale grey stoneware covered with white slip and transparent glaze stopping at the foot. No decoration.

Published: *Kizo Hirota*, no. 61; Hasebe, *Jishuyo*, pl. 24; and *Sogen no bijutsu*, pl. 1-136.

This *mei-p'ing* can be assigned to the eleventh century on the basis of its shape, which is very similar to that of a *ch'ing-pai* ware *mei-p'ing* found in a tomb dated 1027 near Nanking (Fig. 3; *KK*, 1963, no. 6, pp. 343). The *ch'ing-pai* piece has a carved relief ornament of floral scrolls over most of its surface. Another similarly shaped *mei-p'ing* with black glaze was discovered in I-hsien, Liaoning Province, in the Liao Dynasty tomb of one Citizen Hsiao (Fig. 4; *KKHP* 1954, no. 8, pl. 22:6).

[*] Not included in the exhibition

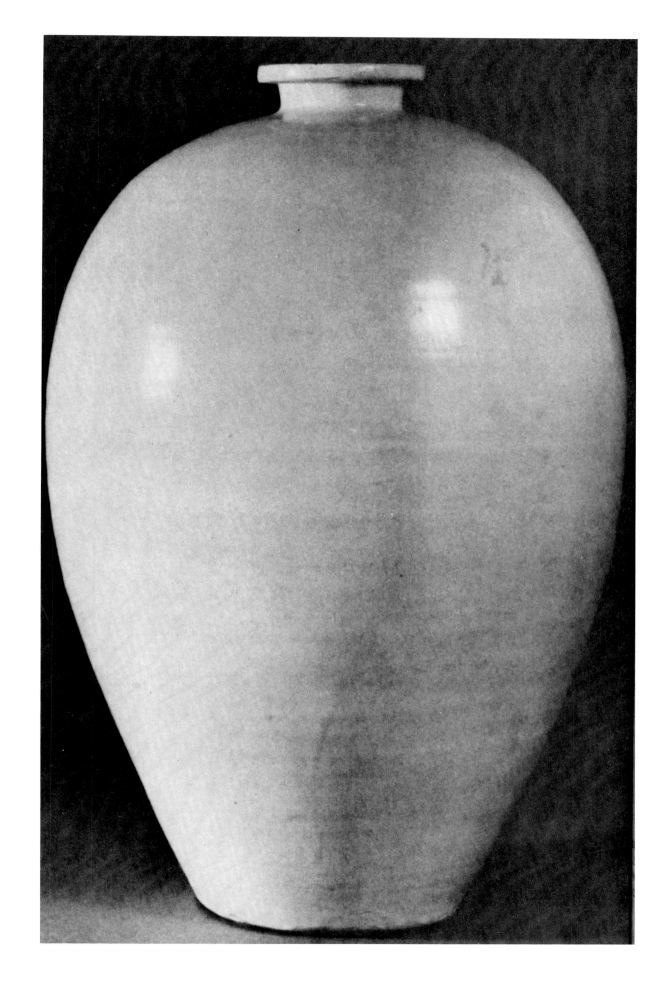

Plate 4
Mei-p'ing
Group 1
Northern Sung Dynasty, late 11th to early 12th centuries
H. 12-3/4 in. (33.6 cm.)
D. 7-9/16 in. (19.1 cm.)
Indianapolis Museum of Art, Gift of Mr. and Mrs. Eli Lilly

Tall vase with ovoid body, wide rounded shoulder and small neck, everted flattened mouth rim; recessed flat base. Grey stoneware covered with white slip and transparent glaze. Crackles in the glaze stained an iron rust color from burial. No decoration.

Published: Wilbur D. Peat, *Chinese Ceramics of the Sung Dynasty*, p. 8, pl. XI.

A plain white *mei-p'ing* with a longer neck but otherwise similar shape is in the Bristol City Art Gallery (Reg. no. 2444). Both examples have the rust-colored stain that is a distinctive feature of ceramics found at Chü-lu-hsien, the Sung dwelling site destroyed by floods in 1108. The finds from this site provide important evidence for the dating of these and a group of other Tz'u-chou wares to the late eleventh and early twelfth centuries.

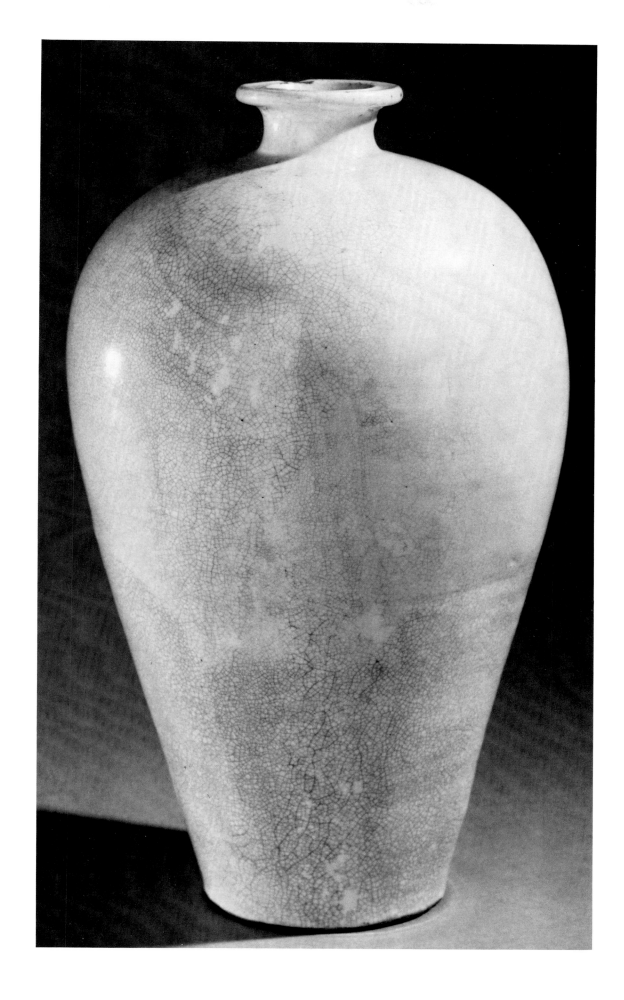

Plate 5
Ewer
Group 1
Northern Sung Dynasty, dated 1105
H. 11-5/8 in. (29.5 cm.)
The Cleveland Museum of Art, The Fanny Tewksbury King Collection

Ewer with ovoid body, wide shoulder tapering to a small base; slender neck with faint horizontal ridges and widely everted mouth; short curving spout on the shoulder; a pulled handle attached to the top of the neck and to the shoulder; splayed foot with recessed, convex base. Pale grey stoneware with white slip and transparent glaze stopping short of the foot. Reddish brown stain. Inscription written in ink on the base, reading: "Fourth year of Ch'ung-ning, twenty-ninth day of the second month, bought price seventy coppers—Ch'in family," the date corresponding to the year 1105.

Published: Lee, *"Two Basement Excavations,"* pl. II a and b; Hasebe, *So no Jishuyo,* pl 2; and Koyama, *So,* pl. 64.

An ewer that is nearly the same shape as this one, but having a slightly longer spout, is in the Tokyo National Museum. (Hasebe, *Jishuyo,* pl. 26.) Another similar piece is in the Victoria and Albert Museum (Reg. no. C 1000-1922).

Three other closely related ewers are known that have a rather more flattened mouth rim, one in a Japanese collection (Fig. 5) and another, its twin, in the Field Museum, Chicago (Reg. no. 127084). The third is in the Royal Ontario Museum (Reg. no. 920.10.15). All of these can be assigned a date in close proximity to that of the Cleveland piece, or around the end of the eleventh century and the early part of the twelfth.

An unusual variation of this type of vessel, an ewer with a long narrow neck and cup-shaped mouth but no handle, that is in the collection of the Museum für Kunst und Gewerbe, Hamburg, also belongs to the same period (Reg. no. 1932.18).

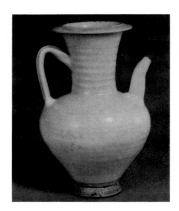

Figure 5

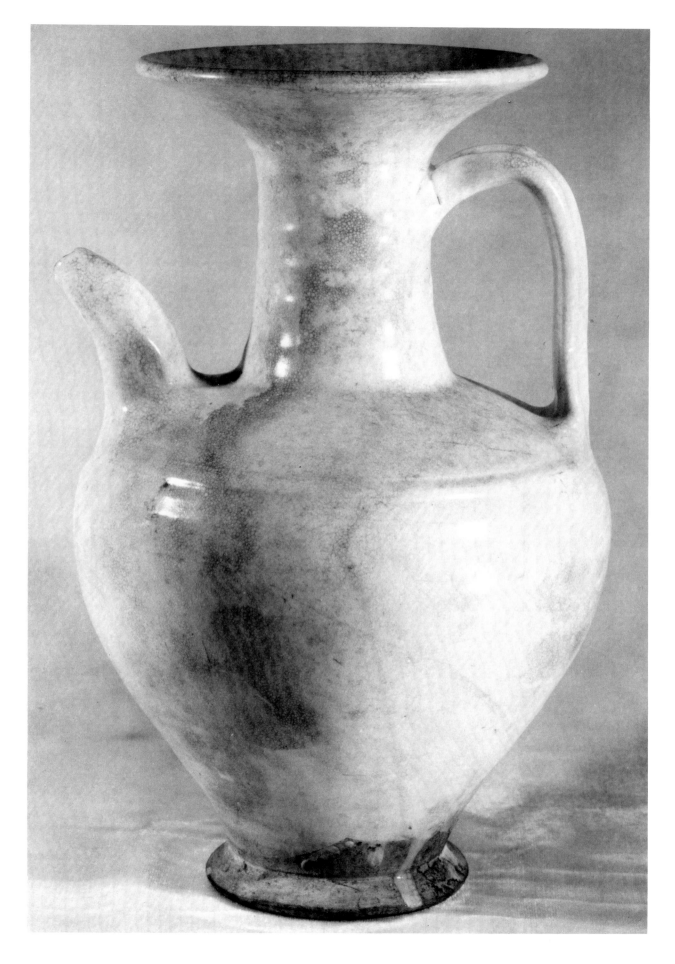

Plate 6
Lobed Jar
Group 1
Northern Sung Dynasty, 11th century
H. 5-1/4 in. (13.3 cm.)
D. 5-1/2 in. (14.0 cm.)
William Rockhill Nelson Gallery—Atkins Museum of Fine Arts, Kansas City

Jar with swelling body marked by evenly spaced vertical indentations, wide cylindrical neck and everted mouth rim; low vertical foot and recessed flat base. Grey stoneware with white slip and transparent glaze stopping above the foot. Glaze crackled and stained a reddish brown color.

Published: *Chinese Ceramics*, Los Angeles, Pl. 245.

The lobed jar appears to have been a relatively common vessel type within Group 1, as shown by the numerous examples that still exist. The Kansas City jar, with its rust-colored stain, is probably from Chü-lu-hsien and is of the same type as a jar known to have been found at that Sung site (Fig. 6, Li Hsiang-ch'i and Chang Hou-huang, *Chü-lu Sung-ch'i ts'ung-lu*, P. 25). A lobed jar was found in a tomb dated 1056 A.D. at Nan-kuan-wai, Cheng-chou (Fig. 7; *KK*, 1965, no. 8, pl. 5:5). A slightly different shape from the Kansas City example, with a higher shoulder and shorter neck, it may be a slightly earlier piece. Lobed jars have been unearthed at a number of kiln sites: at Kuan-t'ai (*WW*, 1964, no. 8, p. 39, fig. 3:1), at Hsi-kuan-yao in Mi-hsien (*WW*, 1964, no. 2, p. 57, fig. 7:3) and at Ch'ü-ho-yao in Teng-feng-hsien (*WW*, 1964, no. 3, p. 52, fig. 11:2).

Other examples that are preserved in Western collections include those in the Bristol City Art Gallery, the Field Museum of Natural History, the Museum für Ostasiatische Kunst, Köln, (Goepper, *Form und Farbe*, pl. 78) and the Herbert F. Johnson Museum of Art at Cornell University (Reg. no. 67.28). A lobed jar like the one in the Herbert F. Johnson Museum, one with a rather long, curved neck that is in the collection of Sammy Lee, bears an inscription dated to the year 1018 (Riddell, *Dated Chinese Antiquities 600-1650*, p. 51). Such an early date, however, seems questionable for this type of jar, and it is possible that the inscription is a later addition.

Figure 6

Figure 7

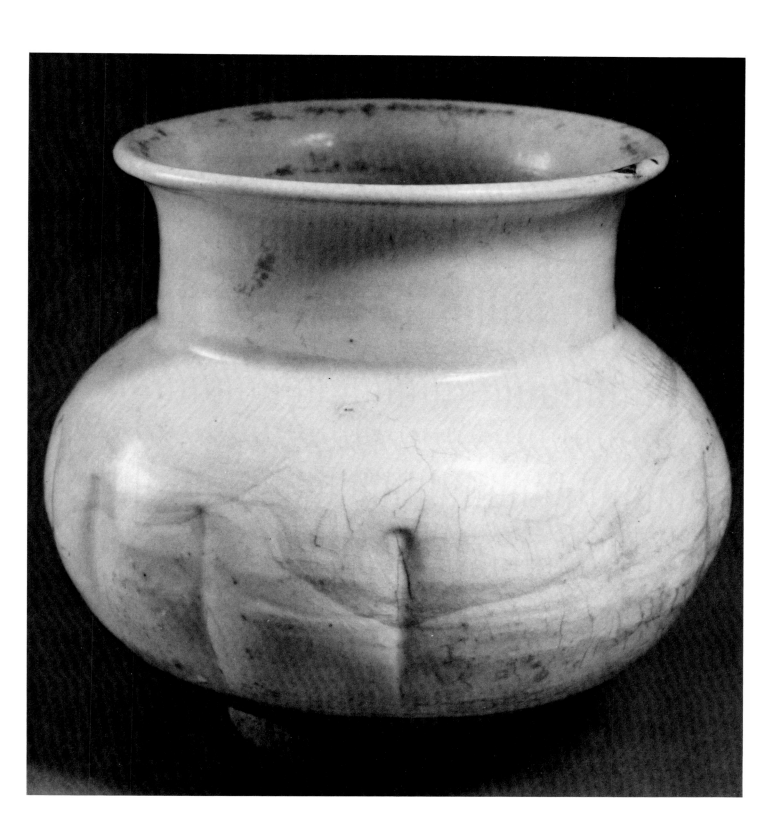

Plate 7
Peony Jars
Group 1
Northern Sung Dynasty, early 12th century
H. 5-1/8 in. (13 cm.)
Collection of Dr. Laurence Sickman

Pair of jars with globular body and short wide neck; vertical foot with recessed flat base. Pale grey stoneware covered with white slip and transparent glaze stopping short of the foot. Five rows of curving, vertically striated petals applied to the neck and body under the slip, the overall appearance like that of a large peony blossom.

Published: *Chinese Ceramics,* Los Angeles, pl. 247; and Trubner, "Tz'u-chou and Honan Temmoku," p. 157, fig. 7.

Although examples of this type of jar are not uncommon, parallels have not been reported among excavated materials from kiln sites, tombs or dwelling sites. A jar without petals but with a similarly shaped body and two loop handles at the neck was found at Chü-lu-hsien. (Fig. 8; Li Hsiang-ch'i and Chang Hou-huang, *Chü-lu Sung-ch'i ts'ung-lu,* p. 26.) A tentative attribution of the peony jars to the period close to or slightly later that of Chü-lu-hsien seems, therefore, not unreasonable.

Similar pieces can be seen in the Brundage collection (Fig. 9; d'Argencé, *Brundage Ceramics,* pl. XXXIX), the Barlow Collection at the University of Sussex (Sullivan, *Barlow Collection,* pl. 58 b), the Kempe Collection (*Kinas Kunst i Svensk og Dansk Eje,* pl. XX), and the British Museum (*Ausstellung* Chinesischer Kunst, Berlin, 1929, no. 643).

Figure 8

Figure 9

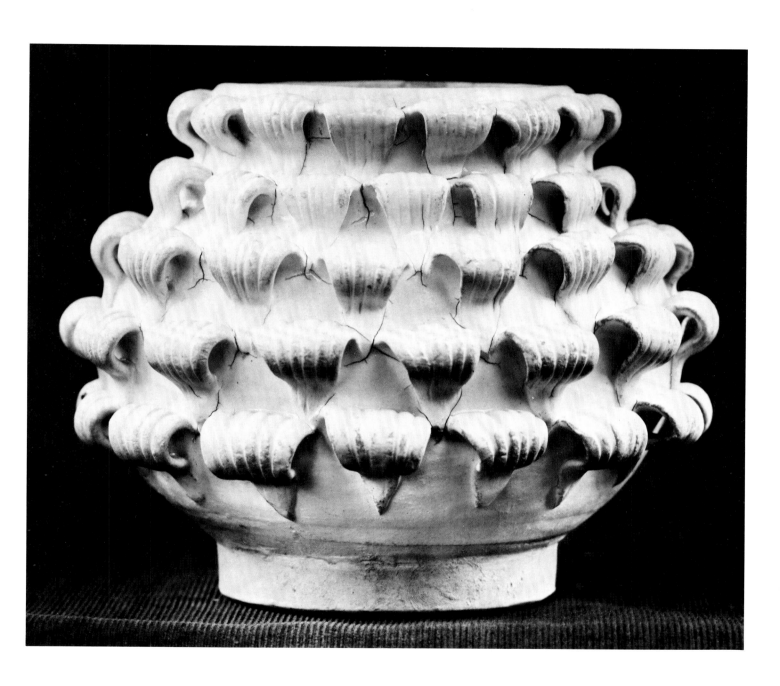

Plate 8
Vase
Group 2
Northern Sung Dynasty, late 10th—early 11th centuries
H. 10-3/8 in. (26.3 cm.)
Collection of Tazawa Yutaka, Tokyo

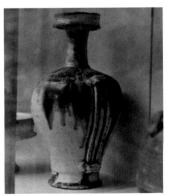

Figure 10

Vase with ovoid body, high rounded shoulder, narrow near-ly cylindrical neck and wide dished mouth with nearly verti-cal rim; slightly flaring foot pierced with two small rectangu-lar holes at opposite sides below the small, horizontally placed handles. Buff stoneware with white slip and trans-parent glaze stopping at the foot; splashes of green glaze around each handle on the shoulder.

Published: Hasebe, *Jishuyo*, Pl. 3; and *Sekai toji zenshu*, vol. 12, 1977, Pl. 225.

Made in a limited number of shapes during the tenth and elev-enth centuries, plain white ware with green splashes on the glaze is also among the earliest of the groups of Tz'u-chou type wares. The Tazawa vase is an unusual type of vase made apparently to be sup-ported by a leather strap or a cord threaded through the holes in the foot and through the flattened handles or guides on the shoulder. Similar vases are known that have more extensive green splashes and two additional handles on the lower part of the body. One of these vases is in the Victoria and Albert Museum (Fig. 10) and another is illustrated in a work by J. J. Marquet de Vasselot published in 1922 (Fig. 11; de Vasselot, *La Céramique Chinoise*, pl. 4, right). Running between the upper and lower handles on either side are two relief cordons separated by the width of the handles that would have further served to keep the threaded strap in place. A Liao Dynasty vase of this type, covered with an amber-brown glaze, was unearthed in T'u-ch'eng-tzu, Ho-lin-ko-erh in Inner Mongolia. (Fig. 12; *WW* 1961, no. 9, pl. 2:1) The vase, found with a parrot-shaped ewer very similar to one from a relic chamber of a pagoda dated 976-977 discovered in Ting-hsien, Hopei Province, can be dated to the tenth century. (See *WW*, 1961, no. 9, front cover; and *WW* 1972, no. 8, pl. 1: right.)

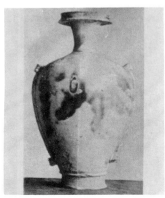

Figure 11

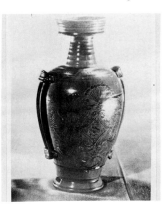

Figure 12

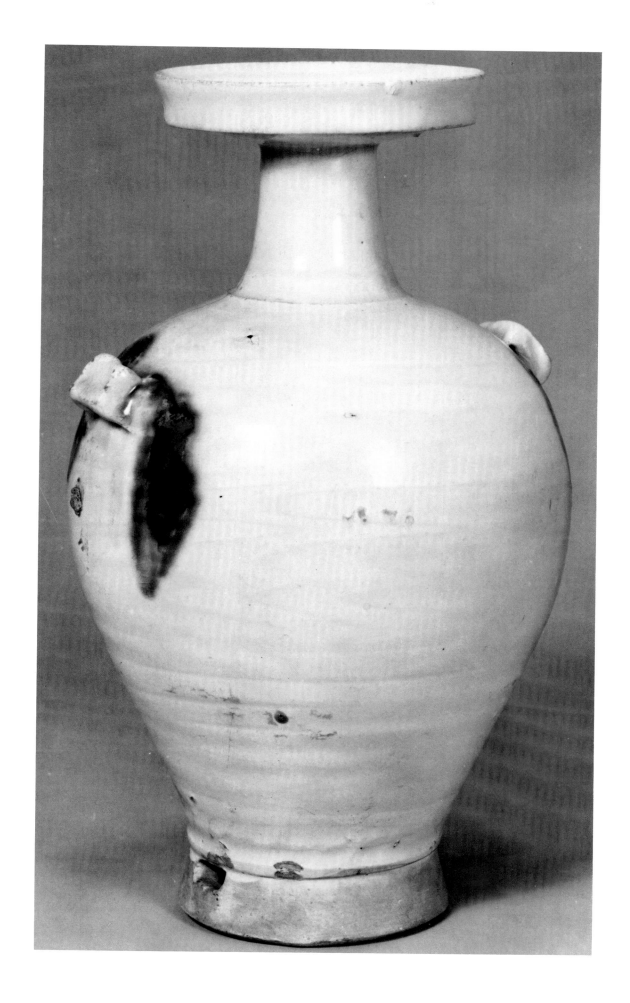

Plate 9
Vase
Group 3
Northern Sung Dynasty, late 10th—early 11th centuries
H. 17-1/16 in. (43.2 cm.)
Indianapolis Museum of Art, Gift of Mr. and Mrs. Eli Lilly

Figure 13

Tall vase with flattened shoulder, long slender neck and dished mouth; flaring foot and recessed flat base. Grey stoneware covered with white slip and transparent glaze. Deeply carved decoration of large peony scrolls in a wide band around the body and in a narrower band on the shoulder; a row of finely incised scrolls on the lower part of the body above carved, overlapping lotus petals around the base.

Published: Ch'en Wan-li, *Sung-tai pei-fang min-chien tz'u-ch'i,* pl. 19; Peat, *Chinese Ceramics of the Sung Dynasty,* p. 13, pl. XXIII; and Mino and Tsiang, "Chinese Art in the Indianapolis Museum of Art," pl. 6.

Manufactured in the tenth and eleventh centuries, Group 3 objects are also among the earliest of Tz'u-chou type wares. The principal motif in the deeply carved ornament on these objects is the peony depicted with two kinds of blossoms and surrounded by scrolling stems and three-pointed, curving leaves. Wares with this style of decoration are known to have been produced in Teng-feng-hsien from finds of kiln wasters like the fragment with a carved peony design that was unearthed at the Ch'ü-ho-yao kiln site (Fig. 13; *WW* 1964, no. 3, p. 53, fig. 12:4).

The most striking of the vessel shapes in this group of wares is the tall vase with long narrow neck and dish-shaped mouth. There are two types of this vase that are readily distinguishable by variations in the shape of the mouth, body and foot. The first type has a mouth of conical shape with low, nearly vertical rim that leans inward slightly. The body has smoothly rounded contours—a high, swelling shoulder and a tapered lower portion that flares outward again toward the base. Examples of this type are in the Freer Gallery (Fig. 14) and the Museum of Fine Arts, Boston (Fig. 15). Both have a large peony band around the widest part of the body. Plain white vases of this type have been found in Liao tombs, one in the tomb of a member of the Liao royal family in Ta-ying-tzu-ts'un, Ch'ih-feng-hsien in Liaoning Province that is dated 959 A.D. (*KKHP,* 1956, no. 3, pl. 8:3). A second such vase was unearthed from a tomb in Chu-lu-k'o-ts'ung, Chien-p'ing-hsien, also in Liaoning (*KK,* 1960, no. 2, pl. 3 and p. 20, fig. 3). The Indianapolis vase is representative of the second type, with its more angular shape and flatter mouth with wider, slightly everted rim. While the style of ornament is very similar to that on vases of the first type, here the elements are more evenly distributed in the three principal bands on the body. The shape of the second type of vase is similar to that of the amber-brown glazed vase found in a Liao tomb in Ho-lin-ko-erh (see Fig. 12) which is probably of the later part of the tenth century. On the basis of the related Liao material, vases of the second type can be considered slightly later than those of the first. Two other examples of the second type are known, one in the Minneapolis Museum of Art (Fig. 16: Hasebe, *So no Jishuyo,* pl. 4) and the second in the Victoria and Albert Museum, where it is currently on loan (Fig. 17, Photograph courtesy of Mr. Giuseppe Eskanazi).

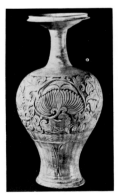

Figure 14

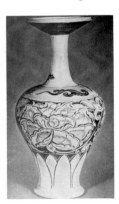

Figure 15

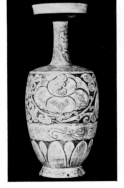

Figure 16

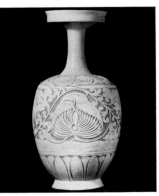

Figure 17

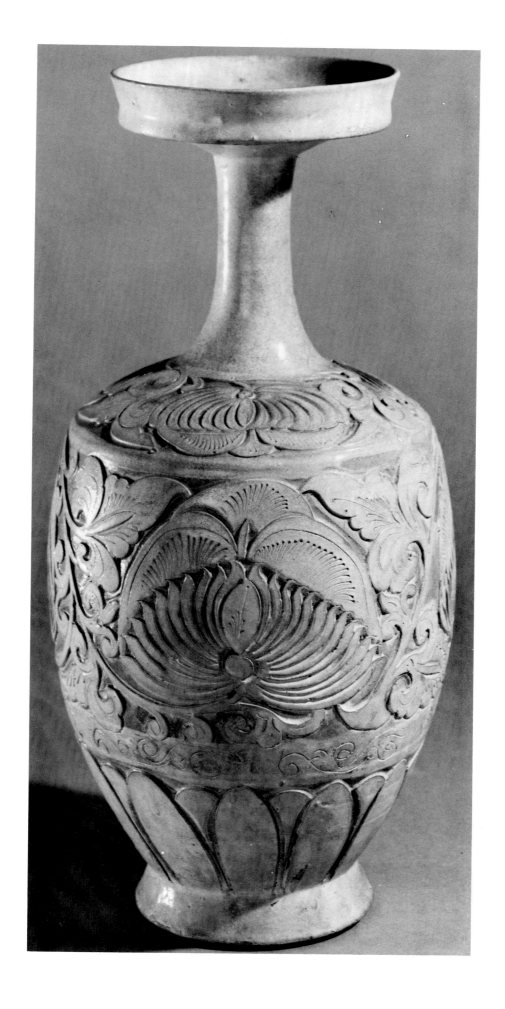

Plate 10
Ewer
Group 3
Northern Sung Dynasty, late 10th—early 11th centuries
H. 8-1/16 in. (20.4 cm.)
Tokyo National Museum

Ewer with depressed globular body, flat sloping shoulder and rather long cylindrical neck; flat curving handle attached to neck and edge of shoulder opposite a narrow spout that bends outward at the top. Slightly flaring low foot and recessed flat base. Domed cover with conical knob at the top and a wide vertical rim fitting over the mouth of the vessel. Pale grey stoneware with white slip and transparent glaze. Deeply carved decoration of large peonies and leaves on curling stems around the body; overlapping lotus petals around the shoulder.

Published: *Sekai toji zenshu*, 1955, vol. 10, pl. 113; Oriental Ceramic Society, "The Ceramic Art of China," *TOCS*, vol. 38, pl. 61; Wirgin, "Sung Ceramic Designs," pl. 41:a; Hasebe, *Jishuyo*, pl. 5; and *Sekai toji zenshu*, 1977, vol. 12, pl. 111.

Ewers are an important part of Group 3. Typically, they are short with nearly globular bodies and are made in two types. The first type like the Tokyo ewer, has a flat shoulder, cylindrical neck and longer spout. The handle, attached at the top to the neck at a right angle, bends abruptly upward then curves back downward to join the body at the shoulder. Closely related examples include those in the Cleveland Museum of Art (see Pl. 11), a collection in Paris (Rivière, *La Cé ramique dans l'art d'Extrême-Orient*, vol. 2, pl. 58 top), and one formerly in the Matsuda collection, Japan (Towakai, *Soji tenkan zuroku*, pl. 4). Another ewer of the first type, in a Japanese private collection (Fig. 18), has only a decoration of large overlapping petals instead of the more common peonies. The second type of globular ewer has a shorter neck and everted mouth, rounded, sloping shoulder and short spout and is probably later in date. Examples in the Yamato Bunkakan (Fig. 19; Wirgin, "Sung Ceramic Designs," pl. 41:d) and the British Museum (Wirgin, *op. cit.*, pl. 41:c) are representative of this type. A related piece, in the Royal Ontario Museum, has a slightly longer, ovoid body and widely everted mouth (Wirgin, *op. cit.*, pl. 41:e). The body is of a softer material than that of the above-memtioned pieces, brick red in color, and may be the product of a different kiln.

A unique example of a third type of ewer, shown here for comparison, is a fine, tall piece with high shoulder and wide trumpet-shaped neck (Fig. 20; from the Photographic Archives of the School of Oriental and African Studies, University of London, catalogue no. 11043). Unfortunately, it is known only from a photograph and seems no longer to exist. With its long, grooved spout, triple strand handle, stepped flared foot and carved peony decoration bordered by rows of small overlapping lotus petals, it is quite unusual in many respects, but can be dated to about the same period as the Tokyo National Museum ewer.

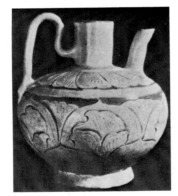

Figure 18

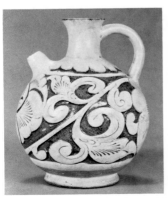

Figure 19

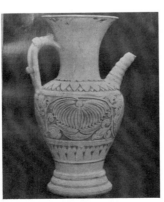

Figure 20

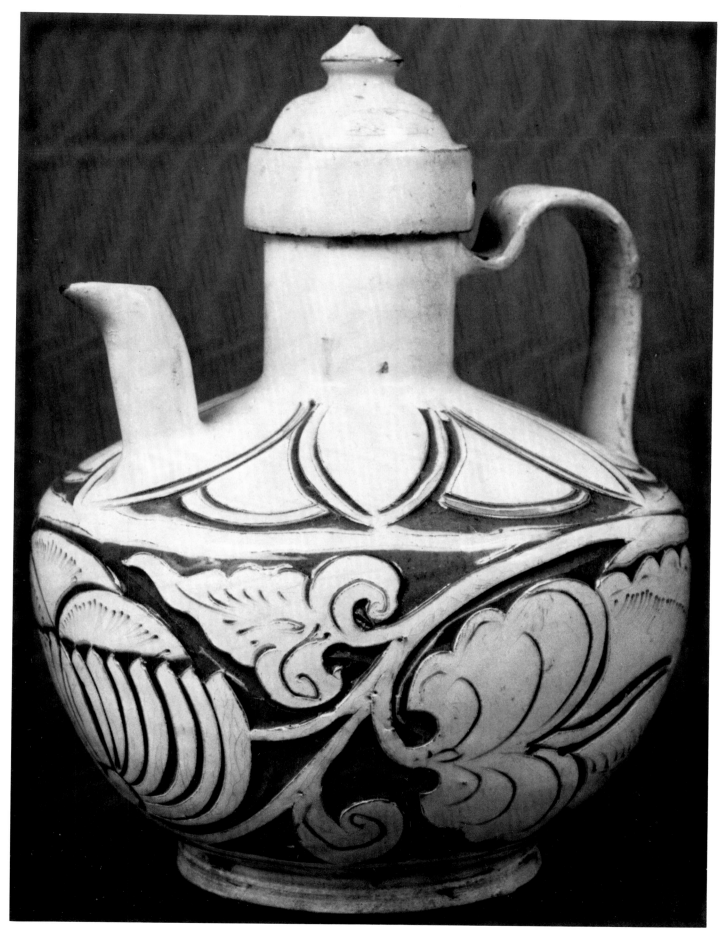

Plate 11
Ewer
Group 3
Northern Sung Dynasty, 11th century
H. 6-7/8 in. (16.5 cm.)
D. 6-1/4 in. (15.9 cm.)
The Cleveland Museum of Art, Purchase from the J. H. Wade Fund.

Ewer with depressed globular body, flat sloping shoulder and cylindrical neck; curving flat handle attached to the neck and shoulder opposite a narrow spout; low flaring foot and recessed flat base. Buff stoneware with white slip and transparent glaze. Deeply carved decoration of large peonies and leaves on a scrolling stem around the body; overlapping lotus petals around the shoulder.

Published: Rivière, *La Céramique dans l'art d'Extrême-Orient*, p. 213, pl. 58; Plumer, "The Potter's Art at Cleveland," *American Magazine of Art*, Apr. 1940, p. 213; Hollis, "More Sung Dynasty Stoneware," p. 11; "Far Eastern Art," *Far Eastern Quarterly*, vol. IX, no. 1, p. 69; *Tosetsu*, no. 41 (Aug. 1956), p. 46; Lee, *A History of Far Eastern Art*, (New York, 1964), p. 363, fig. 473; Hasebe, *So no Jishuyo*, pl. 6 bottom; *Toyo toji ten: Chugoku, Chosen, Nihon*, (Tokyo National Museum, 1970), pl. 230; Wirgin, "Sung Ceramic Designs," pl. 41:b; and Lee, *The Colors of Ink*, pl. 50.

Although of the same type as the Tokyo National Museum ewer (see Pl. 10), differences in shape and ornament point to a slightly later date for the Cleveland ewer. The carved decoration on the Cleveland piece, while quite similar to that on the ewer in the Tokyo National Museum, has a looser, more freely drawn appearance, particularly in the incised details. On the petals around the shoulder, the double outlines have been eliminated. The spout is shorter, midway in length between the Tokyo ewer and examples of the second type (see Fig. 19).

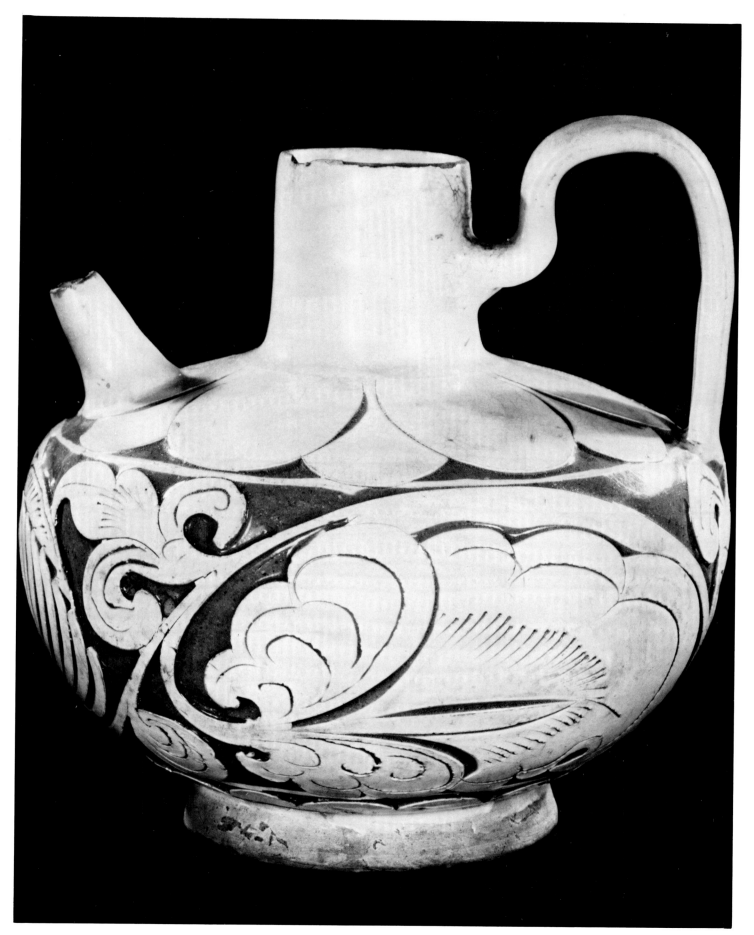

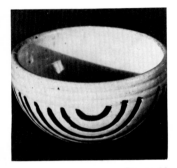

Figure 21

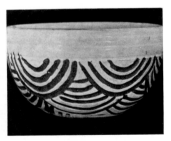

Figure 22

Figure 23

Figure 25

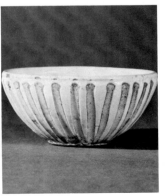

Figure 24

Figure 26

Plate 12
Bowl
Group 3
Northern Sung Dynasty, 11th century
H. 3-1/4 in. (8.2 cm.)
D. 4-7/8 in. (12.4 cm.)
Yale University Art Gallery, New Haven, Conn.,
Gift of Mrs. William H. Moore for the Hobart Moore
and Edward Small Moore
Memorial Collection.

Hemispherical bowl with recessed flat base. Grey stoneware with white slip and transparent glaze stopping at the base. Decorated with deeply carved parallel arcs cut through the white slip; three carved horizontal grooves around the mouth rim beneath the slip.

Published: Lee, George J., *Selected Far Eastern Art in the Yale University Art Gallery* (New Haven, 1970), p. 152, no. 299.

A number of small cups having this distinctive style of decoration can be discussed here with the group of deeply carved wares. A fragment of a bowl with a similar pattern of arcs carved into a dark body was unearthed at the Ch'ü-ho-yao kiln site in Teng-feng-hsien (Fig. 21; *WW*, 1964, no. 3, p. 54, fig. 13). Two cups with similar decoration can be seen in the Museum of Fine Arts, Boston. One has a dark body showing a deep brown color under the glaze (Fig. 22; *The Charles B. Hoyt Collection*, 1952, pl. 280), and the other has a much lighter-colored body (Fig. 23; from the photographic archives of the Fogg Art Museum, no. 1310M 9(W)). A cup with a design of overlapping groups of parallel arcs, believed to have been made in Teng-feng-hsien, is published in the report of the excavation of Ch'ü-ho-yao (Fig. 24; *WW*, 1964, no. 2, pl. 6:4). This piece, with its dark body, appears likely to be from Teng-feng-hsien; however, the variations in color that occur among these cups indicates that they may have been manufactured, also, at other kilns.

A slightly different style of decorating this type of cup can be seen on a piece formerly in the collection of C. T. Loo (Fig. 25; from the photographic archives of the Fogg Art Museum, no. 1310M 9(U)), on which the carved lines radiate upward from the base and the horizontal grooves around the mouth, too, have been cut through the white slip to the dark body beneath. On a similar piece in the Museum of Fine Arts, Boston, the lines on the body are oblique rather than vertical (*The Charles B. Hoyt Collection*, 1952, pl. 281). A shallower, wider cup, in the Umezawa collection, that is also decorated with lines radiating upward from the base is made with the grooved, collar-like mouth rim (Fig. 26; Hasebe, *Jishuyo*, p. 95, fig. 15). The lines on this cup are less uniformly cut than those on the previous examples.

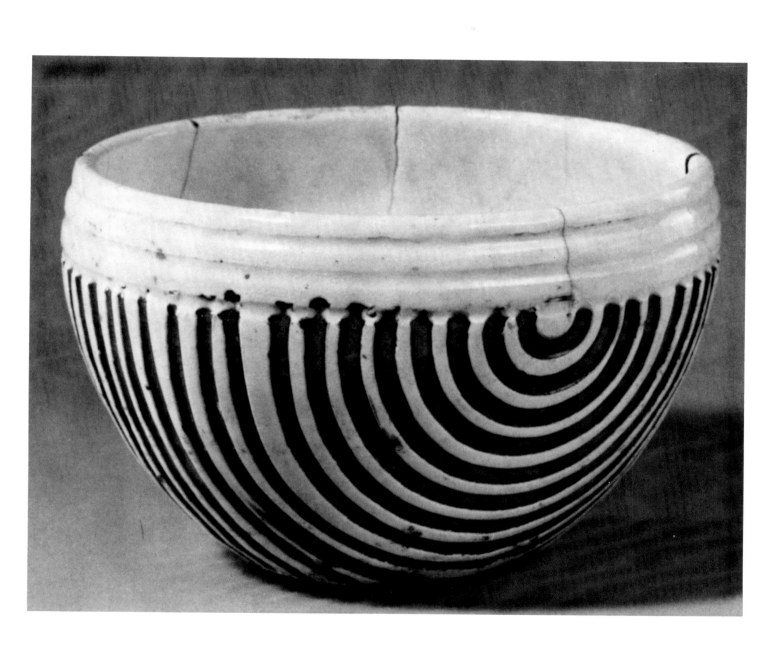

Plate 13
Vase
Group 4
Northern Sung Dynasty, late 10th—early 11th centuries
H. 16-1/4 in. (41.5 cm.)
The Cleveland Museum of Art, Purchase, J. H. Wade Fund.

Vase with flattened shoulder, long slender neck and dished mouth; slightly flaring foot and recessed, flat base. Grey stoneware covered with white slip and transparent glaze. Curvilinear designs inlaid in white slip on the body: large peonies and curling stems and leaves in a wide band around the body above a knobbed scroll border; feathery leaf scrolls on the shoulder.

Published: J. M. Plumer, "The Potter's Art at Cleveland," *American Magazine of Art*, April, 1940, p. 213; *Far Eastern Quarterly*, vol. IX, no. 1, Hollis, "More Sung Dynasty Stoneware," p. 10; Koyama, "Hokuso no Shubuyo," pl. IV; *Chinese Ceramics*, (Los Angeles County Museum, 1952), pl. 228; Mayuyama Junkichi, *Chinese Ceramics in the West*, (Tokyo, 1960), pl. 36; Sherman Lee, *A History of Far Eastern Art*, p. 364, fig. 475; Hasebe, *So no Jishuyo*, pl. 31; Hasebe, "Ju seiki no Chugoku toji," p. 213, fig. 22; Wirgin, "Sung Ceramic Designs," pl. 40:i; Hasebe, *Jishuyo*, pl. 31; and *Sekai toji zenshu*, vol. 12, 1977, pl. 110.

Two main types of wares with inlaid decoration are known. The first, of which the Cleveland Museum vase is an example, has a very finely incised decoration that is filled with white slip and can be dated to the tenth and eleventh centuries. The second is decorated with stamped and molded patterns of a rather later style, probably of the 12th century. A pillow of the second type showing the use of inlay in the stamped decoration of two deer and other ornamental motifs on the top is in the Museum of Fine Arts, Boston (Fig. 27; Kobayashi, *Shina toji zusetsu*, pl. 16). Very few examples of either type are known.

The Cleveland vase is contemporary with vases with deeply carved decoration that have the same shape (see Pl. 9). An inlaid vase with a similarly shaped body but much shorter neck is in the Buffalo Museum of Science (Fig. 28; Hochstadter, "Early Chinese Ceramics," p. 145, fig. 97). The decoration is less finely executed and lacks the knobbed scroll border at the bottom, but closely resembles the Cleveland vase in style. The short neck appears to be the work of a later repairer, and it seems quite probable that the Buffalo piece, too, originally had a long neck and dished mouth.

Figure 27

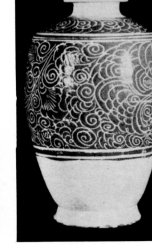

Figure 28

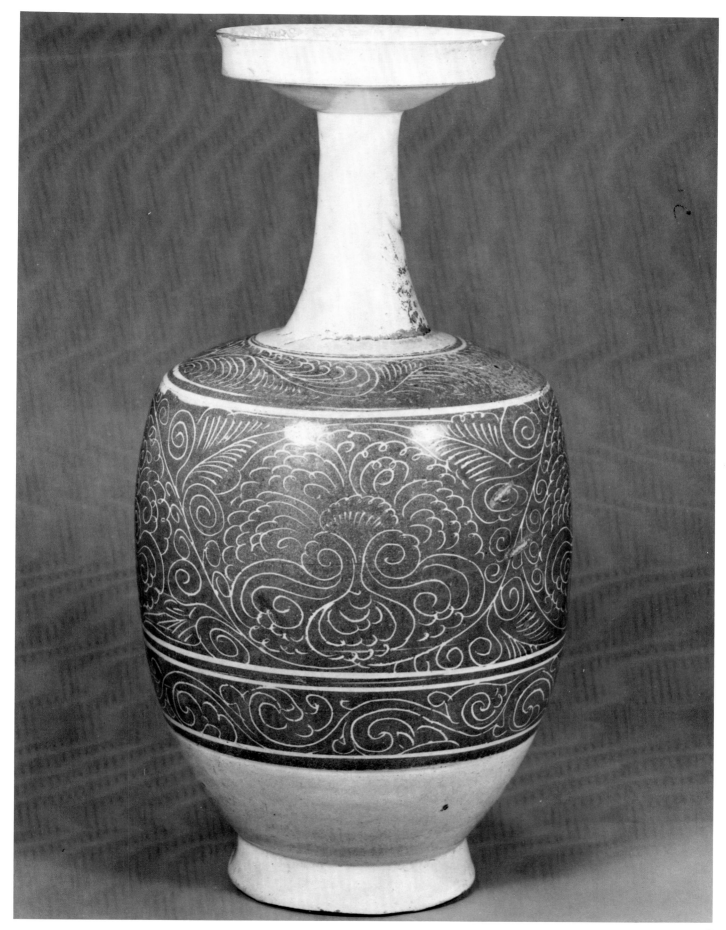

51

Plate 14
Pillow
Group 4
Northern Sung Dynasty, late 10th—early 11th centuries
H. 3-1/2 in. (9.8 cm.)
L. 7-7/8 in. (20.0 cm.)
The Art Institute of Chicago

Cloud-shaped pillow with concave top slightly overhanging the lobed, vertical sides. Grey stoneware with white slip and transparent glaze. An incised peony in a white, reserved diamond-shaped panel on the top surrounded by curvilinear cloud scroll patterns in white slip inlaid in the clay body. Deeply carved peony motifs around the sides.

Published: Wirgin, "Sung Ceramic Designs," pl. 41:k.

The appearance of inlay together with deeply carved decoration on this pillow demonstrates the use of the two ornamental techniques contemporaneously and at the same kiln. It is probable that inlay work was employed in the decoration of wares from Ch'ü-ho-yao in Teng-feng-hsien, where deeply carved ware has already been found (see Fig. 13).

A very similar cloud-shaped pillow that has carved peony designs around the sides and an incised peony in a diamond-shaped panel on the top but no inlaid decoration is in the Yamato Bunkakan (Fig. 29; Hasebe, *Jishuyo*, pl. 33). Another closely related piece is a rectangular pillow whose two narrow ends slant inward toward the base (Fig. 30; Musée Guimet, *Collection Michel Calmann*, Paris, 1969, p. 51, pl. 15). It has carved peonies on the sides and an incised peony on the top flanked by two carved cloud scrolls that closely resemble those on the shoulder of the tall vase in the Museum of Fine Arts, Boston (see Fig. 15).

Figure 29

Figure 30

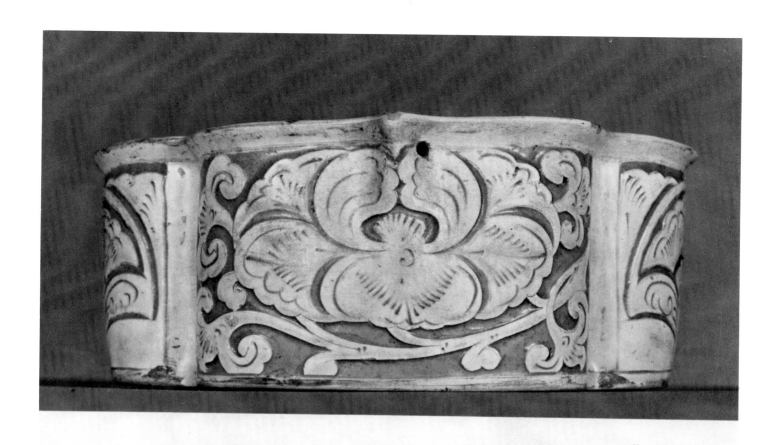

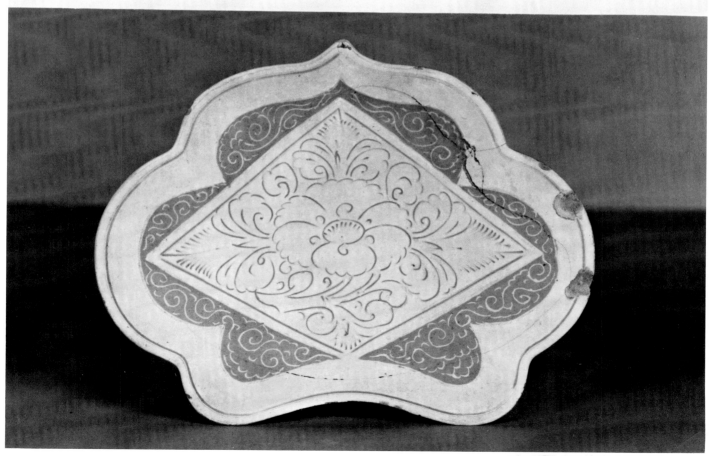

Plate 15
Pillow
Group 5
Northern Sung Dynasty, early 11th century
H. 4-1/16 in. (10.3 cm.)
L. 8-13/16 in. (22.4 cm.)
Okayama Museum of Art, Japan, Gift of Mr. Ichiro Hayashibara

Bean-shaped pillow with slightly concave forward-sloping top. Grey stoneware covered with white slip and transparent glaze. Incised decoration on a stamped 'fish-roe' ground; on the top a parrot in flight among drifting clouds bordered by a band of incised 'classic' scrolls; around the sides, a continuous band of knobbed scrolls on a 'fish-roe' ground.

Published: Hasebe, "Hokuso zenki no Jishuyo," p. 27, fig. 14; Hasebe, *Jishuyo*, pl. 2. *Sekai toji zenshu*, vol. 12, 1977, p. 232, fig. 92, and Mino, "Stamped 'Fish-roe' Ground," Pl. 4.

Tz'u-chou type wares with incised decoration on a ground of closely stamped rings resembling fish-roe were produced from the 10th century to the early 12th century. They can be classified into three principal sub-groups according to their different styles of decoration, which correspond to different places of origin. One sub-group is associated with the kilns in Teng-feng-hsien and Mi-hsien in northern Honan and another with kilns discovered at Kuan-t'ai in Han-tan-hsien, Honan. The third is of unknown provenance, although a number of possible places of manufacture can be suggested.

The wares from Teng-feng-hsien and Mi-hsien are the earliest sub-group, whose style and precision of ornamentation show the influence of T'ang metalwork. On the basis of this similarity, Chinese archeologists have dated the Teng-feng-Mi-hsien wares with stamped 'fish-roe' to the late T'ang Dynasty. Other evidence, however, indicates that they are substantially later, and that their development can be divided into three periods, the earliest of which corresponds to the late tenth and early eleventh centuries. The middle and late periods fall roughly into the middle and late decades of the eleventh century.

Probably one of the earliest existing pieces decorated with 'fish-roe' stamping, the Okayama Museum pillow is closely related to a bean-shaped pillow in the Palace Museum, Peking, that is said to be from Mi-hsien (Fig. 31; *Chugoku nisennen no bi*, pl. 73). The latter has a parrot on the top surrounded by knobbed scrolls. Around the sides are rows of stamped rings alternating with rows of stamped star-like flowers, flowers like those that appear on a fragment of a pillow found at a kiln site in Mi-hsien. (Fig. 32; *WW*, 1964, no. 3, p. 50, fig. 8:2) The parrot depicted on these pillows resembles that of a parrot-shaped ewer found in a tomb dated 976-977 in Ting-hsien, Hopei (Fig. 33; *WW*, 1972, no. 8, pl. 1 right), and another ewer unearthed from a Liao tomb at T'u-ch'eng-tzu, Ho-lin-ko-erh, in Inner Mongolia (*WW*, 1961, no. 9, front cover and p. 32). Close similarities of detail between the incised parrots and those modeled in three dimensional form, such as the lines radiating outward from the back of the beak, indicate a correspondingly close proximity in date.

Figure 31

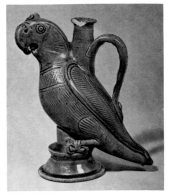
Figure 33

Figure 32

54

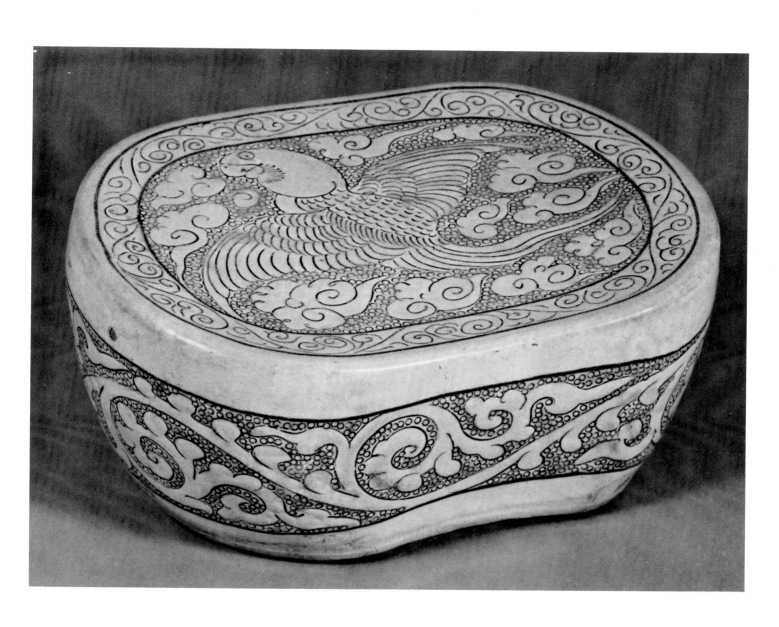

Plate 16
Pillow
Group 5
Northern Sung Dynasty, early 11th century
H. 3-1/8 in. (7.9 cm.)
L. 6-5/8 in. (16.9 cm.)
British Museum

Bean-shaped pillow with flat forward-slanting top surface. Light buff-colored stoneware covered with white slip and transparent glaze with slight yellowish green tint. Incised decoration of a quail, its head turned backward, standing between two tall stalks of grass on a stamped 'fish-roe' ground on the top; an incised feathery leaf scroll around the sides.

Published: Ayers, *The Seligman Collection*, pl. XXXVII: D 106; Wirgin, "Sung Ceramic Designs," pl. 42:d; and Mino, "Stamped 'Fish-Roe' Ground," Pl. 6.

This pillow is also of the early period and bears a close resemblance to a bean-shaped pillow, in the Ashmolean Museum (Fig. 34; Mino, "Stamped 'Fish-Roe' Ground," pl. 7), that has a quail among tall grasses on the top and a knobbed scroll pattern around the sides like that on the Okayama Museum pillow (see Pl. 15). A fragment of a pillow decorated with the quail and grass motif on a 'fish-roe' ground was excavated at the Hsi-kuan kiln site in Mi-hsien (Fig. 35; *WW*, 1964, no. 3, p. 50, fig. 7). The quail appears as the subject matter of a number of surviving academic paintings of the Sung Dynasty. One, entitled 'A Quail and a Flowering Narcissus Plant' and attributed to Hui-tsung, is in the Asano Collection (Siren, *Chinese Painting*, pl. 238, top). A second, depicting a quail nesting among grasses and flowering peach branches, is a twelfth century work attributed to Li An-chung (Fig. 36; *Selected Masterpieces from the Collection of the Nezu Institute of Fine Arts*, Tokyo, 1978, pl. 4).

The leaf scroll design incised around the sides is another feature of pillows of the early and middle periods from Teng-feng-hsien and Mi-hsien. On earlier examples there is a row of looping spirals along the top of the band above the feathery frond-like scrolls, as on the British Museum pillow. A four-lobed pillow of similar shape that displays this same feathery leaf scroll design on the sides is in the Sano Museum, Mishima (Fig. 37; Hasebe, *Jishuyo*, pl. 29). The top of the pillow is decorated with a duck walking among lotuses inside a border of incised feathery fronds.

Figure 34

Figure 35

Figure 36

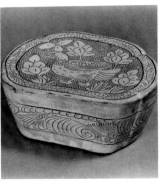

Figure 37

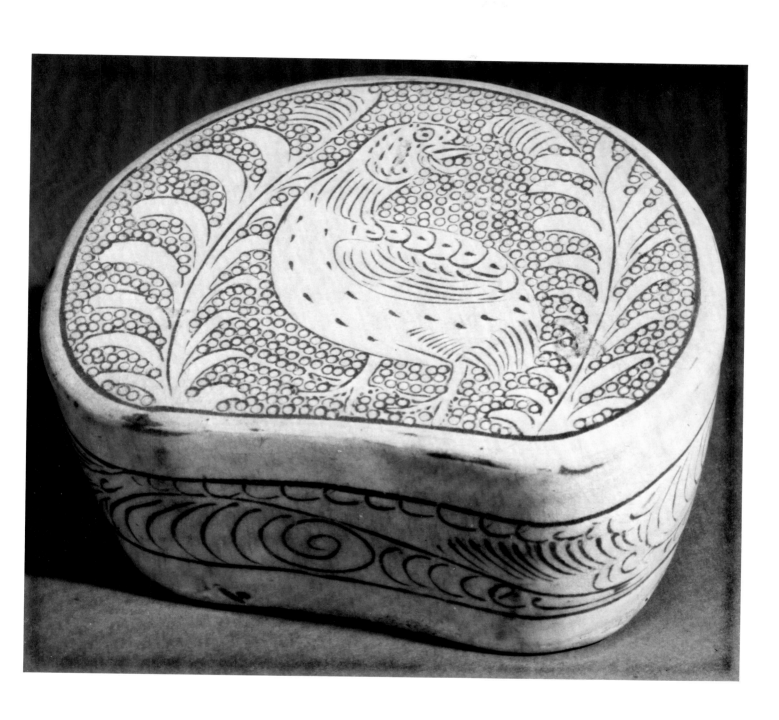

Plate 17
Pillow
Group 5
Northern Sung Dynasty, early 11th century
H. 3-1/2 in. (8.7 cm.)
W. 6-3/8 in. (16.2 cm.)
Museum of Fine Arts, Boston, Gift of C. Adrian Rübel

Four-lobed pillow with slightly concave top and four vertical indentations around the sides. Grey stoneware covered with white slip and transparent glaze. Incised decoration on a ground of stamped 'fish-roe'; on the top, a deer walking through tall grass; on the sides, large flowers and curling leaves in rectangular panels.

Published: Paine, "Chinese Ceramic Pillows," pl. 24; Wirgin, "Sung Ceramic Designs," pl. 43:b, and Mino, "Stamped 'Fish-Roe' Ground" pl. 9.

The tall stalks of grass flanking the deer, seen previously on the quail pillows (see Pl. 16), help to identify this as one of the group of small pillows of the early period from the Teng-feng-Mi-hsien area. A large flower, like that on the front of the Boston pillow shown here, appears on a pillow unearthed at the Hsi-kuan kiln site in Mi-hsien (see Fig. 32; *WW*, 1964, no. 3, p. 50, fig. 8:4). A similar floral design can be seen on the front of a four-lobed pillow in the British Museum that has a goat instead of a deer depicted on the top (Mino, "Stamped 'Fish-Roe' Ground," pl. 8). On another four-lobed pillow, formerly in the Cunliffe collection, a deer strides among grasses and rocks (Fig. 38; Wirgin, "Sung Ceramic Designs," pl. 43:b). Around the sides are large trefoil designs set in trapezoidal panels.

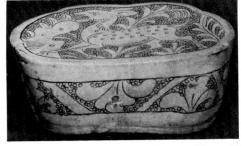
Figure 38

58

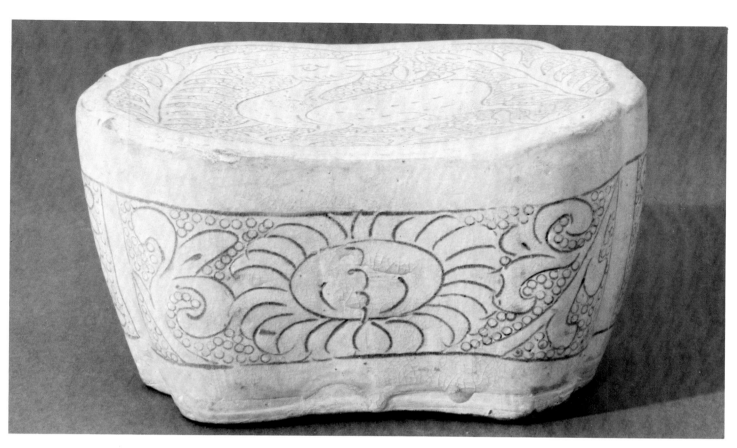

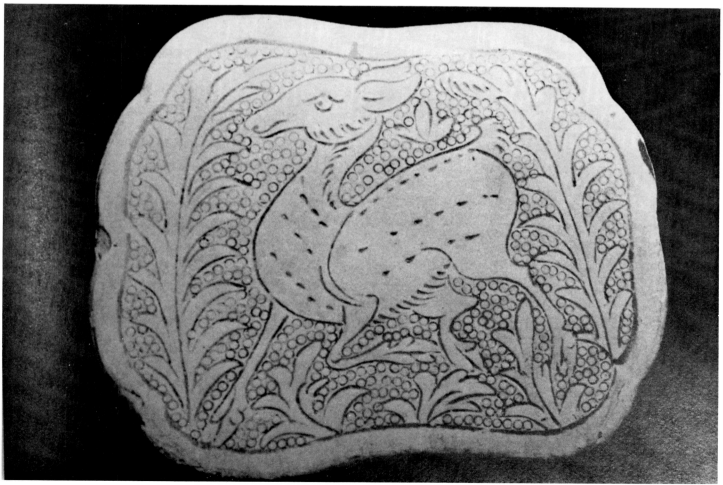

Plate 18
Mei-p'ing
Group 5
Northern Sung Dynasty, early 11th century
H. 15-1/4 in. (36.2 cm.)
William Rockhill Nelson Gallery—Atkins Museum of Fine Arts, Kansas City

Mei-p'ing with ovoid body, narrow at the shoulder and wider at the foot, small everted mouth and recessed, flat base. Grey stoneware covered with white slip but not glazed. Incised decoration on a stamped fish-roe ground; a large floral scroll in the main ornamental band around the body, knobbed scrolls on the shoulder and overlapping lotus petals around the base.

Published: *Handbook of the Nelson Gallery of Art Atkins Museum, Kansas City*, vol. II, (1973), p. 85 right.

This vase, too, is an example of early 'fish-roe' decorated wares. In shape it closely resembles the *mei-p'ing* of *ch'ing-pai* ware that was found in the tomb dated 1027 in Nanking (see Fig. 4). The knobbed scroll design around the shoulder is the same as that seen on pillows of the early period, as around the sides of the Okayama Museum pillow (see Pl. 15). A contemporary vase, also of Teng-feng-Mi-hsien origins, is the *mei-p'ing* in the Palace Museum, Peking, that is decorated with a leopard and other fierce creatures among tufts and longer stalks of grass (Fig. 39; *Ku-kung Po-wu-yüan ts'ang-tz'u hsüan-chi*, pl. 36). The row of lotus petals around the base of the two vases is nearly identical. The stalks of grass on the latter like those seen on the pillows are decorated with deer and quail (see Pls. 16 and 17).

Figure 39

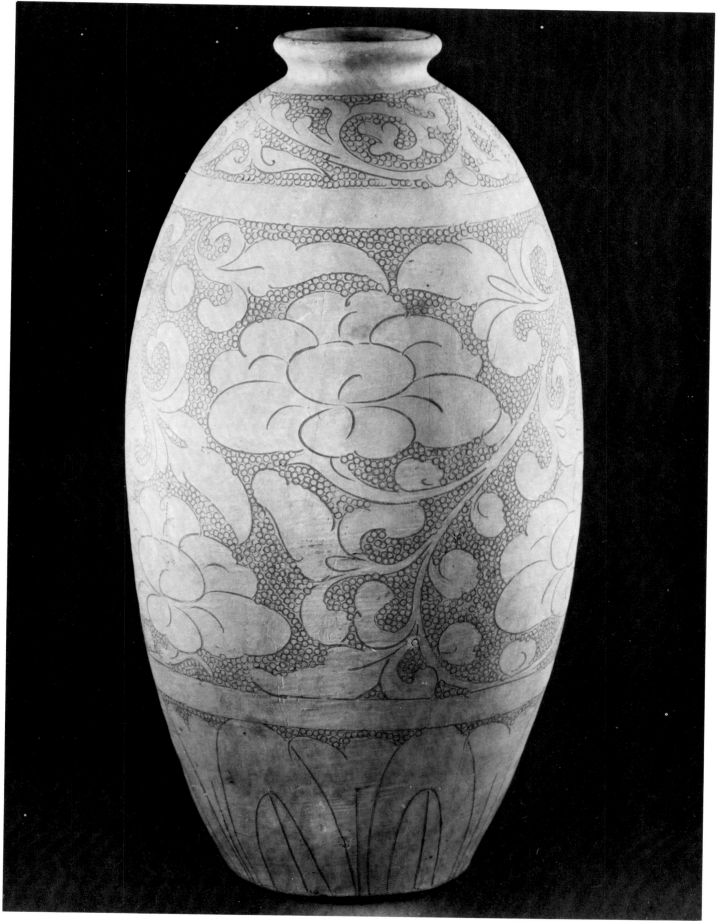

Plate 19
Pillow
Group 5
Northern Sung Dynasty, mid-11th century
H. 3-1/8 in. (8.0 cm.)
L. 8 in. (20.3 cm.)
Indianapolis Museum of Art

Bean-shaped pillow with slightly concave, forward sloping top. Grey stoneware covered with white slip and transparent glaze. Incised decoration on a stamped 'fish-roe' ground on the top, a parrot in flight among drifting clouds; an incised feathery leaf scroll band around the sides.

Published: Paine, "Chinese Ceramic Pillows," pl. 17, no. 25; Wirgin, "Sung Ceramic Designs," pl. 42:e; and Mino, "Stamped 'Fish-roe' Ground," pl. 13.

This pillow is stylistically later than those of the early period and shows a tendency toward simplification and a more cursory style of drawing. The bird on this pillow is derived from the parrots on the Peking and Okayama Museum pillows (see Fig. 31 and Pl. 15), but is now scarcely recognizable as a parrot. It is drawn with long, looser lines, like those of a Chinese phoenix, though the beak is still short and rounded. The clouds around it are fewer in number than on the Okayama piece and rather shapeless. Instead of being swept along with the flight of the bird, they appear to drift in all directions. The feathery scroll pattern on the sides of this pillow differs, too, from earlier examples of the motif, as seen on the British Museum pillow with quail (Pl. 16). It is less carefully drawn and reduced in detail, the row of small looping spirals eliminated from the top of the scroll band. A bean-shaped pillow with this reduced feathery scroll design around the sides, now in the Palace Museum, Peking, was found in Teng-feng-hsien (Fig. 40; *Chugoku nisen-nen no bi,* pl. 76). On the top are three peonies with curling stems and leaves on a background of stamped 'fish-roe.'

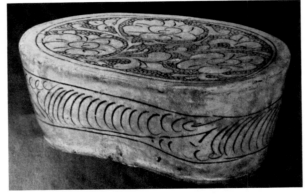

Figure 40

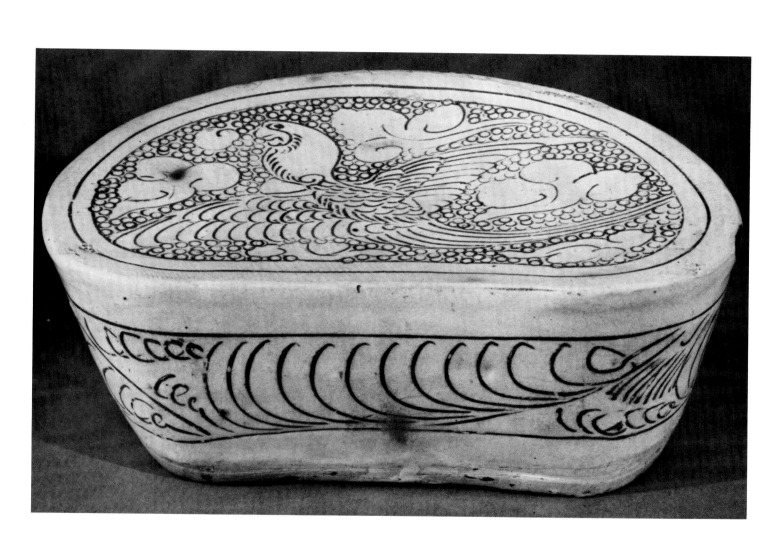

Plate 20
Pillow
Group 5
Northern Sung Dynasty, mid-11th century
H. 3-3/8 in. (8.5 cm.)
L. 8-3/8 in. (21.3 cm.)
Royal Ontario Museum, Toronto

Bean-shaped pillow with flat, forward slanting top surface. Grey stoneware covered with white slip and transparent glaze with a slight yellowish green tint. Incised decoration of chrysanthemum-like flowers on a stamped 'fish-roe' ground on the top; incised feathery leaf scroll around the sides.

Published: Fernald, "Chinese Mortuary Pillows," pl. 6: 13; Wirgin, "Sung Ceramic Designs," pl. 42:c; and Mino, "Stamped 'Fish-Roe' Ground," pl. 15.

Very similar chrysanthemum-like flowers decorate the top of a cloud-shaped pillow in the Art Institute of Chicago (Fig. 41; Reg. no. 83.52). The reduced feathery scroll pattern, too, appears around the sides. One of the flowers, viewed from above, has the narrow petals arranged around an oval center in which there are more petals and, also, stamped 'fish-roe.' The same type of flower can be seen on the front side of a lobed bean-shaped pillow formerly in the collection of Naito Gyoho (Fig. 42; Okuda, ed., *Toyo toji shusei,* vol. 3, pl. 30). On the top are three peonies with oval centers partially filled with ring stamping like that of the chrysanthemum on the front.

Figure 41

Figure 42

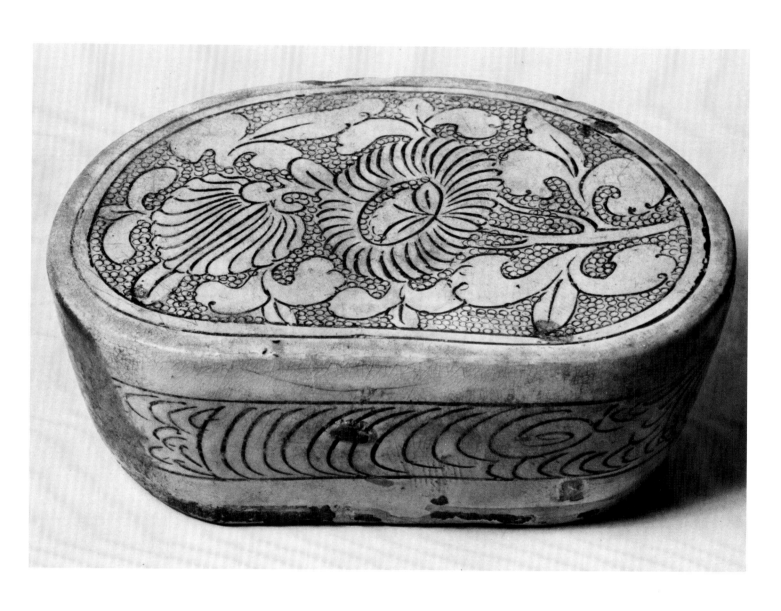

Plate 21
Pillow
Group 5
Northern Sung Dynasty, mid-11th century
H. 4-7/8 in. (12.4 cm.)
L. 10-1/2 in. (26.6 cm.)
Royal Ontario Museum, Toronto

Bean-shaped pillow with forward slanting top surface. Buff stoneware with white slip and transparent glaze. Incised decoration on a densely stamped fish-roe ground; on the top, an infant boy on hands and knees holding a lotus flower and a knobbed scroll branch, with peony scrolls, jewels and ingots around him; large peonies in front and back panels also on a ring stamped ground.

Published: Fernald, "Chinese Mortuary Pillows," pl. 6: 14; Wirgin, "Sung Ceramic Designs," pl. 42:1; *Chinese Art in the Royal Ontario Museum,* (Toronto, 1972), no. 27; Hasebe, "Hokuso zenki no Jishuyo," p. 28, fig. 19; and Mino, "Stamped 'Fish-Roe' Ground," pl. 21.

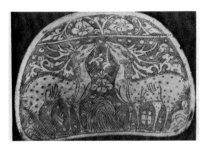

Figure 43

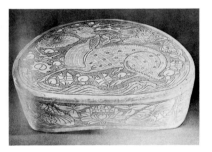

Figure 44

Figure 45

Although more crowded in treatment, the ornament on this pillow can be related to that on other pillows of the middle period. The large peony on the front is of the same type as the peonies on the top of the Naito pillow (see Fig. 42). A greater complexity in the decoration is characteristic of a number of pillows of the middle of the 11th century. Ingots, jewels and other precious objects appear with deer on two other bean-shaped pillows. One in the Victoria and Albert Museum, has a pair of confronted stags on the top, each holding a knobbed scroll branch in its mouth (Fig. 43; Mino, "Stamped 'Fish-Roe' Ground," pl. 22). Between them is a rock with a flower springing from the top and around them are ingots, jewels and other signs of good fortune. On the sides are chrysanthemums whose centers are partially filled with ring stamping. The other pillow has a single running stag on the top that holds in its mouth a lotus plant (Fig. 44; *Shanghai po-wu-kuan ts'ang-tz'u hsüan-chi,* pl. 51). It has on the front a lotus and its large leaves instead of either the peony or the chrysanthemum.

Actual silver ingots identical in shape to those depicted on these pillows were excavated from a Sung tomb on the outskirts of Sian (Fig. 45; *WW,* 1966, no. 1, p. 52, fig. 1). As the shape of ingots varies in different historical periods, these ingots help to date the above pillows firmly to the Sung period.

The symbolic character evident in the decoration of these pillows extends to the main motifs. The infant with the lotus, in Chinese *lien-tzu,* expresses a wish for many successive progeny, *lien-tzu,* with which it is homonymous. The deer is used as an emblem for reward for official service, or *lu,* which sounds like the word for deer, *lu.*

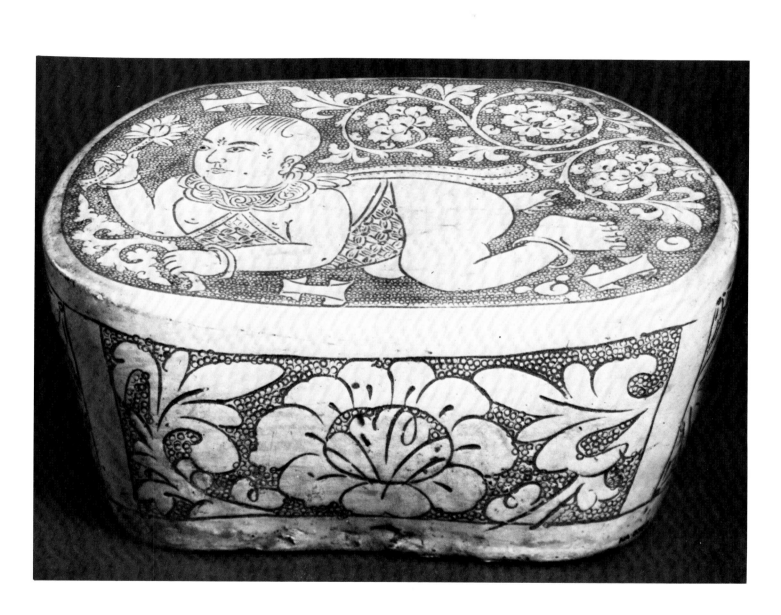

Plate 22
Ewer
Group 5
Northern Sung Dynasty, mid-11th century
H. 9-7/8 in. (25.1 cm.)
D. 6-1/2 in. (16.5 cm.)
The Art Institute of Chicago

Ewer with ovoid body, wide flattened shoulder, trumpet-shaped neck and everted mouth turning downward at the rim; long spout rising from the shoulder and bending outward at the top opposite a flat handle attached to the neck and the edge of the shoulder. Grey stoneware with white slip and transparent glaze. Incised decoration on a ground of stamped 'fish-roe': peonies and scrolling stems in a wide central band on the body, smaller flowers and leaves on the shoulder between the handle and spout, and upright lotus petals around the base.

Published: Ch'en, *Sung-tai pei-fang min-chien tz'u-ch'i,* p. 18; Wirgin, "Sung Ceramic Designs," pl. 43:i; Hasebe, "Hokuso zenki no Jishuyo," p. 28, fig. 20; and Mino, "Stamped 'Fish-Roe' Ground," pl. 18.

The peonies in the central band are the same as those occurring on pillows of the middle period from Teng-feng-hsien and Mi-hsien (see Pl. 21). The smaller flowers on the shoulder have vertical stamens filling the center. Both these types of flowers appear on a contemporary *mei-p'ing,* formerly in the Alexander collection, where their placement is reversed from that on the ewer (Fig. 46; Hobson, Rackham and King, *Chinese Ceramics in Private Collections,* London, 1931, p. 9, fig. 12).

In shape this ewer can be said to be a predecessor of the handsome white ewer of Chü-lu-hsien type, dated 1105, that is in the Cleveland Museum of Art (see Pl. 5). With its wide trumpet-shaped neck and broad base, it bears a closer resemblance to the ewer with deeply carved decoration of Fig. 25.

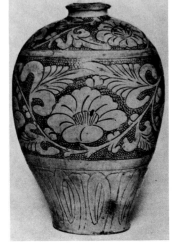

Figure 46

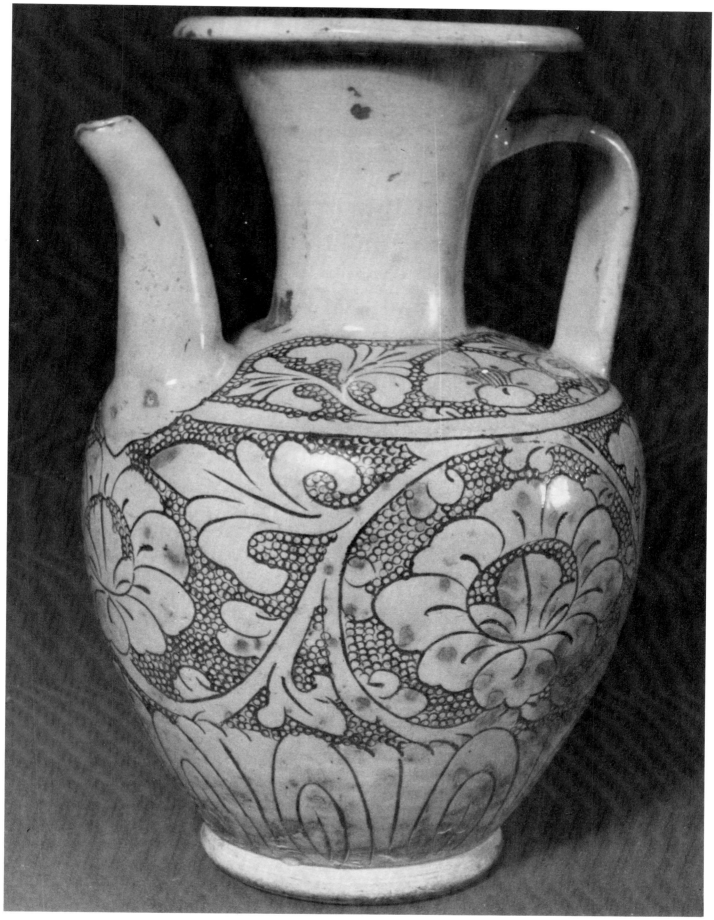

Plate 23
Pillow
Group 5
Northern Sung Dynasty, dated 1071 A.D.
H. 4-1/2 in. (11.4 cm.)
L. 8-7/8 in. (22.5 cm.)
British Museum

Rectangular pillow with concave top and bottom, and sides slanting inward toward the base. Grey stoneware with white slip and transparent glaze. Incised decoration on a ground of stamped 'fish-roe' on the top, four large characters, *Chia-kuo yung-an,* or "Home and country in perpetual peace." Bordered by an incised inscription in two rows of characters reading," . . . [first part indecipherable] pillow of the Chao family, permanently recorded," on the right and, "The fourth year of Hsi-ning [1071 A.D.], the third month the nineteenth day," on the left. Sgraffiato floral motifs on each of the four sides.

Published: Hobson, *A Guide to the Pottery and Porcelain of the Far East,* (London: British Museum, 1924), p. 31, fig. 36; Koyama, "Jishuyo ni tsuite," p. 30, fig. 6; Wirgin, "Sung Ceramic Designs," pl. 42:j; Hasebe, "Hokuso zenki no Jishuyo," p. 26, fig. 10; *Oriental Ceramics: the World's Great Collection,* vol. 5, British Museum, (Tokyo: Kodansha, 1976), pl. 108; Mino, "Stamped 'Fish-Roe' Ground," pl. 25; and Riddell, *Dated Chinese Antiquities,* p. 54, fig. 25.

The only dated piece in Group 5, the pillow of 1071 is important not only for providing a criterion for dating similar pieces to the late eleventh century, but also for establishing a chronological limit for stylistically earlier pieces. It shows that the combined use of the 'fish-roe' stamping and newer sgraffiato techniques becomes characteristic of late eleventh century pillows of the Teng-feng-Mi-hsien subgroup.

The chrysanthemum-like flower on the front of the British Museum pillow is very similar to that, on a ground of stamped rings, seen on pillows of the middle period (see Pl. 20), but the background area and part of the center of the flower have been scraped clean of slip instead of stamped. This technique is reminiscent of the deep carving used on Group 3 wares, but is actually more closely akin to that of Group 9 wares, and marks the initial stage of the sgraffiato technique that flourished in the twelfth century.

A rectangular pillow with the sgraffiato chrysanthemum-like flower on the front and two large characters *fu* or happiness and *te* or virtue on a 'fish-roe' ground on the top appeared in a sale at Parke-Bernet Galleries in New York in 1972 (Fig. 47; *The Cranbrook Collection,* Sotheby, Parke-Bernet, May 2-5, 1972, no. 469). The *fu* rests on a lotus flower and the *te* on a lotus leaf. The pillow has no other inscription. Another rectangular pillow of this type that has the same sgraffiato decoration on the front side and an 'interlocking cash' or grid pattern on the top is in the Siegel collection at the Museum für Ostasiatische Kunst, Köln (Fig. 48; *Forme und Farbe,* pl. 85). Two closely related bean-shaped pillows are known, both having the sgraffiato chrysanthemum motif on the front and a large peony spray on the top on a 'fish-roe' ground. One is in the Siegel collection (Fig. 49; *Forme und Farbe,* pl. 84) and the other in the Ashmolean Museum (Fig. 50; Ashmolean Museum, Reg. no. 1956, 1311).

Figure 47

Figure 48

Figure 49

Figure 50

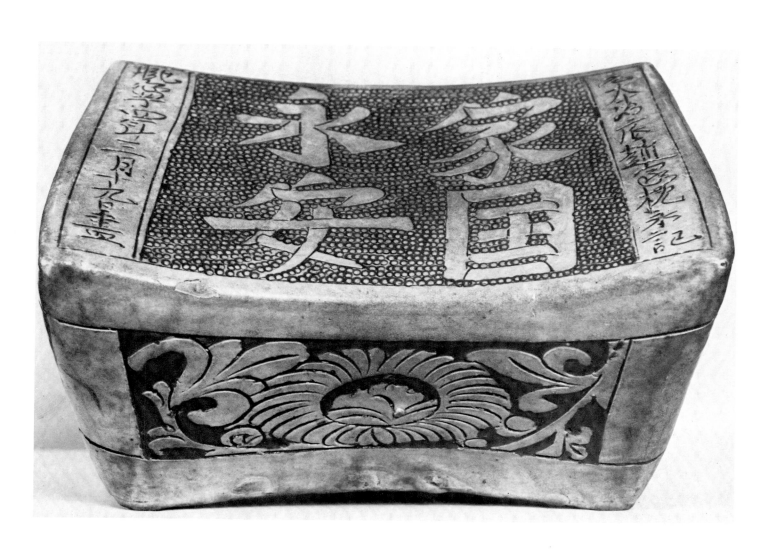

Plate 24
Incense Burner
Group 5
Northern Sung Dynasty, 11th century
H. 13-1/8 in. (33.3 cm.)
D. 10-1/4 in. (26.0 cm.)
The Art Institute of Chicago

Incense burner with nearly cylindrical body and flat wide rim; high flared foot with three pronounced horizontal ribs encircling the middle portion. Greyish white stoneware with white slip and transparent glaze; glaze colorless for the most part but having a few spots of green on the foot. Incised decoration on ground of stamped 'fish-roe,' a wide band of knobbed scrolls around the body, a chrysanthemum scroll pattern around the flat rim.

Published: Mino, "Stamped 'Fish-Roe' Ground," pl. 47.

A knobbed scroll pattern of the same style as that on the incense burner appears on a fragment of a leaf-shaped pillow excavated at the Kuan-t'ai kiln site in Han-tan-hsien near Tz'u-chou (Fig. 51; *WW*, 1964, no. 8, Pl. 6:2). 'Fish-roe' stamped wares were made at Kuan-t'ai in a few distinctive shapes, including the six-spouted jar and the *mei-p'ing*, as well as the leaf-shaped pillow and the incense burner, for an apparently brief period around the later part of the 11th century and the early 12th century. A plain white incense burner similar in shape to this and other examples of the Kuan-t'ai subgroup was found at Chü-lu-hsien, providing an important key to the dating of the Kuan-t'ai pieces (Fig. 52; Anon., "Chü-lu Sung-tai ku-ch'eng,").

The incense burner, a vessel associated with Buddhist ceremony in the Sung period, appears in Sung paintings. A Northern Sung Dynasty work entitled "The Buddha Preaching the Law" depicts an incense burner made of metal placed on a round offering table in front of the Buddha's lotus throne (Fig. 53: *Masterpieces of Figure Painting in the National Palace Museum*, Taipei, 1973, pl. 10). Over its mouth is a pierced cover. Although none of the ceramic examples known have covers it is possible that they, too, were originally fitted with covers, perhaps of metal. Another Northern Sung painting, "Barbarian Royalty Worshipping Buddha," a work in the tradition of Chao Kuang-fu but believed to be of 12th century date, represents a procession of foreign envoys among which is a clean-shaven man holding an incense burner in his hands (Fig. 54; The Cleveland Museum of Art, Reg. no. 57.358). The piece is a golden color and decorated on the rim and body with scroll designs.

Although incense burners of metal have not survived from the Sung Dynasty, an example from the Koryo period does exist, preserved in the Historical Museum of Korea, Pyongyang (Fig. 55; *A Pictorial Encyclopedia of the Oriental Arts: Korea*, Tokyo, 1968, pl. 25). Made of bronze inlaid with silver and gold, the piece is decorated in a fine linear style with floral scrolls and lotus petal panels.

Figure 51

Figure 53

Figure 52

Figure 54

Figure 55

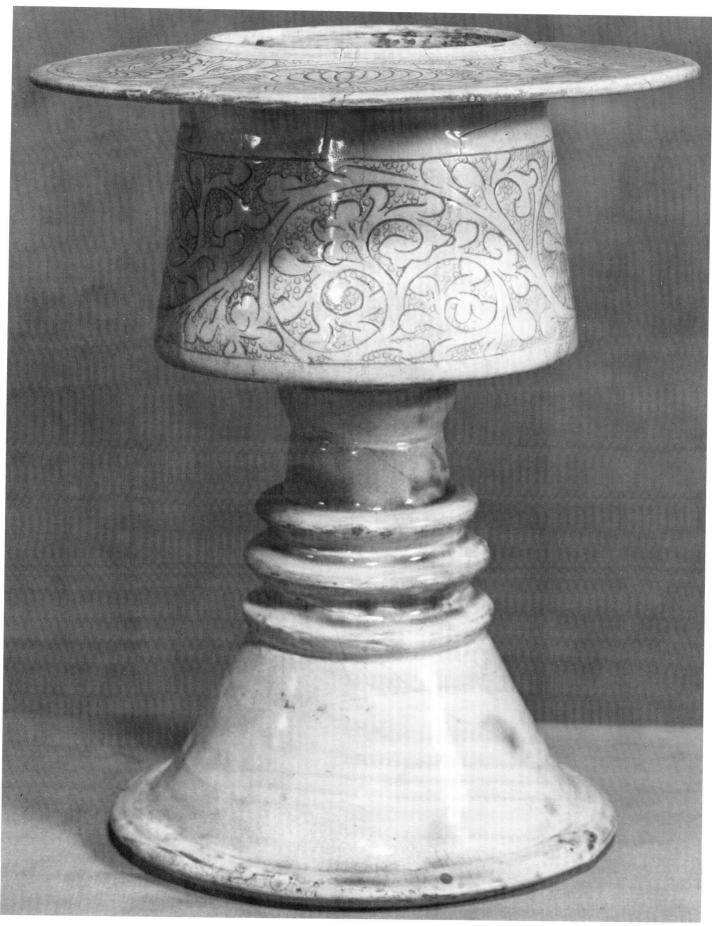

Plate 25
Incense Burner
Group 5
Northern Sung Dynasty, 11th century
H. 10-7/8 in. (27.7 cm.)
D. 8-3/8 in. (21.4 cm.)
Indianapolis Museum of Art, Gift of Sonia and Joseph Lesser

Incense burner with flared body and flat wide rim; high flaring foot with five horizontal ribs encircling the middle portion. Pale grey stoneware covered with white slip and transparent glaze; glaze mostly colorless, but having a few spots of green on the foot. Incised decoration on a ground of stamped 'fish-roe'; on the body, a band of 'interlocking cash' in a grid pattern above a band of knobbed scrolls, and on the rim a peony scroll design. Broken and repaired with some small areas missing.

Not previously published.

This incense burner and the one in the Art Institute of Chicago are two of five known incense burners in Group 5, all belonging to the Kuan-t'ai sub-group. The three remaining pieces are smaller and less impressive than the first two. One, in the Field Museum in Chicago, has a knobbed scroll decoration on the flat rim and a row of large 'interlocking cash' around the body (Reg. no. 12700). Another, whose whereabouts are now unknown, also exhibits a row of 'interlocking cash' around the side while the ornament on the rim is divided into eight sections that are filled with small flowers and knobbed scroll branches in an alternating arrangement (Fig. 56; from the Photographic Archives of the School of Oriental and African Studies, University of London, no. 11040). The fifth example is an incense burner of squatter proportions decorated with a half palmette scroll around the rim and overlapping petals around the body (*The Frederick M. Mayer Collection of Chinese Art,* London, Christie's, June 24-25, 1974, pl. 46).

Figure 56

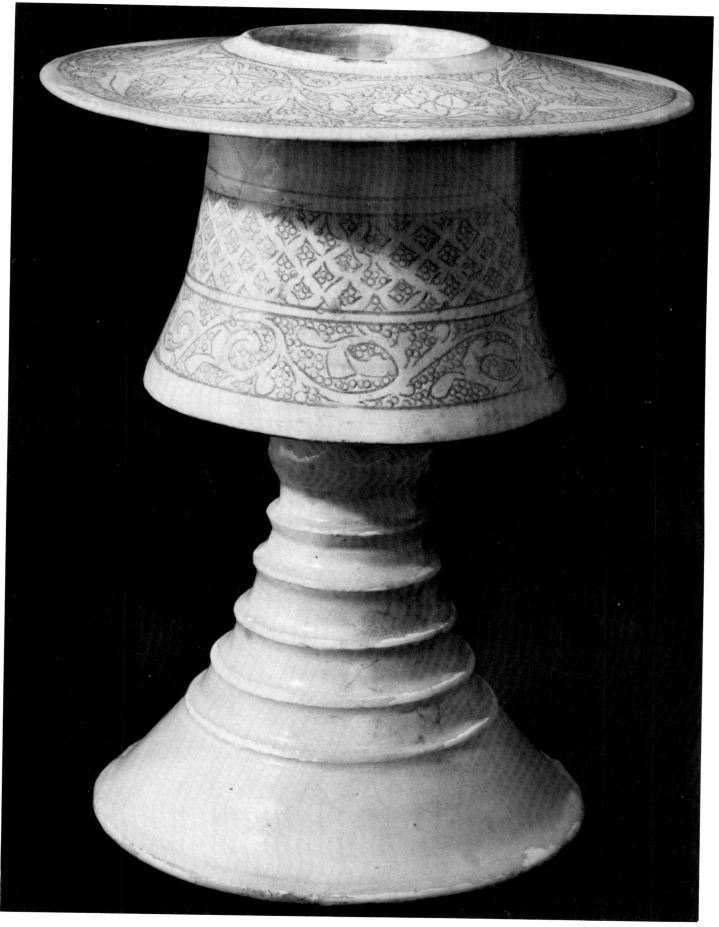

Plate 26
Six-spouted Jar
Group 5
Northern Sung Dynasty, late 11th—early 12th centuries
H. 9-7/16 in. (23.9 cm.)
D. 7-11/16 in. (19.5 cm.)
Collection of Dr. Paul Singer

Figure 57

Jar with ovoid body and six cylindrical spouts around the shoulder; wide neck narrowing slightly toward the mouth; flared foot and recessed, flat base. Grey stoneware covered with white slip and transparent glaze liberally splashed with green; glaze and slip stopping unevenly above the foot. Incised decoration on a ground of stamped 'fish-roe' in two horizontal bands around the body, the upper filled with knobbed scrolls, the lower with wide, overlapping petals.

Published: Mino, "Stamped 'Fish-Roe' Ground," pl. 38.

This distinctive jar belongs, also, to the sub-group of ring-stamped wares from Kuan-t'ai. A jar of this type decorated with a single palmette scroll band on a ground of 'fish-roe' was unearthed at the Kuan-t'ai kiln site (Fig. 57; *WW*, 1959, no. 6, p. 58, fig. 3 left). Other six-spouted jars, too, can be assigned a Kuan-t'ai provenance. An example, now in the Museum of Far Eastern Antiquities, is said to have been found at the Sung dwelling site in Ch'ing-ho-hsien, Hopei (Fig. 58; Palmgren, "Kontakt med Keramiska guldalger Sung," p. 14). It has three bands of ornament around the body, the top a narrow belt of drifting clouds, the middle a trefoil scroll band and the bottom a row of upright petals. Two other six-spouted jars with slightly everted mouth rims are decorated with 'interlocking cash.' On the one in the Museum für Ostasiatische Kunst, Köln, the cash are arranged in a grid pattern, while on the other, in the Fitzwilliam Museum, Cambridge, a single row of large cash encircles the body (Fig. 59; Fitzwilliam Museum, Reg. no. C29-1934).

Figure 58

Figure 59

76

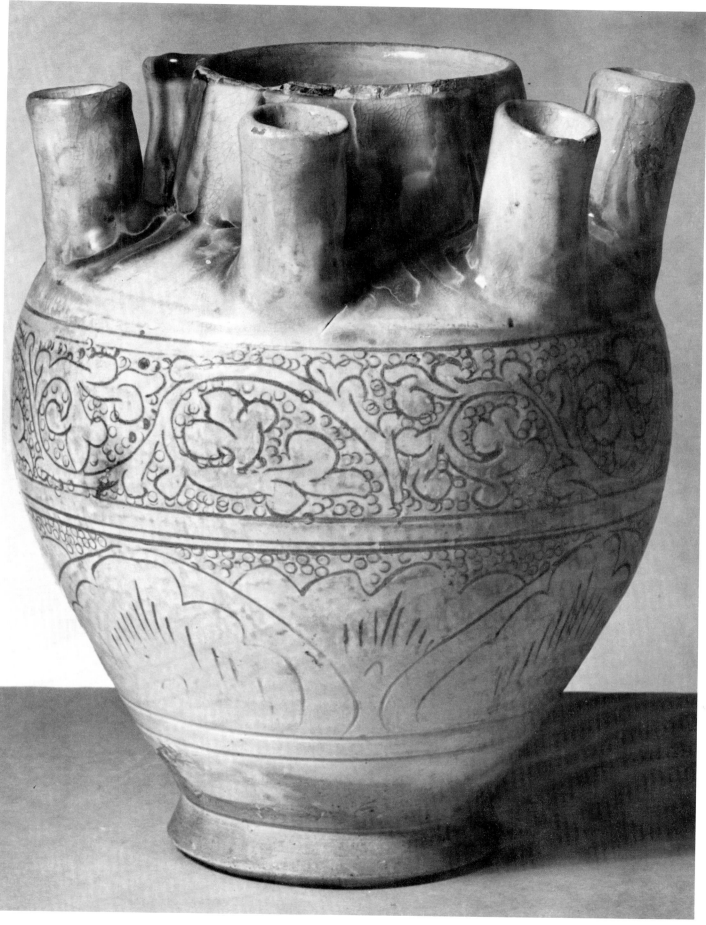

Plate 27
Mei-p'ing
Group 5
Northern Sung Dynasty, 12th century
H. 16-1/8 in. (41 cm.)
The St. Louis Art Museum, Bequest of Samuel C. Davis

Tall vase with ovoid body, flattened shoulder, small neck and mouth in the shape of a conical section; recessed flat base. Grey stoneware with white slip and transparent glaze. Incised leaf scroll band on shoulder, interlocking cash pattern in the middle band and upright lotus petals in the lower band, all on a ground of stamped 'fish-roe.'

Published: Hasebe, *So no Jishuyo,* pl. 8; Wirgin, "Sung Ceramic Designs," pl. 43:j; *The St. Louis Art Museum: Handbook of the Collections,* p. 287; and Mino, "Stamped 'Fish-Roe' Ground," pl. 52.

The third sub-group of wares with stamped 'fish-roe' ground is comprised only of *mei-p'ing.* With their rather straight sides and conical mouth, they are distinct from the *mei-p'ing* of both the Teng-feng-Mi-hsien sub-group (see Pl. 18) and the Kuan-t'ai sub-group, an example of which, in the Bristol City Art Gallery, is illustrated here for comparison. The latter is a vase with rounded sides, small everted mouth and a decoration of clouds, fan-like leaves and overlapping petals in horizontal bands. (Fig. 60; Bristol City Art Gallery, reg. no. 2447.) The scroll pattern on the shoulder of the St. Louis *mei-p'ing* and the large oval petals around the base are unlike those on any examples seen previously. The scroll design is very similar to a pattern seen on a gold ornament found in a tomb of the Liao or Chin period in Fu-yu-hsien, Chi-lin Province. (*KK,* 1963, no. 11, p. 619, fig. 1:9 and Pl. 6:4.)

Other *mei-p'ing* of related type have a similar shape with conical mouth and ornament similarly arranged in three horizontal bands. One example, in the Tokyo National Museum, is decorated with large leaves in the upper band, interlocking cash in the middle and large upright petals around the bottom in each one of which is a small trefoil design. (Hasebe, *Jishuyo,* pl. 36.) Another, in a private collection in Japan, has a large palmette scroll filling the middle band instead of the interlocking cash. The scale of the decorative elements is larger on these pieces and the drawing less precise than on the St. Louis *mei-p'ing.* On a third example, the interlocking cash appear in the central band and the upright petals with small trefoils in the lower, while the upper band is decorated with large black leaves painted under the glaze (Fig. 61). A unique example of the combined use of these decorative techniques, painting and 'fish-roe' stamping, this *mei-p'ing* and the sub-group of related pieces can be dated to the twelfth century.

A number of different possible places of origin can be suggested for these *mei-p'ing.* Ch'en Wan-li expressed the belief that they were produced in Shansi Province but gave no specific evidence supporting this theory. (Ch'en, *Sung-tai pei-fang min-chien tz'u-ch'i,* Pls. 22-25.) The use of stamped 'fish-roe' decoration appears on Tz'u-chou type wares found at kilns in Hsiu-wu-hsien, Pao-feng-hsien, and Lu-shan-hsien, as well as those areas already mentioned. (*WW,* 1954, no. 8, p. 48.) Thus it is possible that this group of *mei-p'ing,* too, was made in the general region of Honan and Hopei Provinces.

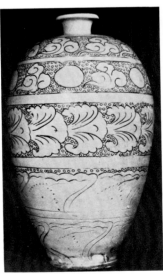

Figure 60

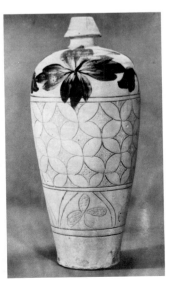

Figure 61

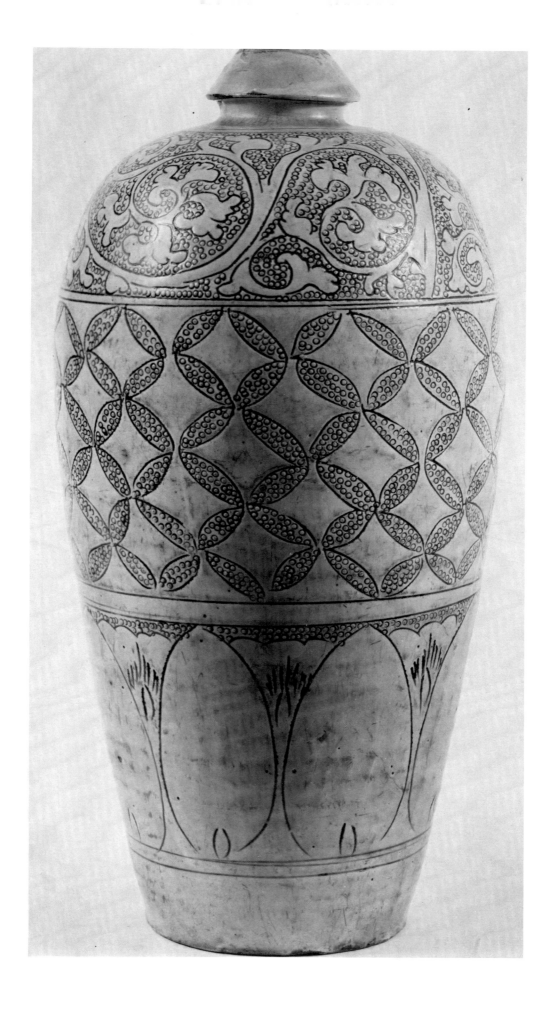

Plate 28
Pillow
Group 6
Northern Sung Dynasty, late 11th—early 12th centuries
H. 4-3/4 in. (12.0 cm.)
W. 8-7/8 in. (22.5 cm.)
The Arthur M. Sackler Collections, New York

Four-lobed pillow with slightly lobed concave top and oval base. Grey stoneware covered with white slip and transparent glaze. Stamped decoration in brown iron pigment under the glaze; on the top, a lozenge-shaped peony design within a lobed border of small stamped florets bounded by double lines, stamped florets around the sides, as well, in a random arrangement below a row of small circles.

Not previously published.

The group of wares with stamped decoration comprises mostly pillows. Very few examples are known outside China, but reports of excavations of pieces in China in recent times have made possible the identification of this group and its tentative dating to the eleventh and early twelfth centuries.

The Sackler pillow is unusual in having a floral motif in the central ornamental field on the top. Most other examples are decorated with stamped deer. A four-lobed pillow found in Chü-lu-hsien has on the top a recumbent deer around which are a few simple landscape elements and a lobed border of small florets (Fig. 62; *Ho-pei ti-i po-wu-kuan pan-yüeh k'an*, no. 21, July 25, 1931, no pag.). The sides of the pillow are plain. The Lü-shan Museum in Liaoning Province has a pillow with very similar ornament in its collection (Fig. 63; Ryojun Hakubutsu-kan, *Koko zuroku*, pl. 59:2). The sides of this pillow are decorated with small stamped star-like flowers below a row of small circles. An oval pillow with stamped decoration that was discovered in a Sung tomb at Shih-chuang, Ching-hsing-hsien, in Hopei, is decorated with a deer stepping over rocks and holding in its mouth the stem of a flower (Fig. 64; *KKHP*, 1962, no. 2, pl. 25:6). A very similar deer appears on a four-lobed pillow in a Japanese collection (Fig. 65; Sakamoto Photographic Studio, Tokyo, no. To 2-53918). Both have a border of stamped florets around the edge. A bean-shaped pillow on which are depicted two recumbent deer, both facing to the left, in a border of florets is in the T'ai-yüan Museum, Shansi (Fig. 66; Mizuno and Hibino, *Sansei koseki-shi*, pl. 10, no. 23). A four-lobed pillow with a pair of confronted deer was found in the same group of Sung tombs as the oval pillow described above from Shih-chuang, Ching-hsing-hsien (Fig. 67; *KKHP*, 1962, no. 2, pl. 25:3). Around the deer is a lobed border of leafy scrolls, enclosed by double lines.

Figure 62

Figure 64

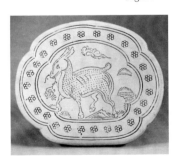
Figure 65

Figure 66

Figure 67

Figure 63

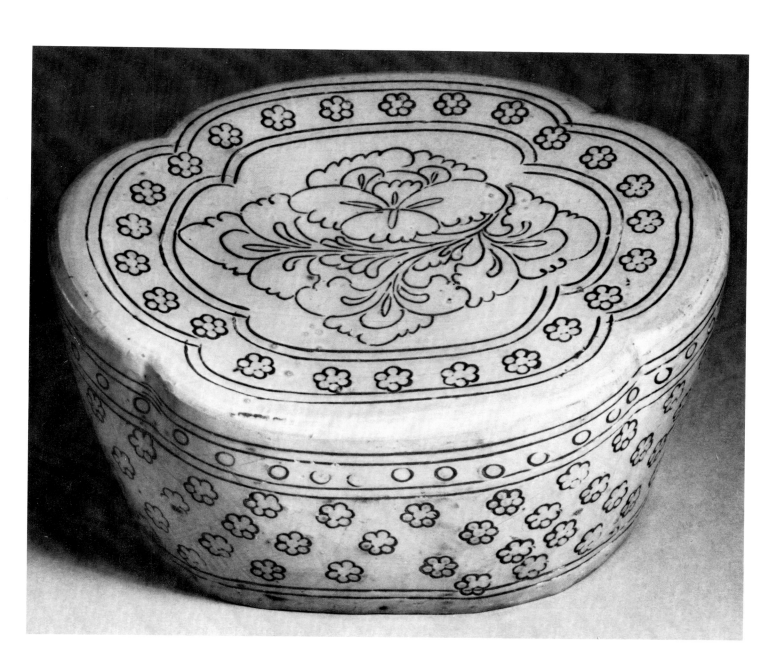

Plate 29
Pillow
Group 6
Northern Sung Dynasty, late 11th—early 12th centuries
H. 5-3/4 in. (14.5 cm.)
L. 8-11/16 in. (22.0 cm.)
Art Gallery of Greater Victoria, Canada

Figure 68

Figure 69

Rectangular pillow with concave top and ends slanting inward toward the base. Grey stoneware covered with white slip and transparent glaze. Stamped decoration on the top of two confronted deer in a rectangular frame bordered by leaf scrolls; molded relief decoration around the sides; a peony and frond-like leaves on the front, an animal mask on the back and a floral petal pattern on the sides.

Published: *Permanent Collection Catalogue,* Art Gallery of Greater Victoria, 1964, no. 7; and *Chinese Ceramics Handbook,* Art Gallery of Greater Victoria, 1978, pl. 38.

The confronted deer and leafy scroll border on this pillow are the same as that on the lobed pillow found in a Sung tomb at Shih-chuang, Ching-hsing-hsien, Hopei Province (see Fig. 67). A rectangular pillow unearthed at the same site has a similar knobbed scroll border around a row of stamped lozenge-shaped floral medallions (Fig. 68; *KKHP,* 1962, no. 2 pl. 26:5). A rectangular pillow in a Japanese collection has the knobbed scroll border around a central panel decorated with stamped leaves and embroidered ball motifs (Fig. 69; Hasebe, *Jishuyo,* pl. 50). There are a few accidental streaks of brown on the top, probably the same brown pigment used in stamping the decoration. Another closely related rectangular pillow that was unearthed at Shih-chuang has three horizontal rows of stamped leaf designs between double lines without an outer border (*KKHP,* 1962, no. 2, Pl. 26:1).

All of the rectangular pillows in Group 6 have molded relief decoration around the sides. Like the lobed and oval pillows of this group they show little stylistic variation and seem to have been made only for a short period of time.

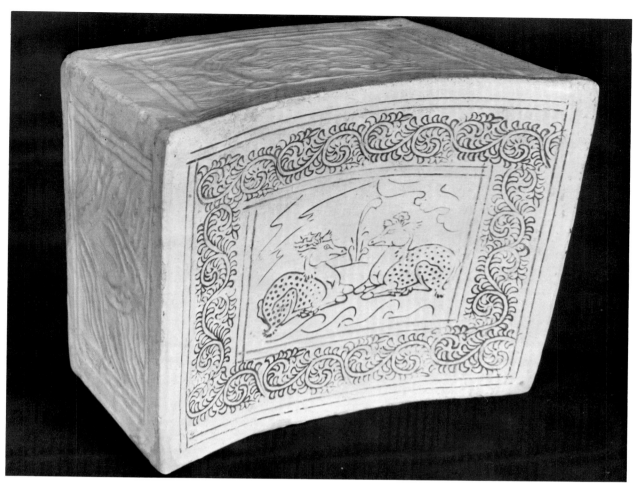

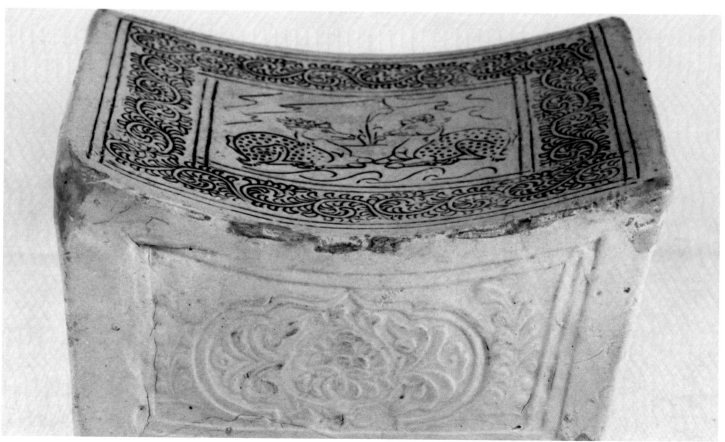

Plate 30
Pillow
Group 6
Northern Sung Dynasty, late 11th—early 12th centuries
H. 4-1/8 in. (10.5 cm.)
L. 8-11/16 in. (22.0 cm.)
Los Angeles County Museum of Art, Gift of Nasli M. Heeramaneck

Bean-shaped pillow with slightly concave, forward-sloping top. Grey stoneware covered with white slip and transparent glaze. Stamped decoration in brown pigment under the glaze; a small child seated in front of a duck on the top bordered by a row of diamond-shaped florets between double lines; the sides stamped with small star-like flowers in a wide band bounded by triple lines.

Published: Cox, *The Book of Pottery and Porcelain,* p. 205, fig. 388. *Chinese Ceramics,* (Los Angeles, 1952), no. 225; Kuwayama, *Chinese Ceramics,* pl. 14.

The decoration of this pillow is unique among those with stamped ornament that are known. Neither the infant and duck in the central panel nor the diamond shaped florets in the border appear on any of the pieces mentioned previously. Similar star-like flowers can be seen, however, on the pillow with recumbent deer in the Lu-shan Museum, Liaoning (see Fig. 63). These small flowers are reminiscent of those decorating the sides of earlier 'fish-roe' stamped pillows from Mi-hsien (see Fig. 31), but instead of having empty centers, they have a small central dot or a small circle from which the petals radiate.

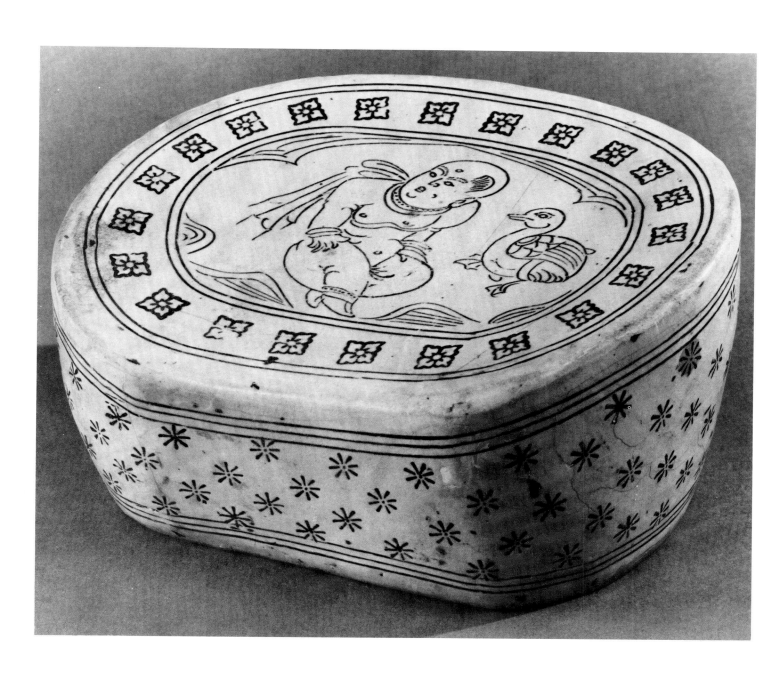

Plate 31
Pillow
Group 7
Northern Sung Dynasty, late 11th—early 12th centuries
H. 7 in. (17.8 cm.)
W. 11-3/4 in. (29.7 cm.)
The Arthur M. Sackler Collections, New York

Pillow in the form of a concave leaf-shaped slab set on a square block-like base. Grey stoneware covered with white slip and transparent glaze. Incised decoration of a large peony spray on a ground of combed hatching.

Not previously published.

Tz'u-chou type wares of Group 7 are decorated with incised designs on a ground of short combed lines. Judging from the narrow range of stylistic variation among the examples of this group, they were made for a relatively brief period of time and seem to have enjoyed their greatest popularity in the early part of the 12th century. The kilns at Kuan-t'ai in Han-tan-hsien appear to have been the principal center of their manufacture.

Fragments of a leaf-shaped pillow with an incised and combed decoration of a small child carrying a bird cage were recovered at Kuan-t'ai (Fig. 70; *Chugoku nisen-nen no bi,* pl. 404). Leaf-shaped pillows were found, also, at the Sung dwelling site in Chü-lu-hsien. One of these is decorated with an incised peony design on a combed ground above a plain ogival area in which the characters *ch'ang-ming chen,* or "longevity pillow," are inscribed (Fig. 71; *Hopei ti-i po-wu-yüan pan-yüeh-k'an,* no. 6). Another leaf-shaped pillow from this site bears an inscription dating it to the year 1103 A.D. (Li and Chang, *Chü-lu Sung-ch'i ts'ung-lu,* vol. 1, pp. 28-29).

Leaf-shaped pillows decorated with large peony sprays resembling that on the Sackler pillow can be seen in the Museum of Fine Arts, Boston (Tseng and Dart, *Hoyt Collection,* pl. 86), in the Royal Ontario Museum, (Fernald, "Chinese Mortuary Pillows," pl. III:6), and the Ashmolean Museum, Oxford. On these pieces, the leaves flanking the peony blossom are extended upward and around it, particularly so on the Boston pillow. Similar peonies appear on a group of basins, large bowls with wide flat base, slightly curving sides and flattened, everted mouth rim. They are drawn in the bottom of these basins and encircled by a ring of narrow petals. An example in a Japanese collection has a flattened meander band below the rim and an 'interlocking cash' pattern in the well (Fig. 72). Closely related basins in the Field Museum of Natural History (Reg. no. 127086) and in the collection of King Gustaf VI of Sweden (*Chinese Art from the Collection of H. M. King Gustaf Adolf of Sweden,* London, British Museum, 1972, no. 128) have a triangular floral design in the well, below the meander band.

Figure 70

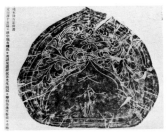

Figure 71

Figure 72

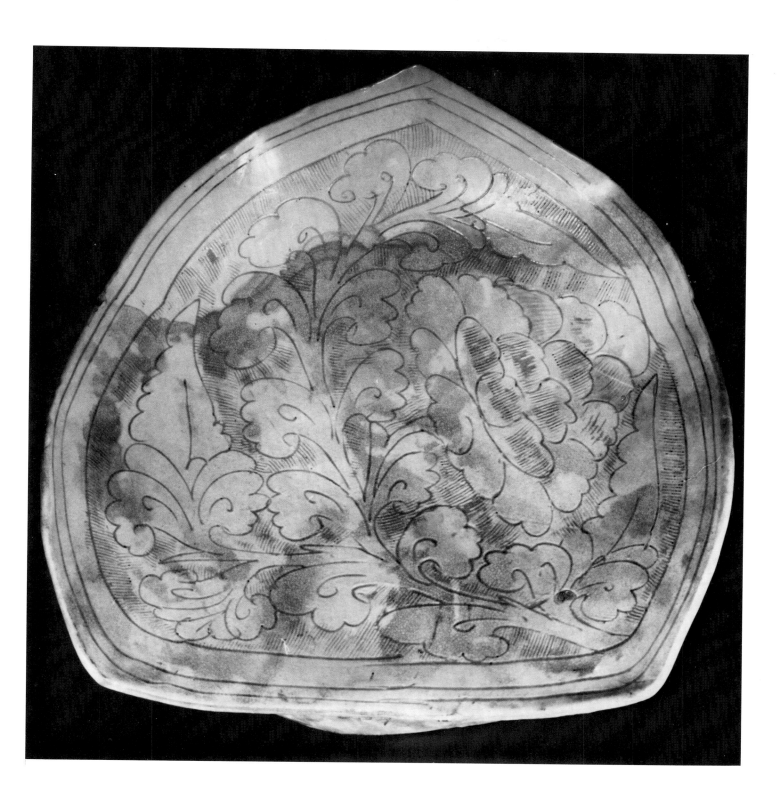

Plate 32
Pillow
Group 7
Northern Sung Dynasty, late 11th—early 12th centuries
H. 8-1/16 in. (20.1 cm.)
Indianapolis Museum of Art, Gift of Mr. and Mrs. Charles B. Miller

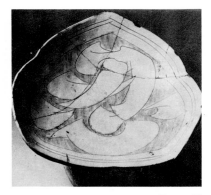

Figure 73

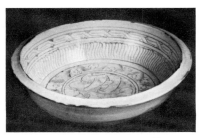

Figure 74

Pillow in the form of a concave, leaf-shaped slab set on a square block-like base. Grey stoneware covered with white slip and transparent glaze. Incised decoration on a ground of combed hatching, a large character *jen*, meaning 'patience' or 'forebearance,' born on a large lotus flower in the center, flanked by two fan-like lotus leaves; a small cloud with wispy tail hovering above.

Published: Mino and Tsiang, "Chinese Art in the Indianapolis Museum of Art," pl. 15.

Two other leaf-shaped pillows with a large character written on the top on a combed ground are known. One with the character *jen,* the same character that is written on the Indianapolis pillow, is in the Royal Ontario Museum (Fig. 73; Fernald, "Chinese Mortuary Pillows," pl. III:5) and another with the character *fu,* "happiness," is in the British Museum (Hobson, *Eumorfopoulos Collection,* vol. 3, Pl. LXXI, no. C 400). On both of these, unlike on the Indianapolis pillow, the large character is the only ornament and fills the entire top surface. A large character *jen* appears, also, on a basin in the Tokyo National Museum (Fig. 74; Koyama, *So,* pl. 60). Encircling it, around the bottom of the basin, is a ring of small florets on a combed ground and in the well above it a band of narrow overlapping petals. The flattened meander band at the top, below the mouth rim, is the same as that on other basins of this type (see Figs. 72 and 74).

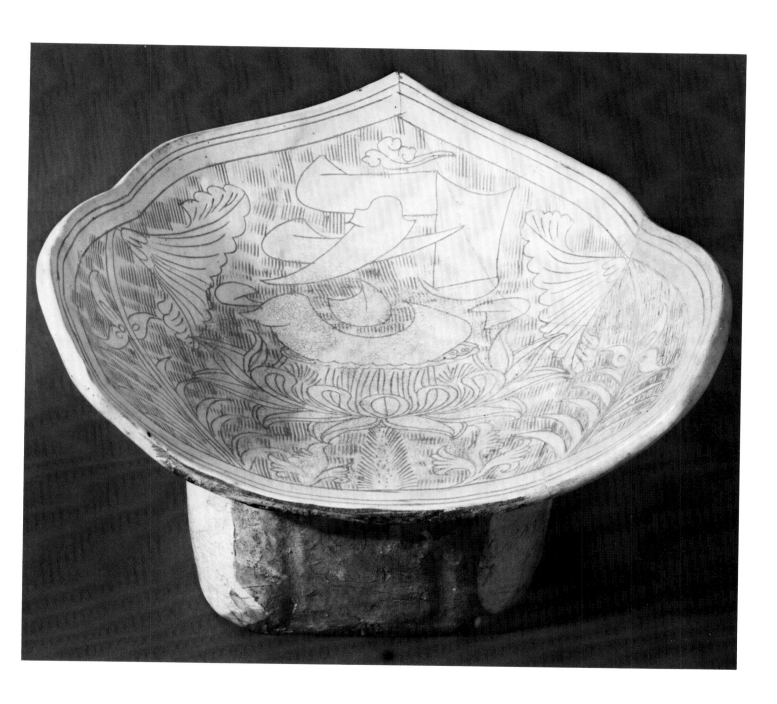

Plate 33
Mei-p'ing[*]
Group 7
Northern Sung Dynasty, early 12th century
H. 11-7/8 in. (30.2 cm.)
D. 7-1/16 in. (18.0 cm.)
The Metropolitan Museum of Art, Rogers Fund, 1923

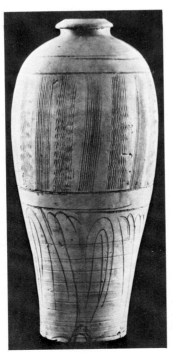

Figure 75

Vase with ovoid body, wide rounded shoulder, small neck and everted mouth rim; small, recessed flat base. Pale grey stoneware with white slip and transparent glaze. Freely incised decoration of peony scrolls on a combed ground on the body; wide overlapping lotus petals around the shoulder. Reddish brown stain lying in the fine crackle in the glaze.

Published: Cox, *Pottery and Porcelain*, vol. I, p. 191, Fig. 359; and Valenstein, *A Handbook of Chinese Ceramics*, pl. 44.

This is the only known example of a *mei-p'ing* in Group 7. The piece is said to have been found at Chü-lu-hsien and has the rust-colored stain that is typically seen on objects from this site.

A number of *mei-p'ing* displaying a closely related technique of decoration but belonging to Group 8 can be discussed briefly here. They have incised and combed decoration but are different from wares of Group 7 in that the combed patterns are a part of the main ornament rather than a filler for the background areas. On one such piece, a tall *mei-p'ing* in the Museum für Ostasiatische Kunst, Köln, has a combed decoration the middle of straight vertical lines alternating with wavy lines in a wide band above freely incised petals around the lower part of the body. (Fig. 75; Goepper, *Form und Farbe*, pl. 83) A sherd with the same type of combed decoration was found at a kiln in Teng-feng-hsien (See Fig. 21, *WW*, 1964, no. 2, pl. 6:3).

[*] Not included in the exhibition

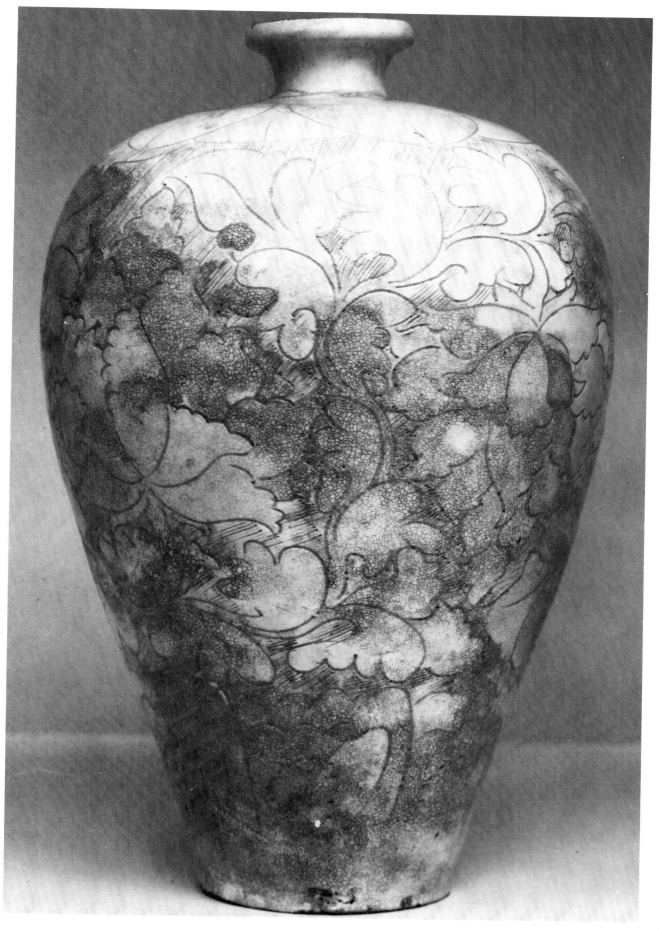

Plate 34
Dish
Group 7
Chin Dynasty, 12th century
H. 1-3/4 in. (4.5 cm.)
D. 8 in. (20.3 cm.)
Fogg Art Museum, Harvard University, Gift of Mrs. Joseph Choate

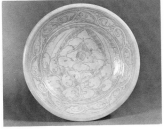

Figure 76

Shallow dish with smoothly curving sides and everted mouth rim; recessed flat vase. Grey stoneware with white slip and greyish transparent glaze stopping at the foot. Incised decoration of flowers and leaves on a ground of combed hatching on the inner surface. Five small oblong spur marks in the bottom.

Not previously published.

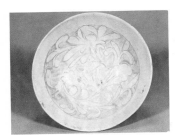

Figure 77

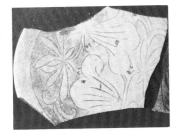

Figure 78

A number of rounded dishes and bowls are known that are decorated with lotuses in a style resembling that on the Fogg Museum dish. A bowl with very similar decoration was found at the Kuan-t'ai kiln site in Han-tan-hsien (Fig. 76; *WW*, 1959, no. 6, p. 58, fig. 1). Another can be seen in a Japanese collection (fig. 77). A similar type of ornament can also be seen on a fragment of a bowl unearthed at Ho-pi-chi in T'ang-yin-hsien (Fig. 78; *Ku-kung po-wu-yüan yüan-k'an*, no. 2, 1960, p. 114, fig. 5).

Rounded bowls of this group decorated with peonies like those seen previously on basins (see Figs. 73 and 74) are also known. The example shown here is in the Tokyo National Museum (Fig. 79; Hasebe, *Jishuyo*, pl. 47). The lotus designs are drawn in a much freer and looser style than the peonies and therefore seem to be a later development. The appearance of the lotus motif among the wall paintings in a Chin Dynasty tomb at Li-ts'un-kou, Ch'ang-chih, in Shansi Province, lends support to the stylistic evidence (Fig. 80; *KK*, 1965, no. 7, pl. 7:4).

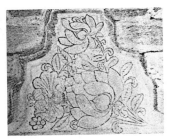

<table>
<tr><td>Figure 79</td><td>Figure 80</td></tr>
</table>

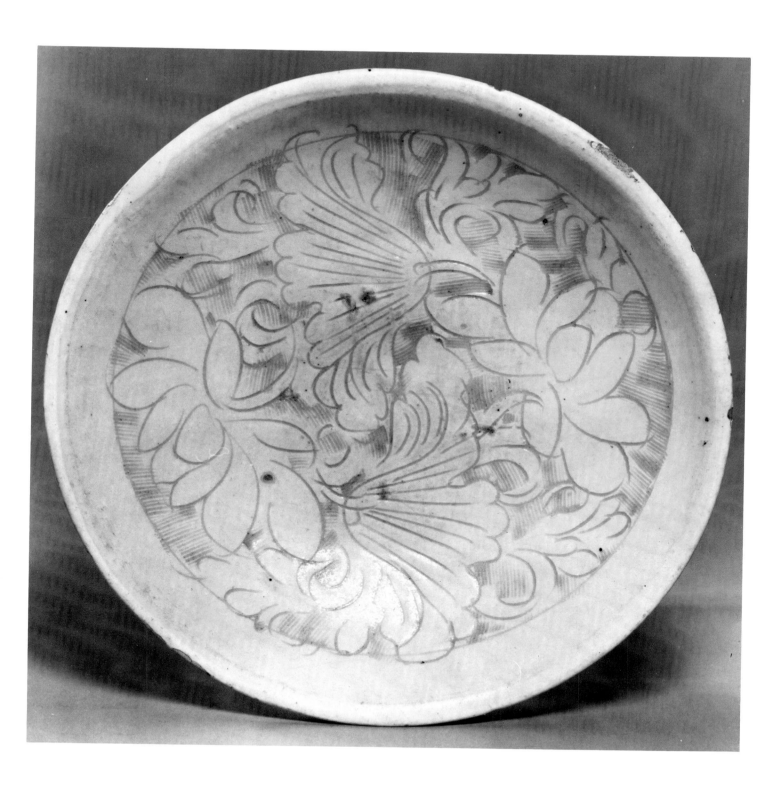

Figure 81

Figure 82

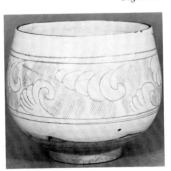

Figure 83

Figure 84

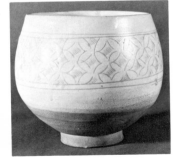

Figure 85

Plate 35
Bowl
Group 7
Northern Sung Dynasty, early 12th century
H. 4-3/4 in. (12.0 cm.)
D. 4 in. (10.1 cm.)
Field Museum of Natural History, Chicago

Deep bowl with globular body narrowing at the mouth, slightly flaring foot and recessed convex base. Pale grey stoneware with white slip and transparent glaze stopping unevenly above the foot. Decorated with a row of incised cloud-like scrolls on a ground of combed hatching in a wide band around the outside.

Not previously published.

A number of deep, rounded bowls of Group 7 are known that all appear to be the product of the Kuan-t'ai kilns. One example, in the Tokyo National Museum, has a large palmette scroll band around it (fig. 81; Hasebe, *Jishuyo*, pl. 46) that closely resembles patterns seen on sherds found at Kuan-t'ai. On the sherd illustrated here, the palmette scroll appears on a 'fish-roe' ground (Fig. 82; *WW*, 1964, no. 8 pl. 6:2). Another deep bowl, formerly in the collection of Mrs. Alfred Clark, is decorated with scrolling elements similar to the cloud-like motif on the Field Museum bowl (Fig. 83; *Catalogue of Important Chinese Ceramics*, Sotheby and Co., London, March 25, 1975, no. 17). On the Clark piece the scrolling motifs are placed alternatingly along the upper and lower borders of the ornamental band.

A bowl decorated with a band of 'interlocking cash' designs below a flattened meander band is in the Royal Ontario Museum (Fig. 84; Royal Ontario Museum, Reg. no. 922.20.194). Two other bowls, one in the Fitzwilliam Museum and one in a Japanese collection (Fig. 85; Sakamoto, no. 73-3544), have the 'interlocking cash' design in a grid pattern around the sides.

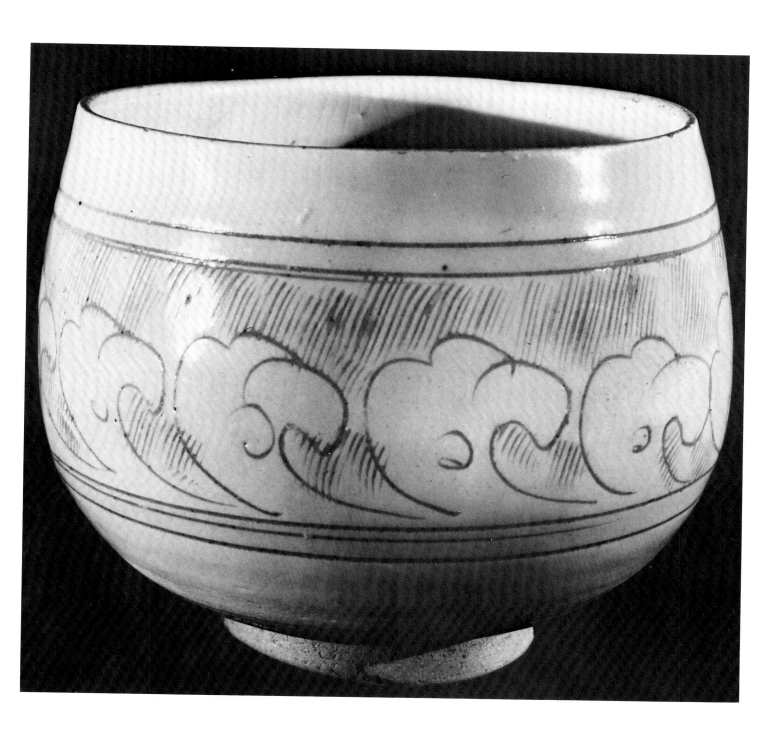

Plate 36
Pillow
Group 9
Northern Sung Dynasty, 12th century
H. 4-3/8 in. (11.0 cm.)
L. 11-1/16 in. (28.0 cm.)
Museum für Ostasiatische Kunst, Köln

Eight-sided pillow with flat top sloping downward toward the front. Brick red stoneware covered with white slip and transparent glaze. Sgraffiato decoration of two peony flowers and scrolling leafy stems on the top inside a wide white border with combed lines radiating outward at the corners; leaf patterns in small rectangular panels around the sides.

Published: Goepper, *Form und Farbe*, pl. 86.

Tz'u-chou type wares with sgraffiato designs in white slip cut through to the body are an extensive group of wares made in various styles and at a number of kiln sites from the late eleventh century into the fourteenth century. The technique can be seen to have had its beginnings in the late eleventh century when it was used together with 'fish-roe' stamping on pillows from the kilns in Teng-feng-hsien and Mi-hsien (see Pl. 23). It becomes a popular decorative technique in the early twelfth century and appears on objects like the handsome *mei-p'ing*, in a private collection in Japan, decorated with large peonies (Fig. 86; Hasebe, *Jishuyo*, pl. 6). These early examples are closely related to the large sub-group of black and white sgraffiato wares (Group 10) that were made at Kuan-t'ai.

The latest wares with sgraffiato decoration in white slip on the clay body are another distinct sub-group of pieces. A pear-shaped bottle with inscription dating it to the Yen-yu reign (1314-1320) is the key for dating this sub-group to the Yüan Dynasty (see Appendix A). It is decorated in several horizontal bands filled with floral designs and lotus petals, the ornamental elements quite small and crowded together. The body is typically a light grey color under the glaze. A *kuan* jar with a similar style of ornament, found at a Yüan dwelling site in Ch'a-yu-ch'ien-ch'i, Inner Mongolia, is decorated with phoenixes in flight among large peonies (Fig. 87; see Appendix C; no. 29).

The pillow from the Museum für Ostasiatsche Kunst belongs to a sub-group whose origins have been determined with some certainty by recent excavations at Tang-yang-yü in Hsiu-wu-hsien, Honan Province. At this kiln site a sherd with the same scrolling branches and rounded leaves as seen on the pillow was found (Fig. 88; *WW*, 1965, no. 9, pl. 5:7). The brick-red body color of the pillow, too, is characteristic of wares found at Tang-yang-yü. A pillow of identical shape and arrangement of decoration is in the Shanghai Museum (Fig. 89; *Shang-hai Po-wu-kuan ts'ang-tz'u hsüan-chi*, pl. 53).

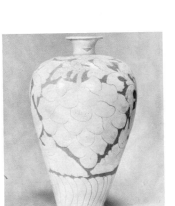

Figure 86

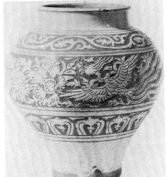

Figure 87

Figure 88

Figure 89

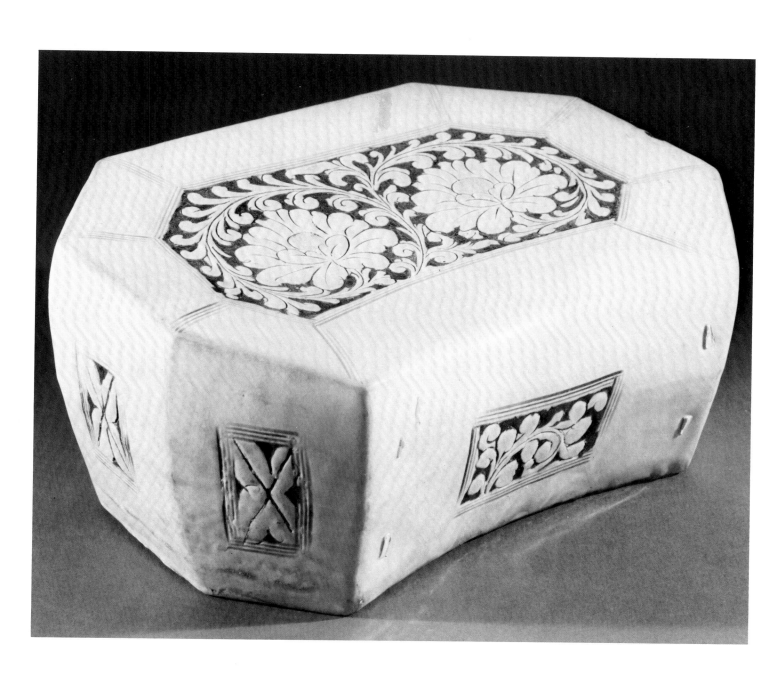

Figure 90

Figure 91

Plate 37
Bowl
Group 9
Chin Dynasty, 12th century
H. 4-7/8 in. (12.4 cm.)
D. 10-1/8 in. (25.7 cm.)
Collection of Mr. and Mrs. Myron Falk, New York

Deep rounded bowl with everted mouth, vertical foot and recessed, flat base. Buff stoneware covered with white and brown slips and transparent glaze. Sgraffiato decoration in white slip on the interior of a bouquet of lotus flowers and a large lotus leaf tied with a ribbon. The exterior covered with brown slip stopping at the foot. Five spur marks in the bottom.

Not previously published.

A sub-group of Group 9 pieces of the Chin Dynasty have white sgraffiato decoration on a ground in which relatively large areas of the slip have been removed revealing the buff-colored clay body. An octagonal pillow that is also decorated with a bouquet of lotus plants tied with a ribbon is in the collection of Arthur Sackler (Fig. 90). A leaf-shaped pillow that has an unusual ornament of ducks by a pond may be mentioned here, as well. The piece, in a Japanese collection, has a pair of ducks standing on a bank beneath a large lotus leaf on the upper half (Fig. 91; Kobayashi, *Shina toji zenshu,* pl. 16). The background on the upper half is scraped clean of slip, while on the lower half the fish and rolling currents are simply incised on a solid, white ground.

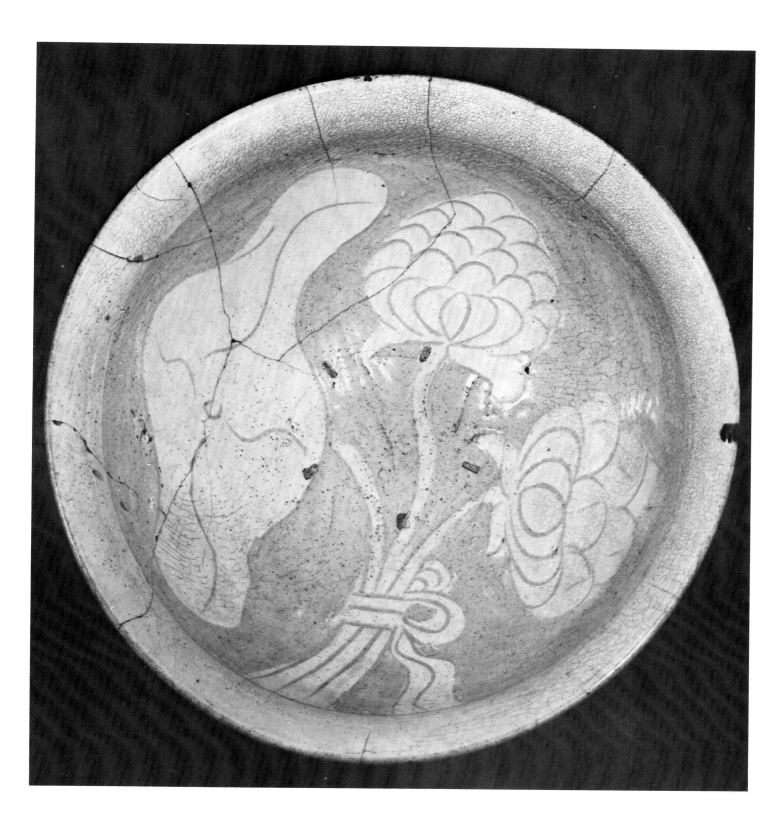

Figure 92

Figure 93

Figure 94

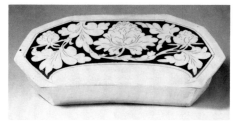

Figure 95

Plate 38
Pillow
Group 9
Chin Dynasty, late 12th—early 13th centuries
H. 4-5/8 in. (11.8 cm.)
L. 17-3/8 in. (44.1 cm.)
*The Cleveland Museum of Art, Purchase,
Edward L. Whittemore Fund.*

Long eight-sided pillow with top overhanging the sides. Buff stoneware covered with white slip and transparent glaze. Sgraffiato decoration in white slip on the top organized into three panels: a rectangular central panel with bird on a branch within an ogival frame; stylized leaf sprays in the panels at either side.

Published: Plumer, "The Potter's Art at Cleveland," p. 212; Hasebe, *So no Jishuyo,* pl. 45 bottom; Wirgin, "Sung Ceramic Designs," pl. 48:e; and Lee, *The Colors of Ink,* pl. 52.

This pillow is one of a number of related pieces of similar shape that comprise another sub-group of wares with sgraffiato decoration in white slip. It can be said to be of a provincial type, though its actual place of manufacture is as yet unknown. An eight-sided pillow that has an identical arrangement of the ornament into three panels, with a bird on a branch in the central ogival frame and leaf patterns at the sides, is in a private collection in Japan (Fig. 92; Hasebe, *Jishuyo,* pl. 52). Other pillows in this sub-group have large peony branches decorating the top. On an example in the Tokyo National Museum (Fig. 93; *Tokyo National Museum Catalogues: Chinese Ceramics,* pl. 288), the central peony resembles that painted in enamel colors on a bowl dated 1201 (see Pl. 105). A very similar pillow is in the Brundage collection at the Asian Art Museum of San Francisco (Fig. 95; d'Argencé, *Brundage Ceramics,* pl. XL:B). Although the peony flowers are rather different in appearance, the sweeping lines of the branch and the symmetrical placement of the leaves are the same as on the Tokyo piece. A closely related pillow, formerly in the collection of Frederick Mayer, exhibits a less symmetrical arrangement of the floral decoration, which consists primarily of lotuses rather than peonies, but still has a single branch sweeping horizontally across the top (*The Frederick M. Mayer Collection of Chinese Art,* Christie's, London, 1974, no. 45).

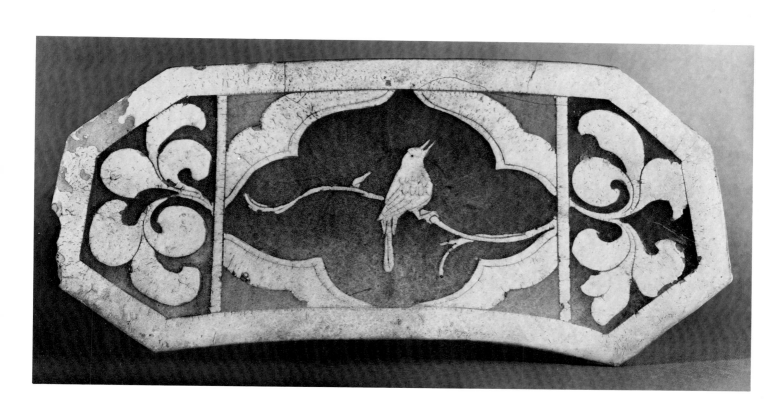

Figure 96

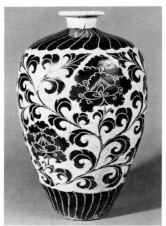

Figure 97

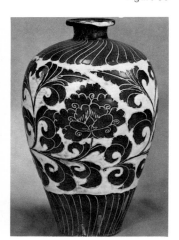

Figure 98

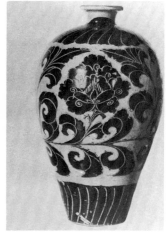

Figure 99

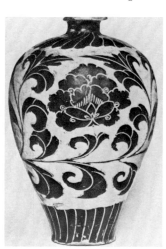

Figure 100

Plate 39
Mei-p'ing
Group 10
Northern Sung Dynasty, late 11th—12th centuries
H. 12-1/2 in. (31.7 cm.)
D. 7-1/2 in. (19.0 cm.)
Worcester Art Museum, Bequest of Mrs. Margaret C. Osgood

Vase with long ovoid body, sloping shoulder, small neck and flattened mouth rim; recessed flat base. Buff stoneware covered with white slip and black slip under transparent glaze. Sgraffiato decoration of large peony scrolls in black on a white ground around the body between narrow overlapping petals on the shoulder and around the base.

Published: K. Jacobson, "Notes on Chinese Ceramics," *Worcester Art Museum Annual*, vol. VII (1959), p. 32, fig. 8 and p. 33, fig. 9.

Tz'u-chou type wares with sgraffiato decoration in black slip over white slip were made in large numbers from the late eleventh century through the twelfth century. It includes many of the most handsome examples of Tz'u-chou type wares in existence today. The group can be divided into two sub-groups, the first of which is represented by a large number of objects including the Worcester Art Museum *mei-p'ing*. The wares of the first sub-group generally are decorated with bold designs in black on a white ground. The peony is the most common motif, appearing with its flowers, leaves and stylized scrolling branches on many pieces. These wares can be shown to have been manufactured largely at kilns in the Kuan-t'ai area, near the former Tz'u-chou. The wares of the second sub-group, to be discussed below, have a different style of decoration, often employing white designs on a black ground as well as black on white and are the product of kilns in Hsiu-wu-hsien.

The Worcester *mei-p'ing* exhibits clearly the traces of the technique of incising the designs and removing the black slip around them to reveal the white slip beneath. The peony flowers are drawn with a large bissected central petal incised with short vertical striations, around which are arranged the outer petals. The outer petals have scalloped edges and a small spiral at the base of each. On a fragment found at Kuan-t'ai, a portion of a very similar peony ornament, with the curling leaves and a few petals of a flower showing the scalloped petals and small spirals at their base, are visible (Fig. 96; *WW,* 1964, no. 8, pl. 6:1).

Several other *mei-p'ing* with very similar ornament are known, among which are the examples in the Kyoto National Museum (Fig. 97; *Sekai toji zenshu,* vol. 10, 1955, pl. 94), in the Yamato Bunkakan (Fig. 98; (*Chinese Ceramics from the Yamato Bunkakan Collection,* no. 7, 1977, pl. 62), the collection of the former royal house of Yi, in Seoul (Fig. 99; *Chosen koseki zufu,* p. 1128, pl. 3718), the British Museum (Fig. 100) and in Henri Rivière's book, published in 1923 (Rivière, *La Céramique dans l'Art d'Extrême-Orient,* vol. 2, pl. 57). All these examples exhibit a bow-tie configuration near the base of the flower, below the large central petal. This appears to be a stylized rendering of two of the lower petals flanking the center of the peony on the Worcester vase.

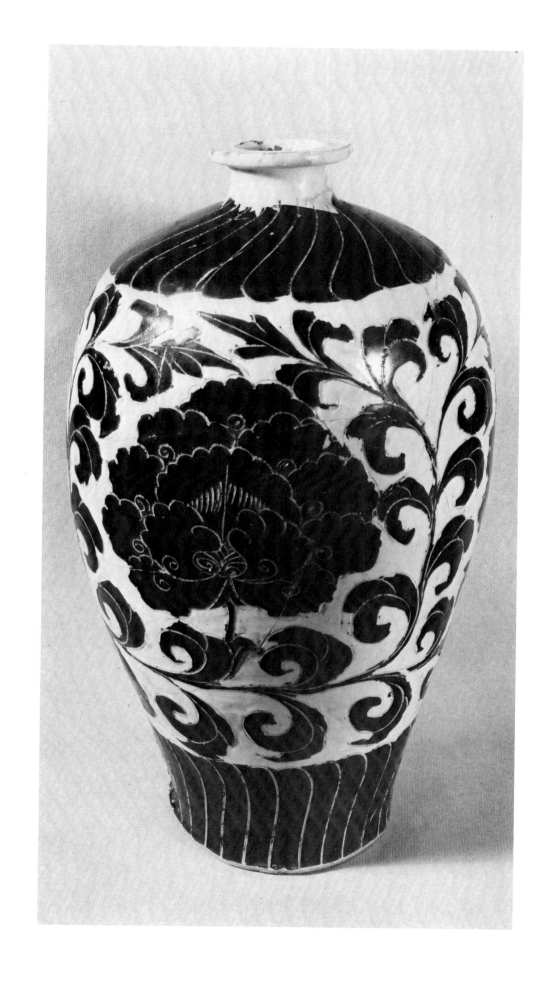

Plate 40
Pillow
Group 10
Northern Sung Dynasty, late 11th—early 12th centuries
W. 12-1/4 in. (31.5 cm.)
British Museum

Pillow in the form of a concave leaf-shaped slab set on a square block-like base. Grey stoneware covered with white and black slips under transparent glaze. Sgraffiato decoration of a bear holding a walking stick and tied to a wooden stake, set in a large ogival frame; the spaces between the frame and the outer border filled with small curling leaves.

Published: Hobson, *The Eumorfopoulos Collection,* vol. III, pl. LXIX: C 412; *Austellung Chinesischer Kunst,* (Berlin, 1929) pl. 626; Wirgin, "Sung Ceramic Designs," pl. 45:j; Hasebe, ed., *Chugoku bijutsu,* vol. 5, (Tokyo, 1973), pl. 26; Hasebe, *Jishuyo,* p. 116, fig. 49; and *Oriental Ceramics: The World's Greatest Collections,* vol. 5, (Tokyo, 1976), pl. 31.

This pillow is closely related to a leaf-shaped pillow found at Chü-lu-hsien, the site of the Sung town inundated in 1108. The pillow from this site has four large characters *ch'ing-ching tao-sheng* "the pure Taoist way of life" in white on a square central reserve in black. (Fig. 101; *Hopei ti-i po-wu-yüan pan-yüeh k'an,* vol. 7). At either side of the central area, inside the border, are small curling leaves like those on the British Museum pillow. A peony flower and leaves fill the triangular space at the top.

Figure 101

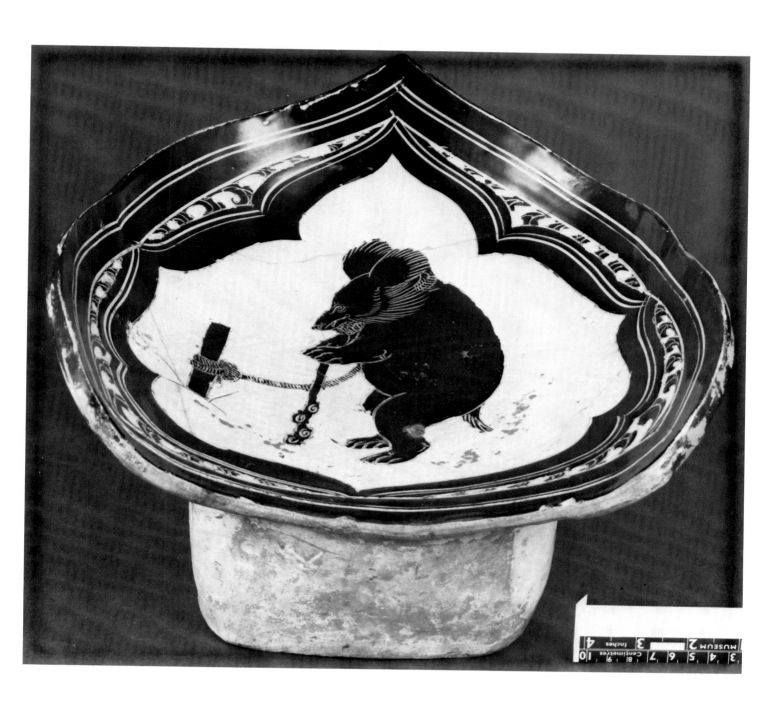

105

Figure 102

Figure 103

Figure 104

Figure 105

Plate 41
Pillow
Group 10
Northern Sung Dynasty, late 11th—early 12th centuries
H. 7-1/2 in. (19.0 cm.)
W. 7 in. (17.8 cm.)
Field Museum of Natural History, Chicago

Leaf-shaped pillow set on a square block-like base. Grey stoneware with white and black slips under transparent glaze. Sgraffiato decoration of a large peony spray in black on a white ground, within the black outer border.

Not previously published.

A nearly identical and better known pillow is in the Seikado collection in Tokyo (Fig. 102; *Sekai toji zenshu*, vol. 10, 1955, pl. 98). A fragment of a bowl found at Kuan-t'ai on which part of a peony with scalloped petals and very similar long leaves can be seen shows these pillows to be the product of the Kuan-t'ai kilns (Fig. 103; *WW*, 1964, no. 8, Pl. 6:1). A related pillow with a small peony spray in a lobed central panel and small leaf scrolls in the area around it is in the Idemitsu Art Gallery (Fig. 104; Hasebe, *Jishuyo*, pl. 44 and p. 90, fig. 6). The scroll pattern resembles that appearing on a sherd from Kuan-tai (Fig. 105).

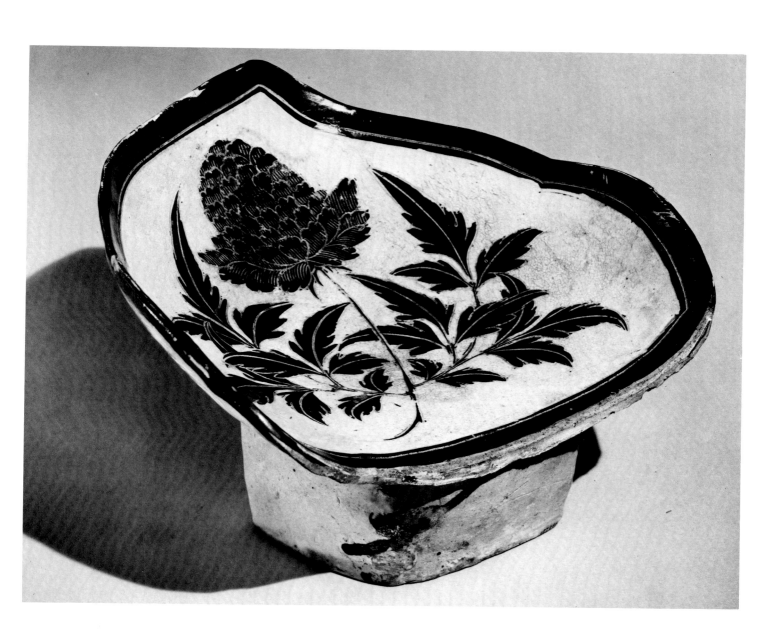

Plate 42
Tsun-shaped Vase
Group 10
Northern Sung Dynasty, 12th century
H. 22-3/8 in. (56.9 cm.)
D. 10 in. (25.5 cm.)
William Rockhill Nelson Gallery—Atkins Museum of Fine Arts

Large vase with ovoid body, high-rounded shoulder, long trumpet-shaped neck and mouth rim widely everted and rolled downward; low, widely flaring foot and recessed flat base. Grey stoneware covered with white and black slips under transparent glaze. Sgraffiato decoration in black on a white ground; a large dragon winding around the body and neck of the vase, its scales, hairs, claws and other features rendered in fine detail; upright lotus petals around the base decorated with incised floral scrolls; an incised scroll pattern on the foot. Inscription, *hua-p'ing Liu-chia tsao* "flower vase, made by the Liu family."

Published: International Exhibition of Chinese Art, (London, Burlington House, 1935), no. 246; Sickman, ed., *The University Prints, Oriental Art,* Series O; *Early Chinese Art,* Section II, (Newton, Mass., 1938), pl. 248; *Masterpieces of Asian Art in American Collections,* (New York, Asia Society, 1960), p. 18; Koyama, ed., *Meito hyakusen,* pl. 54; *Sung-tai min-chien t'ao-tz'u wen-p'ing,* pls. 140, 141, 142 and 143; Wirgin, "Sung Ceramic Designs," pl. 49:h; Koyama, *So,* pl. 38; *Chinese Art in Western Collections, Ceramics,* vol. 5, (Tokyo: Kodansha, 1972), color pl. 25; Sherman Lee, "The Changing Taste for Chinese Ceramics," *Apollo,* XCVII, (March 1973), p. 255, pl. 11; *Handbook of the Collections in the William Rockhill Nelson Gallery of Art,* vol. 2, (Kansas City, 1973), p. 84; and *Sekai toji zenshu,* vol. 12, (1977), pl. 230.

This is the largest and most impressive of the *tsun*-shaped vases of Group 10. Both its large size and its decoration make it a very fine and rare piece. Other vases of this shape have a floral decoration and are much smaller in size. Numerous examples of the latter are known, of which only a few will be mentioned here. One, in the Tokyo National Museum, has large peonies and curling stems and leaves (Fig. 106; *Kizo Hirota,* pl. 59). The flowers are formed of round petals clustered around a center drawn as a large scalloped petal with vertical striations. Near the base of the flower is a bowtie configuration resembling that seen on *mei-p'ing* of this subgroup (see Figs. 97-100). A similar vase is in the Victoria and Albert Museum. On other *tsun*-shaped vases, the bow-tie is simplified into a horizontal figure "8," a development exhibited on the example in the Kikusui Museum, Yamagata Prefecture (Fig. 107: Hasebe, *Jishuyo,* pl. 15), and another in the Bristol City Art Gallery (Reg. no. 2445).

The style of the decoration on the Nelson Gallery vase is not unique. A dragon with similarly detailed rendering of its scales claws, curling mane, etc., appears on a *mei-p'ing* in the Hakutsuru Museum (Fig. 108; *Sekai toji zenshu,* vol. 12, 1977, pl. 117). Around the shoulder and the base of the *mei-p'ing* are very narrow overlapping petals, like those seen on many other *mei-p'ing* decorated with peony scrolls.

A portion of a lotus petal of the same shape as those around the base of the Nelson vase is discernible on a fragment found at Kuan-t'ai (Fig. 109; *WW,* 1964, no. 8, pl. 6:1). The fragment bears an incised, undecipherable inscription written, as on the Nelson vase, in the undecorated outer edge of the petal. Instead of finely incised floral scrolls, the petal on the fragment is filled with a sgraffiato leaf scroll pattern. The finely incised scrolls on the foot of the Nelson vase can be seen, also, on a leaf-shaped pillow where it decorates a ribbon tied around the neck of a large cat (Fig. 110; Wirgin, "Sung Ceramic Designs," pl. 45:k). This pillow, in a Swedish collection, can be dated to the early Chin period on stylistic grounds owing to its narrower shape and the larger scale

Figure 106

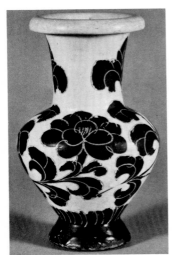

Figure 107

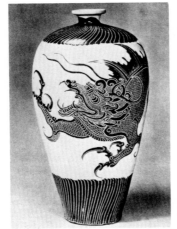

Figure 108

Figure 109

Figure 110

Figure 111

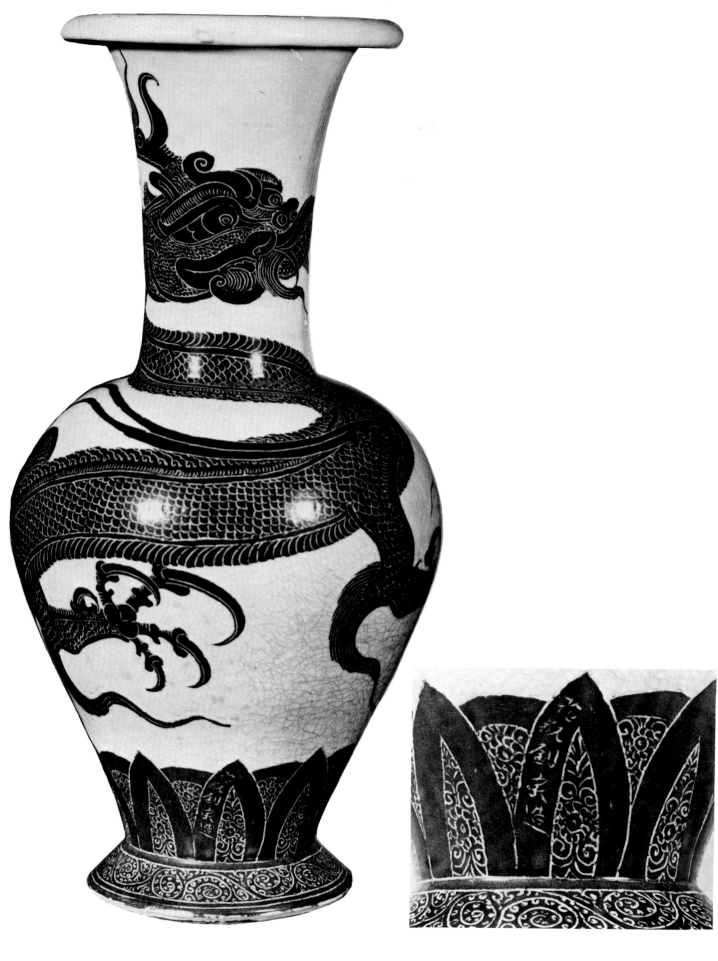

of the main motif in comparison to those of leaf-shaped pillows of the late 11th and early 12th centuries. Furthermore, a cat painted on the wall of a tomb believed to be of the Chin Dynasty is depicted in a very similar manner, with one paw raised and with a ribbon tied around its neck (Fig. 111; *KK*, 1965, no. 7, pl. 8:11). The tomb was excavated at Ch'ang-chih in Shansi Province.

<div style="text-align: right">

Plate 43
Bowl
Group 10
Northern Sung Dynasty, late 11th—early 12th centuries
H. 5-7/8 in. (14.9 cm.)
D. 6-11/16 in. (17.0 cm.)
Metropolitan Museum of Art, Rogers Fund, 1923

</div>

Deep globular bowl curving inward slightly toward the mouth; nearly vertical small foot and recessed convex base. Grey stoneware covered with white and black slips and transparent glaze stopping unevenly above the foot. Sgraffiato decoration in black on a white ground on the exterior: a flattened meander border above a wide central band with nine upright, fan-shaped peonies interspersed with small florets.

Published: Warren Cox, *Pottery and Porcelain*, vol. 1, (New York, 1944), p. 194, pl. 59; Hasebe, *So no Jishuyo*, pl. 28; and Wirgin, "Sung Ceramic Designs," pl. 47:k.

The fan-shaped peony appears, also, above the inscription *ch'ing-ching tao-sheng* on a leaf-shaped pillow of Group 10 that was found at Chü-lu-hsien (see Fig. 101). This provides an important clue in the dating of the Metropolitan Museum bowl and related pieces to the late eleventh and early twelfth centuries. Several other deep bowls with black sgraffiato decoration are known, among them an example in a Japanese collection that has a wide band of black and white "interlocking cash," that can also be seen as four-petaled flowers, around it (Fig. 112; Hasebe, *So no Jishuyo*, pl. 29). Another, in the British Museum, has a wide band of diamond-shaped flower patterns (Ayers, *The Seligman Collection*, pl. D 107).

A related, nearly cylindrical bowl with a flat base may be discussed here, also. The bowl, in a Japanese collection, is decorated with a row of upright lotus petals below a band of curling peony leaves (Fig. 113; *Sekai toji zenshu*, vol. 10, 1955, p. 228, fig. 101). The leaves are like those that appear frequently among peony scrolls on *mei-p'ing* and *tsun*-shaped vases of the Kuan-t'ai subgroup and also as a border pattern on the above-mentioned pillow from Chü-lu-hsien (see Fig. 101). The incised scrolling lines in the center of the lotus petals and in the spaces between the petals recall the floral designs incised on the petals of the large *tsun*-vase in the Nelson Gallery (see Pl. 42) and appear to be roughly contemporary.

Figure 112 Figure 113

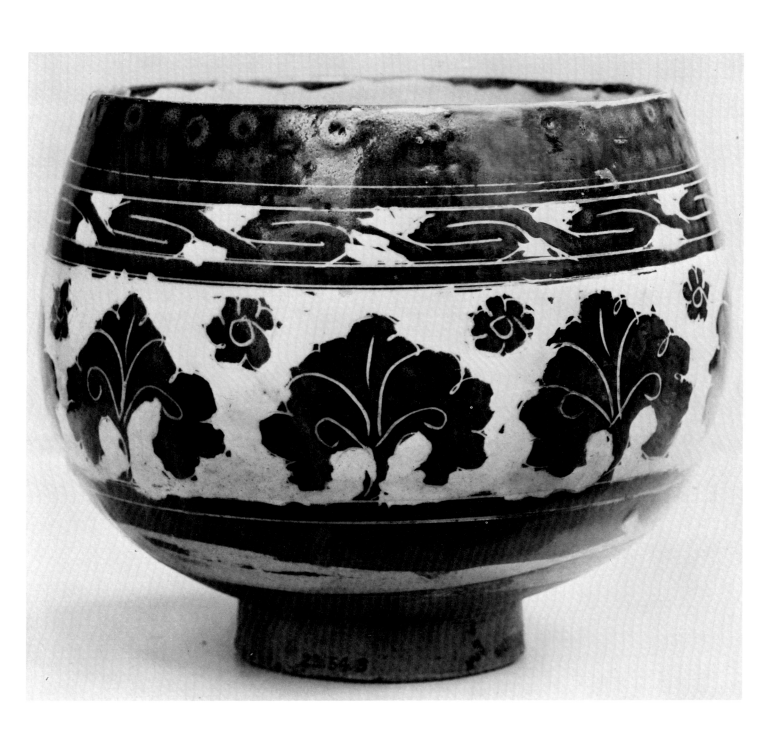

Plate 44
Jar
Group 11
Northern Sung Dynasty, 12th century
H. 6-1/8 in. (15.5 cm.)
D. 6-7/8 in. (17.4 cm.)
The Metropolitan Museum of Art,
Gift of Mrs. Wilfred Wolff in memory of her father,
John Platt, 1942.

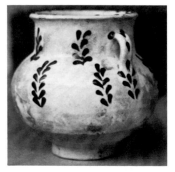

Figure 114

Jar with globular body, very wide cylindrical neck and slightly everted mouth rim; two double-strand loop handles attached to the neck and shoulder; small vertical foot and recessed flat base. Grey stoneware with white slip and transparent glaze. Painted decoration in brown glaze over the transparent glaze: upright frond-like branches with teardrop-shaped leaves dispersed over the exterior of the body and neck, a row of dots around the top of the rim, and brown splashes at the junctures of the handles to the jar.

Published: Warren Cox, *Pottery and Porcelain*, vol. I, (New York, 1944), p. 195, pl. 60 a.

The group of Tz'u-chou type wares decorated with black or brown glaze in patterns composed of dots or teardrops can be dated to the eleventh and twelfth centuries on the basis of their shape and their relationship to objects from Chü-lu-hsien. This type of decoration may be regarded as an important precursor to the underglaze painted Tz'u-chou wares but differs fundamentally from them in both style and technique of painting.

A plain white jar of the same shape as the Metropolitan Museum jar was found at Chü-lu-hsien (see Fig. 8). A jar with very similar painted fronds, in the Museum of Fine Arts, Boston, is marked with the reddish brown stain that is characteristic of objects from this site (Fig. 114; *Hoyt Collection*, pl. 286). Another similar jar is in the Victoria and Albert Museum (Reg. no. C 579-1927). The frond pattern also appears on a vase with wide cylindrical neck, angular shoulder and everted, flattened mouth rim that is in the British Museum. Other vases of this type are decorated with arrangements of four to seven dots like small flowers strewn over the surface. The latter vases tend to have a more rounded body shape and slightly higher, flaring foot. Examples illustrated here are in the Victoria and Albert Museum (Fig. 115; Reg. no. C 457-1920) and in a private collection in Japan (Fig. 116; Hasebe, *Jishuyo*, pl. 56).

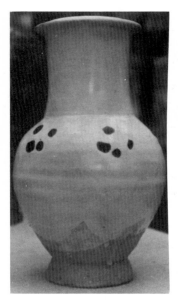

Figure 115

Figure 116

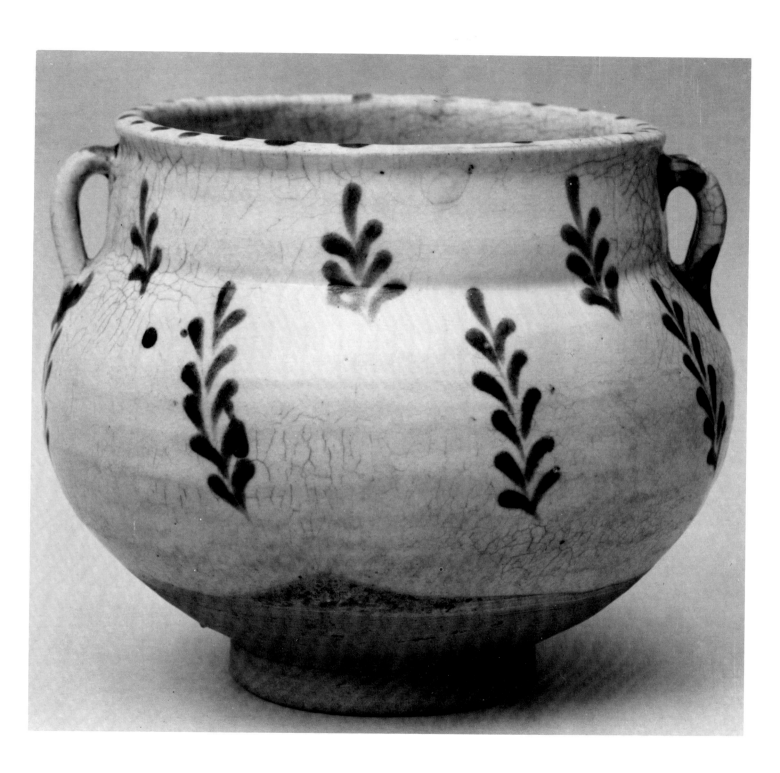

Plate 45
Jar
Group 11
Northern Sung Dynasty, early 12th century
H. 3-15/16 in. (10.0 cm.)
D. 4-7/16 in. (11.2 cm.)
Collection of Dr. Paul Singer

Small jar with depressed globular body, wide cylindrical neck and everted mouth rim; low thick foot and recessed flat base. Light buff stoneware with white slip and transparent glaze stopping unevenly above the foot. Painted decoration in brown glaze over the transparent glaze, groups of five dots like small flowers widely spaced around the shoulder.

Not previously published.

A bowl with a similar pattern of painted dots on the exterior was found at the Sung site of Chü-lu-hsien (Fig. 117; *Kuo-li li-shih po-wu-kuan ts'ung-k'an*, vol. 1, no. 1, no pag.). Another small bowl decorated with dotted flowers was discovered at the Kuan-t'ai kiln site (Fig. 118; *WW*, 1964, no. 8, p. 41, fig. 8:3). In shape and size, as well as ornament, these bowls have a close affinity with the Singer jar.

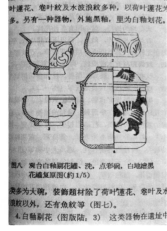

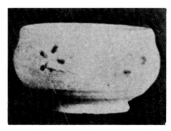

Figure 117　　　　　　　Figure 118

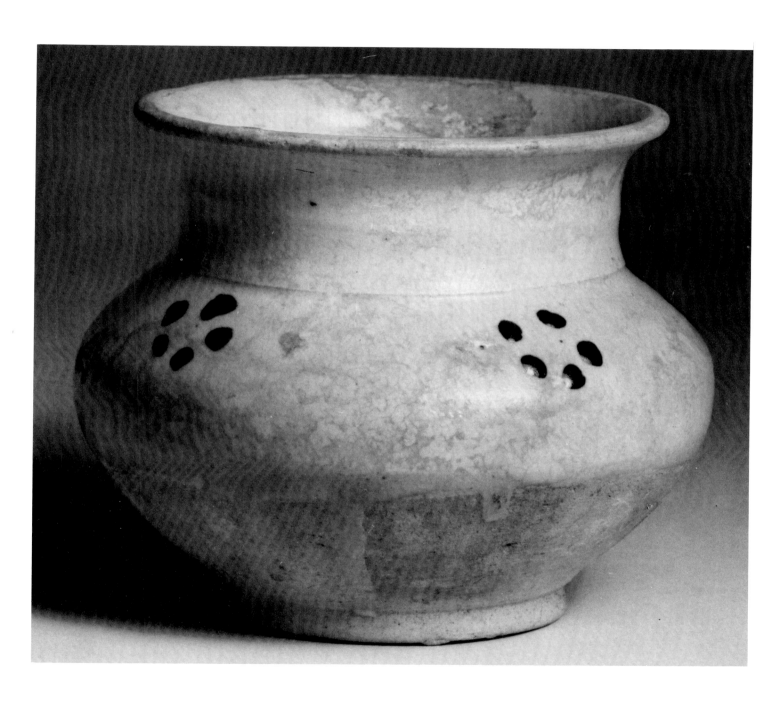

Plate 46
Pillow
Group 12/A
Chin Dynasty, late 12th—early 13th centuries
H. 4-7/32 in. (10.7 cm.)
L. 11-7/16 in. (29.0 cm.)
The Montreal Museum of Fine Arts

Figure 119

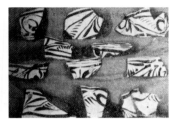

Figure 120

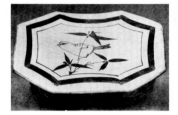

Figure 121

Figure 122

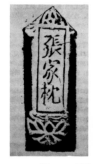

Figure 123

Figure 124

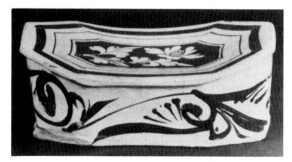

Figure 125

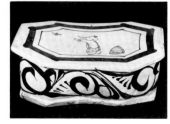

Figure 126

Figure 127

Octagonal pillow with concave, forward sloping top slightly overhanging the sides. Grey stoneware with white slip and transparent glaze. Painted decoration in underglaze black iron pigment: a bird perched on a stalk of bamboo, bounded by a thin line within a dark, heavy line following the outline of the pillow; stylized palmette scrolls around the sides. Three-character mark *Chang-chia chen*, "Chang family pillow," stamped on the base.

Published: Ch'en Wan-li, *T'ao-chen*, pl. 27; Leo Rosshandler, "The New Oriental Gallery," *M* (Bulletin of the Montreal Museum of Fine Arts), no. 1, 1969, p. 21, fig. 8; Wirgin, "Sung Ceramic Designs and Their Relation to Painting," p. 37, pl. II:c; Peter Swann, "The Timeless Quality of Far Eastern Art," *Apollo*, vol. CIII, no. 171, p. 369, fig. 3; and Yutaka Mino, "Asiatic Art," in *Guide*, (The Montreal Museum of Fine Arts, 1977), fig. 102.

The wares with painted underglaze black or dark brown decoration are the largest and most long-lived group of Tz'u-chou type wares. The classification of the great variety of objects of Group 12 into sixteen sub-groups according to their shapes facilitates their comparative study and, furthermore, is reinforced by the fact that the styles of painting and the ornamental motifs employed frequently can be correlated with specific kinds of objects. Unlike the deeply carved or incised and stamped ornament in which the same motifs were used on a wide range of pieces, the painting medium seems to have offered a greater flexibility and spontaneity of design. The technique was first used in the 12th century, apparently only after the fall of the Northern Sung Dynasty. No dated examples of Group 12 from the Northern Sung period are known, nor were any examples found at the site of Chü-lu-hsien.

The octagonal pillows, the first sub-group of underglaze black painted wares, are of two main varieties. The first has a top with a circumference larger than that of the supporting sides so that there is a slight overhang. The second variety has the top and sides fitted together exactly at the edges, which are smoothly finished and slightly rounded off. On pillows of the first variety, the sides are decorated with large, curling leaf scrolls resembling half-palmettes rendered in a bold, freehand style. The top is painted with a picture within an octagonal border like that seen on the Montreal pillow. Fragments of pillows painted with similar dark borders (Fig. 119; *WW*, 1964, no. 8, pl. 6:4) as well as fragments decorated with the large half-palmette scrolls (Fig. 120; *WW*, 1964, no. 8, p. 45, fig. 20) have been found at the Tung-ai-k'ou kiln site.

A pillow of the first variety with a painting of a small bird in the same pose as that of the bird on the Montreal pillow, and also viewed from below, appears in a Japanese work on Sung ceramics published in 1929 (Fig. 121: Towakai, ed., *Soji*, Tokyo, 1929, pl. 59). A small bird on a branch depicted from a similar point of view appears in a painting attributed to the Emperor Hui-tsung (Fig. 122; Siren, *Chinese painting*, vol. III, 1956, pl. 236; see, also, Wirgin, "Sung Ceramic Designs and Their Relation to Painting," p. 28).

The mark on the base of the Montreal Museum pillow is a very unusual one, as most examples with a mark have the characters *Chang-chia tsao*, or "made by the Chang family," rather than *Chang-chia chen*. A fragment of a pillow with this very same mark, however was found at the Yeh-tzu-chen kiln site in Tz'u-hsien, which is very close to Tung-ai-k'ou and on the opposite bank of the Chang River (Fig. 123; *WW* 1964, no. 8, p. 44, fig. 16).

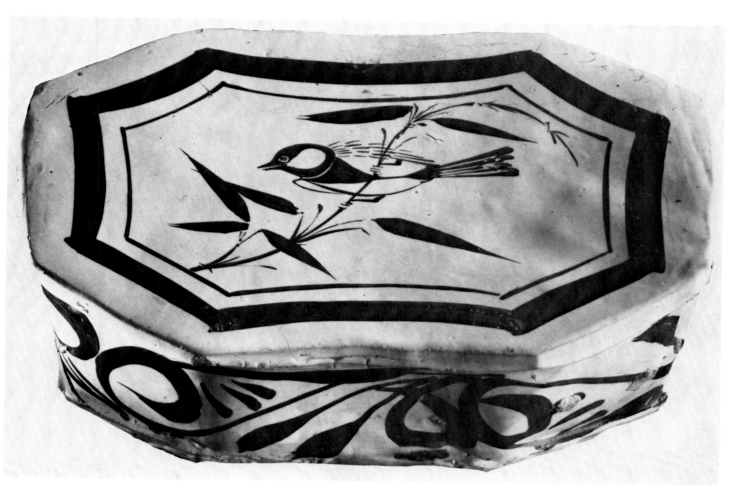

A variety of subject matter, such as animals, flowers and human figures appear in the decoration of other octagonal pillows of this type. An example with a spotted stag on the top, a character *fu*, or "happiness," written above its back, was excavated from a tomb in Hsing-t'ai, just north of Tz'u-hsien, in 1955 (Fig. 124: *KK* 1959, no. 7, p. 369). The mark *Chang-chia tsao* is stamped on its base. Floral decorations appear on pillows in the Yale University Art Gallery (Lee, *Selected Far Eastern Art,* pl. 297), in the Art Museum at the University of Malaysia (Fig. 125; *University of Malaysia Art Museum,* Singapore, 1959, p. 34) and in the collection of Michel Beurdeley (Beurdeley, *Le Céramique Chinoise,* 1974, p. 146, pl. 80). On the latter two examples, the floral sprays are reserved in white on a

black painted ground. Human figures such as the child calling a pet bird back to its cage, on the pillow in the Royal Ontario Museum (Fig. 126; Reg. no. 960.238.176), are depicted with liveliness and charm. A child at play appears on the top of another pillow that was found at a kiln site in Hsing-t'ai (*KK*, 1961, no. 3, p. 171, fig. 1).

A final, unusual example of this variety of octagonal pillow has four lines of verse inscribed on the top without any other ornament inside the octagonal border (Fig. 127; Wirgin, "Sung Ceramic Designs," pl. 46:1). The piece, in a Japanese collection, has the same palmette-like scroll painted around the sides.

Plate 47
Pillow
Group 12/A
Chin Dynasty, late 12th—early 13th centuries
H. 4-1/2 in. (11.0 cm.)
L. 9-7/8 in. (25.1 cm.)
Museum of Fine Arts, Boston, Gift of C. Adrian Rübel

Figure 128

Figure 129

Figure 130

Octagonal pillow with slightly concave, forward-sloping top; vertical sides, the front side curving inward. Grey stoneware covered with white slip and transparent glaze. Painted and incised decoration in black underglaze iron pigment on the top: a bird on a leafless tree branch watching an insect in flight; a few stalks of bamboo at the bottom; a wide black border with combed wavy lines and straight incised lines around the edge of the pillow. Around the sides, painted leaf clusters resembling palm leaves in a wide continuous band.

Published: Paine, "Chinese Ceramic Pillows," pl. 13, no. 20.

This pillow, an example of the second variety of octagonal pillows, has the characteristic palm-leaf pattern painted around the sides. The pattern appears here to be a stylization of peony leaves, as a peony flower is painted in the center of a group of leaves on the front side. On most other related pieces, the flower is eliminated. The top is decorated with painted designs in which the details are incised through the black pigment to the white slip beneath. Although this technique is also dealt with in Group 13, below, it is included here because of its use with the designs like the palms around the side that are simply painted and not incised.

An octagonal pillow of the same type with combed and incised border around the top and palm leaves around the sides appears in a Japanese publication of 1925 (Fig. 128; Okuda, ed., *Toyo toji shusei,* vol. 3, Tokyo, 1925, pl. 27). The top is decorated with a lily stalk with small butterflies fluttering around it. A closely related pillow decorated with a peony spray is in the Royal Ontario Museum (Fig. 129; Fernald, "Chinese Mortuary Pillows," no. 16). The veins of the leaves are incised into the white slip, but the black border has been left free of incised designs.

These pillows can be seen to be the product of kilns in Yü-hsien, Honan Province. Fragments found at the Pa-ts'un kilns in Yü-hsien have painted and incised ornament, as the floral design shown here (Fig. 130; *WW*, 1964, no. 8, p. 33, fig. 13). The small hatched markings on the stem of the flower are like those on the stem of the peony on the Toronto pillow (see Fig. 129). Also found at Pa-ts'un is a *tsun* vase with high flaring foot and undulated mouth rim that is decorated with palm leaves closely resembling those on the sides of the pillows. (see Fig. 206)

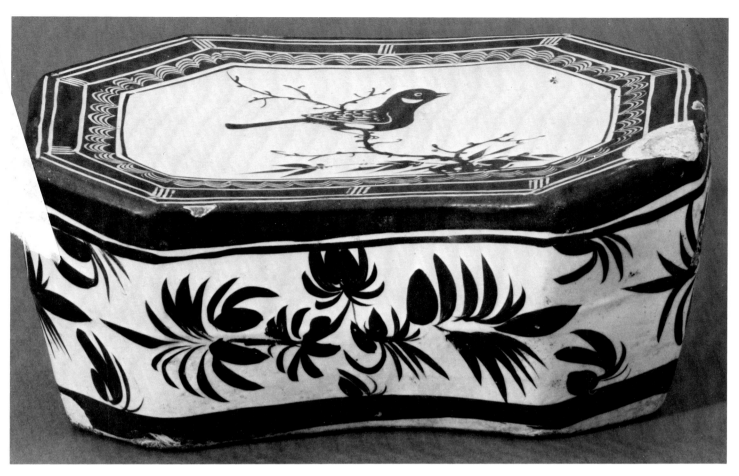

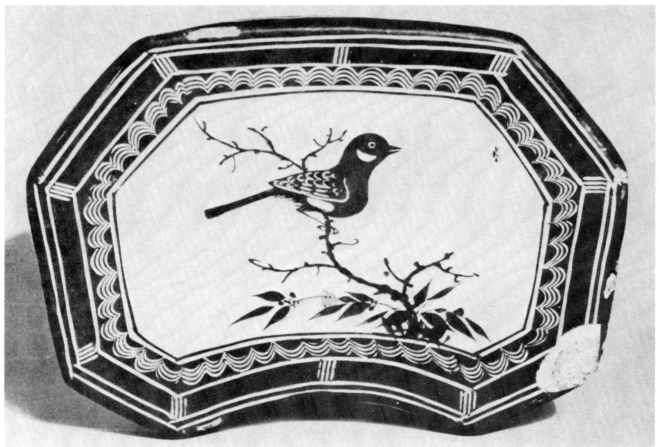

Plate 48
Pillow
Group 12/A
Chin Dynasty, late 12th—early 13th centuries
H. 4-1/4 in. (10.5 cm.)
L. 9-3/8 in. (23.5 cm.)
Fogg Art Museum, Harvard University, Gift of C. Adrian Rübel in honor of Professor Max Loehr

Octagonal pillow with slightly concave, forward-sloping top surface and vertical sides. Buff stoneware with white slip, and transparent glaze. Painted underglaze decoration in streaky, brown iron pigment: a chrysanthemum spray and two butterflies on the top in a dark border; palm leaves around the sides.

Published: Paine, "Chinese Ceramic Pillows," pl. 14, no. 21.

The painting on this pillow has an unusually blurred appearance and is brown in color instead of black. This effect is probably due to an excess of iron oxide in the pigment that acts as a flux, causing the glaze to run. In all other respects, however, this piece is similar to the pillows from Yü-hsien.

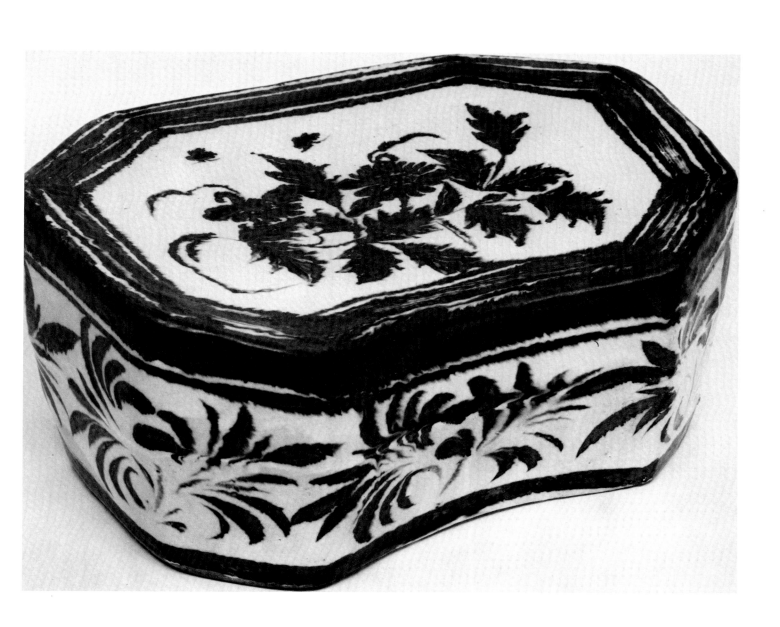

Plate 49
Pillow
Group 12/B
Chin Dynasty, 13th century
H. 6-1/8 in. (15.5 cm.)
L. 16 in. (40.6 cm.)
The Brooklyn Museum, Anonymous loan

Large, cloud-shaped pillow with concave, forward-sloping top slightly overhanging the sides. Grey stoneware with white slip and transparent glaze. Painted underglaze decoration in black iron pigment: on the top a scene of ducks on a pond being pursued by a hawk; tall grasses growing on the bank; a border of wide and narrow painted lines following the outline of the pillow; stylized half-palmette scrolls around the sides. Three-character mark *Chang-chia tsao*, "made by the Chang family," stamped on the base.

Published: Ch'en Wan-li, *T'ao-chen*, pl. 26.

Like the octagonal pillow, the cloud-shaped pillows are of two main varieties, the first having a top that juts out over the sides, and the second having the top smoothly joined to the sides and the edges rounded off. The two varieties of cloud-shaped pillows, however, are for the most part much more closely related than the two varieties of Group 12/A and appear to have been made at the same kilns in the Tz'u-chou area. Both have the same boldly painted leaf scrolls as on the octagonal pillow of the first type painted around the sides. These scrolls are exhibited on the pillow from the Brooklyn Museum.

The tall stalks of grass in the scene painted on the top of this pillow are the same as those found on sherds from Tung-ai-k'ou in Han-tan-hsien (see Fig. 119). The Chang-chia-tsao mark, too, appears on the numerous fragments from the Tung-ai-k'ou kilns (Fig. 131; *WW*, 1964, no. 8, p. 46, fig. 24).

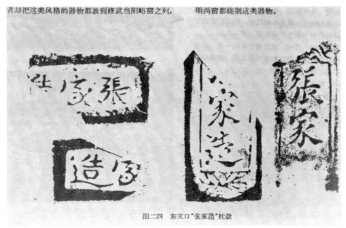

者却把这类风格的器物都放到修武当阳峪窑之列。　明两窑都烧制这类器物。

图二四　东艾口"张家造"枕款

Figure 131

122

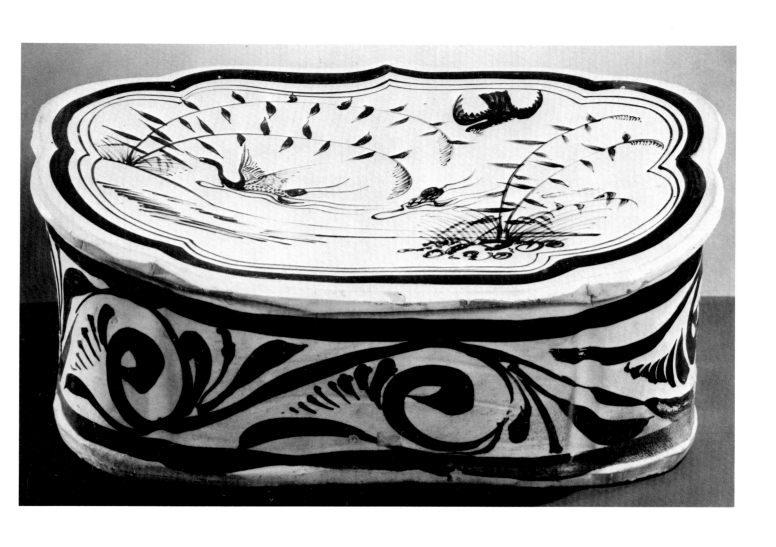

123

Plate 50
Pillow
Group 12/B
Chin Dynasty, 13th century
H. 6 in. (15.2 cm.)
L. 15-1/4 (38.7 cm.)
The Art Institute of Chicago

Large, cloud-shaped pillow with concave, forward-sloping top slightly overhanging the sides. Grey stoneware with white slip and transparent glaze. Painted underglaze decoration in black iron pigment: on the top a large fish flanked by long waving strands of seaweed, bordered by wide and narrow lines following the outline of the pillow; stylized half-palmette scrolls around the sides. Four-character mark *Chang chin-chia tsao,* "made by an apprentice of the Chang family," in a horizontal row stamped on the base.

Published: Wirgin, "Sung Ceramic Designs," pl. 46:k.

One of the most handsome of the painted pillows, this piece is important in verifying the direct relationship between the two types of cloud-shaped pillows of Group 12/B. The same seaweed pattern is used as a border design on cloud-shaped pillows of the second type.

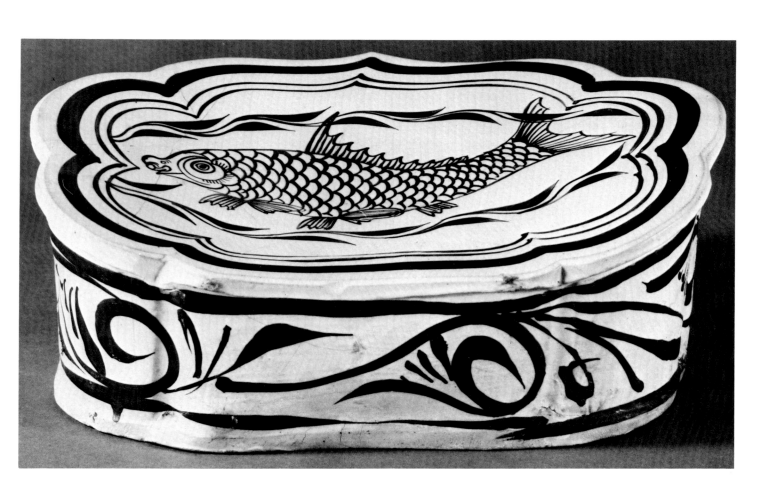

Plate 51
Pillow
Group 12/B
Chin Dynasty, 13th century
H. 6 in. (15.2 cm.)
L. 13-1/8 in. (33.3 cm.)
Royal Ontario Museum, Toronto

Figure 132

Figure 133

Cloud-shaped pillow with concave forward-sloping top and lobed sides. Grey stoneware with white slip and transparent glaze. Painted underglaze decoration in black iron pigment: on the top, a child holding a large lotus leaf and pursuing a duck, bordered by wide and thin lines and a seaweed pattern around the edge; boldly painted half-palmette scrolls around the sides. Three-character mark *Chang-chia tsao* stamped on the base.

Published: Fernald, "Chinese Mortuary Pillows in the Royal Ontario Museum of Archaeology," pl. 15; Wirgin, "Sung Ceramic Designs," pl. 47:a; and Patricia Proctor, "Chinese Ceramics," *Arts of Asia*, vol. 9, no. 2, (March-April 1979), p. 99, fig. 34.

The seaweed border around the edge of this pillow of the second type of cloud-shaped pillows is painted in the same style as the trailing strands of seaweed flanking the fish on the Chicago pillow above (see Pl. 50). The palmette scrolls, too are the same.

A nearly identical cloud-shaped pillow, also in the Royal Ontario Museum, is decorated with the child holding a lotus leaf but has no duck (Fig. 132). Another pillow of this variety has a small rabbit crouched under tall stalks of grass (Ch'en Wan-li, *T'ao-chen*, Pl. 19). The stalks of grass are like those seen previously on sherds from Tung-ai-k'ou (see Fig. 119). A related piece with a large dragonfly hovering over small plants was excavated from a tomb believed to have been of the Sung period, but more probably of the Chin, at Hsing-t'ai, Hopei, in 1961 (Fig. 133; *KK*, 1961, no. 3, p. 174, fig. 1).

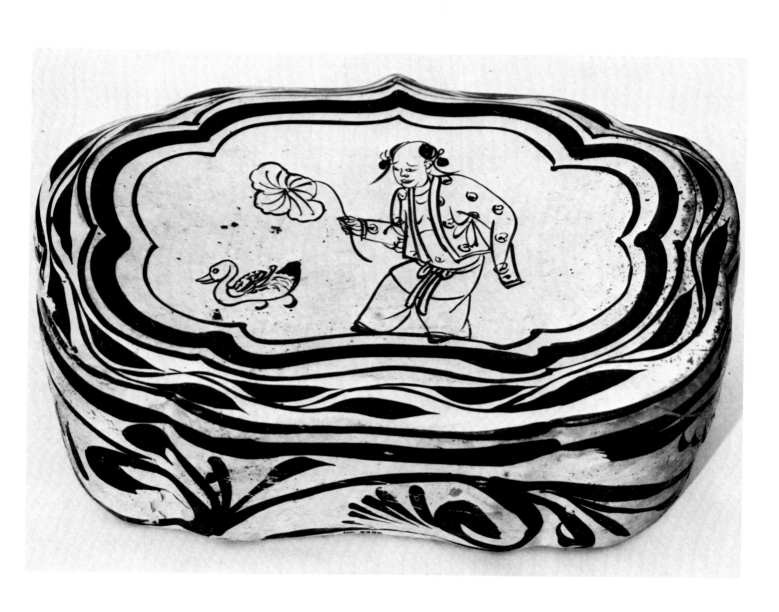

Plate 52
Pillow
Group 12/B
Chin Dynasty, 13th century
H. 5-1/4 in. (10.8 cm.)
L. 12-1/2 in. (31.7 cm.)
The Cleveland Museum of Art, Gift of Mrs. Langdon Warner

Cloud-shaped pillow with concave forward-sloping top surface and lobed sides. Grey stoneware with white slip and transparent glaze. Painted decoration in black iron pigment: on the top, a leaping stag in a border of wide and narrow lines and a band of seaweed around the edge; half-palmette scrolls around the sides.

Published: Wirgin, "Sung Ceramic Designs," pl. 47:b.

An octagonal-shaped pillow with a stag painted on the top was found at Hsing-t'ai, Hopei, in 1955 (see Fig. 124). A closely related piece with a tiger instead of a deer was in the collection of the late J. M. Plumer (Fig. 134; Wirgin, "Sung Ceramic Designs," pl. 47:3). Other cloud-shaped pillows of this variety are inscribed with lines of verse. One was found at Hsing-t'ai (Fig. 135; *KK*, 1961, no. 3, p. 174, fig. 1), and a second is in a private collection in Japan (Fig. 136). A third, on which the inscription is written in the bolder style, is the only known example of the Yü-hsien type (Fig. 137; Goepper, et al, *Form und Farbe,* pl. 81). The palm leaf patterns around the sides are painted in the same style as those seen on octagonal pillows and other objects from Yü-hsien.

Figure 134

Figure 135

Figure 136

Figure 137

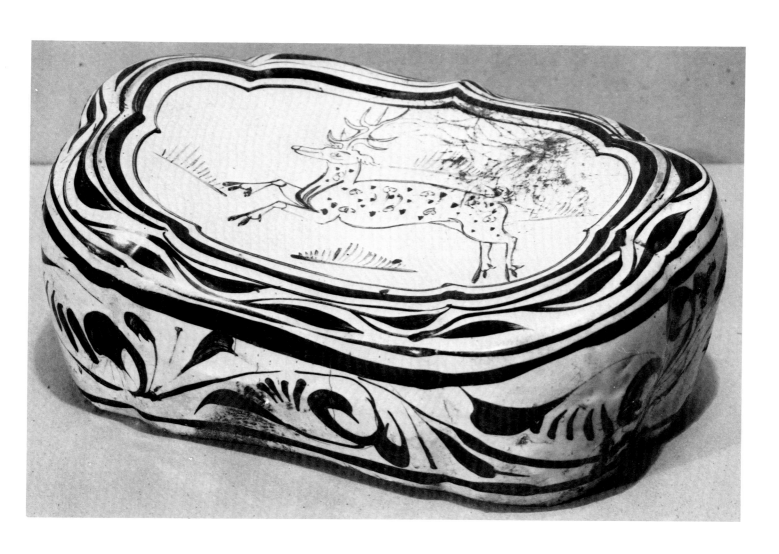

Figure 138

Figure 139

Figure 140

Figure 141

Plate 53
Pillow
Group 12/C
Chin Dynasty, 13th century
H. 2-3/4 in. (7.0 cm.)
W. 7-7/8 in. (20.0 cm.)
The St. Louis Art Museum, Purchase W. K. Bixby Fund.

Oval pillow with rounded sides and forward-sloping top overhanging the sides. Grey stoneware with white slip and transparent glaze. Painted underglaze decoration in black iron pigment: a bird sitting on a tree branch looking downward at an insect in flight; a cloud-shaped border drawn in thin lines; sides undecorated. Three-character mark, *Chang-chia tsao,* in a lotus frame stamped on the base.

Published: *Chinese Ceramics,* (Los Angeles, 1952), pl. 214; Trubner, "Tz'u-chou and Honan Temmoku," p. 157, fig. 6; and *The St. Louis Art Museum: Handbook of the Collections,* (1975), p. 287.

Bean-shaped pillows are the most common in this sub-group, but ovoidal and crescentic forms also occur. They are all of the Chin period. A number of these have an oval or bean-shaped top overhanging the sides, around the edge of which is painted a thick, dark line and within that a thin line bordering the decoration. They frequently have stylized half-palmette scrolls around the sides. An example, painted on the top with a small boy holding a fishing pole, was found in a tomb at Hsing-t'ai (Fig. 138; *WW,* 1965, no. 2, p. 40, fig. 4 and pl. 4:2) and appeared in the recent Chinese Exhibition (*The Genius of China,* London, 1973, no. 338). Two other pillows with a thin cloud-shaped border within the thick line also are decorated with small boys. On one, a boy dressed in riding habit swings a small mallet at a ball on the ground (Fig. 139; Ch'en, *T'ao-chen,* pl. 10), and on the other in the Metropolitan Museum of Art, New York, a boy gallops about on a bamboo hobbyhorse (Fig. 140 Ibid., pl. 9).

A nearly rectangular, oblong pillow that is decorated with a bird on a branch eyeing an insect flying over its head is in the Honolulu Academy of Art (Fig. 141). Like the St. Louis pillow, it has no palmette scroll around the sides. The St. Louis piece, however, seems to be the later of the two on stylistic grounds, as it is painted in a looser style. The thick black line at the outer edge has been reduced to a thin line.

Plate 54
Pillow
Group 12/C
Chin Dynasty, 13th century
H. 3-5/8 in. (9.9 cm.)
W. 9-7/8 in. (25.1 cm.)
Museum of Fine Arts, Boston

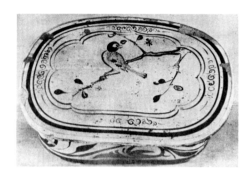

Figure 142

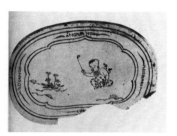

Figure 143

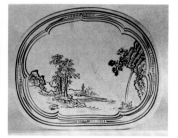

Figure 144

Figure 145

Figure 146

Figure 147

Figure 148

Bean-shaped pillow with concave, forward-slanting top slightly overhanging the sides. Grey stoneware covered with white slip and transparent glaze. Painted and incised decoration in black underglaze iron pigment: on the top a long-tailed bird on a flowering branch observing an insect on a leaf; cloud-shaped border drawn in double lines and decorated with four spiral-like patterns made of small circles and arcs like pairs of parentheses around them; freely painted half-palmette scrolls around the sides. Three-character mark, *Chang-chia tsao*, in a lotus frame stamped on the base.

Published: Paine, "Chinese Ceramic Pillows," pl. 26, no. 37; and Wirgin, "Sung Ceramic Designs," pl. 46:d.

This pillow is closely related to the St. Louis pillow above (see Pl. 53). The elaborated border pattern on the Boston pillow is a feature of a number of bean-shaped pillows that also display the half-palmette scrolls around the sides. An example with a similar border pattern enclosing a bird on a branch was found in Yü-hsien in 1954 (Fig. 142: *WW*, 1954, no. 9, p. 63). Two other examples of this type are decorated with small children at play. On one, a bean-shaped pillow of the same proportions as the Boston pillow, an infant is seated on the ground waving a small mallet at a ball (Fig. 143; Ch'en, *T'ao-chen*, pl. 8). On the other, less elongated in shape, two children leap about, one with a small bird on its head (Fig. 144, *Ibid.*, pl. 7). The shorter and wider (from front to back) shape of these pillows seems to correspond to later manufacture, that is, toward the end of the Chin period. A pillow with cloud-shaped border and small spiral-like patterns on the top and half-palmette scrolls painted in thin, wispy strokes of the brush was discovered in a tomb dated 1265 A.D. near Sian (Fig. 145; *WW*, 1958, no. 6, p. 59, fig. 15). The pillow is quite wide in shape and is decorated with a landscape scene, only a few elements of which are discernible from the illustration. A very wide bean-shaped pillow in the Staatliche Museen, Berlin, with the same border pattern and wispy palmette scrolls, has a fine landscape painting on the top (Fig. 146; Goepper, *Kunst and Kunsthandwerk Ostasiens*, p. 289, pl. 178). The painting is a skillful composition of trees, rocks, river and a small human figure gazing at a waterfall on the right, the shape and scale of which have a close affinity to Chinese fan painting. Other pillows of the wider shape, and presumably later date, include one decorated with a large fish flanked by tufts of aquatic weeds (Fig. 147; Ch'en, *T'ao-chen*, pl. 32). The fish becomes a common theme in Yüan Dynasty painting, occurring, also, on a number of large Yüan Dynasty basins of Tz'u-chou type ware (see Pl. 86) as well as on 14th century blue-and-white porcelains. Another example, in the Tokyo National Museum, is decorated with a bovine creature recumbent in a field, a crescent moon floating on a cloud over its head (Fig. 148). This theme, too, deriving from the popular belief that the rhinoceros acquired its horn by gazing at the moon, was prevalent in the Chin and Yüan periods.

Plate 55
Pillow
Group 12/C
Chin Dynasty, dated 1178 A.D.
H. 4 in. (10.2 cm.)
L. 10-7/8 in. (27.6 cm.)
Philadelphia Museum of Art

Cresent-shaped pillow with concave top, the front side curved inward. Greyish buff stoneware covered with white slip and transparent glaze. Painted decoration on the top in dark brown underglaze iron pigment of three sages playing *wei-ch'i*, a Taoist priest seated at the right, a Confucian scholar at the left, and a Buddhist monk in the center, officiating; a thick line painted around the edge. Inscription on the base written in ink, "The first year of the Ta-ting period," corresponding to the year 1178 A.D. Broken and repaired.

Published: Jean Gordon Lee, "A dated Tz'u-chou pillow," p. 77, fig. 2, and Riddell, *Dated Chinese Antiquities*, p. 59, Pl. 31

This is the only example of its type known. The crescent shape of pillows occurs in other groups, however, decorated in different techniques.

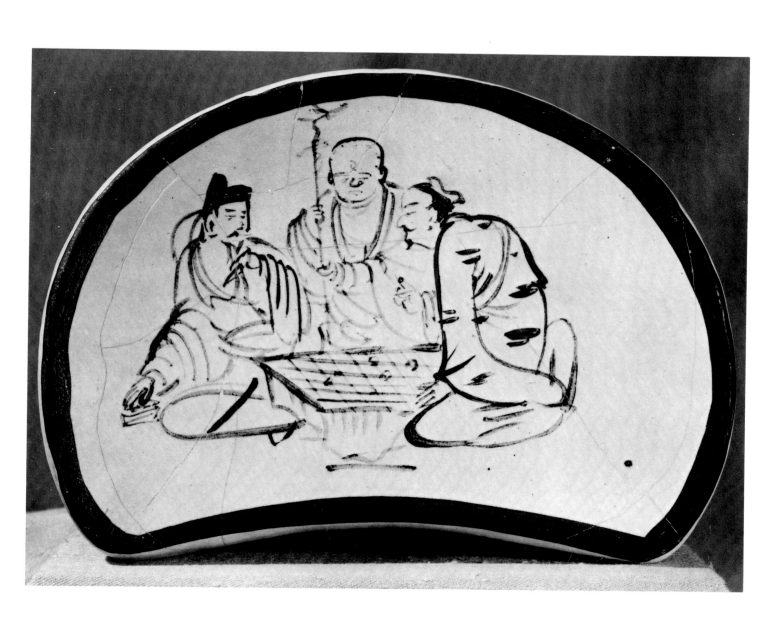

Plate 56
Pillow
Group 12/C
Yüan Dynasty, dated 1336 A.D.
H. 4-7/8 in. (12.4 cm.)
W. 11-5/16 in. (28.8 cm.)
Museum of Fine Arts, Boston, Gift of Mr. and Mrs. C. Adrian Rübel

Ovoid pillow in the form of a flattened bottle with small everted mouth at one end and low foot and recessed convex base at the other. Grey stoneware covered with white slip and transparent glaze. Painted decoration in black underglaze iron pigment: chrysanthemum-like flowers with dark leaves and curling stems around the body. Inscription on the shoulder of the bottle, "The second year of Shih-yüan [1336 A.D.], the fourth month, the twenty-fourth day, jar pillow of Li Ming-chi." (From Paine, "Chinese Ceramic Pillows.")

Published: Paine, "Chinese Ceramic Pillows," pl. 34, no. 45; Ayers, "Some Characteristic Wares of the Yüan Dynasty," p. 86, pl. 46, fig. 50; Lee and Ho, *Chinese Art Under the Mongols*, pl. 38; Hasebe, *Jishuyo*, p. 120, fig, 58; and Riddell, *Dated Chinese Antiquities*, p. 64, pl. 39.

This piece provides an important clue to the dating of a number of other pieces with similar painted decoration.

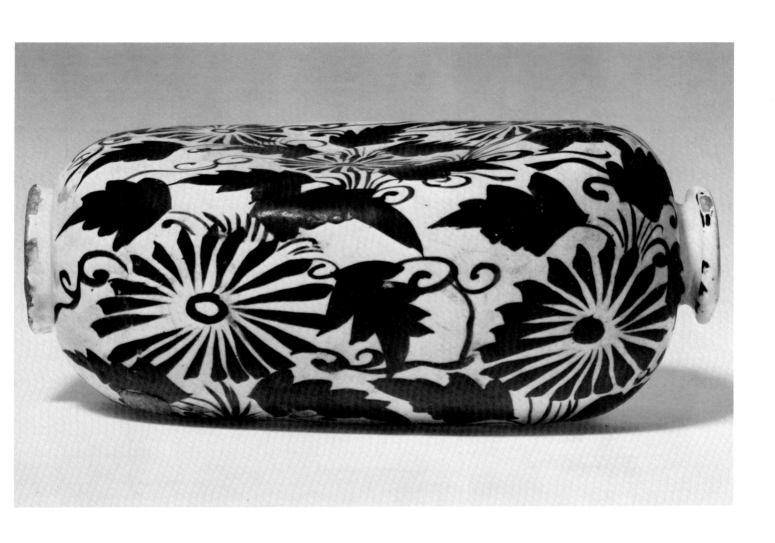

Figure 149

Figure 150

Figure 151

Figure 152

Figure 153

Plate 57
Pillow
Group 12/D
Chin Dynasty, 13th century
H. 6-1/2 in. (16.5 cm.)
L. 16-1/2 in. (41.9 cm.)
Los Angeles County Museum, Gift of Nasli M. Heeramaneck

Rectangular pillow with slightly concave, forward-sloping top surface overhanging the nearly vertical sides. Grey stoneware with white slip and transparent glaze. Painted underglaze decoration in dark brown iron pigment on each surface, the ornament enclosed in ogival frames filled with densely scrolling floral patterns; on the top, two figures in a landscape, one figure standing on the bank and the other setting off on a raft, three mountain peaks in the background; around the outer edge a narrow border pattern resembling twisted ribbon. On the front a landscape scene with a small boat; on the back a peacock standing on a rock among peonies. The two end panels decorated with a double lotus medallion. Three-character mark *Chang-chia tsao,* "Made by the Chang family," in a rectangular frame stamped on the base.

Published: Kuwayama, *Chinese Ceramics,* pl. 16.

The rectangular pillows decorated with paintings of landscape scenes are a unique sub-group of the painted wares. They are covered intensively on five sides, all but the bottom, with painted ornament, the principal pictures appearing on the long rectangular surfaces of the top and the front and back sides. A characteristic feature of these pillows is the lobed, ogival frames filled with dense floral scroll patterns that enclose the principal ornament. The precise dating of these pillows is difficult; in general, however, they can be assigned to the thirteenth and fourteenth centuries. Within this general group they can be arranged tentatively in chronological series according to their stylistic variations, the earlier examples exhibiting a greater preciseness and compactness in the painting of the elements of the decoration.

The Heeramaneck pillow can be considered one of the earlier examples of this type. The landscape scenes are finely painted by a skillful hand, and the border patterns, too, are carefully executed. Other pillows that are similar in style and can be regarded as contemporary include a very large example excavated from a tomb at Pieh-kai-shan near Anyang, the top of which is decorated with a scene depicting a horseman riding toward a group of three trees along a road (Fig. 149; *WW,* 1956, no. 8, p. 74 and plate inside front cover). The front side, too, is decorated with a landscape scene. Another pillow, in the Tokyo National Museum, has on the top a man playing the *ch'in* beside the water while his young attendant looks on. (Fig. 150) In the water, two ducks swimming by turn back to look at the musician, and in the background two groups of triple mountain peaks tower over distant mists. A painting of a scholar and attendant on a bank observing a pair of fish in the water, showing a composition very similar to that on the pillow, appears on the east wall of a tomb dated 1265 that was excavated in Ta-t'ung, Shansi (Fig. 151; *WW,* 1962, no. 10, p. 46, fig. 2). On the front of the Tokyo National Museum pillow is another landscape scene with three mountain peaks in the background, and stamped on the base the three character mark *Chang-chia tsao* in a vertical column with an inverted lotus leaf above and a lotus flower below. Still another pillow decorated on both top and front sides with landscapes showing wide vistas of water, houses on the shore and small figures is in the Umezawa collection (Fig. 152; Hasebe, *Jishuyo,* pls. 71 and 72). Large clouds drawn in double, scalloped outlines drift through the scene on the top. On the side, the triple peaks motif appears again, and on the back a large phoenix in

flight is painted among trailing clouds.

The representation of the mountains as being built up of successive layers of rock one in front of the next derives from landscape painting of the Five Dynasties and Northern Sung periods. Mountain peaks painted in a manner similar to that seen on the pillows appear in a hanging scroll in the National Palace Museum, Taipei, entitled "Mountains rising through the Mist along the River Shore," attributed to the Emperor Hui-tsung (Fig. 153; Siren, *Chinese Painting*, vol. III, pl. 240). The grouping of the three darker peaks near the top of the painting resembles that of the more conventionalized mountain forms on the pillows. It is a configuration that has particular symbolic significance in that it resembles the form of the written Chinese character for mountain, or *shan*.

Figure 154

Figure 155

Plate 58
Pillow
Group 12/D
Chin Dynasty, 13th century
H. 6-1/4 in. (16.5 cm.)
L. 12-3/4 in. (32.5 cm.)
The Art Institute of Chicago, Gift of Mr. Russell Tyson

Rectangular pillow with slightly concave, forward-sloping top overhanging the nearly vertical sides. Grey stoneware with white slip and transparent glaze. Painted decoration in dark brown underglaze iron pigment, on each side the ornament enclosed in ogival frames filled with densely scrolling floral patterns; on the top two figures in a landscape setting, one seated and sharpening a knife on a whetstone; a twisted ribbon pattern in the outer border. On the front, a landscape scene with three mountain peaks in the background; the two ends decorated with a double lotus medallion; the back with a tiger seated beside a group of trees. Three character mark *Chang-chia tsao* in a vertical column with a lotus leaf at the top and a lotus flower at the bottom stamped on the base.

Not previously published.

The tiger on the back of this pillow resembles, in its seated pose (Fig. 154), the placement of its front paws and the curve of its tail, a tiger in a painting dated 1269 that is attributed to Mu Ch'i (Fig. 155; Siren, *Chinese Painting*, Vol. III, Pl. 342). The painting, attributed to Mu Ch'i is the collection of Daitoku-ji temple, Kyoto. The scene on the top of the pillow appears to be an illustration of a scene from the popular literature of the day. Such scenes taken from moral tales and adventure stories involving warriors and supernatural events appear on a number of the rectangular pillows.

Plate 59
Pillow
Group 12/D
Late Chin Dynasty, 13th century
H. 6-3/8 in. (16.2 cm.)
L. 12-1/2 in. (31.8 cm.)
Collection of Mr. and Mrs. Myron Falk, New York

Rectangular pillow with slightly concave, forward-sloping top overhanging the nearly vertical sides. Pale grey stoneware covered with white slip and transparent glaze. Painted underglaze decoration in dark brown and light brown iron pigment: on the top, in an ogival frame filled with dense floral scrolls, a scholarly figure standing by a clump of trees on a shore looking at a gourd floating on the water; a twisted ribbon pattern in a narrow border around the outer edge. On the front side a pair of water fowl, one standing on the shore and one flying overhead; on the back a lion with an embroidered ball. The sides filled with dense floral scrolls. Three-character mark *Chang-chia tsao* stamped on the base in a vertical column with a lotus leaf at the top.

Published: Ruth Spelman, *The Arts of China: A Retrospective*, (C. W. Post Gallery, Long Island University, Feb. 4—Mar. 27, 1977), pl. 104

This piece displays a technique of painting not seen previous examples, that of using the dark pigment in lower concentrations, producing a lighter shade of brown, to paint some of the leaves on the trees and to fill in the gourd and details on the scholar's robe. It is a technique closely related to that used on objects with black and light brown or tan colored painted decoration, discussed in Group 14. Views of the front and back of the pillow and of the mark on the base are shown in plates 59 B-D.

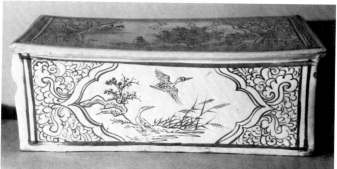

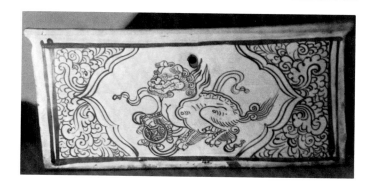

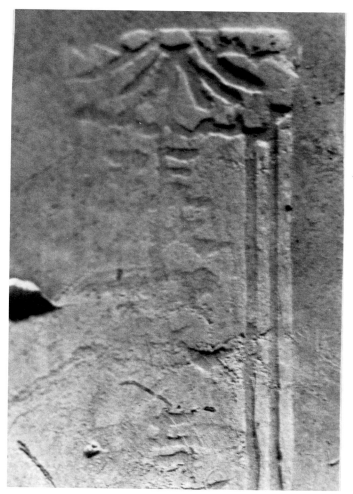

Plate 60

Pillow
Group 12/D
Yüan Dynasty, late 13th century
H. 5 in. (12.7 cm.)
L. 15-1/2 in. (39.3 cm.)
The Seattle Art Museum

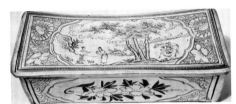

Figure 156

Figure 157

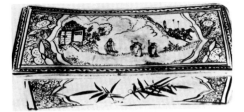

Figure 158

Figure 159

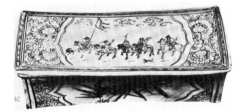

Figure 160

Rectangular pillow with slightly concave, forward-sloping top overhanging the nearly vertical sides. Buff stoneware covered with white slip and transparent glaze. Painted underglaze decoration in dark brown iron pigment: on the top figures in a landscape with three central pine trees in an ogival frame filled with floral scrolls, a man approaching a house on the left in which a scholarly figure is seated at a desk, a groom leading a horse in from the right; narrow outer border of cross-hatched lines and small semicircles. On the front side a large floral spray, on the back a peony, and on either end a lotus, all enclosed in ogival frames. Inscription written on the back under the glaze reading, *Fu-yüan Wang-chia tsao,* "Made by the Wang family of Fu-yüan."

Published: A. du Boulay, *Chinese Porcelain,* (1963), p. 37, pl. 28.

The Fu-yüan of the inscription written on the back of the pillow is in present day Tz'u-hsien, north of the Chang River. This inscription appears on three other rectangular pillows, one in the Honolulu Academy of Art (Fig. 156; Reg. no. Cl-1930), the second in the Philadelphia Museum of Art (Reg. no. 14-201), and the third in the collection of Dr. Ralph Marcove (see Pl. 62). Of these only the Honolulu piece, like the Seattle pillow, has a scene of figures in a landscape or garden setting. A man seated at a desk asleep on the Honolulu pillow is surrounded by a large cloud. At the lower left of the picture is a figure of a peasant in a rice field. Another pillow that is very similar to the Seattle one, in all respects, including the pattern in the ogival frames, the floral spray on the front side and the composition of the scene painted on the top, is in the Royal Scottish Museum (Fig. 157; Royal Scottish Museum, *Chinese Pottery and Porcelain,* 1955, pl. 5). On it an attendant holds a horse at the right of a group of three central trees while a scholarly figure pays respects to a lady on the left. A pillow in the Kulturen Museum, Lung, has the same floral pattern in the ogival frames and floral spray on the front (Bo Gyllensvard, *Kinesiskt Porslin,* 1966, p. 45, fig. 25). On the top a man surrounded by a cloud stands at the right gazing at a family of four in a garden. The cloud, as on the Honolulu pillow may be a device to represent a different state of being or of conciousness, such as dreaming or remembering events of the past. (Roderick Whitfield has expressed the opinion that the scene on the Honolulu may be an illustration of the "Story of the Pillow." Whitfield, "Tz'u-chou Pillows with Painted Decoration," p. 78.) The Lund pillow bears an inscription that reads *Hsiang-ti Chang-chia tsao, Ai-shan-chen yung-gung* which can be translated as "Made by the Chang family of the Hsiang territory, Ai Mountain pillow, use for good results."

A number of other pillows depicting scenes from literature or drama have a mark *Ku Hsiang Chang-chia tsao* stamped on the base, "Made by the Chang family of ancient Hsiang." The name Hsiang or Hsiang-chou, former name of the Anyang area in Honan, was changed to Chang-te-fu during the Chin Dynasty, a fact that provides an important clue to the dating of these pillows. Almost certainly made after the change, the pillows with the inscription "ancient Hsiang" are stylistically later than those with the simple *Chang-chia tsao* mark. Like the Seattle pillow, they show a rather more cursive treatment of the floral patterns in the ogival frames and in the narrow border around the top. The twisted ribbon pattern disintegrates into a row of cross-hatched lines or small semicircles, and the landscape scene on the front side is replaced by a

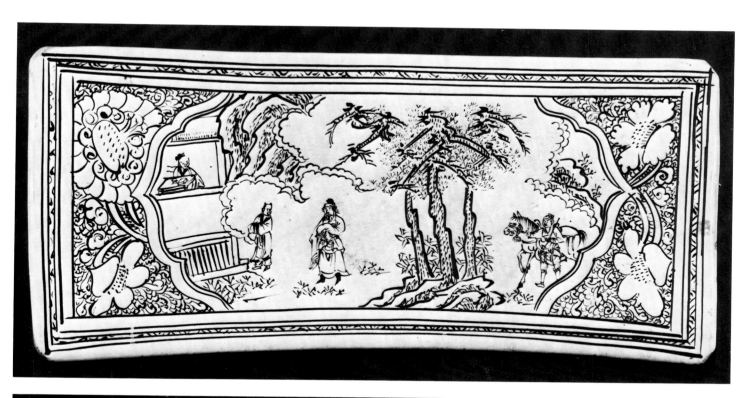

Figure 161

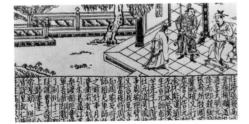

Figure 162

larger single motif of bamboo leaves or a floral spray. One example decorated with figures around a large tree in a garden setting is in the Museum für Ostasiatische Kunst, Köln (Fig. 158; Goepper, *Form und Farb*, pl. 82). Another, on which a pair of envoys holding official tablets approach a man in front of his small hut, was formerly in a collection of Dr. Frank Marshall (Fig. 159; *Catalogue of Fine Chinese Ceramics and Works of Art*, London Sotheby and Co., March 13, 1973, no. 125). On another pillow with the *Ku Hsiang Chang-chia tsao* mark, in the British Museum, there is a procession of mounted figures that appears to be an illustration of the story of Wang Chao-chün (Fig. 160), although Roderick Whitfield has suggested, also, that it may be a scene from the story of Lady Wen Chi (Whitfield, *op cit.*, p. 84). The procession, led by a horseman carrying a banner, includes two women, one of whom carries a *p'i-pa*, or lute, and an archer bringing up the rear. A mounted procession crossing a bridge, the lead figure being shaded by a parasol held by an attendant, appears on a pillow formerly in the Sunglin collection but now in the Asian Art Museum of San Francisco (*Catalogue of the Sunglin Collection of Chinese Art and Archaeology*, Peking, 1930, pl. XXXVI). Other pillows with the same mark and decorated with figures in garden settings are in the Buffalo Museum of Science and in an unknown collection in China (Fig. 161; *Chugoku Eirakukyu hekigaten*, Tokyo, 1963, no. pag.).

If the relative number of pillows with these types of scenes painted on them can be taken as a measure of their popularity, these rectangular pillows must have been in great demand and the pictures on them widely familiar. It seems quite likely that illustrated books of popular literature and drama that were then in print may have provided the models for the scenes depicted on the ceramic pillows, for example, this scene from the 1321-1323 illustrated edition of the *Romance of the Three Kingdoms* (Fig. 162; Chien An-lu, *Hsin-chün hsiang San-kuo chih p'ing-hua*).

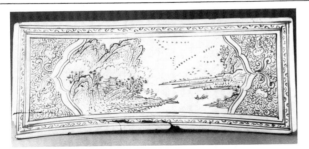

Figure 163

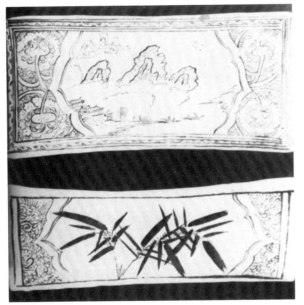

Figure 164

Plate 61

Pillow

Group 12/D

Yüan Dynasty, Late 13th—early 14th centuries

H. 5-1/8 in. (13.0 cm.)

L. 12 in. (30.5 cm.)

Fogg Art Museum, Harvard University, Gift of C. Adrian Rübel

Rectangular pillow with slightly concave, forward-sloping top overhanging the nearly vertical sides. Grey stoneware covered with white slip and transparent glaze. Painted underglaze decoration in dark brown iron pigment: on the top a landscape with high rocky promontory overlooking fishing boats on the water, set in an ogival frame filled with a floral pattern; narrow outer border decorated with small arcs in each of which is a dot. A stalk of bamboo on the front, a floral spray on the back and peony-like flowers at either end, all in ogival frames. Five-character mark *Ku Hsiang Chang-chia tsao*, "Made by the Chang family of ancient Hsiang," with an inverted lotus leaf at the top and a lotus flower at the bottom stamped on the base.

Published: Paine, "Chinese Ceramic Pillows," pl. 28, no. 39; and Whitfield, "Tz'u-chou Pillows with Painted Decoration," p. 93, pl. 3.

The landscape on this pillow is much less carefully painted than the landscapes on examples seen previously (see Pls. 57 and 58), a feature that coincides with the more cursive treatment of the ornamental elements and with the appearance of the *Ku Hsiang Chang-chia tsao* mark on the base, identifying the pillow as a later product. Landscape-decorated pillows of roughly contemporary date can also be seen in the Museum of Art of the Rhode Island School of Design (Fig. 163; Reg. no. 161076) and in an unknown collection

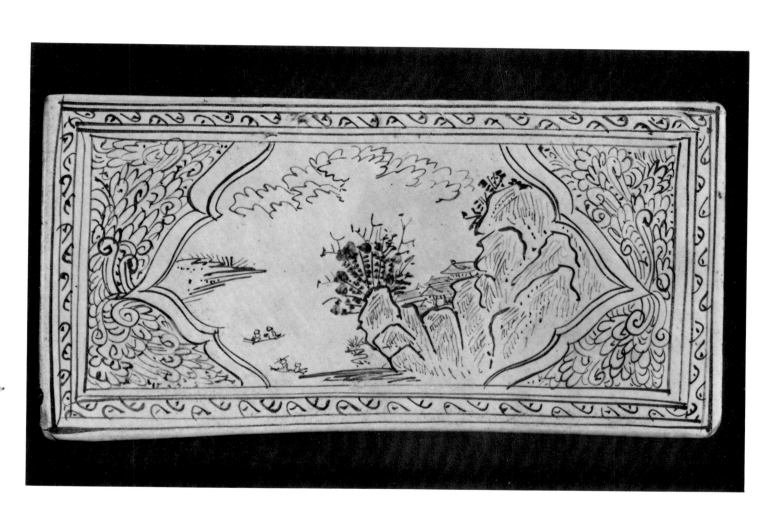

in China (Fig. 164; *Sung-tai min-chien t'ao-tz'u wen-yang*, pl. 73). These examples share a characteristic decline in a technical refinement of the painting and a loss of the solid, upright quality of the mountain forms. The peaks lean precariously and have a destabilizing effect on the entire composition. On the pillow in China, three mountain peaks loom over a river scene with houses on the shore and fishing boats. They appear to be gliding through the landscape on the backs of the clouds at their foot. Strangely echoing the forms of the mountains, a cluster of clouds hovers in the upper left corner of the picture.

Plate 62
Pillow
Group 12/D
Yüan Dynasty, 14th century
H. 5-1/2 in. (14.0 cm.)
L. 12 in. (30.5 cm.)
Collection of Dr. Ralph Marcove, New York

Rectangular pillow with slightly concave, forward-sloping top surface overhanging the nearly vertical sides. Buff stoneware covered with white slip and transparent glaze. Painted underglaze decoration in dark brown iron pigment; on the top a lion playing with an embroidered ball attached to a ribbon, a floral spray on the front, a peony on the back and a lotus on either end, all enclosed in ogival frames filled with densely painted floral patterns. Inscription written on the back under the glaze, *Fu-yüan Wang-chia tsao* or "Made by the Wang family of Fu-yüan."

Not previously published.

The motif of the lion and embroidered ball appears on two other nearly identical pillows, one in the Philadelphia Museum of Art (Reg. no. 57-26-5) and the other in a collection in China (*Sung-tai min-chien t'ao-tz'u wen yang*, pls. 75 and 76). The latter has, instead of the inscription on the back, a four-character mark *Wang-shih Shou-ming*, probably the name of the potter, in a square seal-like arrangement stamped on the base.
Lions and embroidered balls appear in molded tile reliefs on the walls of a tomb dated 1265, unearthed at Chia-li-ts'un, in Hsin-feng-hsien, Shansi Province (Fig. 165; *KK*, 1966, no. 1, pl. 8:11)

Figure 165

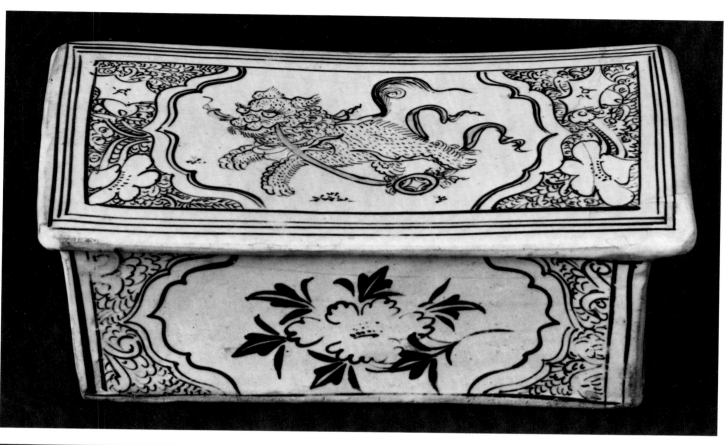

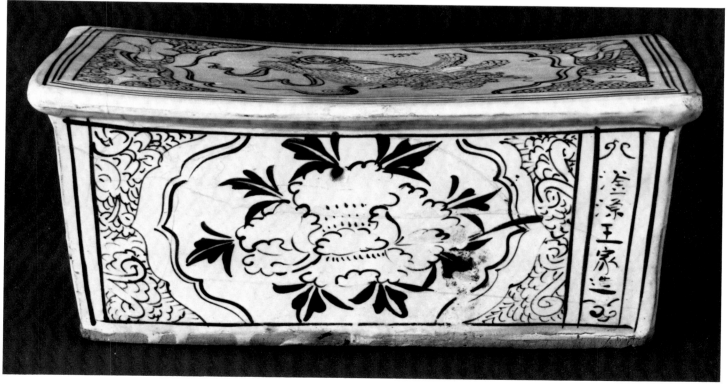

Plate 63
Jar
Group 12/E
Yüan Dynasty, dated 1353
H. 12-3/8 in. (31.5 cm.)
D. 10-7/8 in. (27.6 cm.)
Buffalo Museum of Science

Globular jar with small, slightly everted mouth, rounded shoulder and wide body tapering to a small, recessed flat base. Reddish brown stoneware covered with white slip and transparent glaze. Painted underglaze decoration in black iron pigment: fan-shaped leaf patterns in a wide central band with a wavy line beneath; a row of small petals around the base of the neck, below which is an inscription encircling the shoulder, "Made by Wang Shih-pao in the 12th month of the 13th year of Chih-cheng [1353 A.D.], a pair of spirit jars for the Dragon King Hall of the Wang Family." In the among the leaf patterns, the characters *Wang man feng, yüan chen,* and *wei na,* which most likely refer to the donor.

Not previously published.

Related jars of this sub-group have a ridge around the neck below the mouth rim and the Buffalo jar, too, would probably have had such a mouth originally. A very similar jar, without any inscription, appears in a Japanese publication of 1925 (Fig. 166; Okuda, ed., *Toyo toji shusei,* vol. 3, Tokyo, 1925, pl. 20), and another was found at the site of the ancient city in Yü-lin, Inner Mongolia, north of Shensi Province (Fig. 167; *WW,* 1976, no. 2, p. 79, fig. 10). A closely related piece in the British Museum is decorated with peony sprays and stylized ducks in flight, and bears the inscription *feng hua hsüeh, yüeh,* "wind, flower, snow, moon" (Medley, *Yüan Porcelain and Stoneware,* P l. 100A). Another, decorated in two principle bands with patterns of leaf sprays and ducks in flight, is in the Buffalo Museum of Science (Fig. 168; Reg. no. Ch 361). All are painted with very rapid, bold strokes of the brush.

This shape of vessel appears to have evolved from jars of the truncated *mei-p'ing* type, those with small mouth, depressed body shape and very wide base, that were made in the Northern Sung and Chin periods. An example with painted decoration was excavated from what is believed to be the Chin Dynasty layer at the Kuan-t'ai kiln site (see Fig. 250). A black-glazed jar closer in shape to the Buffalo Museum of Science jar illustrated in this Plate, but still with rather squatter proportions and a wider base, is believed to be dated 1305 A.D. by an inscription incised in the glaze (Fig. 169; Lee and Ho, *Chinese Art Under the Mongols,* pl. 56). This northern black-glazed piece, in the British Museum, has a decoration of small boys among lotuses incised and scraped through the glaze into the clay body beneath.

Figure 166

Figure 167

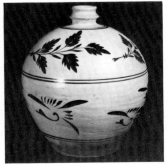

Figure 168

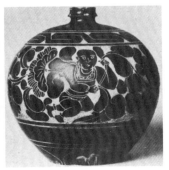

Figure 169

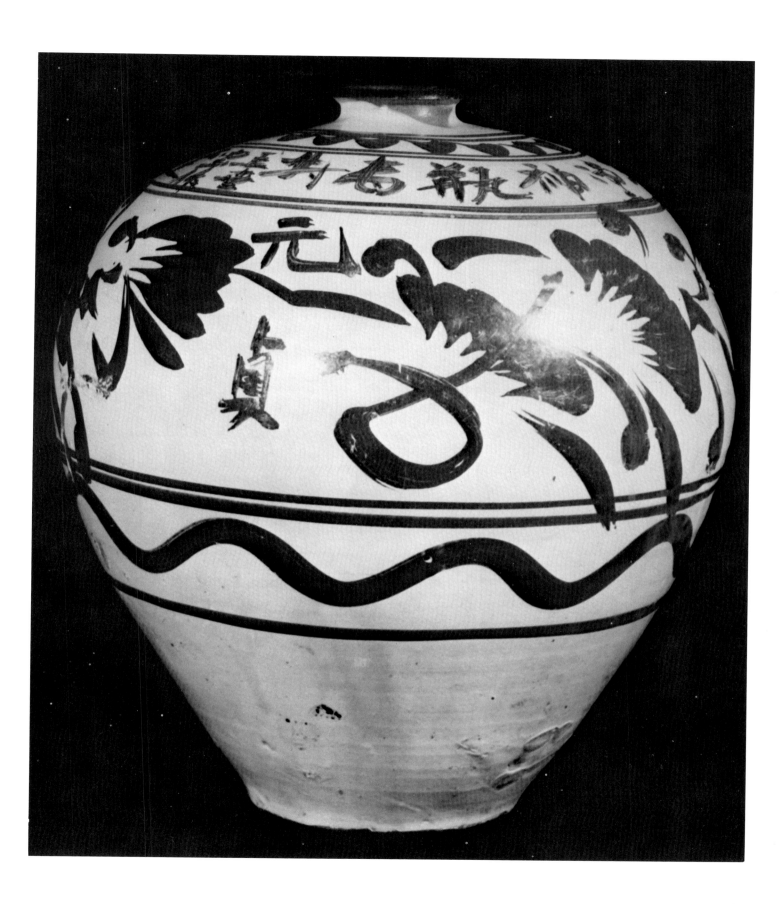

Plate 64
Bowl
Group 12/F
Chin Dynasty, 12th—13th centuries
H. 4-1/16 in. (10.3 cm.)
D. 6 in. (15.2 cm.)
Collection of Mr. and Mrs. Stanley Herzman, New York

Deep bowl with globular body narrowing toward the mouth; slightly flaring foot and recessed convex base. Light buff stoneware with white slip and transparent glaze stopping well above the foot. Painted underglaze decoration in black iron pigment; three large leaf sprays around the exterior.

Not previously published.

Made during the 12th and 13th centuries, the deep, globular bowls of this sub-group are painted with a limited number of distinctive and striking patterns. Their affiliation with kilns in the Tz'u-chou area can be demonstrated on the basis of excavated finds. The leaf sprays like those on the Herzman bowl are the most prevalent of the decorative motifs. Apparently derived from peony leaves, they are composed of three large leaves joined to a central stem that curls upward at the base. The spaces between the larger leaves are filled with small feathery brush strokes. This motif appears on a covered jar found at the Kuan-t'ai kiln site (see Fig. 118; *WW*, 1964, no. 8, p. 41, fig. 8:4). Numerous other globular bowls with this pattern are also known, one, illustrated here, in a private collection in Japan (Fig. 170). Others can be seen in the Ashmolean Museum (Reg. no. 1956.1304), the Barlow collection at the University of Sussex (Sullivan, *Barlow Collection*, pl. 56 a), the Detroit Art Institute (Reg. no. 51.281), the Menasce collection *(The George de Menasce Collection*, London, 1971, pl. 149), and the Siegel collection in the Museum für Ostasiatische Kunst, Köln (Goepper, *Form und Farbe*, pl. 80).

Another globular bowl, in a Japanese collection, is decorated with a large spiraling leaf design (Fig. 171), a pattern that appears, also, on a cylindrical, covered jar excavated at Tung-ai-k'ou (Fig. 172; *WW*, 1964, no. 8, p. 46, fig. 23). A third pattern decorating these globular bowls is a large "cash" or four-petaled pattern seen on a bowl in the Art Institute of Chicago (Fig. 173).

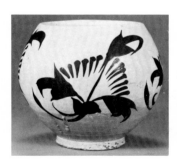

Figure 170

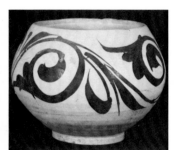

Figure 171

Figure 172

Figure 173

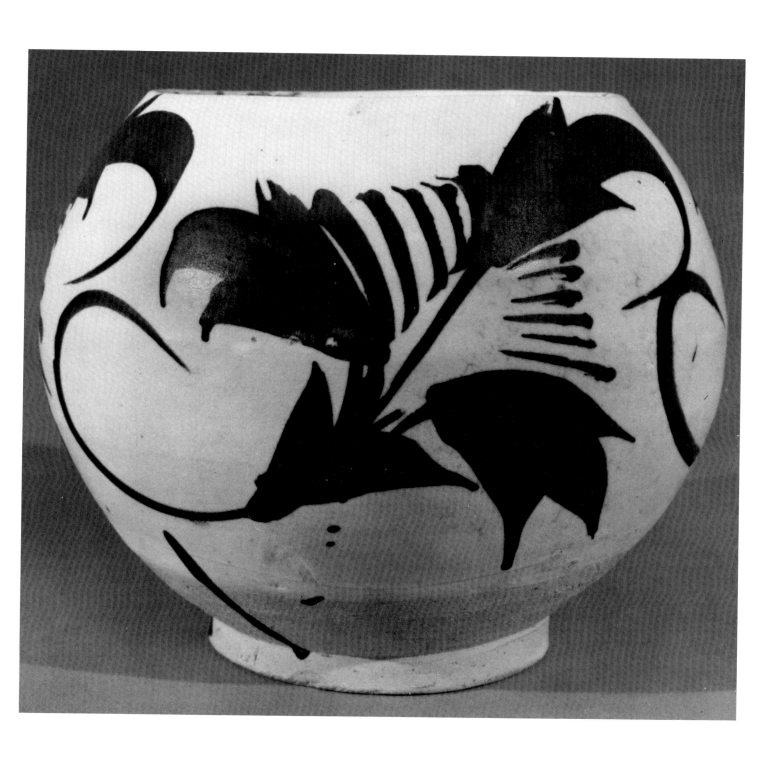

Plate 65
Bowl
Group 12/F
Chin Dynasty, 12th century
H. 4-1/8 in. (10.5 cm.)
D. 6-1/8 in. (15.6 cm.)
The University of Michigan Museum of Art, Gift of Mrs. Henry Jewett Greene,
Mr. and Mrs. Henry Jewett Greene Memorial Collection

Figure 174

Bowl with nearly vertical sides, slightly flaring foot and recessed, flat base. Grey stoneware with white slip and transparent glaze stopping short of the foot. Painted underglaze decoration in black iron pigment of feathery leaf sprays around the exterior between double lines.

Published: *The Mr. and Mrs. Henry Jewett Greene Memorial Collection of Far Eastern Ceramics,* (The University of Michigan Museum of Art, Ann Arbor, 1973), no pag.

Fragments decorated with the same style of frond-like leaves have been discovered at the Pa-ts'un kiln site in Yü-hsien, Honan (Fig. 174; *WW* 1963, no. 8, pl. 5:3). A bowl like the Michigan piece was excavated from a tomb at Shih-li-miao, Nan-yang, south of Yü-hsien (Fig. 175; *WW,* 1960, no. 5, p. 87). The tomb was believed by Chinese archeologists to be of the Sung period but is almost certainly of Chin date. The feathery frond-like leaves appear, also, on similar bowls in the Tokyo National Museum (Fig. 176; *Tokyo National Museum Catalogues,* pl. 315), the Idemitsu Art Gallery (*Tosetsu,* no. 320, Nov. 1979, front cover), the Metropolitan Museum of Art (Reg. no. 50.221.8) and the collection of Dr. Paul Singer.

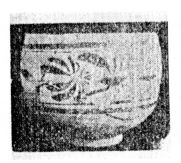

Figure 175

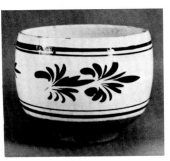

Figure 176

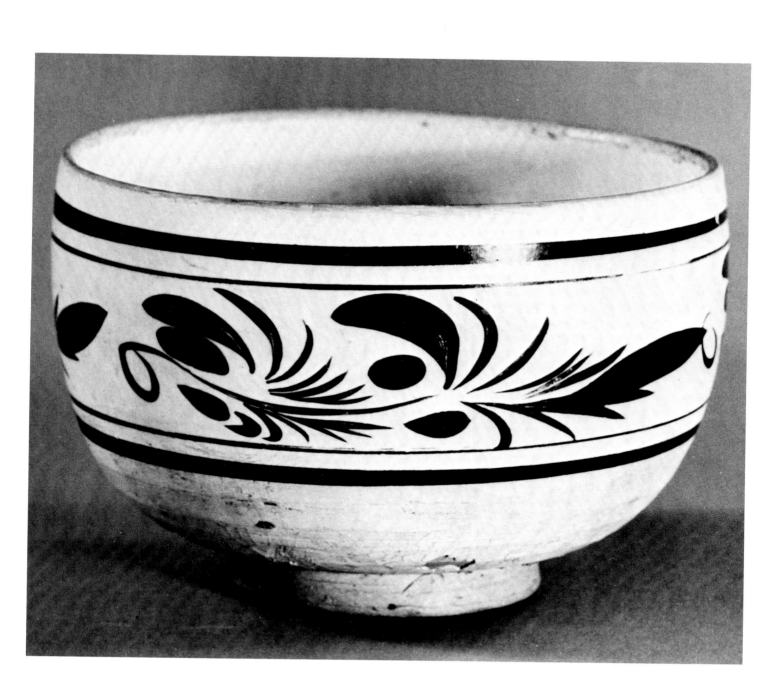

Plate 66
Covered Jar
Group 12/G
Chin Dynasty, 12th—13th centuries
H. 6-1/4 in. (15.9 cm.)
D. 5-1/2 in. (14.0 cm.)
Asian Art Museum of San Francisco, The Avery Brundage Collection

Jar with cover, body in the shape of a deep bowl with nearly vertical sides, low slightly flaring foot and recessed flat base; cover in the form of an inverted saucer fitting over the rim of the body; correct positioning of cover on body indicated by two small applied buttons like rivets near the rim of each. Pale grey stoneware with white slip and transparent glaze stopping well above the foot. Painted underglaze decoration in iron pigment of peony leaf sprays on the body and cover and a butterfly on the top of the cover.

Published: d'Argencé, *Brundage Ceramics*, pl. XXXIX:B.

Jars of Group 12/G are made in two basic shapes, one a rounded bowl with a low foot and the other a cylindrical vessel with nearly flat base. They are closely related to the deep, globular bowls of the previous sub-group, and like them, are the product of kilns in the Tz'u-chou area. The leaf sprays on the Brundage jar are nearly the same as those on the bowl in the Herzman collection (see Pl. 64) and on the cylindrical covered jar found at Kuan-t'ai (see Fig. 118). The spiraling leaf design also appears on the rounded jars, as seen on an example in the collection of Mme. Paul Pechère (Fig. 177; Oriental Ceramic Society, "The Ceramic Art of China," pl. 60, no. 87). Another jar of the same cylindrical shape as the one excavated at Tung-ai-k'ou (see Fig. 172) and decorated with a nearly identical spiraling leaf pattern painted in very bold and sweeping yet controlled brushwork is known from the photographic archives of the Fogg Art Museum (Fig. 178; Catalogue no. 13109 (uu)). The piece, whose whereabouts are now unfortunately unknown, has lost its original cover and is fitted with a metal rim. It is interesting to note that the ornament, though quite similar in style on the two types of jars, is treated in slightly different ways. On the cylindrical jars the designs on the cover and those on the body are painted independently of one another, while on the rounded, bowl-shaped jars the decoration typically extends from the body up onto the cover, treating the two parts as a single ornamental surface.

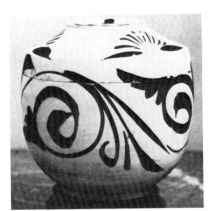

Figure 177

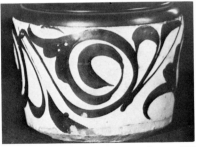

Figure 178

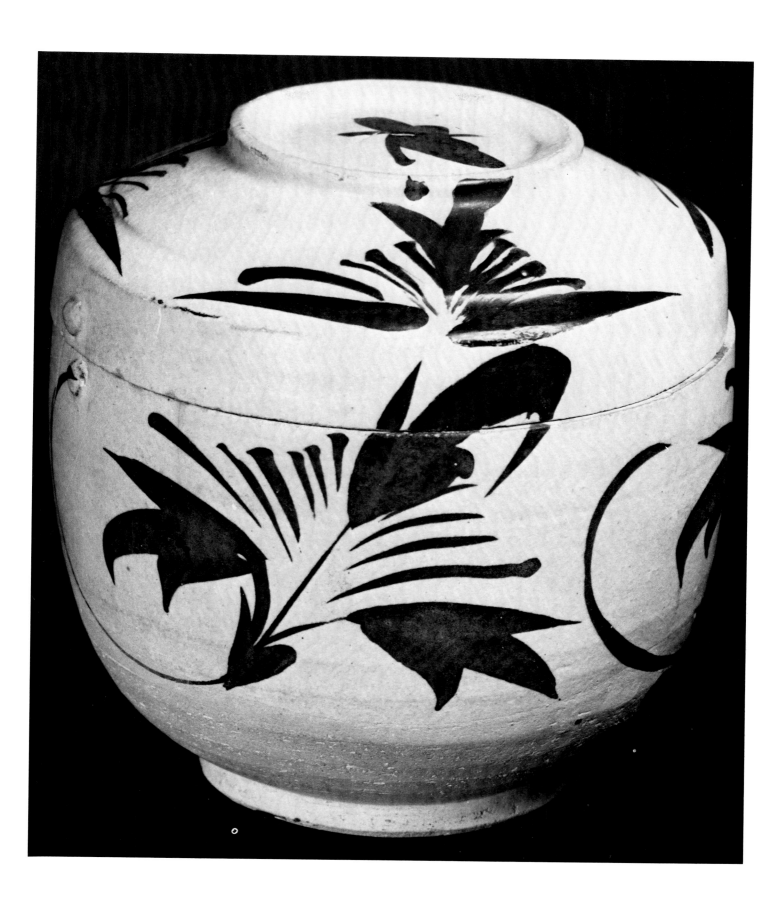

Plate 67
Covered Jar
Group 12/G
Chin Dynasty, 12th—13th centuries
H. 5 in. (12.5 cm.)
D. 5 in. (12.5 cm.)
Collection of Mr. and Mrs. Janos Szekeres, Stamford, Connecticut

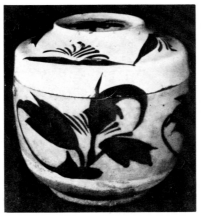

Figure 178A

Jar with cover, body in the shape of a deep bowl with nearly vertical sides, low flaring foot and recessed flat base; cover in the form of an inverted saucer fitting over the rim of the body; correct positioning of cover on body indicated by two small, applied buttons near the rim of each. Grey stoneware with white slip and transparent glaze stopping well above the foot. Painted underglaze decoration in dark brown pigment of peony leaf sprays around the body, fan-like leaves and a butterfly on the cover.

Not previously published.

This piece very closely resembles the one of the previous Plate but is smaller. A third, very similar example, in the British Museum, has a darker, brick-red body (Fig. 178A; Ayers, *The Seligman Collection*, vol. 2, pl. D 113).

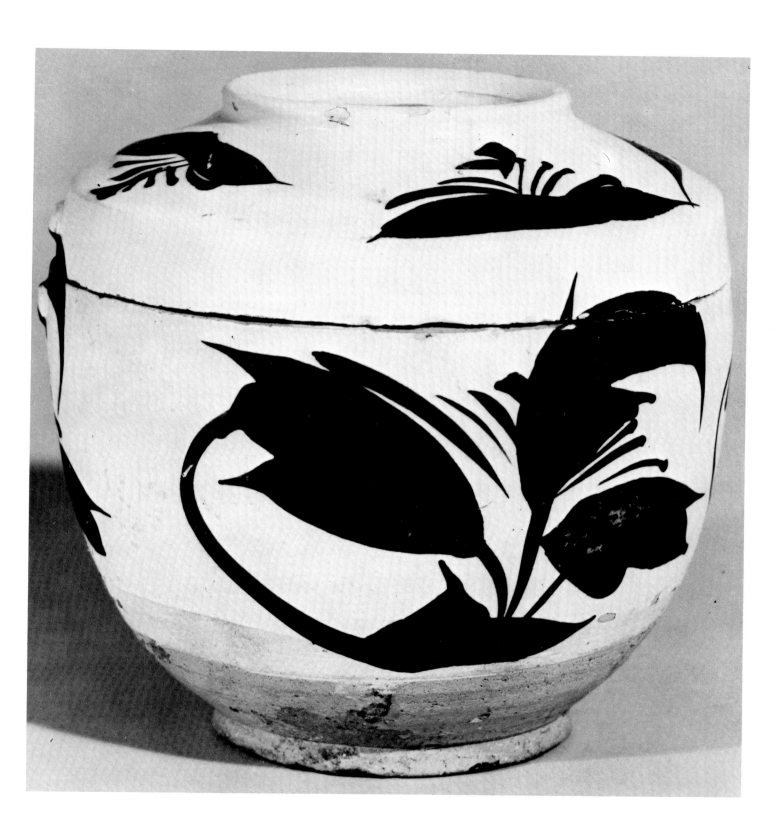

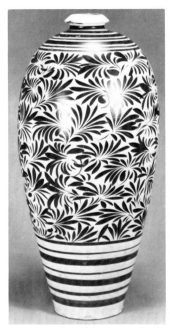

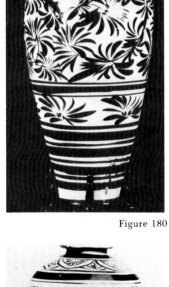

Figure 179

Figure 180

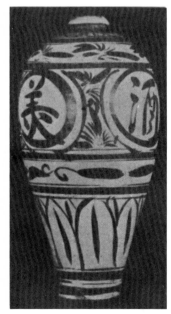

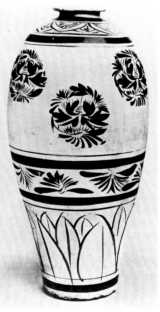

Figure 181

Figure 182

Plate 68
Mei-p'ing
Group 12/H
Chin Dynasty, 12th—13th centuries
H. 19-1/2 in. (49.5 cm.)
*William Rockhill Nelson Gallery—
Atkins Museum of Fine Arts, Kansas City*

Vase with tall ovoid body, rounded shoulder, small neck and low conical mouth; recessed, flat base. Buff stoneware with white slip and transparent glaze. Painted underglaze decoration in black iron pigment: fan-like leaves and feathery fronds in the upper three ornamental bands, marked off by thick horizontal lines, and upright, bissected lotus petals around the base.

Not previously published.

A large number of *mei-p'ing* with painted decoration were made at various kilns for use as wine jars from the 12th through the 14th centuries. They can be divided into two principal types according to shape, the first having a flat or slightly turned-back mouth rim and a rounded, though elongated, body that tapers to a small base. The second type has a taller mouth with sharply turned-back rim, a rather squarer shoulder, straighter sides and a wider base.

Examples of the first type, like the Nelson Gallery *mei-p'ing* are most frequently decorated with frond-like patterns painted with flicking brush strokes that radiate from a central point, a style that is characteristic of wares made in Yü-hsien (see *WW*, 1964, no. 8, pp. 27-36). A very fine example of this type, densely covered with palm leaves that are particularly carefully painted, is in a private collection in Japan (Fig. 179; Hasebe, *So no Jishuyo*, pl. 33). The principal motif is bordered by a sharply contrasting pattern of horizontal stripes on the shoulder and lower portion of the vase. A similar piece with a cup-shaped cover decorated with horizontal stripes matching those on the body is known from the photographic archives of the Fogg Art Museum (Fig. 180; Wirgin, "Sung Ceramic Design," pl. 53:d). A related *mei-p'ing* inscribed with four large characters *ch'ing-ku mei-chiu*, "clear spirits, fine wine," is in the Palace Museum, Peking (Fig. 181; *WW*, 1965, no. 2, pl. 4:5). Said to be from Yü-hsien, the vase is decorated with frond-like leaves on the shoulder and between the circular reserves enclosing the written characters, and with bissected lotus petals around the base like those on the Nelson Gallery *mei-p'ing*. The same lotus petals appear on a *mei-p'ing* in the Bristol City Art Gallery that has frond-like leaves and lotuses arranged in circular medallions in the main ornamental band below which are fan-like leaves and, at the bottom, bissected lotus petals (Fig. 182; Hetherington, *The Early Ceramic Wares of China*, pl. 32).

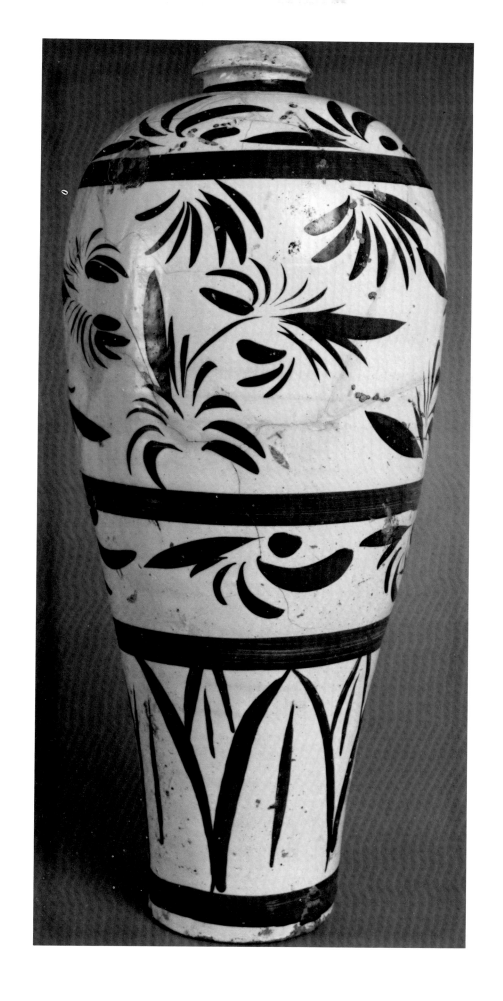

Plate 69
Mei-p'ing
Group 12/H
Chin Dynasty, 13th century
H. 14-5/8 in. (37.2 cm.)
Royal Ontario Museum, Toronto

Vase with tall ovoid body, sloping shoulder, small neck and low conical mouth; recessed flat base. Buff stoneware with white slip and transparent glaze. Painted underglaze decoration in black iron pigment organized into several horizontal bands, the principal motif on a background of painted vertical striations. The wide middle band decorated with lotus flowers and leaves set in three large, diamond-shaped, ogival panels, and small flowers in the spandrels; above it a row of bamboo leaves arranged in a zigzag pattern, and below, a flattened meander band in white on a black ground; around the base of the neck a row of overlapping lotus petals; small leaf patterns in narrow bands and thick horizontal stripes filling the remainder of the surface.

Not previously published.

The ornament on this vase is of the same style as that on objects found at the Pa-ts'un kiln site in Yü-hsien. A portion of a large *tsun*-shaped vase from Pa-ts'un has densely painted designs on a striated ground and a meander band very similar to that on the Toronto vase around the lower half (see Fig. 206). Lotuses on a ground of painted striations resembling those on the Toronto vase appear on a basin from the same site (Fig. 183; Ch'en, *Sung-tai pei-fang min-chien tz'u-ch'i*, pl. 21). This intensive style of decoration appears to have been developed at the Pa-ts'un kiln site in the later part of the Chin period.

Paintings of lotuses like those on the *mei-p'ing* can also be seen on the walls of the Chin tomb at Li-ts'un-kou, Ch'ang-chih, in Shansi Province (see Fig. 80).

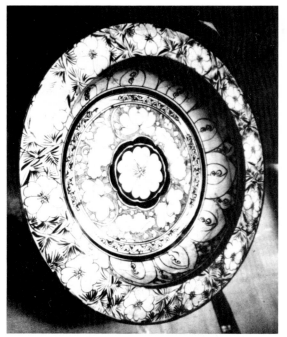

Figure 183

162

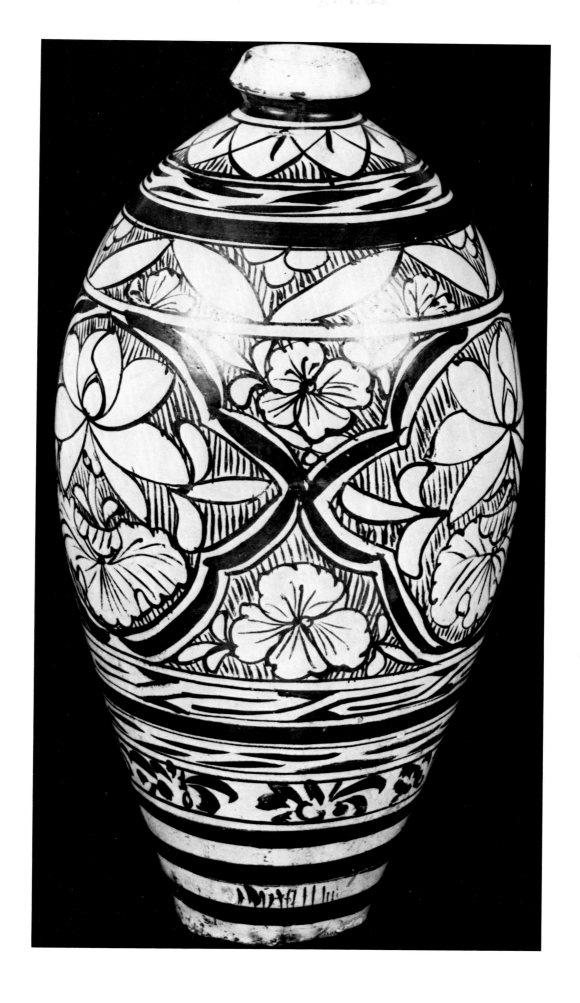

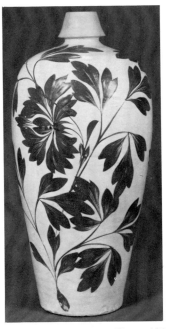

Figure 184

Plate 70
Mei-p'ing
Group 12/H
Chin Dynasty, 12th—13th centuries
H. 16-7/8 in. (42.9 cm.)
The Cleveland Museum of Art

Vase with tall ovoid body, flattened shoulder, small neck and conical mouth; recessed flat base. Buff stoneware with white slip and brownish transparent glaze. Painted underglaze decoration in reddish brown iron pigment of peonies with long leafy stems.

Published: Rivière, *La Céramique dans l'Art d'Extrême-Orient*, vol. 2, pl. 61; Hollis, "More Sung Dynasty Stoneware," p. 10; and *Chinese Ceramics*, (Los Angeles, 1952), pl. 222.

This is an example of a painted *mei-p'ing* of the second type that displays the thick mouth in the shape of a conical section and the characteristic peony motif in the decoration. Vases of this type have been assigned a Shansi provenance by Ch'en Wan-li (Ch'en, *Sung-tai pei-fang min-chien tz'u-ch'i*, pl. 24). Archeological evidence supporting this theory has yet to be found; although, as a group, the vases do appear to be the product of provincial kilns. The example illustrated in Ch'en's book and very similar ones in a Japanese collection (Fig. 184) and in the Victoria and Albert Museum (Wirgin, "Sung Ceramic Designs," pl. 54: d), as well as two others in Japanese collection shown here (Figs. 185 and 186; Koyama, *So*, pls. 54 and 55), are representative of this type of *mei-p'ing* at its most graceful. On these pieces the long stems of the peonies are so slender that they seem hardly able to support the large flowers and sway and bend under their weight. Though the painting on the Cleveland *mei-p'ing* is less sophisticated in style, it is not unattractive and is actually better suited to the more robust form of the vessel.

Figure 185

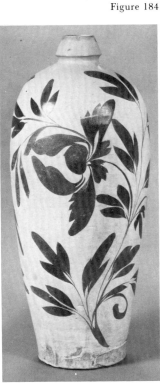

Figure 186

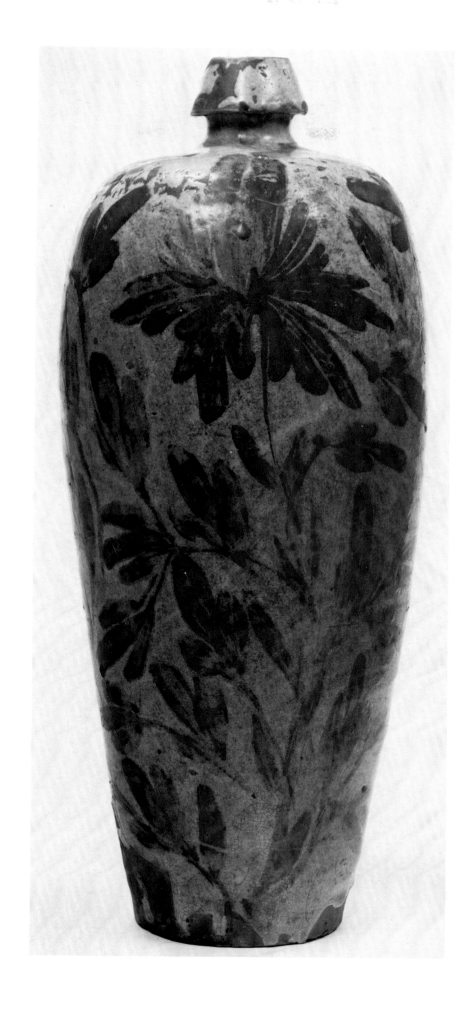

Plate 71
Mei-p'ing
Group 12/H
Chin Dynasty, 12th—13th centuries
H. 12-1/2 in. (31.7 cm.)
Indianapolis Museum of Art, Gift of Mr. and Mrs. Eli Lilly

Tall vase with ovoid body, rounded shoulder, small neck and conical mouth; recessed flat base. Buff stoneware covered with white slip and transparent glaze. Painted underglaze decoration in dark brown pigment of large peony sprays filling the surface of the vessel. Mouth repaired.

Published: Wilbur D. Peat, *Chinese Ceramics of the Sung Dynasty*, (John Herron Art Museum, no date), p. 13, pl. XXI; and Ch'en, *Sung-tai pei-fang min-chien tz'u-ch'i*, pl. 25.

Also of the second type of *mei-p'ing* with painted decoration, the Indianapolis piece is closely related to examples in the Musée Guimet (Wirgin, "Sung Ceramic Designs," pl. 54:f) and in the Hoyt collection, Boston (Boston Museum of Fine Arts, *Hoyt Collection*, pl. 267).

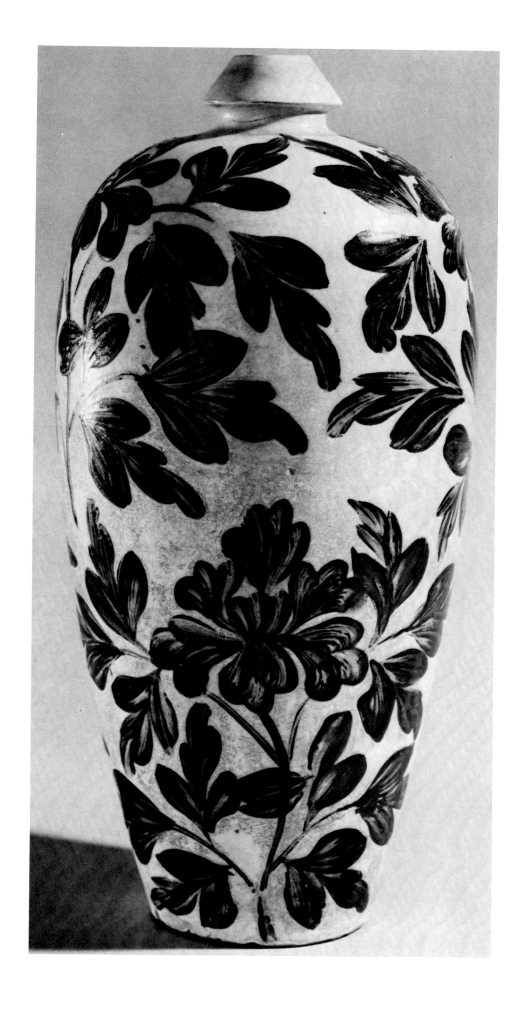

Plate 72
Mei-p'ing
Group 12/H
Chin Dynasty, 12th century
H. 14-3/4 in. (37.5 cm.)
The Art Institute of Chicago

Vase with tall ovoid body, flattened shoulder, small neck and conical mouth; recessed flat base. Buff stoneware with white slip and transparent glaze. Painted underglaze decoration in dark brown pigment: lotus flowers and leaves around the shoulder and leaf sprays around the base. Four large characters *hung-hua man-yüan*, "red blossoms filling the garden," incised on a combed ground in a wide central band around the body. Mouth repaired, not original.

Published: *Chinese Ceramics*, (Los Angeles, 1952), pl. 223.

A number of *mei-p'ing* of the second type have painted decoration used in combination with incised and combed designs, the latter in a wide band around the middle and the former in bands above and below, as on the example in the Art Institute of Chicago. A nearly identical piece is in the Philadelphia Museum of Art (Reg. no. 25-53-22; Cox, *Pottery and Porcelain*, p. 200, pl. 61, left), and two other closely related vases in private collections in Japan. One has the characters for the four seasons incised around the middle, painted peony leaf sprays on the shoulder and lotus petals around the base (Fig. 187); the other has similar painted patterns and large, incised quatrefoils in the central band (Fig. 188).

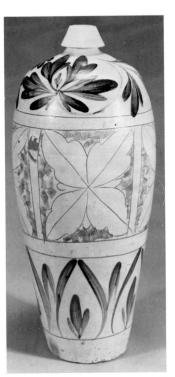

Figure 187 Figure 188

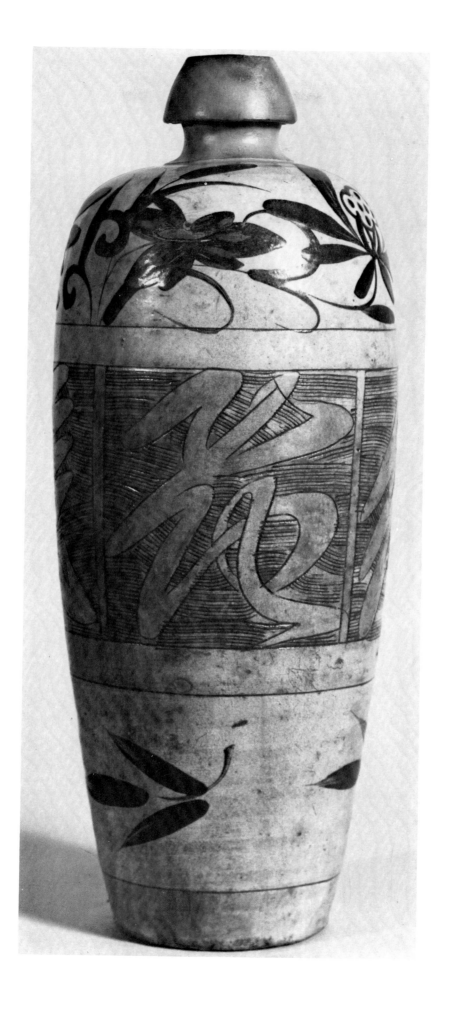

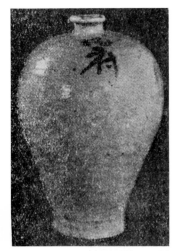

Figure 189

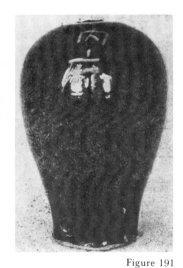

Figure 190

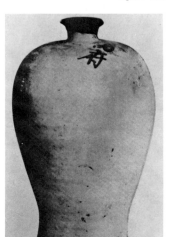

Figure 191

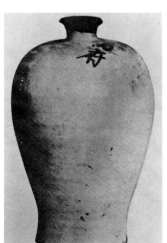

Figure 192

Figure 193

Plate 73
Mei-p'ing
Group 12/H
Yüan Dynasty, early 14th century
H. 14-9/16 in. (37.0 cm.)
Tokyo National Museum

Vase with swelling ovoid body, high-rounded shoulder, small neck and everted mouth rim; body tapering toward the base and then flaring outward slightly; recessed flat base. Grey stoneware covered with white slip and transparent glaze stopping well short of the base. Painted underglaze decoration in brown iron pigment: two-character inscription *Nei-fu,* "Palace repository," on the shoulder.

Published: *Tokyo National Museum Catalogues,* pl. 312; Hasebe, *Jishuyo,* p. 122, fig. 60.

In shape, this *mei-p'ing* is related to those of the first type; however, it is undecorated but for the characters *Nei-fu* written on the shoulder. A few examples of *mei-p'ing* inscribed in this manner are known, all of which can be assigned a Yüan Dynasty date. One was found in a Yüan storage cellar at Liang-hsiang-chen in Peking (Fig. 189; *KK,* 1972, no. 6, p. 33, fig. 4) and another, of taller more slender form and with a more widely flaring base, excavated at a Yüan dwelling site in Hou-ying-fang, also in Peking (Fig. 190; *KK,* 1972, no. 6, p. 10, fig. 8). In addition, a black-glazed piece with *Nei-fu* incised on the shoulder through the glaze was unearthed at the Kuan-t'ai kiln site in 1957-58 (Fig. 191; *WW,* 1959, no. 6, p. 60, fig. 11).

Similar pieces with the characters written in brown underglaze pigment are in a private collection in Japan (Fig. 192) and in the Feng-t'ien National Museum in Shen-yang, Liaoning Province (Fig. 193; Kato Hajime, *Shina Mansen no togyo o mite,* Nagoya, 1936, no pag.).

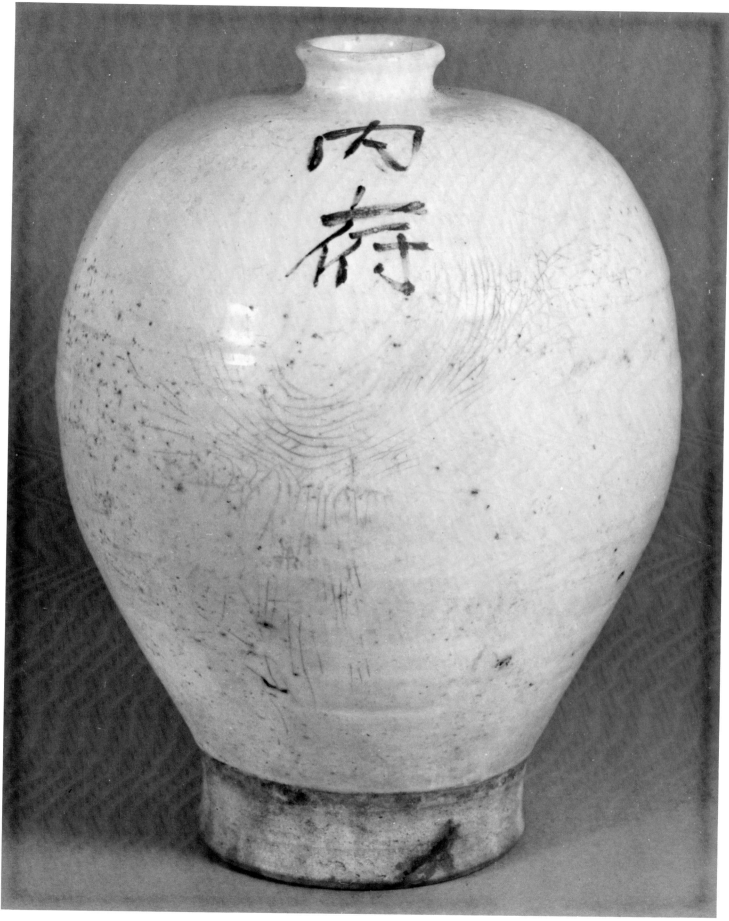

Plate 74
Bottle
Group 12/I
Chin Dynasty, 13th century
H. 12-3/8 in. (31.5 cm.)
Matsuoka Museum, Tokyo

Pear-shaped bottle with long slender neck widening at the mouth, slightly flaring foot and recessed flat base. Buff stoneware covered with white slip and transparent glaze. Painted underglaze decoration in black iron pigment organized into five horizontal bands: in the principal band around the body, two large peonies in ogival panels on a ground of painted 'fish-roe' (small overlapping circles with a dot in the center of each); around the neck, rows of knobbed foliated scrolls and of willow leaves in a zigzag arrangement, both on a ground of cross-hatching; a row of 's'-shaped overlapping petals and small lotus petals below the mouth.

Not previously published.

Pear-shaped bottles, although generally assigned to the Yüan Dynasty, are known to have been made in the Chin period, as well. The Matsuoka bottle can be dated to the Chin Dynasty for a number of reasons. A peony very close in style to those painted in the wide band around the body appears on a bowl dated 1201 that is in the Tokyo National Museum (see Pl. 105). Bottles similar in shape to the Matsuoka piece and a knobbed scroll pattern resembling that around its neck are painted on a wall of the Chin tomb found at Li-ts'un-kou, Ch'ang-chih, in Shansi (Fig. 194; *KK*, 1965, no. 7, pl. 7:4). Very similar scrolls also appear on the upper half of a *mei-p'ing*, believed by Chinese archeologists to be of the Sung Dynasty, but quite certainly Chin instead, that was found in Chen-p'ing-hsien, Honan Province (Fig. 195; *Chuka jinmin kyowakoku shitsudo bunbutsu-ten*, Nagoya, 1977, pl. 92). A pear-shaped bottle in the collection of Ruth Dreyfus, Paris, previously thought to be Yüan, can also be assigned to the Chin Dynasty. Decorated with a pheonix in flight on one side and flowering lotus on the reverse in the wide band around the body, it has a number of the same designs on the neck as those on the Matsuoka bottle, i.e., the small lotus petals, the narrow, 's'-shaped petals, and the knobbed scrolls (Fig. 196; Lee and Ho, *Chinese Art Under the Mongols*, pl. 48).

By comparison, a Yüan Dynasty bottle with brown and black painted decoration, found at the Ho-pi-chi kiln site in T'ang-yin-hsien, can be seen to be a later product (Fig. 197; *Chuka jinmin kyowakoku shutsudo bunbutsu-ten*, Tokyo, 1973, pl. 123). On it the bands of decoration around the neck have been reduced to horizontal and vertical stripes. The body is less rounded in shape and approaches a conical form, flattened at the base.

Figure 194

Figure 195

Figure 196

Figure 197

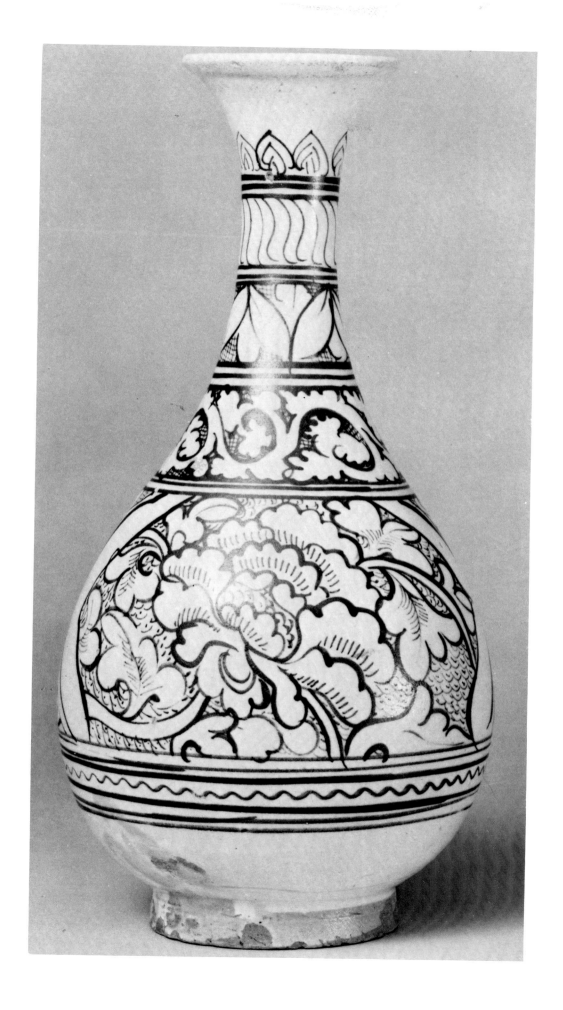

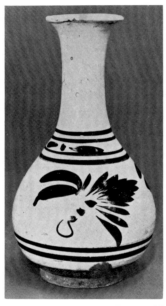

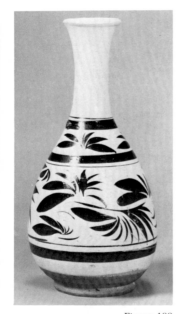

Figure 198 Figure 199

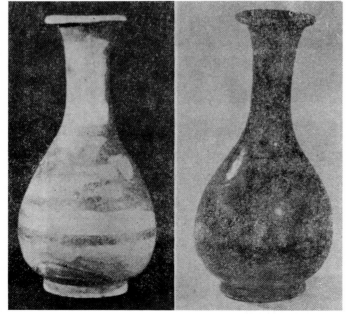

Figure 200

Plate 75
Bottle
Group 12/I
Chin Dynasty, late 12th—early 13th centuries
H. 8-1/4 in. (21.0 cm.)
D. 3-1/4 in. (8.2 cm.)
William Rockhill Nelson Gallery—
Atkins Museum of Fine Arts, Kansas City

Bottle with pear-shaped body, long slender neck widening toward the everted mouth rim; flaring foot and recessed flat base. Grey stoneware with white slip and transparent glaze stopping above the foot. Painted underglaze decoration in dark brown iron pigment: frond-like leaf patterns in a wide band around the body between horizontal lines.

Not previously published.

Wares with this style of painted decoration have been shown to be the product of kilns in Yü-hsien, and a pear-shaped bottle decorated in a similar manner with fan-like leaves was found in Pa-ts'un, Yü-hsien, although not actually in a kiln area (Fig. 198; *WW*, 1964, no. 8, p. 33, fig. 11). A very attractive bottle, formerly in the Sanpo-do collection, has more numerous frond patterns painted in two bands around the body (Fig. 199). Two bottles of the same shape but decorated with three-color lead glazes were discovered in the tomb of Yen Te-yüan, dated 1189 A.D., in Ta-t'ung, Shansi (Fig. 200; *WW*, 1978, no. 4, p. 11, fig. 35).

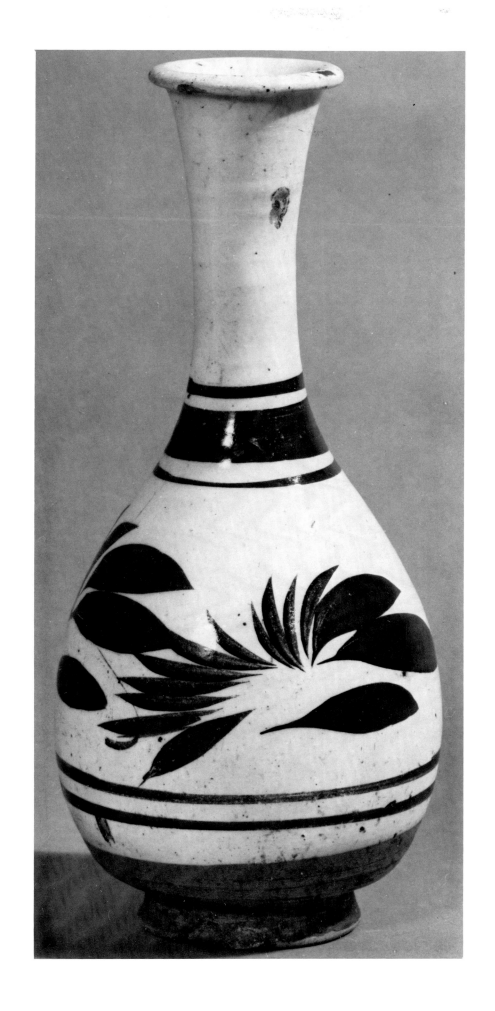

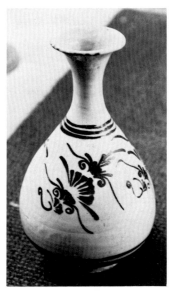

Figure 201

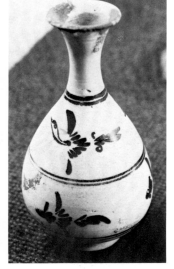

Figure 202

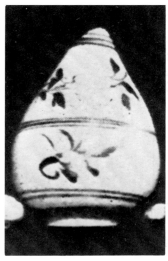

Figure 203

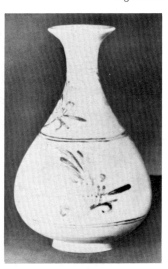

Figure 204

Plate 76
Bottle
Group 12/I
Yüan Dynasty, 14th century
H. 12 in. (30.5 cm.)
D. 6-3/4 in. (17.2 cm.)
The Art Institute of Chicago

Bottle with pear-shaped body, slender neck and everted mouth rim; low flaring foot and recessed flat base. Buff stoneware with white slip and dull yellowish transparent glaze stopping at the foot. Painted underglaze decoration in dark brown iron pigment: three floral sprays in a wide band around the body and three fan-like leaf clusters around the base of the neck between horizontal lines.

Not previously published.

A similarly shaped, black-glazed bottle was found in a Yüan dwelling site at Hu-kuang-i-yüan, in Sian (*Ch'üan-kuo-chi-pen chien-she kung-ch'eng chung ch'u-t'u wen-wu chan-lan t'u-lu*, 1954, pl. 96:4). Two bottles, also of the same shape, and decorated in a style related to that of the Chicago piece, are in the Sackler Collections, one with fan-like leaf clusters around the body (Fig. 201) and the other with birds in flight (Fig. 202), the birds painted in the same manner as the leaf patterns. Similar decoration can be seen on a piece, broken at the neck, that was excavated from a tomb at Hua-t'a-ts'un, T'ai-yüan (Fig. 203; *KK*, 1955, no. 4, pl. 14:4) and on another bottle in the Palace Museum, Peking (Fig. 204; *Chugoku Eirakukyu hekiga-ten*, Tokyo, 1963, no. pag.). Still another example, decorated with long-stemmed floral designs and phoenixes in flight, is in the Barlow Collection (Sullivan, *Barlow Collection*, pl. 64 b). The Chicago bottle appears to be a later example in this group, with its wider, heavier-looking body and shorter neck and its almost haphazardly painted ornament.

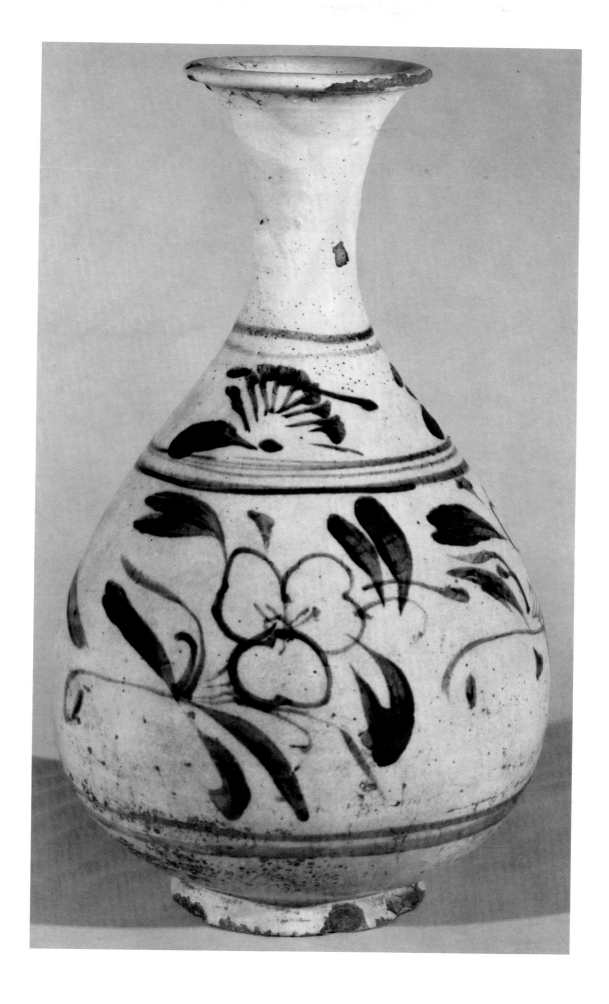

Plate 77
Tsun-shaped Vase
Group 12/J
Chin Dynasty, 13th century
H. 35 in. (88.9 cm.)
D. 12-1/4 in. (31.1 cm.)
Seattle Art Museum

Very tall vase with long neck, widely everted large mouth and undulated mouth rim; high, widely flaring conical foot. Grey stoneware covered with white slip and transparent glaze. Painted underglaze decoration in black iron pigment covering the piece intensively in 16 horizontal bands. The main band around the body decorated with infant boys among lotuses on a striated wave-patterned ground in four ogival panels, the spandrels filled with lotus scrolls; small boys and lotuses repeated in a continuous band around the foot, bordered by a flattened meander band above and a row of circles filled with large black dots below. Lotus scrolls also painted on the down-turned edges of the mouth, and similar mixed floral scrolls around the base of the foot. Rows of lotus petals around the base of the mouth, on the shoulder and base of the body, and around the top of the foot. Long willow-like leaves in zigzag and diamond-shaped arrangements on the neck interspersed with small flowers on a striated ground; a narrow band of classic scrolls around the base of the neck.

Published: Medley, *Yüan Porcelain and Stoneware,* pl. 97.

There are two types of *tsun*-shaped vases with painted decoration, one having a high, conical foot and rounded body, and the other with a flatter, splayed foot and longer body in proportion to the total height of the vase. The Seattle piece is the largest and most impressive of the *tsun* vases of the first type. An example of the second, dated the 11th year of Ch'un-yu, or 1251 A.D., is in the Barlow Collection (see Appendix A).

The Seattle vase is decorated in the same intensive style as a rounded jar-like fragment found in Pa-ts'un, Yü-hsien (Fig. 205; *WW*, 1964, no. 8, p. 32 and pl. 5:1). Believed by Chinese archeologists to be a *kuan,* it is far more likely, as has been noted by Western scholars, to be the central portion of a large vase like that in the Seattle Art Museum and displays nearly identical patterns of small boys and lotuses in ogival panels with lotus scrolls in the spandrels and lotus petals around the shoulder and base.

Figure 205

Figure 206

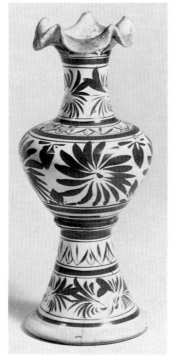

Figure 207

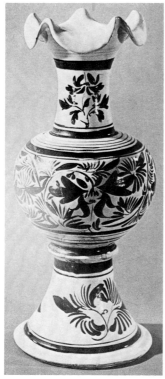

Figure 208

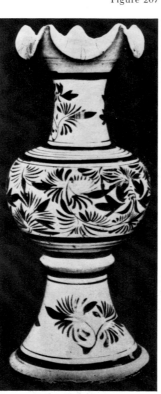

Figure 209

Plate 78
Tsun-shaped Vase
Group 12/J
Chin Dynasty, 13th century
H. 8-13/16 in. (22.3 cm.)
D. 3-7/8 in. (19.8 cm.)
Collection of Mr. and Mrs. Joseph Lesser, New York

Vase with long neck, everted mouth and undulated mouth rim; high flaring foot. Grey stoneware covered with white slip and transparent glaze. Painted underglaze decoration in black pigment of pairs of leafy fronds on the body and foot and upright fronds around the neck. Broken and repaired.

Not previously published.

The smaller *tsun*-vases like this lovely example can also be seen to have been manufactured in Yü-hsien. A piece very similar in shape and ornament to the vase in the Lesser collection was found in Pa-ts'un (Fig. 206; *WW*, 1964, no. 8, p. 32 and p. 33, fig. 12). Several closely related vases are known all of which are decorated with floral and leaf patterns painted in this same manner. One, in the Royal Ontario Museum, has frond patterns on the foot and neck while around the body are flowers painted with narrow petals radiating around a central dot (Fig. 207) that resemble the flowers on the flattened bottle-shaped pillow dated 1336 (see Pl. 57). Other examples include one in the Shanghai Museum (Fig. 208; *Shang-hai po-wu-kuan ts'ang-tz'u hsüan-chi*, pl. 54), a very similar vase formerly in the collection of Sato Ryuzo (Fig. 209; Okuda, ed., *Toyo toji shusei*, vol. 3, pl. 7), a third in a private Japanese collection (Hasebe, *Jishuyo*, pl. 62) and a fourth in the Yale University Art Gallery (George Lee, *Selected Far Eastern Art*, pl. 295).

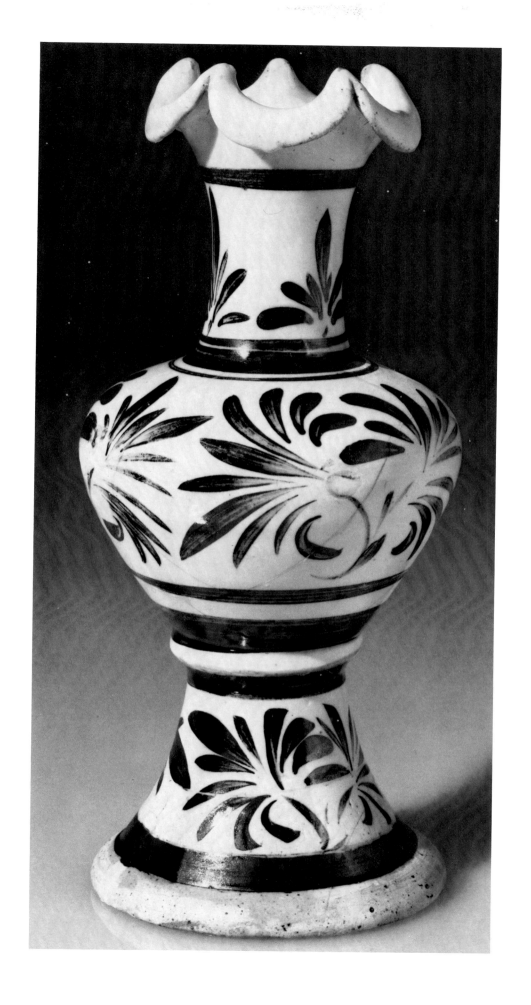

Plate 79
Jar
Group 12/K
Chin Dynasty, 12th—13th centuries
H. 6-1/2 in. (16.5 cm.)
Lowe Art Museum, The University of Miami

Wide-mouthed jar with nearly vertical sides and small loop handles on the shoulder; slightly flaring, small foot and recessed flat base. Pale grey stoneware covered with white slip and transparent glaze stopping well above the foot. Painted underglaze decoration in black iron pigment of frond-like leaf patterns around the body between horizontal lines.

Not previously published.

Painted decoration of this type is known to have been used on wares from Yü-hsien, as noted above, and a *tsun*-shaped vase with frond-like leaves very similar to those on the Lowe Art Museum jar was found in Pa-ts'un (see Fig. 206).

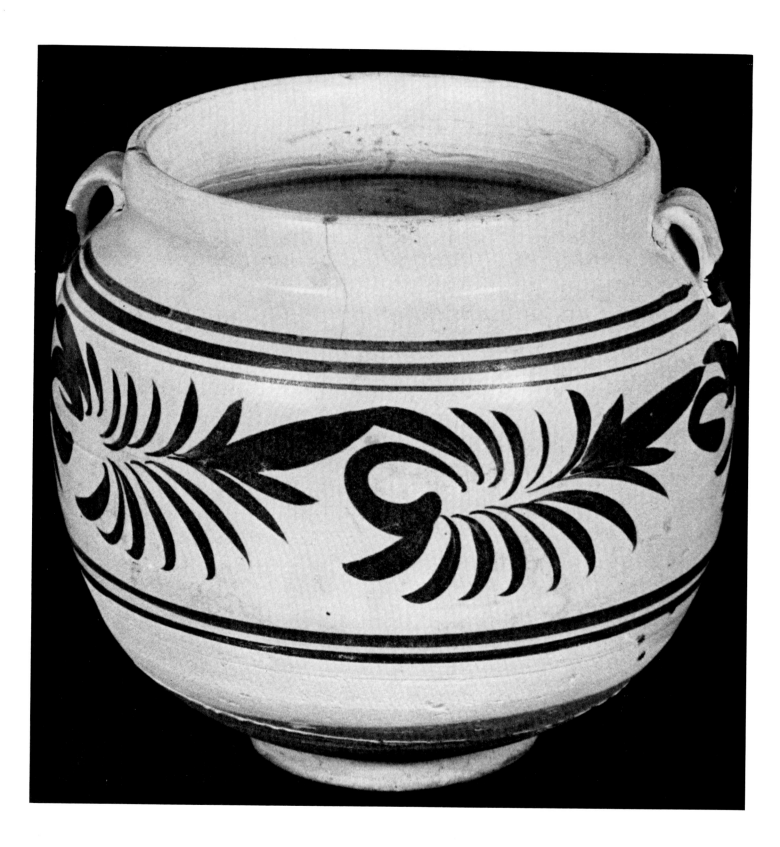

Figure 210

Plate 80
Jar
Group 12/K
Chin Dynasty, 13th century
H. 8 in. (20.2 cm.)
W. 8-1/2 in. (21.6 cm.)
Asian Art Museum of San Francisco, The Avery Brundage Collection

Jar with globular body, wide low neck and slightly everted mouth rim; two small loop handles attached to the neck and shoulder; wide, slightly flaring foot and recessed flat base. Buff stoneware with white slip and transparent glaze stopping unevenly on the foot. Painted underglaze decoration in dark brown pigment of gracefully curving leaf sprays on the shoulder. Mouth and neck extensively repaired.

Published: Honey, *The Ceramic Art of China and Other Countries of the Far East*, (London, 1945), pl. 72(a); d'Argencé, *Brundage Ceramics*, pl. XXXIX:A; and Koyama, *So*, pl. 52.

Wide-mouthed jars with two loop handles at the neck and painted decoration were made from the late 12th to the early 14th century. The jar in the Brundage Collection originally may have had a neck like that of an otherwise very similar jar in a Japanese collection (Fig. 210). The longer neck and sharply turned back mouth rim, however, are very unusual features on jars of this subgroup.

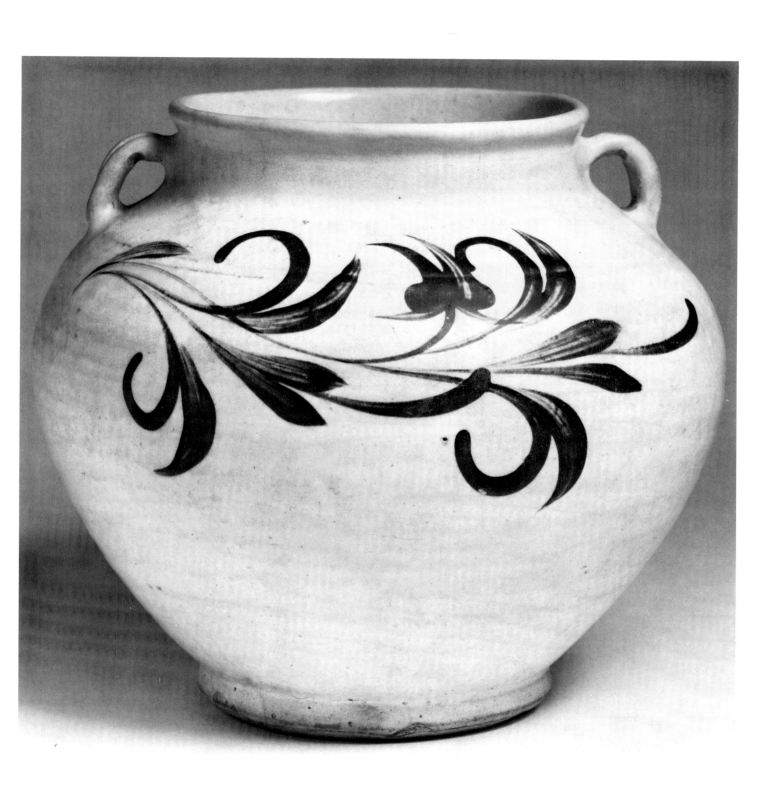

Figure 211

Plate 81
Jar
Group 12/K
Chin Dynasty, 13th century
H. 6-1/2 in. (16.4 cm.)
D. 8-1/2 in. (21.5 cm.)
Collection of Mr. and Mrs. Myron Falk, New York

Jar of depressed globular shape with wide low neck and mouth rim turned back down onto the neck; two double strand loop handles attached to the neck and shoulder; small low foot and recessed flat base. Pale grey stoneware covered with white slip and transparent glaze stopping well above the foot. Painted underglaze decoration of stylized leaf designs in brown iron pigment. Splashes of brown glaze at both ends of the handles where joined to the body.

Published: Loehr, *Chinese Art: Symbols and Images,* (Boston, Wellesley College, 1967), pl. 23.

A similar jar painted with rudimentary leaf patterns between double horizontal lines is in a Japanese collection (Fig. 211). Another with wider neck and slightly everted mouth rim was sold at auction in New York in 1975 (*Fine Chinese Works of Art,* New York, Sotheby Parke-Bernet, March 12 and 13, 1975, no. 286). A jar that is also painted with double horizontal lines, but no leaf patterns is in the Staatliches Museum für Volkerkunde, Munich (display no. 128 in the Oriental gallery).

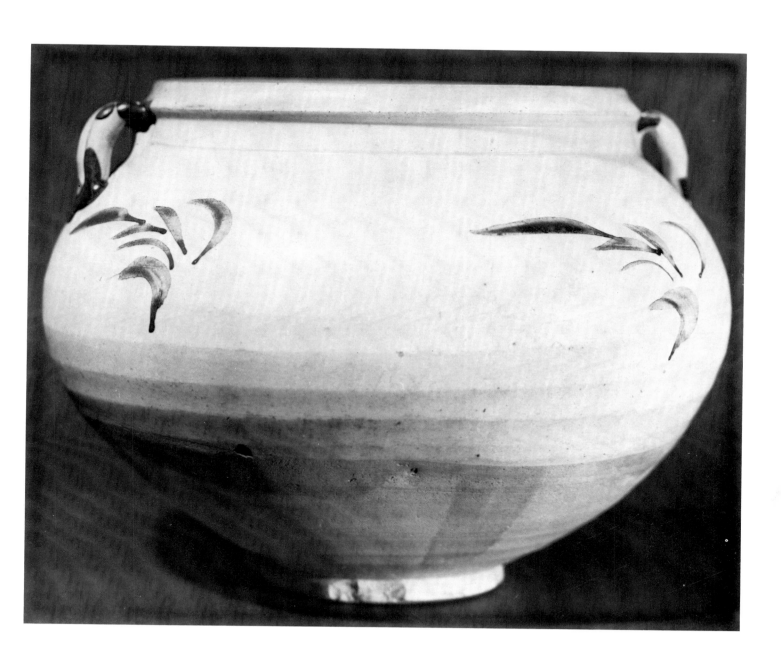

Figure 212

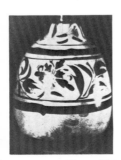

Figure 213

Plate 82

Small-mouthed Jar
Group 12/L
Yüan Dynasty, 14th century
H. 15 in. (38.0 cm.)
D. 11-1/2 in. (29.0 cm.)
Collection of Mr. and Mrs. Stanley Herzman, New York

Ovoid jar with short narrow neck and slightly everted mouth rim; four small loop handles on the shoulder; slightly flaring, low foot and recessed flat base. Buff stoneware covered with white slip and transparent glaze stopping well short of the foot. Painted underglaze decoration in brown iron pigment: willow-like leaf sprays and fan-shaped leaf clusters in a wide band around the middle of the body, a row of dots above and below, bounded by thick horizontal lines; the upper part of the neck also painted brown.

Not previously published.

Ovoid jars with small, slightly everted mouth and two or four handles around the base of the neck were made from the late twelfth to the fourteenth centuries. The two-handled variety appears to be earlier, generally, than that with four handles, and are closely related to the wide-mouthed jars with brown glaze splashes (See Pl. 81), having very similar decoration of rudimentary leaf patterns. An example of nearly globular shape, in the British Museum, is dated 1303 A.D. by an ink inscription around the foot (Fig. 212; R. L. Hobson, *A Guide to the Pottery and Porcelain of the Far East*, British Museum 1924, p. 32, fig. 37). A similar jar is in a private collection in Japan (Fig. 213). Another without any leaf patterns on it is in the Museum für Kunst und Gewerbe, Hamburg (Reg. no. 1948.11).

The four-handled jars are of three different types. The first, like the two-handled jars, have double-strand handles sometimes splashed with brown glaze, and a rounded egg-shaped body. The second, of which the Herzman piece is an example, has flattened, combed handles and, often, a more elongated body with black glaze covering the lower portion. The third type resembles the second in most respects but is decorated with a distinctively bold style of painting.

A jar of the first type with decoration similar to that on jars of the two-handled variety is in the Field Museum (Reg. no. 127235). Another, of nearly identical shape but decorated with delicate floral sprays and small scroll patterns, is in the Art Institute of Chicago (Fig. 214; Reg. no. 64.859), and a third was discovered by Russian archeologists in the Trans-Baikal region of southern Siberia (Fig. 215; S. V. Kiselev, et al, *Drevne Mongolskie Goroda*, Moscow, 1965, p. 126; and *KK*, 1960, no. 2, pl. 6:7). A closely related vase is in the Staatliches Museum für Völkerkunde (display no. 121 in the Oriental gallery). A jar of the same type, found in Chu-ch'eng-hsien, Shantung, has a longer narrow neck and a decoration of peonies painted in a rather cursory manner in a wide band around the body (Fig. 216; *Shan-tung wen-wu hsüan-chi*, Peking, 1959, pl. 236). Two similarly shaped pieces have, instead of a floral decoration, inscriptions written laterally around the body. One, in the collection of Malcolm McDonald, is inscribed with the characters *chao-ts'ai li-shih*, expressing the wish for attracting wealth and for a prosperous market (I. L. Legeza, *The Malcolm MacDonald Collection of Chinese Ceramics*, London, 1972, pl. XLIV:138). The other, found in the Hsüan-wu district of Peking in the site of the ancient Yüan city, is inscribed with an excerpt of a poem by Tu Fu (Fig. 217; *Chuka jinmin kyowakoku shutsudo bunbutsu-ten*, Tokyo, 1973, no. 229). The piece has black glaze on the lower portion of the body and the foot and on the mouth rim, a feature that became prevalent on these jars in the 14th century.

An unusually fine example of the second type, the jar in the Herzman collection with its large, swelling shape and freely

Figure 214

Figure 215

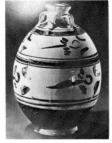

Figure 216

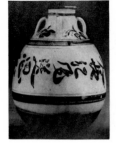

Figure 217

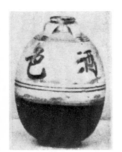

Figure 218

Figure 219

Figure 220

Figure 221

Figure 222

Figure 223

Figure 224

Figure 225

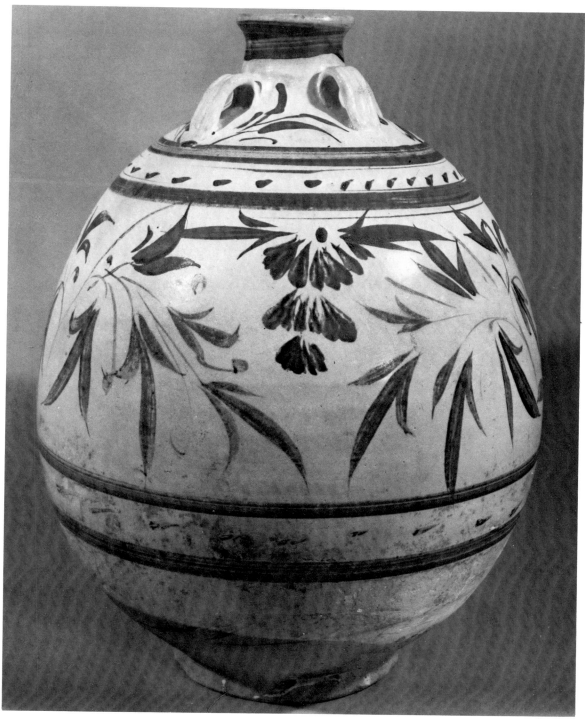

painted decoration, is doubly unusual in that it has no black glaze on the lower portion. Like other examples with the black bottom and a similarly rounded shape it appears to be earlier than the jars of second type with a more elongated form. Other earlier pieces include one in the British Museum (Ayers, *The Seligman Collection*, pl. XL, no. D 114), one found in Liao-yang-hsien, Liaoning Province (Fig. 218; *WW*, 1954, no. 9, fig. 71), and a third discovered in a Yüan tomb at T'ou-ho shui-k'u, T'ang-shan, in Hopei (Fig. 219; *KK*. 1958, no. 3, pl. 3:6). The latter has a four-character inscription *chiu-se ts'ai-ch'i*, "the color of wine, an air of wealth," written upright around the body. Jars of the second type with a more elongated body are also frequently inscribed. An example with four large characters *feng hua hsüeh yüeh*, "wind, flower, snow, moon," around it is in the Tokyo National Museum (Tokyo National Museum Catalogues, pl. 314). A piece with a small figure

holding a leafy branch and standing by the inscription *Jen-ho-kuan*, probably the name of a wine shop, is in the Percival David Foundation (Fig. 220; display no. 316 in the Sung gallery). Another piece, that is inscribed with a poem by Li Po in columns of two characters each, was found in an early Yüan kiln site at Ho-pi-chi in 1963 (Fig. 221; *WW*, 1964, no. 8, pl. 3:9). Broken when unearthed, and reconstructed by Chinese archeologists as a deep jar with wide mouth, it is certain, instead, to have been a jar of the type under discussion. A related jar in the British Museum has an inscription in Bashpa, deciphered as meaning "good wine," written obliquely across one side (Fig. 222; Hobson, "Chinese Porcelain Fragments from Aidhab, and Some Bashpa Inscriptions," *TOCS*, 1926-27, p. 21, fig. 1). Another, without inscription but decorated with simple fan-like floral patterns, is in the collection of Dr. Singer.

Uniformly glazed black on the lower portion and, usually, on the mouth rim, the four-handled jars of the third type resemble those of the second type with the more elongated bodies, but are decorated with boldly painted patterns often using heavy, dark strokes of the brush. Three examples can be seen in the Sackler Collection. One is decorated with large white flowers with solid black centers and black spiky leaves (Fig. 223). The floral decoration closely resembles that on a *kuan*, also in the Sackler collections (see Pl. 83), and the leaves are like those on the flattened bottle-shaped pillow dated 1336 A.D. (see Pl. 57), in the Museum of Fine Arts, Boston. Another has large white flowers with spirals in the center and heavy, black curving and spiky lines, presumably stylized stems and leaves (Fig. 224). A piece with nearly identical

decoration is in the Fitzwilliam Museum, Cambridge. These bold linear designs approach abstract patterns in their stylization on a third jar in the Sackler Collections where they appear without the flowers. Other jars of the third type are decorated with dragons and phoenixes also painted with rapid, though less heavy strokes of the brush, as on an example with a dragon and a phoenix in flight in ogival panels that was excavated from the site of a Yüan Dynasty building at Hou-ying-fang in Peking (Fig. 225; *KK*, 1972, no. 6, p. 9, pl. 9:1), a building that has been dated to the early fourteenth century. On another piece, in the Tokyo National Museum, a phoenix has been rather roughly painted and the black glaze carelessly applied so as to hide the bottom of the design (*Tokyo National Museum Catalogues*, pl. 313).

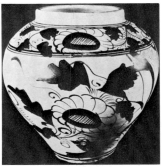

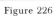

Figure 226 Figure 227

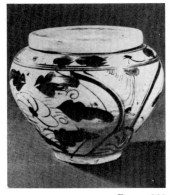

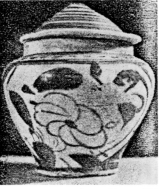

Figure 228 Figure 229

Plate 83
Kuan
Group 12/M
Yüan Dynasty, early 14th century
H. 11-1/2 in. (29.1 cm.)
D. 11-1/2 in. (29.1 cm.)
The Arthur M. Sackler Collections, New York

Globular jar with high rounded shoulder, wide mouth and vertical rim; small, recessed flat base. Buff stoneware covered with white slip and transparent glaze. Painted underglaze decoration in dark brown iron pigment: large white flowers with solid black centers and dark, spiky leaves enclosed in two sets of large parentheses, cloud-like and floral motifs in the spandrels; a narrow band of flowers with cross-hatched centers and dark leaves around the shoulder.

Not previously published.

This *kuan* can be dated to the early part of the fourteenth century on the basis of the close resemblance of the dark, spiky leaves to those on the bottle-shaped pillow dated 1336 A.D. (see Pl. 56). Three very similar *kuan* have been excavated in China, all exhibiting the spiky leaves and flowers in the same arrangement as on the Sackler piece. On one example, found at Ch'u-t'ou-lang, Ch'ih-feng-shih, in Chao-wu-cheng-men County, Inner Mongolia, flowers with large, scalloped petals appear on the body while multi-petaled flowers with solid black centers decorate the shoulder (Fig. 226; *Nei Meng-ku ch'u-t'u wen-wu hsüan-chi*, Peking, 1963, pl. 168). Flowers with cross-hatched centers, like those on the shoulder of the Sackler piece, decorate both body and shoulder of a second *kuan*, found at Ch'en-chia-chuang in the vicinity of Chi-nan, Shantung (Fig. 227; *Shan-tung-sheng wen-wu kuan-li-so, Shan-tung wen-wu hsüan-chi*, pl. 244). On the third, found at Liang-hsiang, Peking, multi-petaled flowers with solid, black centers appear on both body and shoulder (Fig. 228; *KK*, 1972, no. 6, p. 33, fig. 3, and pl. 12:2). The same type of flowers can be seen, between pairs of large parentheses, on smaller jars where the band of ornament around the shoulder have been eliminated. The leaves on these smaller jars, too, have been reduced to a single, broad stroke of the brush. One example was excavated in Chin-hsien near Lü-ta city in Liaoning Province (Fig. 229; *Hsin Chung-kuo ch'u-t'u wen-wu*, pl. 196) and a nearly identical piece is in the Malcolm MacDonald collection (Fig. 230; I. L. Legeza, *The Malcolm MacDonald Collection of Chinese Ceramics*, London, 1972, pl. XLIV: 136). Each has a conical cover decorated with a spiraling line.

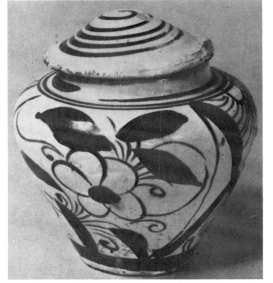

Figure 230

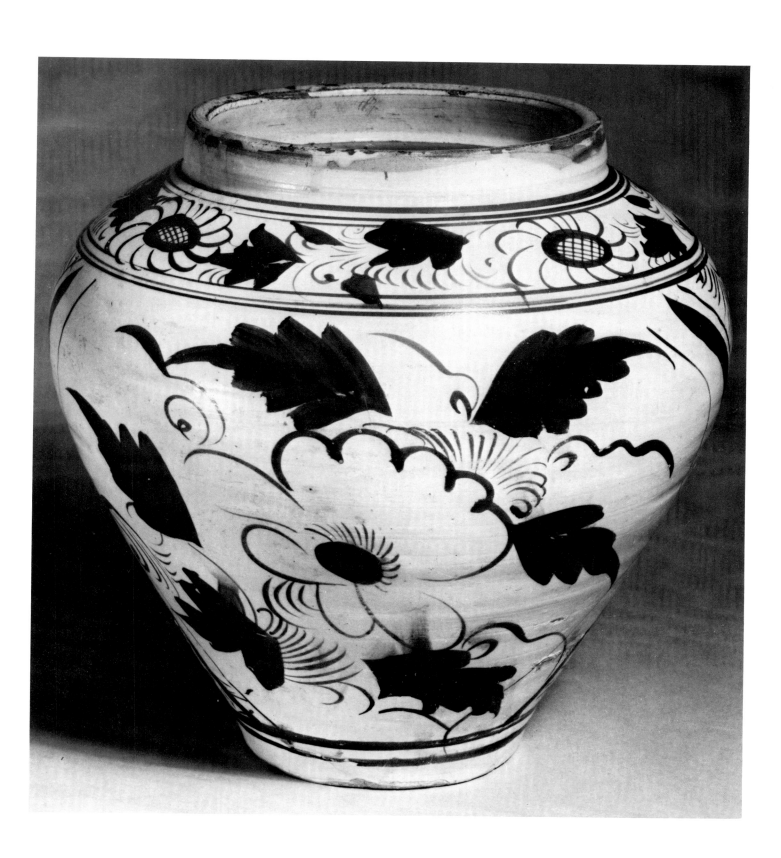

Plate 84
Kuan
Group 12/M
Ming Dynasty, dated 1541 A.D.
H. 11-1/4 in. (28.7 cm.)
*Herbert F. Johnson Museum of Art, Cornell University,
Collection of George and Mary Rockwell*

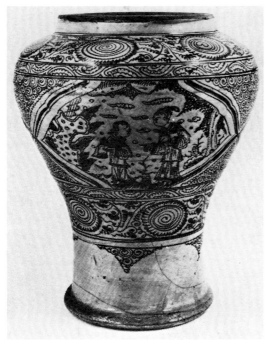

Figure 231

Tall jar with wide mouth and high swelling shoulder tapering to a nearly cylindrical lower portion; splayed foot and base recessed in two levels. Grey stoneware covered with white slip and transparent glaze. Painted underglaze decoration in dark brown pigment, organized in three principal horizontal bands: in the central band, small landscape scenes, one with a crane, one with a seated figure and a third with a figure standing, all in lozenge-shaped panels; closely painted spiral patterns in the spandrels. The bands above and below the central band decorated with large chrysanthemums with spiraling centers and corkscrew-like leaves. Inscription written on the lower part of the vessel near the foot, "made on an auspicious day in the 9th month of the 19th year of Chia-ching," the year corresponding to 1541 A.D.

Not previously published.

The painting on these vessels of the later part of the Ming Dynasty is rendered in fine lines and on a smaller scale than that on earlier pieces of related type. The shape too, is unique to the period. Two similar *kuan* can be seen in the Gemeentemuseum, The Hague (Fig. 231; Beatrice Jansen, *Chinese ceramiek*, Haags Gemeentemuseum, 1976, pls. 121 and 122) and another in the Burrell Collection at the Camphill Museum, Glasgow (Reg. no. 38/397).

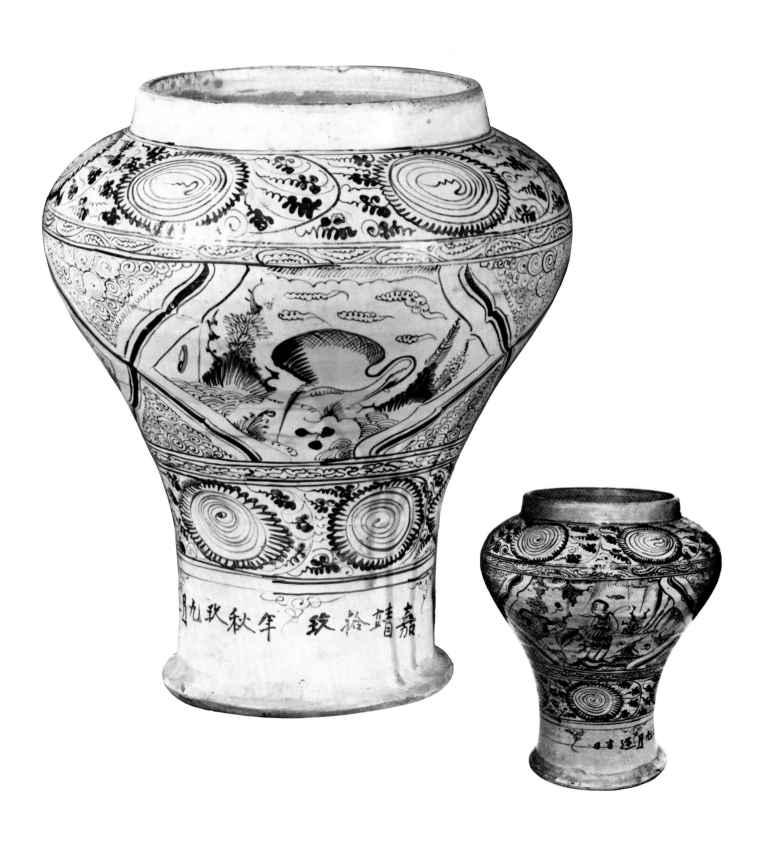

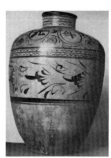

Figure 232 Figure 233

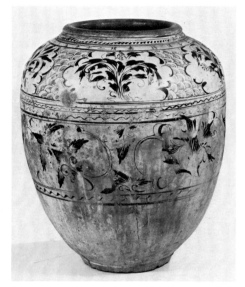

Figure 234

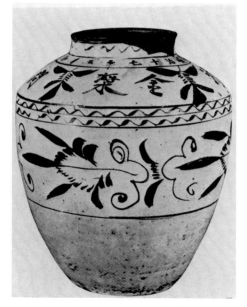

Figure 235

Plate 85
Large Jar
Group 12/N
Ming Dynasty, dated 1571 A.D.
H. 23-3/4 in. (60.3 cm.)
D. 17-1/2 in. (44.4 cm.)
Royal Ontario Museum, Toronto

Large jar with ovoid body, small abbreviated neck and thick unglazed mouth rim; recessed, concave base. Buff stoneware covered with white slip and transparent glaze. Painted underglaze decoration in black pigment of stylized fan-shaped leaves between lobed brackets in a wide band around the center of the body, above which are two narrow bands of wavy lines. Two rows of characters around the shoulder, in the narrower, upper one the inscription reading, "Made on an auspicious day in the twelfth month in the fifth year of the Lung-ch'ing period," the date corresponding to 1571 A.D.; leaf patterns between each pair of characters. In the lower band the inscription, "Fine rice selected in spring for this jar of fragrant, sweet wine of high quality," each character enclosed within lobed brackets.

Published: *Arts of the Ming Dynasty*, (Detroit Institute of Fine Arts, 1952), pl. 208; Hasebe, *Jishuyo*, p. 125, fig. 67; Riddell, *Dated Chinese Antiquities: 600-1650*, p. 65, fig. 41; and P. W. Proctor, "Chinese Ceramics," *Arts of Asia*, (March-April, 1979), p. 97, fig. 29.

Produced in the Ming Dynasty as containers for wine, the large jars of ovoid shape with slightly flattened shoulder were made either with a wide mouth and low collar-like rim or with a narrower, higher, cylindrical neck. The Royal Ontario Museum jar appears to have been of the latter style. A jar with narrow cylindrical neck, formerly in a private collection in Germany, is dated to the first year of Wan-li, just two years after the Toronto piece (Fig. 232; Otto Kümmel, *Chinesische Kunst*, Berlin, 1930, pl. 116). The rim is covered with black glaze, an extension of the black glaze on the interior. By comparison, the mouth of the Toronto piece can be seen to be a repair, having been previously broken and ground down, a fact that would explain the unglazed rim. The narrow cylindrical neck also appears on another large jar in the Royal Ontario Museum (Fig. 233).

The wider, lower neck can be seen on a jar in the Art Institute of Chicago (Medley, *Yüan Porcelain and Stoneware*, pl. 98). Exhibiting the same leaf patterns around the body as the jar dated 1571, in addition to floral sprays in lobed brackets around the shoulder, the Chicago jar can be considered a close contemporary. A jar in the Newark Museum has a wide neck that has been ground down almost to the shoulder, and an inscription in a narrow band at the base of the neck that dates it to the year 1547 (Fig. 234; *2000 Years of Chinese Ceramics*, Newark Museum, 1977, pl. 36). It is decorated with leafy patterns resembling birds with outspread wings in the band around the body and with palms in lobed brackets on a ground of overlapping waves around the shoulder. The style of painting is more delicate though equally as cursive as that on the later pieces. Another wide-mouthed jar, in a Japanese collection, bears an inscription dating it to the year 1660 (Fig. 235; Hasebe, *Jishuyo*, P. 125, fig. 68). The latest known example in this sub-group, it is the latest dated piece of Tz'u-chou type ware.

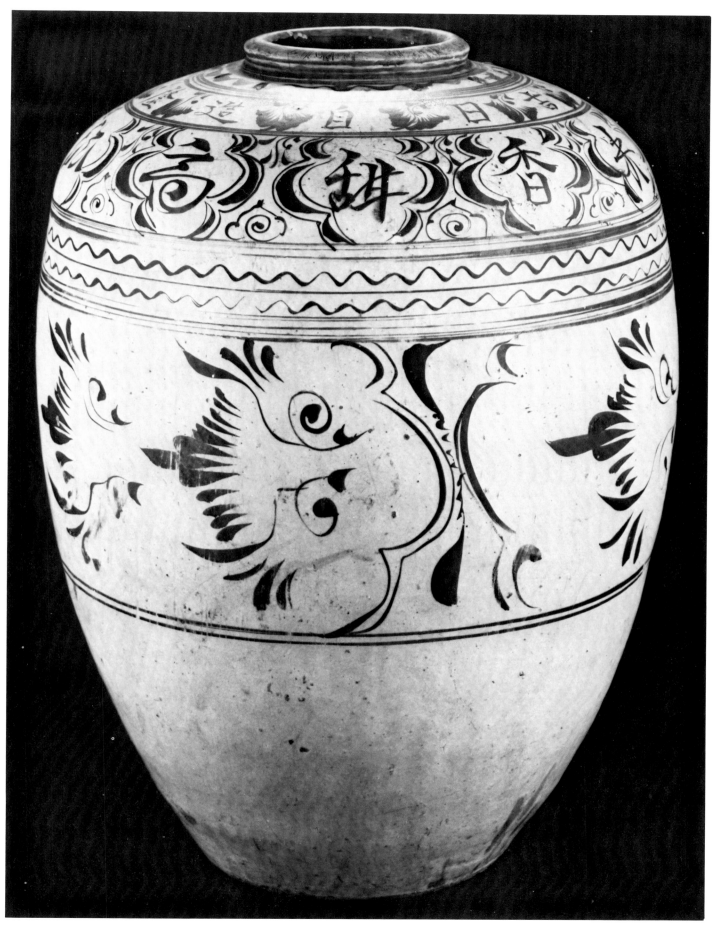

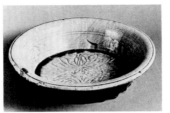

Figure 236

Figure 237

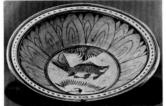

Figure 238

Figure 239

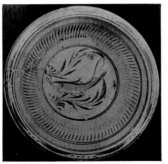

Figure 240

Figure 241

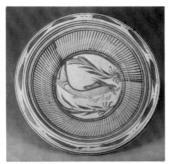

Figure 242

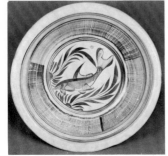

Figure 243

Figure 244

Plate 86
Basin
Group 12/O
Yüan Dynasty, late 13th—early 14th centuries
H. 3-1/2 in. (8.9 cm.)
D. 13-5/8 in. (34.6 cm.)
British Museum

Basin with straight sides tapering toward the base and flattened rim turned upward slightly at the edge: thick foot and small recessed base. Buff stoneware covered with white slip and transparent glaze on the interior, dark brown glaze on the exterior stopping short of the foot. Painted underglaze decoration on the interior in brown iron pigment: a carp swimming among aquatic grasses in the bottom, bordered by large leaves and rippling wave patterns around the sides; parallel encircling lines on the rim.

Published: Ayers, *The Seligman Collection of Oriental Art*, vol. II, pl. XLIII, no. D 119; and *Oriental Ceramics: The World's Great Collections*, vol. 5, British Museum, (Tokyo; Kodansha, 1976), pl. 115.

Made for a relatively brief period in the late thirteenth and early fourteenth centuries, the basins with painted ornament are a uniform sub-group of vessels, all of very similar shape and characteristically decorated with large carp among aquatic plants. They are heavy, sturdy vessels made of a coarse body material that is sometimes exposed at the rather large spur marks found in the interior. Vessels of this shape are known to have been manufactured at the Ho-pi-chi kiln site in T'ang-yin-hsien (Fig. 236; *WW*, 1964, no. 8 pl. 2:1 and 6; see also pl. 2:3 and 4), and fragments of pieces decorated with fish and aquatic plants have been found at the same site (Fig. 237; *Ku-kung po-wu-yüan yüan-k'an*, no. 2, 1960, p. 114, fig. 4).

A basin found in Lo-t'ing, Hopei has a carp in the center and large lotus petals painted around the sides instead of the leaves and waves seen on the British Museum piece (Fig. 238; *Hsin Chung-kuo ch'u-t'u wen-wu*, pl. 196). Around the sides of most other examples is a pattern of lines, closely spaced and radiating upward from the bottom, that is made by a roulette. Frequently painted around the rim of such pieces are long slender leaves. One such basin was found in the Yüan city site at Hsi-t'ao Hu-t'ung, Peking (Fig. 239; *KK*, 1973, no. 5, pl. 8:1) and another, very recently, in Tz'u-hsien (Fig. 240; *KK*, 1978, no. 6, pl. 5:1). Similar basins are in the Feng-t'ien National Museum in Shen-yang (Fig. 241; Kato, *Shina Mansen no togyo o mite*, no pag.) and in a private collection in Japan (Fig. 242). Another basin in a Japanese collection has a very similar design but has a rounded rim that is left free of ornament (Fig. 243). An unusual example in the Ashmolean Museum is decorated with a large fish leaping out of the waves that fills the entire interior surface (Fig. 244). Only the front half of the fish is visible behind the scalloped wave, and it is flanked by long aquatic grasses. The rim is painted with parallel encircling lines like the rim of the British Museum basin.

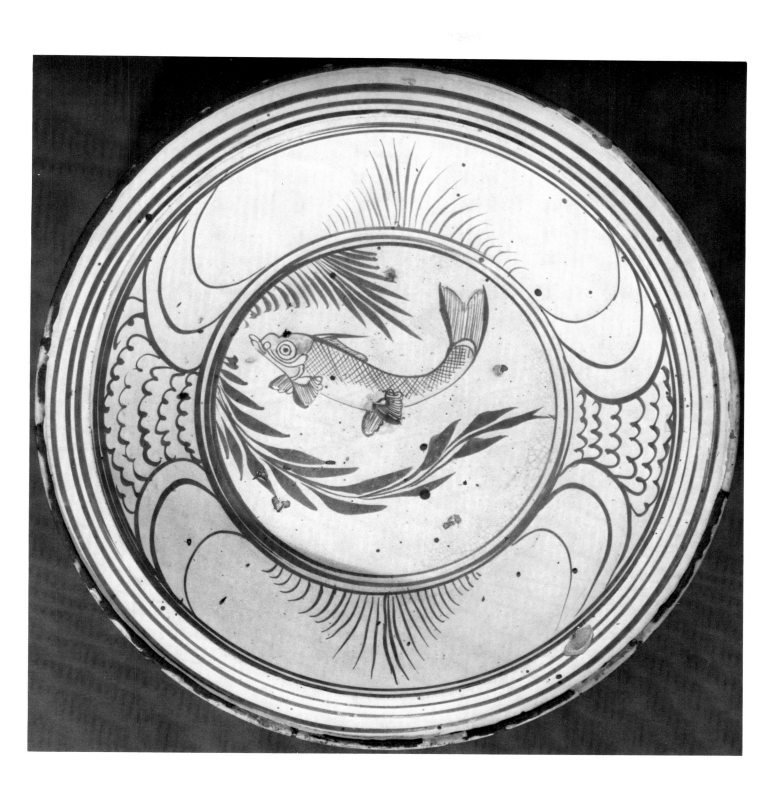

Plate 87
Truncated Mei-p'ing
Group 13
Chin Dynasty, 12th century
H. 7-13/16 in. (19.8 cm.)
Kyusei Hakone Art Museum

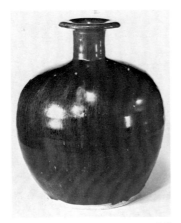

Figure 245

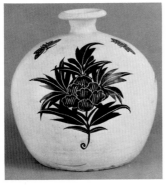

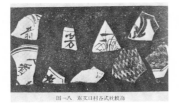

Figure 246

Figure 247

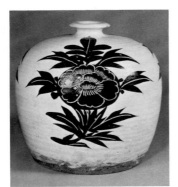

Figure 248

Figure 249

Vase with globular body, small neck and flattened everted mouth rim; wide, recessed flat base. Grey stoneware covered with white slip and transparent glaze. Painted and incised decoration in underglaze black pigment: two large peony sprays with long slender leaves, and butterflies fluttering around them.

Published: Hasebe, *Jishuyo*, Tokyo, 1974, pl. 61; and *Meihin zuroku* (Selected Catalogue of Hakone Art Museum and Atami Art Museum), vol. II, (Atami, 1976), pl. 7.

The painted and incised wares of Group 13 are decorated by painting the silhouette of the design in black, on which the details are incised through to the white slip beneath. It is a method that appears to have evolved originally as a short-cut to the handsome effects achieved by means of the sgraffiato technique. Two sub-groups of painted and incised wares are distinguishable, an earlier one that can be dated to the twelfth century, and a later that belongs to the thirteenth and fourteenth centuries.

The earlier subgroup includes truncated *mei-p'ing*, globular bowls and leaf-shaped pillows, objects on which sgraffiato decoration also commonly appears. A truncated *mei-p'ing* with black glaze, in the Idemitsu Art Gallery, is dated by an inscription on the base to the year 1119 A.D. (Fig. 245; Koyama Fujio, *Chugoku toji*, Tokyo, 1970, pl. 41). Very similar in shape to the Hakone piece, but with a longer neck and curving, everted mouth rim, it is a valuable key to the dating of these wares. While it is possible that the painted and incised wares were introduced in the last years of the Northern Sung Dynasty, they appear not to have become prevalent until the Chin Dynasty, with the decline of the sgraffiato technique. Peony sprays with long, slender leaves, like those on the Hakone vase, are a common motif, one that can be seen on sherds from the Tung-ai-k'ou kiln site (Fig. 246; *WW*, 1964, no. 8, p. 44, fig. 18), and painted and incised butterflies appear on fragments found at Kuan-t'ai (Fig. 247; *WW*, 1964, no. 8, p. 42, fig. 10), both sites in the vicinity of the former Tz'u-chou.

Other truncated *mei-p'ing* decorated with peony sprays and butterflies are in the collections of the Tokyo National Museum (Fig. 248; *Tokyo National Museum Catalogues*, pl. 283) and the Sano Museum (Fig. 249; Hasebe, *Jishuyo*, p. 99, fig. 23). The latter, with its high, squarish shoulder and shorter, thicker painted leaves, seems to be a late example of this type. A closely related piece decorated with peony sprays but no butterflies is shown in Plate 89.

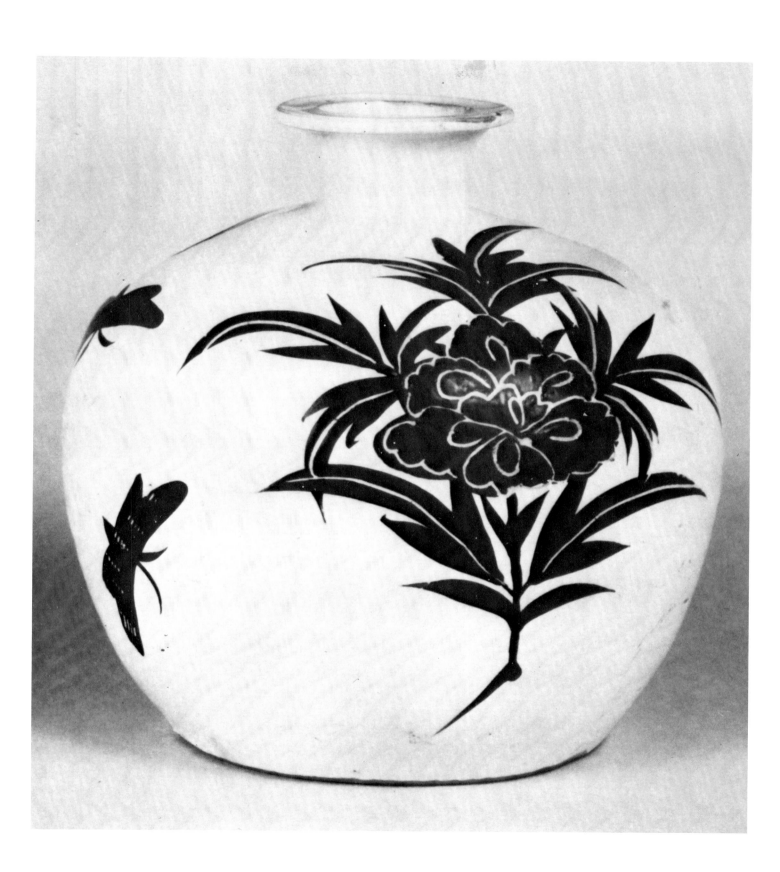

Plate 88
Truncated Mei-p'ing
Group 13
Chin Dynasty, 12th century
H. 8-1/8 in. (20.7 cm.)
D. 7-1/2 in. (19.0 cm.)
William Rockhill Nelson Gallery—Atkins Museum of Fine Arts, Kansas City

Vase with globular body, small neck and flattened everted mouth rim; wide, recessed flat base. Grey stoneware covered with white slip and transparent glaze. Painted and incised decoration in underglaze black pigment of two large peony sprays with the details of the petals and the veins of the leaves incised in the dark pigment.

Not previously published.

(See Plate 87.)

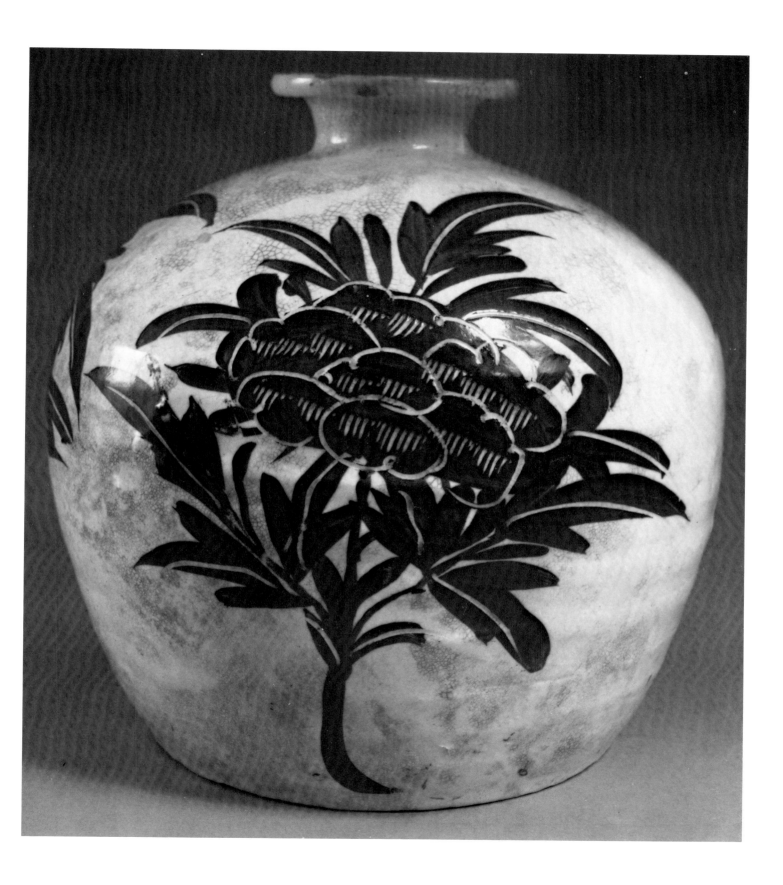

Figure 250

Plate 89
Truncated Mei-p'ing
Group 13
Chin Dynasty, 12th century
H. 7-1/16 in. (18 cm.)
Collection of Hans and Gretel Popper, San Francisco

Small vase with globular body, small neck and flattened everted mouth rim; wide, recessed flat base. Grey stoneware covered with white slip and transparent glaze stopping at the base. Painted and incised decoration in underglaze black pigment of two large peony leaf sprays.

Published: Wirgin, "Sung Ceramic Designs," pl. 44:j.

A truncated *mei-p'ing* very similar to that in the Popper collection, but without incised veins on the long leaves, was found in the third layer at the Kuan-t'ai kiln site, a layer that Chinese archeologists have identified as being of Chin date (Fig. 250; *WW*, 1959, no. 6, p. 58, fig. 2).

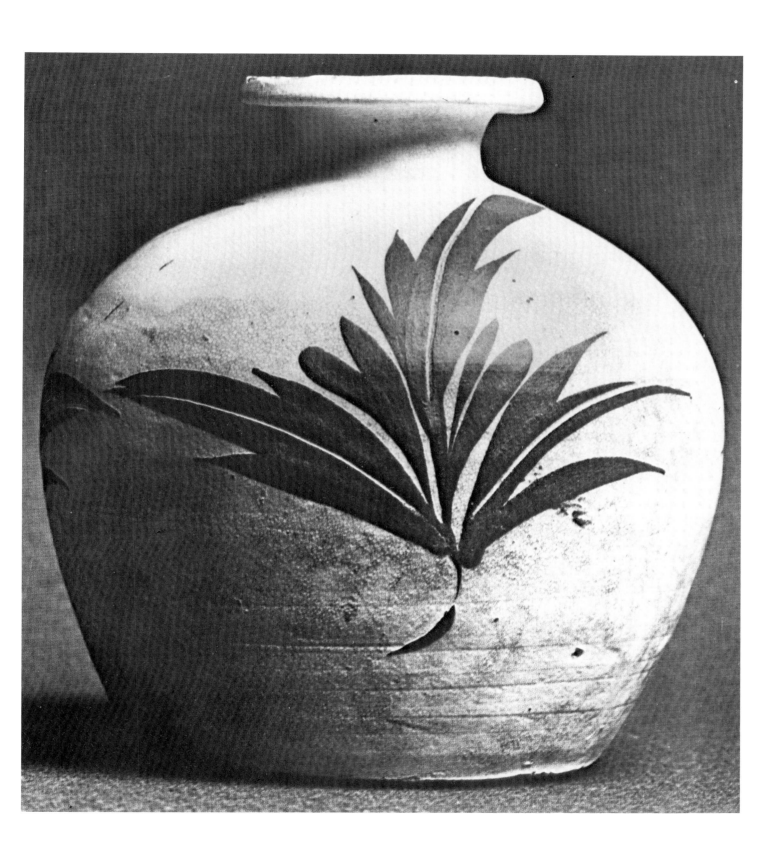

Plate 90
Vase
Group 13
Chin Dynasty, 12th century
H. 9-1/16 in. (23.0 cm.)
D. 3-15/16 in. (10.0 cm.)
Buffalo Museum of Science

Tsun-shaped vase with ovoid body, long nearly cylindrical neck and everted mouth with undulated rim; widely flaring foot and small, recessed flat base. Pale grey stoneware with white slip and transparent glaze stopping on the foot. Painted and incised decoration in black underglaze pigment of two large peony sprays with long slender leaves.

Published: Hochstadter, "Early Chinese Ceramics," pl. 93.

The long leaves with incised central veins are much like those seen on a sherd found at Tung-ai-k'ou (see Fig. 246). Most other known vases of similar shape and style of incised and painted decoration are covered with green glaze (see Pl. 95).

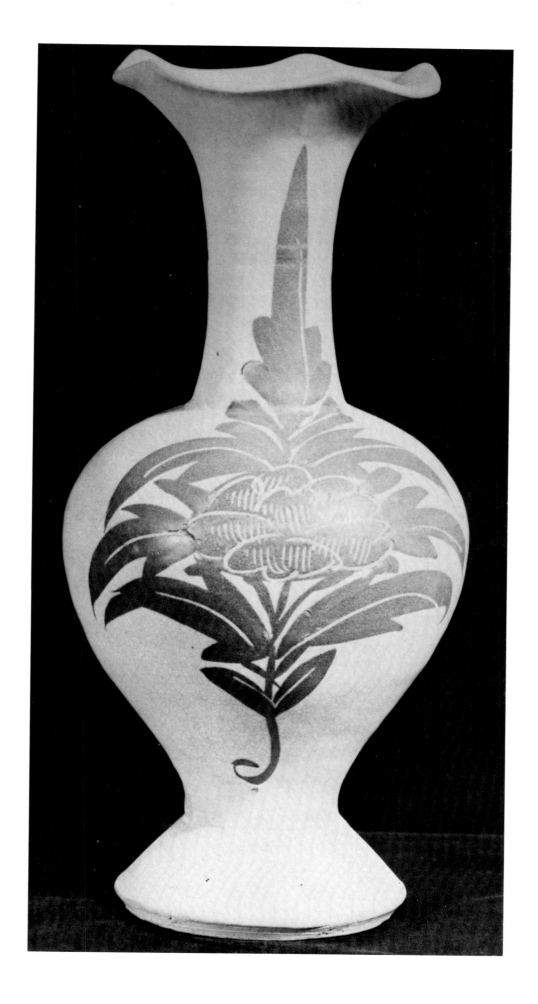

Figure 251

Figure 252

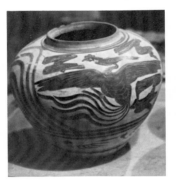

Figure 253

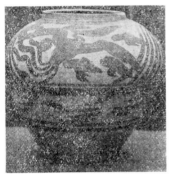

Figure 254

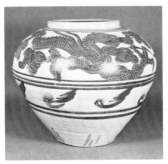

Figure 255

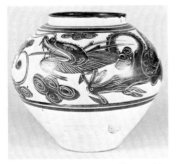

Figure 256

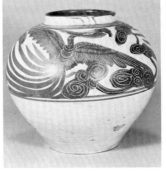

Figure 257

Figure 258

Plate 91
Kuan
Group 13
Yüan Dynasty, late 13th—early 14th centuries
H. 12 in. (30.5 cm.)
D. 13-1/2 in. (34.2 cm.)
Asian Art Museum of San Francisco, The Avery Brundage Collection

Globular jar with wide mouth and low vertical rim; recessed convex base. Brick red stoneware covered with white slip and transparent glaze. Painted and incised decoration in dark brown underglaze pigment: two large phoenixes in flight between drifting clouds in a wide band around the central portion of the body, the subjects painted in silhouette form and the details of the feathers and the scrolling patterns in the clouds lightly incised in the dark pigment. Wide lotus petals on a ground of vertical striations painted in a band around the shoulder.

Not previously published.

The second sub-group of painted and incised wares, made in the Yüan Dynasty, has a style of ornament featuring more complex motifs than those on the earlier examples of Group 13 and relying more heavily on the use of incised details. Numerous *kuan* of the same shape as the Brundage piece are known, also decorated with phoenixes and dragons. A very fine example was found in a Yüan storage cellar at Liang-hsiang near Peking (Fig. 251; *KK*, 1972, no. 6, pl. 12:1). The phoenix is depicted flying with its head turned backward. The details are more closely incised than those on the Brundage jar, and the streaming tail feathers, too, decorated with incised designs. Around the shoulder is a band of finely painted floral scroll patterns similar to those in the ogival frames of the rectangular pillows of Group 12/D. Stylistically, it appears to be an early example of this type. A *kuan* with a narrow border of small, crescent-shaped marks on the shoulder above a phoenix among clouds, closely resembling those on the Brundage jar, is in a private collection in Japan (Fig. 252). A phoenix among clouds flanked by curving parallel lines rising and falling like the contours of a mountain appears on a piece in the Musée Cernuschi (Fig. 253). Below it is a band of painted rudimentary leaf patterns. A nearly identical ornament can be seen on a jar excavated in Ch'u-chou-hsien, Hopei, east of Han-tan-hsien (Fig. 254; *WW*, 1960, no. 3, p. 90). A jar decorated with an incised and painted dragon among clouds with a band of similar, painted leaf patterns below it is in a Japanese collection (Fig. 255). Other examples have only the single wide band of ornament around the body. One, in the Idemitsu Art Gallery, is decorated with a bearded dragon of rather whimsical appearance (Fig. 256) and a second, in another private Japanese collection, with a phoenix (Fig. 257). A final example of this type, also decorated with a phoenix among clouds, was found in Sarawak, Malaysia (Fig. 258; Tom Harrisson, "Ceramics Penetrating Central Borneo," *Sarawak Museum Journal*, vol. VI, no. 6, 1955, pl. XIII).

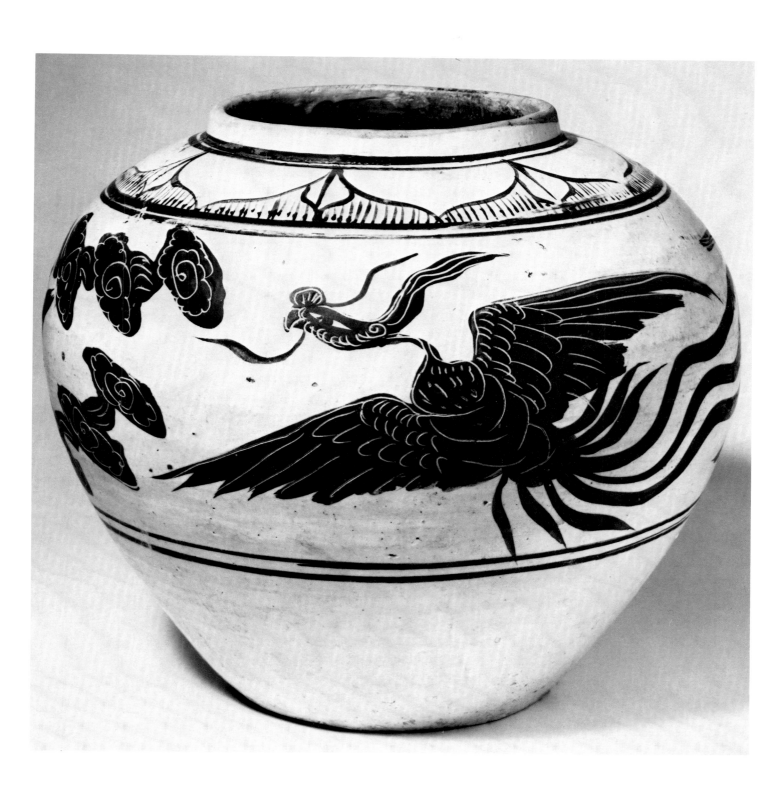






















Figure 259

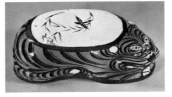

Figure 261

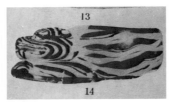

Figure 263

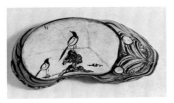

Figure 260

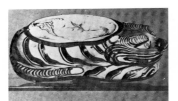

Figure 262

Figure 265

Figure 264

Figure 266

Figure 267

Plate 92
Pillow
Group 14
Chin Dynasty, late 12th century
H. 4-1/2 in. (11.4 cm.)
W. 15 in. (38.1 cm.)
Asian Art Museum of San Francisco, The Avery Brundage Collection

Pillow in the shape of a reclining tiger, head resting on front paws, tail curled around the body on the right side; back flattened into a slightly concave surface. Buff stoneware covered with white slip and transparent glaze. Painted underglaze decoration in black and tan on the body of the tiger, black only on the headrest; the oval surface painted with a bird on a bamboo branch.

Published: d'Argencé, *Chinese Ceramics in the Avery Brundage Collection*, pl. XL:C; and Wirgin, "Sung Ceramic Designs," pl. 52:k.

Tz'u-chou type ware decorated with black and light brown, or tan-colored, painted patterns comprises a group known to have been made at Ho-pi-chi in T'ang-yin-hsien, and possibly at other sites, from the middle of the 12th century to the 16th century. It includes pillows, *kuan*, pear-shaped bottles and *mei-p'ing*. Among the earliest of these are the pillows made in the shape of recumbent tigers, a fact indicating that this technique of decoration may have developed initially for the painting of these specific objects. A tiger pillow with black and tan painted decoration that is dated by an inscription on the bottom to the year 1162 A.D. is in the Shanghai Museum (Fig. 259; *KK*, 1979, no. 5, pl. 9:1). On the top a bird is depicted with head turned, looking up at two other birds flying away into the distance. A very similar pillow in the Royal Ontario Museum with stippled eyebrows and wavy stripes on the head, like on the Shanghai pillow, is decorated on the top with two birds, one standing on a rock gazing at two birds in flight in the distance (Fig. 260). On two other examples, one in the Tokyo National Museum (Fig. 261; Hasebe, *Jishuyo*, p. 121, fig. 59) and another formerly in the collection of Mrs. Peters (Fig. 262; *Chinese Porcelains and Pottery of the Early Dynasties*, Parke-Bernet Galleries, New York, Jan. 12-14, 1944, no. 366), a bird is depicted in flight, holding a long stalk of grass held in its bill.

These pillows were manufactured at the Ho-pi-chi kilns site, as evidenced by the discovery of fragments of a tiger pillow there (Fig. 263; *WW*, 1964, no. 8, pl. 2:14 and p. 8). The top of the pillow is not shown in the illustration published in the excavation report and may not have survived. A bird that resembles closely the birds on the Royal Ontario Museum pillow appears on a fragment of a dish, also found at Ho-pi-chi (Fig. 264; *Chuka jinmin kyowakoku shutsudo bunbutsu-ten*, Tokyo, 1973, pl. 211).

Two white tiger pillows also are known, one in the Victoria and Albert Museum (Fig. 265; Medley, *Yüan Porcelain and Stoneware*, pl. 99 B) and the other in the Art Institute of Chicago (Fig. 266; Lee and Ho, *Chinese Art Under the Mongols*, pl. 42). Nearly identical, they are both decorated with black stripes on a white body with only small spots of tan on the ears and eyebrows. Each has a large floral spray on the top featuring tan flowers and black leaves, a motif like that seen on a fragment of a dish found, again, at Ho-pi-chi (Fig. 267; *WW*, 1965, no. 9, pl. 5:6).









208

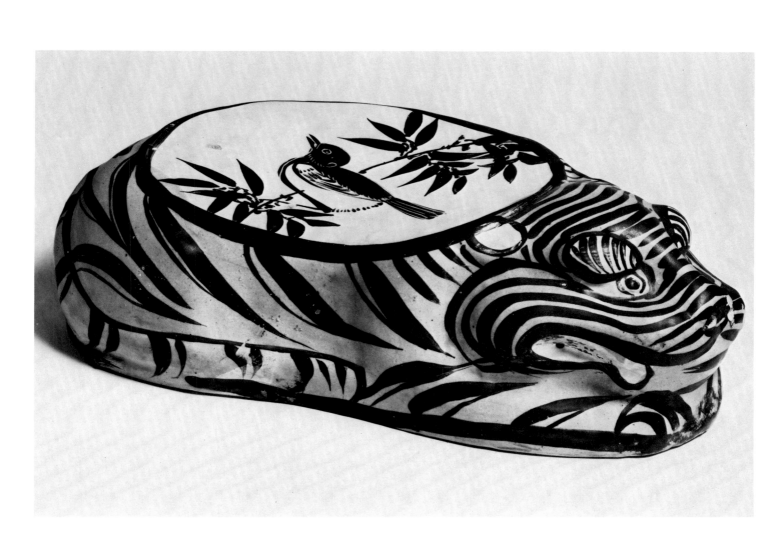

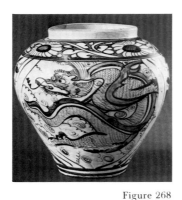

Figure 268

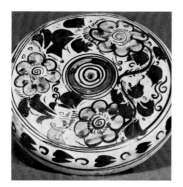

Figure 269

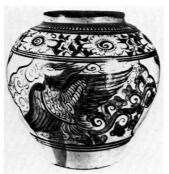

Figure 270

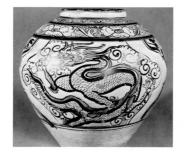

Figure 271

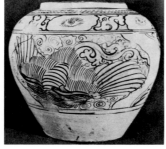

Figure 272

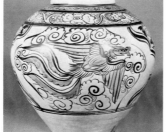

Figure 273

Plate 93
Kuan
Group 14
Yüan Dynasty, late 13th century
H. 11 in. (28.0 cm.)
The Cleveland Museum of Art, Purchase from the J. H. Wade Fund

Wide-mouthed jar with high rounded shoulder and nearly straight sides tapering to a recessed flat base. Buff stoneware with white slip and transparent glaze. Painted underglaze decoration in brown and black iron pigments; a large dragon among spiraling waves on one side and a phoenix in flight among clouds on the reverse, both enclosed in pairs of large parentheses; floral patterns in the spandrels. Above, encircling the shoulder, a band of large flowers with cross-hatched centers and rounded leaves on a ground of cross-hatching.

Published: James M. Plumer, "The Potter's Art at Cleveland, *American Magazine of Art*, (April, 1940), p. 214; Cox, *The Book of Pottery and Porcelain*, fig. 372; Hollis, "More Chinese Stoneware of the Yüan Dynasty," pp. 159-60; Lee, *A History of Far Eastern Art*, p. 398, fig. 524; Lee and Ho, *Chinese Art Under the Mongols*, pl. 45; and Lee, *The Colors of Ink*, pl. 63.

A jar with nearly identical ornament is in the Los Angeles County Museum (Fig. 268; Reg. no. 53.74). A similar jar, with the dragon facing on the opposite direction, its mouth open, was excavated beneath the wall of the Yüan capital of Ta-tu in Peking (Fig. 269; *KK*, 1973, no. 5, pl. 8:2). A phoenix swooping downward in its flight, surrounded by clouds, appears on a closely related piece found in the Tung-ch'eng district of Peking in 1972 (Fig 270; *Chuka jinmin kyowakoku shutsudo bunbutsu-ten*, Tokyo 1973, pl. 228). These jars were probably produced at the Ho-pi-chi kiln site. A floral scroll band with flowers resembling those on a cover of a vessel that was found at Ho-pi-chi (Fig. 271; *WW*, 1964, no. 8, pl. 3:12) appears around the shoulder of a *kuan* that was sold in an auction in 1973 (Fig. 272; *Fine Chinese Ceramics and Works of Art*, Sotheby and Co., March 13, 1973, no. 130). The flowers have spiraling centers surrounded by small radiating lines and pointed black leaves on thin, scrolling stems. While the flowers on the excavated cover are painted brown, those on the *kuan* are white. The knobbed scrolls of the tail of the phoenix are very similar to those on the jar found in Tung-ch'eng, Peking. Possibly an earlier example, another jar, in a private collection in Japan, has more conventional-looking representations of the dragon and phoenix, smaller in scale and less tightly crowded into their ornamental spaces (Fig. 273). Almost the entire dragon is visible, and the tail feathers of the phoenix trail freely behind it. Around the shoulder are four-petaled flowers and scrolling stems, and at the base of the neck is a narrow border of classic scrolls.

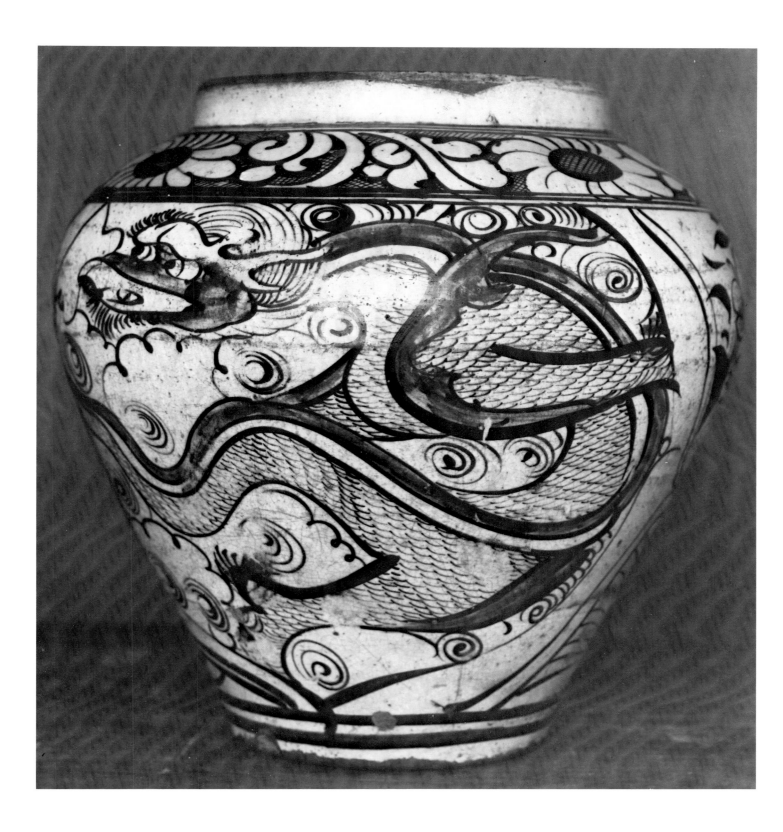

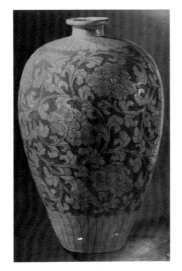

Figure 274

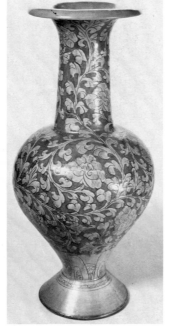

Figure 275 Figure 276

Plate 94
Mei-p'ing
Group 15
Northern Sung Dynasty, late 11th—early 12th centuries
H. 15 3/4 in. (40.0 cm.)
British Museum

Vase with long ovoid body, flattened shoulder, small cylindrical neck with flattened mouth rim; small, recessed flat base. Buff stoneware covered with white slip and transparent, colorless glaze under green lead glaze. Sgraffiato decoration in white slip under the glaze: graceful peony scrolls covering most of the body, the petals of the blossoms marked with finely combed striations; narrow, overlapping petals around the shoulder and base.

Published: Hobson, *Chinese Pottery and Porcelain*, pl. 32, fig. 2; Hobson, *Catalogue of the George Eumorfopoulos Collection*, no. C 388, pl. LXIII; London, Royal Academy of Arts, *International Exhibition of Chinese Art*, 1935-36, no. 1233, pl. 121; Gray, *Early Chinese Pottery and Porcelain*, color plate B; Oriental Ceramic Society, "The Ceramic Art of China," no. 88, color plate B; Wirgin, Sung Ceramic Designs," pl. 49:c; Hasebe, ed., *Chugoko Bijutsu* (Chinese Art in Western Collections) vol. 5, Tokyo, 1973, pl. 27; and *Oriental Ceramics: the World's Great Collections*, vol. 5, British Museum, (Tokyo, 1976), pl. 30.

Made from the late eleventh through the thirteenth centuries, the green lead-glazed wares are decorated under the glaze in a variety of techniques that are closely related to those used on contemporary Tz'u-chou type wares of other Groups. The green glaze may be applied directly on the white slip or over a previously fired transparent, colorless glaze.

The large *mei-p'ing* from the British Museum is one of the most impressive examples of this group. In technique and style of decoration, it is similar to the sgraffiato wares of Group 9. A *mei-p'ing* with almost identical ornament under a transparent, colorless glaze was found in T'ang-yin-hsien, Honan (Fig. 274; *Hsin Chung-kuo ch'u-t'u wen-wu*, pl. 174). Finds of sherds from the Kuan-t'ai kiln site that are decorated with a similar sgraffiato peony pattern in black and white indicate that these vases, too, are likely to have been made at the same site (Fig. 275; *WW*, 1964, no. 8, pl. 6:1). Green glazed wares are also known to have been produced at Kuan-t'ai.

Another vessel with the same style of ornament is a large *tsun*-shaped vase in the Idemitsu Art Gallery (Fig. 276; Koyama, *So*, pl. 83). The peony scrolls cover the nearly globular body and long, cylindrical neck. Around the sharply tapered, small base is a row of incised lotus petals and on the widely flaring, conical foot is narrow band of incised scrolling lines.

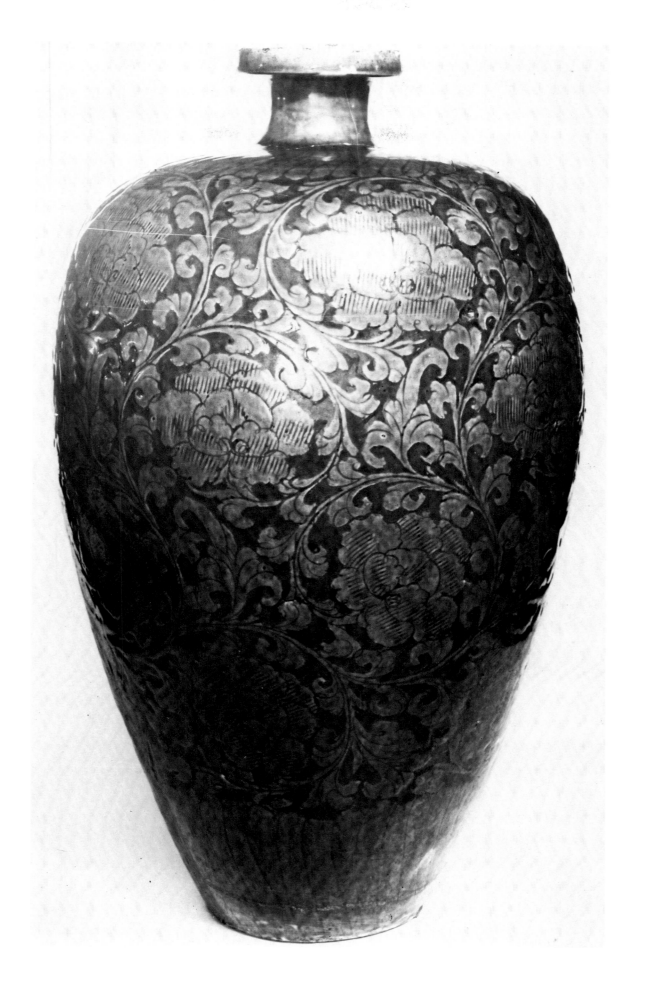

213

Plate 95
Vase
Group 15
Chin Dynasty, 12th century
H. 8-1/8 in. (20.6 cm.)
D. 3-3/4 in. (9.5 cm.)
Fogg Art Museum, Harvard University, Gift of Ernest B. and Helen P. Dane

Tsun-shaped vase with long, nearly cylindrical neck widening to a trumpet-shaped mouth; ovoid body with high shoulder tapering toward a small base; widely flaring conical foot and recessed flat base. Brick-red stoneware covered with white slip and transparent glaze under green lead glaze. Painted and incised decoration in dark brown iron pigment of two lotus sprays with round central blossom and large leaves at the sides.

Not previously published.

Underglaze painted and incised decoration appears with green glaze primarily on *tsun* vases with trumpet-shaped mouth and conical foot. The motif represented most frequently is the peony spray with long slender leaves like those seen on a sherd from Tung-ai-k'ou (see Fig. 246). Examples of *tsun* vases with such decoration can be seen in several Japanese collections, one of which is illustrated here (Fig. 277), and another in the Burrell collection at the Camphill Museum, Glasgow (Fig. 278; Reg. no. 38/199). On the Burrell piece and, more clearly on a vase formerly in the Hsi Hsi-chung collection in Peking (Nils Palmgren, *Sung Sherds,* Stockholm, 1963, p. 227, fig. 9), the green glaze appears to have been applied directly over the painting and, in running during firing, has caused the black pigment to streak. On most other examples of this type, however, the green lead glaze is applied over the transparent stoneware glaze.

Figure 277

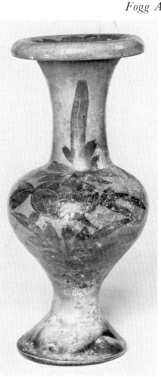

Figure 278

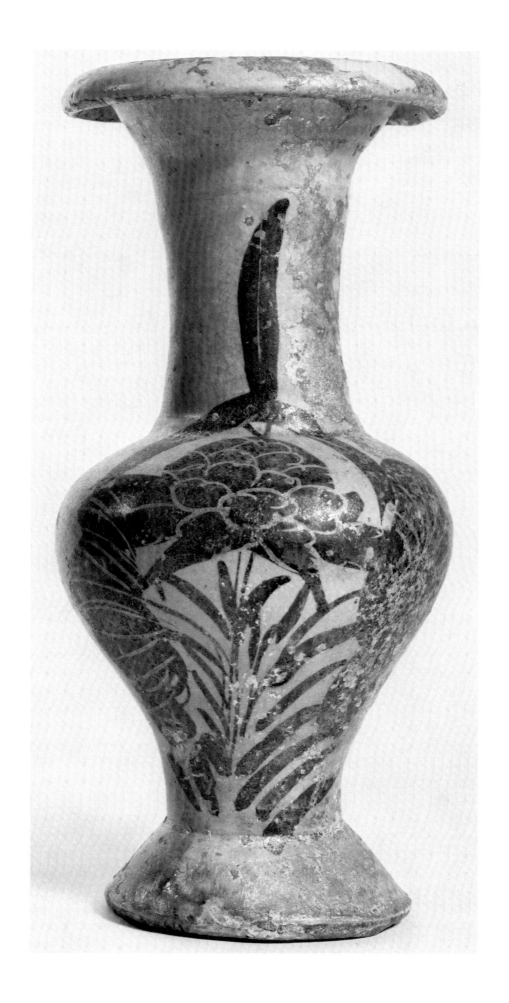

215

Figure 279

Plate 96
Vase
Group 15
Chin Dynasty, 12th century
H. 13-1/4 in. (33.6 cm.)
Indianapolis Museum of Art, Gift of Mr. and Mrs. Eli Lilly

Tsun-shaped vase with nearly globular body, long neck and widely everted mouth and undulated rim; high flaring foot and small base. Buff stoneware covered with white slip and transparent colorless glaze under irridescent green lead glaze. No decoration.

Published: *Chinese Ceramics*, (Los Angeles, 1952), pl. 79.

An identical piece is in the Cleveland Museum of Art (Reg. no. 42.656), and a very similar piece with amber yellow glaze was unearthed from a tomb believed to be of the Sung Dynasty at Chai-kou-ts'un near T'ai-yüan, Shansi Province (Fig. 279; *KK*, 1965, no. 1, p. 26, pl. 7:8).

216

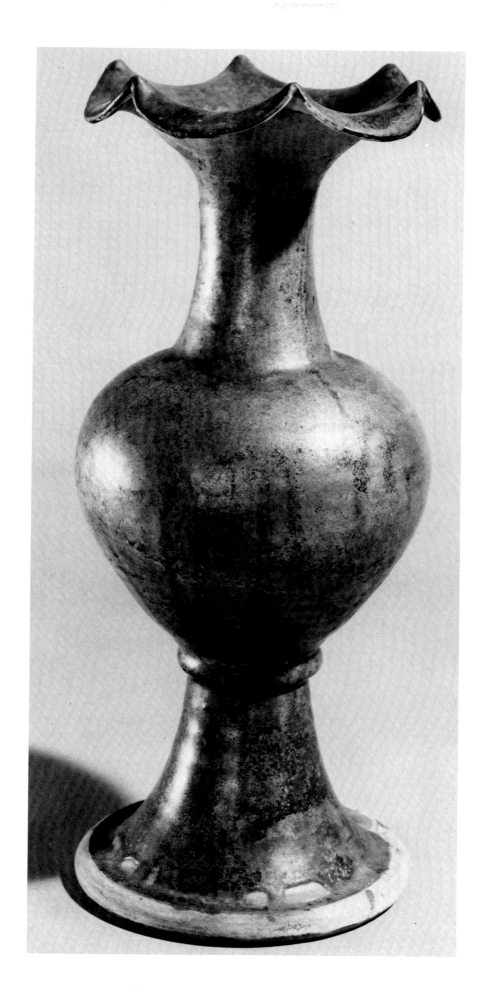

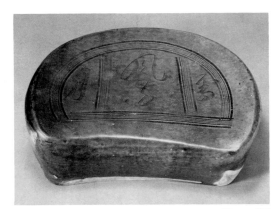

Figure 280

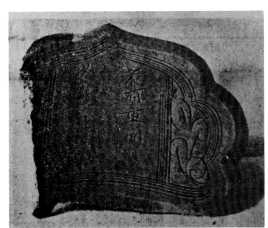

Figure 281

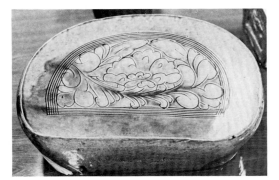

Figure 282

Plate 97
Pillow
Group 15
Chin Dynasty, 12th century
H. 4-1/4 in. (10.5 cm.)
L. 11-1/2 in. (29.5 cm.)
Fogg Art Museum, Harvard Universit, Gift of C. Adrian Rübel

Bean-shaped pillow with concave, forward-sloping top surface. Buff earthenware covered with white slip and green lead glaze stopping short of the base. Incised and combed decoration on the top: an incised inscription, framed and divided into three panels by combed lines. Two characters in each of the end panels, *feng hua* or "wind, flower" on the right, and *hsüeh yüeh* or "snow, moon" on the left. The verses in the middle panel have been translated as follows, "Butterflies fluttering through the willow path seem like pieces of jade seen through mist. Orioles sitting among pomegranate flowers appear like golden, yellow flames." (From Paine, "Chinese Ceramic Pillows," no. 11, p. 902.)

Published: Paine, "Chinese Ceramic Pillows," pl. 6 no. 11.

Pillows represent by far the largest sub-group of the green glazed wares. They are made in two principal shapes, bean-shaped and rectangular, and may be decorated with either incised and combed designs or with stamped and molded decoration. The bean-shaped pillows with incised and combed designs are a distinct type to which the example in the Fogg Museum of Art belongs. Another bean-shaped pillow that has the character *feng hua hsüeh yüeh* written in the three panels on the top, but without any other inscription, is in a Japanese collection (Fig. 280). A green cloud-shaped pillow with similarly combed border and three panels on the top was unearthed from the site of an old town in Feng-t'ai, Anhui (Fig. 281; *WW*, 1965, no. 10, p. 52, figs. 17 and 18). A poem, that can be translated as follows: "Flowers can bloom again another day , but man has no second youth," is written in the central panel, and incised leaf designs fill the side panels.

The key to the dating of these pillows is a bean-shaped pillow with green glaze, a large incised peony spray inside the combed border and an inscription written in ink on the base that includes the date 1156 A.D. (Fig. 282; *Tokyo National Museum Catalogues*, pl. 299). Two similar examples decorated with incised peony sprays are in the Royal Ontario Musuem.

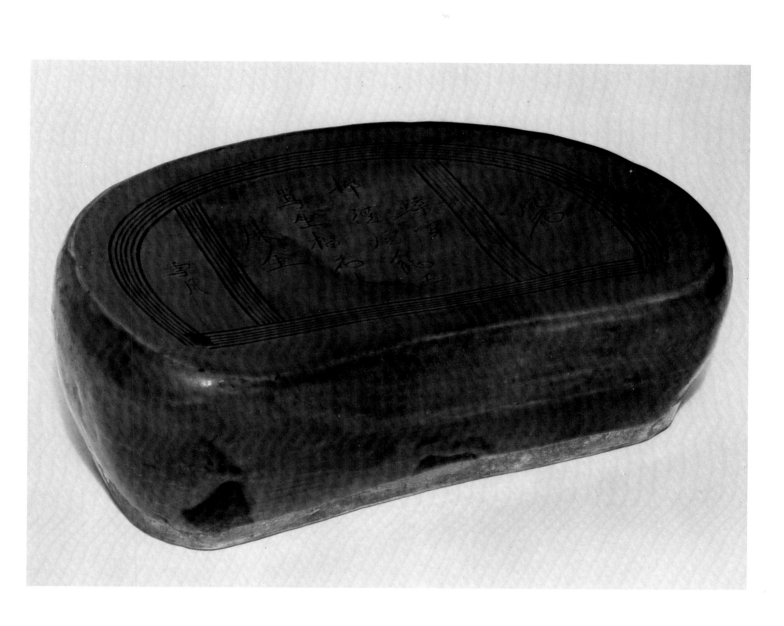

Plate 98
Incense Burner
Group 16
Yüan Dynasty, 14th century
H. 6-1/4 in. (16.0 cm.)
D. 6-1/2 in. (16.5 cm.)
Collection of Mrs. Josephine Knapp, Washington, D.C.

Tripod vessel with depressed globular body, wide cylindri-cal neck and flattened everted mouth rim; two upright, rec-tangular handles attached to the base of the neck and to the mouth rim; three small, tapering legs attached to the bottom of the body. Buff earthenware covered with white slip and turquoise glaze. Painted underglaze decoration in black iron pigment: flowers and feathery patterns around the body and scrolling lines on the neck, all executed in a highly cursive style. Molded floral design on the base.

Not previously published.

Tz'u-chou type wares with turquoise glaze are decorated with painted underglaze patterns in black, iron pigment, some of which resemble those seen on the painted wares of Group 12. They were produced from the late thirteenth to the sixteenth centuries, dur-ing which time two principal sub-groups of wares appeared, an earlier one of Yüan Dynasty date and a later one of the middle of the Ming.

An incense burner very similar in shape to the one in the collec-tion of Mrs. Knapp was found in a tomb at Pei-yü-kou, Wen-shui-hsien in Shansi Province (Fig. 283; *KK*, 1961, no. 3, p. 136, fig. 1) along with two *mei-p'ing* of typically Yüan Dynasty shape. Another tripod resembling the Knapp piece is depicted in a wall painting of a group of vessels in the Chin Dynasty tomb excavated at Li ts'un-kou, Ch'ang-chih, Shansi (Fig. 284; *KK*, 1965, no. 7, pl. 7:3).

A nearly identical incense burner can be seen in the Freer Gal-lery of Art (Reg. no. 07.53) and a similar example, also with tur-quoise glaze and underglaze painting, is in the Victoria and Albert Museum (Reg. no. C94-1910).

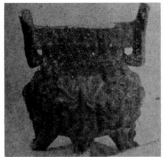

Figure 283 Figure 284

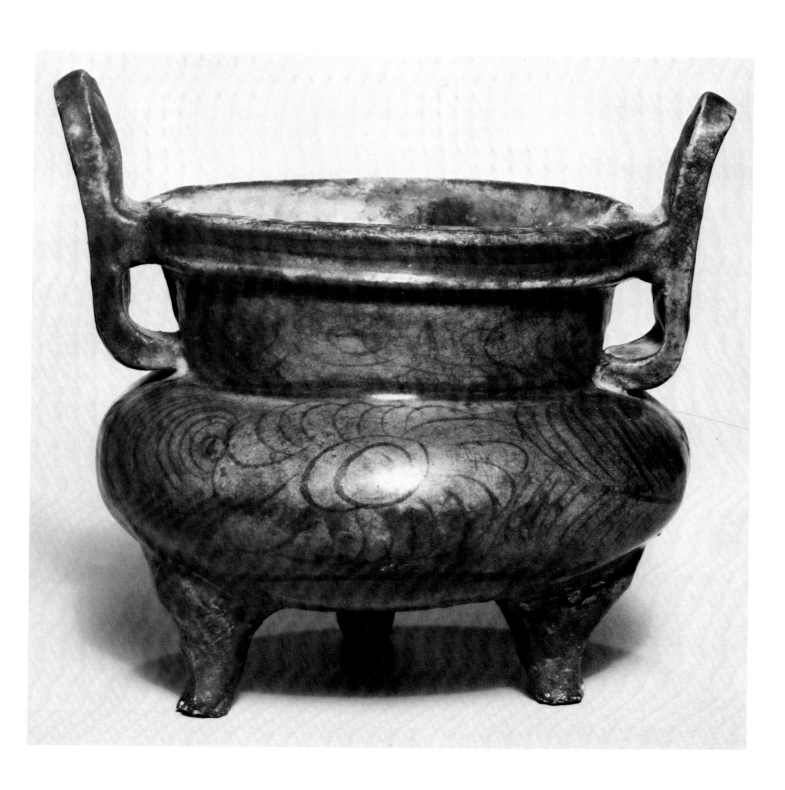

221

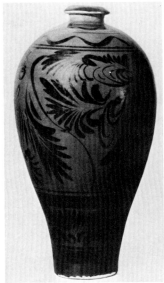

Figure 285

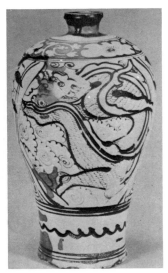

Figure 286

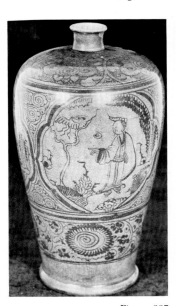

Figure 287

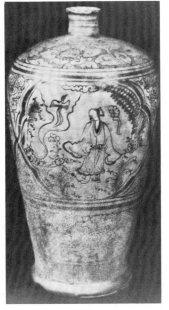

Figure 288

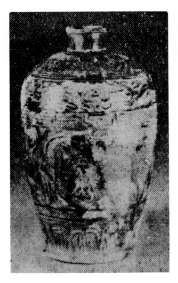

Figure 289

Plate 99
Mei-p'ing
Group 16
Ming Dynasty, 16th century
H. 10-1/2 in. (26.8 cm.)
Fogg Art Museum, Harvard University, Bequest of Helen Pratt Dane

Vase with high shoulder, small neck and slightly everted mouth rim; splayed foot and recessed, flat base. Buff earthenware covered with white slip and turquoise glaze. Painted underglaze decoration in black iron pigment in three principal bands around the body: in the wide central band, large stylized peonies with scalloped petals, each having a dark streak in the middle, and scrolling stems and leaves on a ground of hatched lines; floral scrolls around the shoulder, also on a hatched ground. In the lower band, chrysanthemum-like flowers with large spiraling centers and curling leaves.

Not previously published.

Mei-p'ing like this example in the Fogg Museum represent the latest stage in the development of *mei-p'ing* with turquoise glaze. The earliest example, and also the earliest known Chinese vessel of any shape to have a turquoise-colored glaze, is a *mei-p'ing* in the Palace Museum, Peking, that is decorated with painted fan-like leaves similar in style to those on some Chin Dynasty wares from *Yü-hsien (Fig. 285; Ku-kung po-wu-yüan ts'ang-tz'u hsüan-chi*, Peking, 1962, pl. 37). An example of the Yüan Dynasty, a *mei-p'ing* decorated with a dragon among clouds in a style closely resembling that on the *kuan* with black and brown painting from the Cleveland Museum of Art (see Pl. 93), is in a Japanese collection (Fig. 286; *Sekai tōji zenshū*, vol. 11, 1956, pl. 135). On it the turquoise glaze has largely fallen off and still clings to the vessel only in a few patches.

Most other *mei-p'ing* with turquoise glaze belong to the later sub-group and can be assigned to the sixteenth century. Chrysanthemum-like flowers around the lower part of the Fogg *mei-p'ing* are very similar to those on the jar dated 1540 from the Johnson Art Museum at Cornell University (see Pl. 84). The narrow band of cloud-like scrolling lines also appears on the Johnson Museum jar. Chrysanthemums with spiraling centers can be seen on a *mei-p'ing* of similar shape that is in the Lowe Art Museum at the University of Miami (Fig. 287; Reg. no. 58.286.000). The floral scrolls around the shoulder of this piece, too, are very similar to those on the Fogg *mei-p'ing*. In the central band are three ogival panels in which are small illustrations. In one a man stands looking at a bird floating upward in a cloud, a subject that appears on another *mei-p'ing* with turquoise glaze that is in the collection of Ruth Dreyfus (Fig. 288; Lee and Ho, *Chinese Art Under the Mongols*, pl. 50). Related pieces, all of similar shape with the small mouth and splayed foot, can be seen in the Museum of Fine Arts, Boston, the collection of Mr. and Mrs. Myron Falk, and the Victoria and Albert Museum (Honey, *The Ceramic Art of China and Other Countries of the Far East*, pl. 75(a)).

Three *mei-p'ing* of the same shape were excavated from the site of a Ming city at Hui-fa-ch'eng in Chi-lin Province of which two are illustrated here (Fig. 289; *WW*, 1965, no. 7, p. 42, figs. 17 and 18).

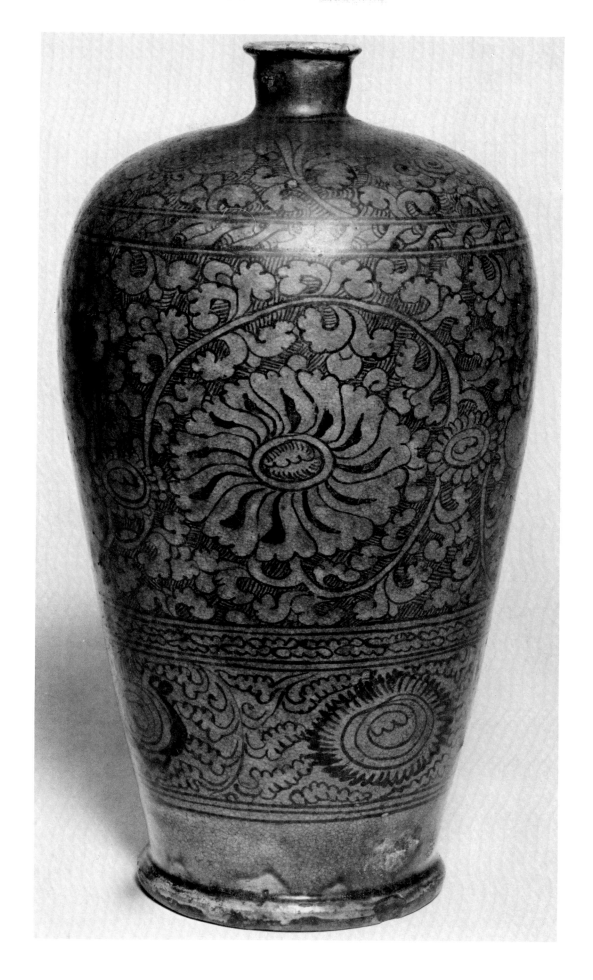

Plate 100
Pillow
Group 17
Chin Dynasty, 12th—13th centuries
H. 4-7/8 in. (12.5 cm.)
L. 15-3/8 in. (39.0 cm.)
Buffalo Museum of Science

Bean-shaped pillow with concave, forward sloping top surface. Pinkish earthenware covered with white slip and green, amber-yellow and colorless lead glazes stopping less than halfway down the sides. Incised, combed and scraped decoration on the top: sgraffiato lotus plants on a ground of knobbed scrolls in the central field on the top within a combed border, the lotus blossom white, the leaves green and the scrolls yellow; incised classic scroll patterns in four groups in the outer border. Around the sides, a band of sketchily incised leaf scrolls.

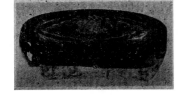

Figure 290

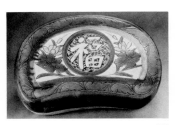

Figure 291

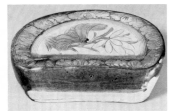

Figure 292

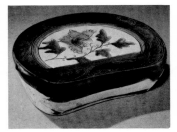

Figure 293

Figure 294

Figure 295

Figure 296

A large sub-group of the three-color lead glazed wares comprises only pillows, primarily bean-shaped, that are decorated with incised and sgraffiato designs. These generally have a combed border on the top, set in somewhat from the edge, that marks off a central ornamental field. This feature appears, also, on the closely related bean-shaped pillows with monochrome green glaze (Group 15), an example of which, decorated with an incised peony, is dated 1156 A.D. (see Fig. 282).

A bean-shaped pillow with three-color glaze was excavated from a tomb in Loyang (Fig. 290; *KK,* 1960, no. 10, p. 12, fig. 4), a tomb assigned to the Sung Dynasty on the basis of the presence of Sung coins. The pillow is decorated with a peony in an ogival panel on the top. A very similar pillow, in the Royal Ontario Museum, has a peony in a central ogival frame with knobbed scrolls around it (Reg. no. 918.21.501). A pillow that is similar in style and technique of decoration to the Buffalo pillow is in a Japanese collection (Fig. 291). With a large character *fu,* meaning "happiness," on a ground of knobbed scrolls in a circular medallion and lotus plants at either side of it, it is, like the Buffalo pillow, quite impressive in its detail and coloring. Around the outer edge is a band of incised scrolling leaves, a motif appearing on many of these pillows. Examples in the Idemitsu Art Gallery and the Philadelphia Museum of Art display a sgraffiato treatment of the leaf scroll border, while the central motifs are incised on a plain white ground. The Idemitsu pillow has a lotus spray in the central field (Fig. 292; Reg. no. B2462), and the Philadelphia piece is decorated with a peony spray (Fig. 293; Reg. no. 57-26-7). The peony and the lotus are the two most common motifs on these pillows. Human and animal figures are comparatively rare. A very unusual piece is charmingly decorated with a woman reclining on a couch in a garden and reading a book (Fig. 294; Ch'en Wan-li, *T'ao-chen,* pl. 4). A pillow in a Japanese collection has a heron standing among lotuses, looking upward at two birds flying in the distance, within a plain outer border (Fig. 295). A simplification of the scrolling leaf border appears to have occurred over time that resulted, finally, in its elimination. The use of the sgraffiato technique, in both the border design and in the central ornament, seems to be restricted to the earlier examples of this type.

These pillows cannot be assigned with certainty to any particular kilns. A cloud-shaped pillow with three-color glaze and incised peony spray decorating the top was found at the Pa-ts'un kiln site in Yü-hsien (Fig. 296; *WW,* 1964, no. 8, p. 35, fig. 18). Three-color wares are reported also to have been excavated at kilns in Kuan-t'ai in Han-tan-hsien (*WW,* 1964, no. 8, p. 42) at Ch'ü-ho-yao in Teng-feng-hsien (*WW,* 1964, no. 3, p. 54), at Ch'ing-lung-ssu in Pao-feng-hsien (*WW,* 1951, no. 2, p. 52), and at Tang-yang-yü in Hsiu-wu-hsien (*WW,* 1952, no. 2, p. 56).

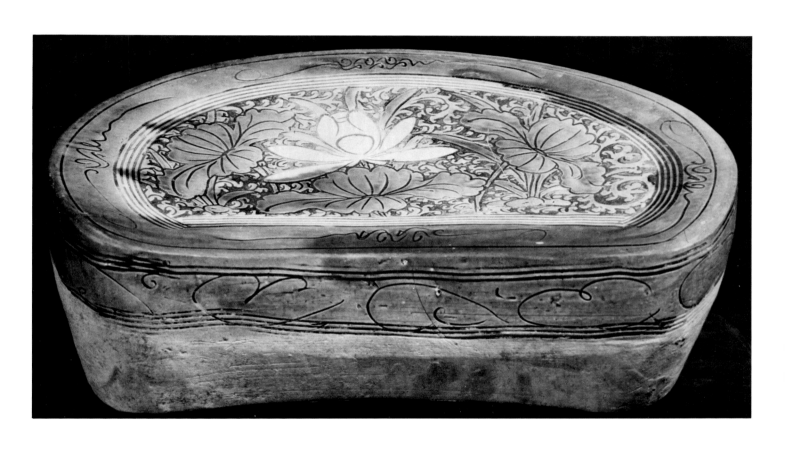

Plate 101
Bottle
Group 17
Chin Dynasty, late 12th—13th centuries
H. 12 in. (30.4 cm.)
Indianapolis Museum of Art, Gift of Mr. and Mrs. Eli Lilly

Pear-shaped bottle with long slender neck and everted mouth; low flaring foot and recessed flat base. Brick-red stoneware covered with white slip and green, yellow and colorless lead glazes. Incised and painted decoration of lotuses, the tips of the petals painted in iron brown pigment under the glaze, in the wide band around the body; a row of upright lotus petals around the base of the neck and two horizontal stripes of yellow around the neck.

Published: Indianapolis Museum of Art, *Newsletter,* (May/June, 1980), no pag.

A second sub-group of three-color glazed wares is decorated with incised and painted designs under the glaze. The painting on these wares is minimal, consisting of spots of brown or black pigment that provide emphasis to the incised patterns. The objects in the sub-group have a relatively hard, brick-red body and are made in the forms of pillows, dishes, pear-shaped bottle and *tsun*-vases. A *tsun*-vase that is unglazed but decorated with incised lotuses with painted petals clearly illustrates the techniques involved in the decoration—incising into the white slip, painting, and bisque firing—before the application of the glaze. A nearly identical ornament appears on a pear-shaped bottle in the Cincinnati Art Museum that has the three-color glaze (Fig. 297; Reg. no. 1950.50). The Indianapolis bottle is decorated with the same motif but is less deeply incised. Another similar piece is in the Freer Gallery of Art (*Oriental Ceramics: the World's Great Collections*, vol. 10, Tokyo, 1976, pl. 31). Bottles of this shape, with narrow body widening gradually toward the base, but with the mouth rim slightly rolled back, were excavated from the tomb of Yen Te-yüan, dated 1189 A.D. (see Fig. 200).

A small dish decorated in this manner with a rabbit, the brown spots marking the tops of the ears, the eye and the tail. is dated to the year 1269 by an ink inscription on the base. This piece, in the Tokyo National Museum, is very important in establishing the dating of this sub-group. (see Appendix A). A dish with very similar decoration is published in Henri Rivière's book of 1923 (Rivière, *La Céramique dans l'Art de l'Extrême-Orient,* vol. I, pl. 21).

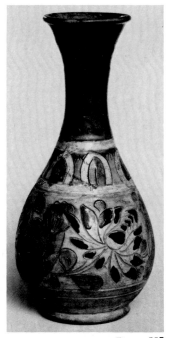

Figure 297

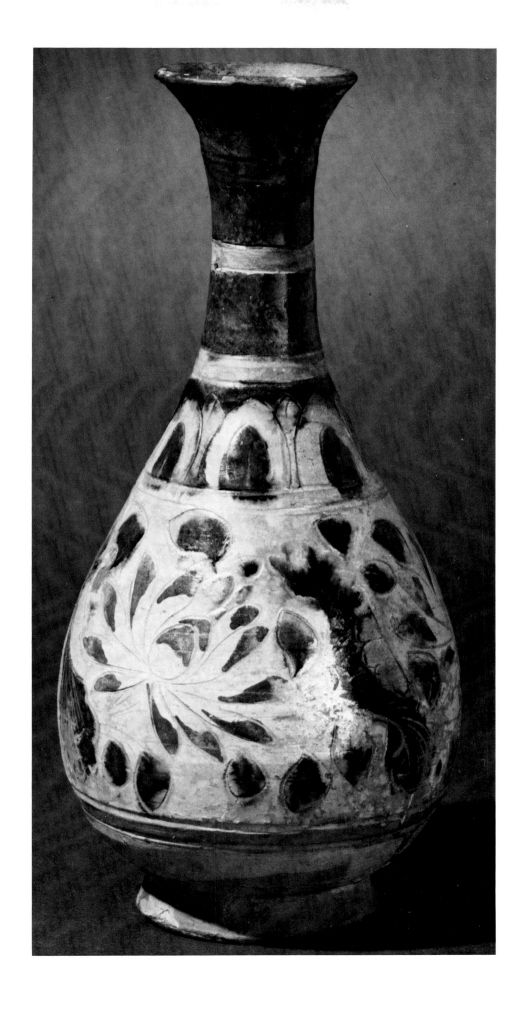

Figure 298

Figure 299

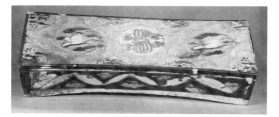

Figure 300

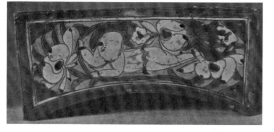

Figure 301

Plate 102
Pillow
Group 17
Chin Dynasty, late 12th—13th centuries
H. 4-9/16 in. (11.6 cm.)
L. 14-13/16 in. (37.5 cm.)
Buffalo Museum of Science

Rectangular pillow with curving front side and slightly concave top. Brick-red earthenware covered with white slip and green, yellow and colorless lead glazes stopping two-thirds of the way down the sides. Incised and painted decoration under the glaze: an infant boy among large lotuses on the top; bamboo leaves in a zigzag arrangement around the sides with a small flower bud in each triangular section thus marked off.

Published: Hochstadter, "Early Chinese Ceramics," pl. 100; and Wirgin, "Sung Ceramic Designs," pl. 52:f.

Nearly all the three-color pillows of this sub-group are rectangular in shape and are decorated on the sides with a bamboo leaf and flower bud pattern like that on the Buffalo Museum of Science pillow. This pattern can be seen, also, around the well of a small three-color glazed dish in the Victoria and Albert Museum with incised and painted rabbits in the center (Fig. 298). Here the small buds are represented as tightly curled flowers. On other pieces they are reduced to simple circles.

A rectangular pillow of this type was excavated from a tomb dated 1265 in Ch'ih-hsi-ts'un, Ch'ü-chiang, near Sian (Fig. 299; *WW*, 1958, no. 6, p. 61 and back cover, fig. 8). Displaying a rather unusual ornament, it has two long bamboo leaves on the top extending from the lower edge to the upper corners, filled with a knobbed scroll pattern. The lower corners are decorated with a four-leaf grid design. The incised motif in the upper part is not visible in the published illustration from the excavation report. Knobbed scrolls appear on other pillows of this sub-group, including one long example in a Japanese collection that has an exceptionally detailed ornament arranged in and around a number of circles on the top (Fig. 300). The three central circles enclose a double melon pattern and two ducks, respectively, and the knobbed scrolls fill the ground around them. The other circles, only partial ones, cut off at the edges of the pillow, are decorated with small floral sprays.

A pillow in the Tokyo National Museum has an infant among lotuses and other flowers incised and painted in a central rectangular panel on the top (*Tokyo National Museum Catalogues*, no. 326). More lotuses appear at either side. The motif of infant among lotuses can be seen, also, on a piece published by Henri Rivière, where it is drawn much more cursively and almost carelessly (Fig. 301; Rivière, *La Céramique dans l'Art d'Extrême-Orient*, vol. 1 pl. 21).

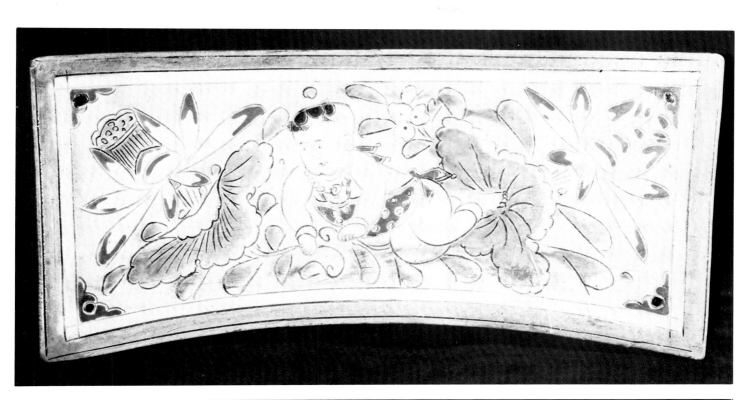

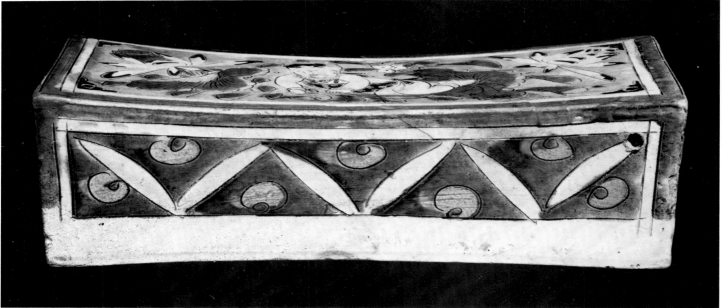

Plate 103
Pillow
Group 17
Chin Dynasty, 13th century
H. 3-3/4 in. (9.6 cm.)
L. 14-3/16 in. (36.0 cm.)
The Metropolitan Museum of Art, Gift of Mrs. Samuel T. Peters, 1926

Eight-sided pillow with concave top slightly overhanging the sides. Reddish earthenware covered with white slip and green, amber-yellow and colorless lead glazes. Sgraffiato decoration of an egret and duck in a lotus pond on the top; molded decoration around the sides: the back panel with a peacock, flowering plant and rock, the remaining sides with a floral lattice pattern.

Published: Suzanne G. Valenstein, *A Handbook of Chinese Ceramics*, (New York, 1975), pl. 55; and *Oriental Ceramics: the World's Great Collections*, vol. 12, The Metropolitan Museum of Art (Tokyo, 1977), color plate 19.

The third sub-group of three-color glazed ware comprises only pillows that are decorated with both sgraffiato and molded designs. Characteristic of this sub-group is the molded lattice pattern around the sides of the pillows, called by Wirgin the 'geometric fleur-de-lis' (Wirgin, "Sung Ceramic Designs," p. 110). The eight-sided shape of the Metropolitan Museum pillow, resembling a trapezoid on which the corners have been trimmed, is distinctive and the most common shape seen among these pillows, though rectangular and bean-shaped forms are known, also. A similar example, decorated with two geese on a bank, is in the former collection of the King of Sweden (Wirgin, *op. cit.* pl. 52:g).

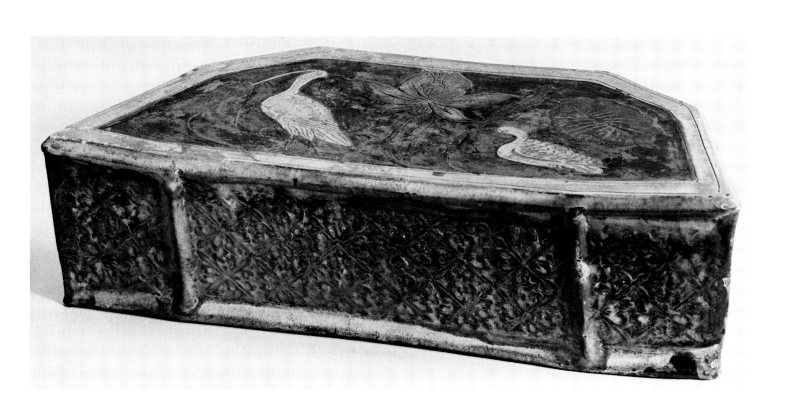

Plate 104
Pillow
Group 17
Chin Dynasty, 13th century
H. 3-1/2 in. (9 cm.)
L. 10 in. (25.3 cm.)
The Metropolitan Museum of Art, Rogers Fund, 1920

Rectangular pillow with concave top slightly overhanging the sides; the two end panels slanting inward toward the base. Brick red earthenware covered with white slip and green, amber and colorless lead glazes. Sgraffiato decoration of a large peony spray in an ogival frame on the top; Molded floral lattice pattern in relief on the sides.

Not previously published.

A very similar piece is in the Tokyo National Museum (Fig. 302; *Kizo Hirota*, pl. 37). A large peony spray also appears on the top of an eight-sided pillow in the Museum of Fine Arts, Boston (Wirgin, "Sung Ceramic Designs," pl. 52:h).

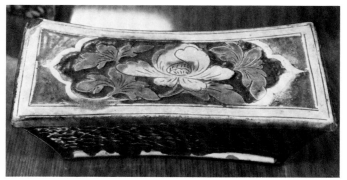

Figure 302

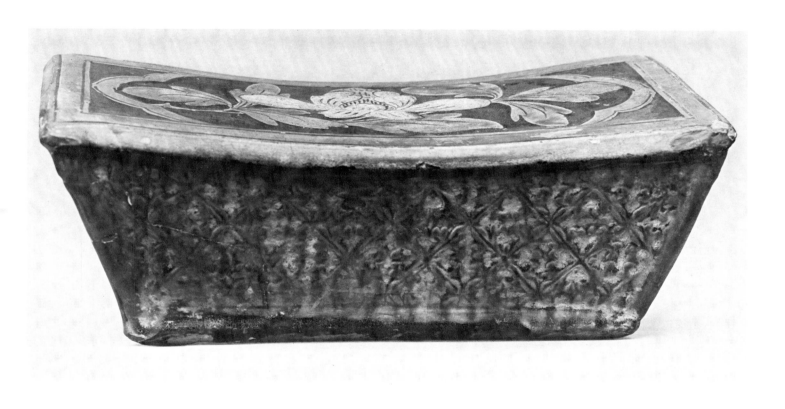

Plate 105
Bowl
Group 18
Chin Dynasty, dated 1201 A.D.
H. 1-9/16 in. (4.0 cm.)
D. 6-1/16 in. (15.4 cm.)
Tokyo National Museum

Figure 303 Figure 304

Figure 305 Figure 306

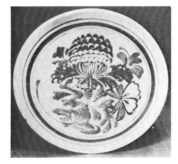

Figure 307 Figure 308

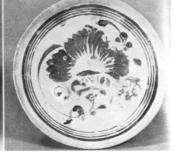

Figure 309

Shallow bowl with low foot and recessed flat base; buff stoneware covered with white slip and transparent glaze stopping well above the foot. Painted decoration in red, green and yellow overglaze enamels on the interior: a central peony spray outlined in red, the petals shaded red and the leaves marked with small hatched lines, the background filled in with green: a narrow border marked off in five equal segments by small hourglass shapes, each segment bisected lengthwise; mouth rim painted yellow. Inscription written in ink, on the exterior, around the foot: "Recorded the first year of the Tai-ho period, the 15th day of the second month," the year corresponding to 1201 A.D.

Published: Okuda, "So-yo akae wan nitsuite," no pag.; *Sekai toji zenshu*, vol. 10, (1955), p. 237, fig. 138; *Tokyo National Museum Catalogues*, pl. 307; Koyama, *So.*, pl. 86; and Medley, *Yüan Porcelain and Stoneware*, pl. 101A.

Enamel-painted wares of Tz'u-chou type were made almost exclusively in the thirteenth century. They have been discovered at five kiln sites, as reported by Feng Hsien-ming. These include the kilns at Ho-pi-chi, Pa-ts'un and Ch'ü-ho-yao in Honan Province, Pa-i-chen in Kao-p'ing-hsien, Shansi Province, and Te-chou in Te-hsien, Shantung Province (Hasebe, *Jishuyo*, p. 103). Owing to the lack of published materials on these kiln sites, however, it is not possible to classify these wares according to place of manufacture. Another factor contributing to this difficulty is the similarity among the enamel-painted wares, most being bowls with a low foot and all decorated with the colors red, yellow and green. Nevertheless stylistic variations are apparent in the ornament of the pieces that are known.

Numerous examples of the enamel-painted wares are decorated by the technique of painting first in red outlines and then filling the areas in and around them with red, yellow and green. Two bowls of this type that are dated 1201 are known, of which the Tokyo National Museum bowl is one, and they appear to be among the earliest examples of wares with enamel-painted decoration. The second dated bowl, in the Ataka collection, is decorated with a duck in flight, carrying in its bill a large floral spray (Fig. 303; *Sekai toji zenshu*, vol. 10, 1955, pl. 122). The inscription on the bottom is precisely the same as that on the Tokyo National Museum piece. A third bowl, nearly identical to the latter in the design and style of its peony motif, can be considered contemporary, if not actually attributable to the same hand (Fig. 304; *Sekai toji zenshu*, vol. 10, 1955, pl. 123). All three are precisely painted with sharp, crisp outlines, and all have the same border pattern with segments of a circle marked off by small hourglass shapes. Other bowls of this type display a relaxation of the painting style. Instead of the segmented border, most have a solid red band with rows of green or yellow dots spaced around it. A bowl painted in this freer style with a duck on a pond is in the Tokyo National Museum (Fig. 305; Hasebe, *Jishuyo*, pl. 18). Another, decorated with a large peony, is in the Idemitsu Art Gallery (Fig. 306; Reg. no. B 1737). A related example decorated with a lotus spray also appears in this exhibition (see Pl. 106). In addition to the bowls, other types of vessels exhibit this style of decoration. Two small jars with wide mouth and splayed foot are known that have peonies and lotuses outlined in red and filled in with red and green enamels. One is in the Yamato Bunkakan (Hasebe, *Jishuyo*, pl. 84) and the other was formerly in the collection of Mrs. Alfred Clark (Fig. 307;

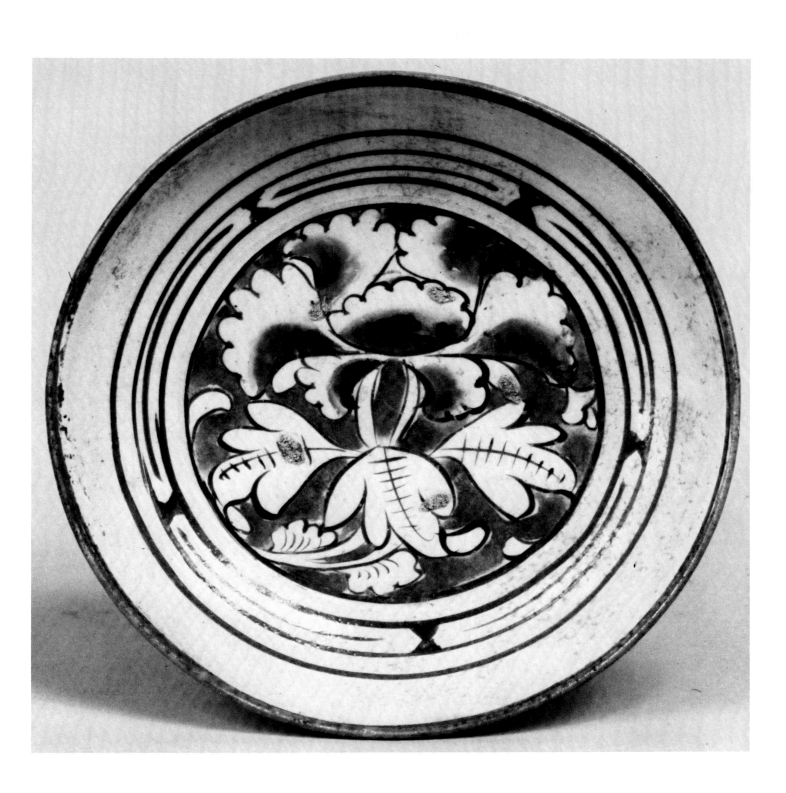

Catalogue of Important Chinese Ceramics, Sotheby and Co., London, March 25, 1975, no. 18).

Peonies depicted by rows of wavy lines, resembling the scalloped edges of the peonies on the Clark jar but not filled in with color, appear to be a late stylistic stage within this development. Such peonies can be seen together with a smaller flower that is painted in red outlines on bowls in the Fitzwilliam Museum (Fig. 308; Wirgin, "Sung Ceramic Designs," pl. 56:d), the British Museum (*Ibid.,* pl. 56:e), the Victoria and Albert Museum, and in a private collection in Japan (*Sekai toji zenshu,* vol. 10, 1955, p. 238, fig. 140).

In another style of enameled decoration, flowers are not painted in outline but the petals rendered with quick, narrow brush strokes that are rounded at one end and pointed at the other. A representative bowl decorated in this style and dated to the year 1230 A.D. by an ink inscription on the base is in the Tokyo National Museum (Fig. 309; Hasebe, *Jishuyo,* pl. 103, fig. 31).

Plate 106
Bowl
Group 18
Chin Dynasty, 13th century
D. 6-3/16 in. (15.7 cm.)
The Art Institute of Chicago

Shallow bowl with low foot and recessed flat base. Buff stoneware covered with white slip and transparent glaze stopping well above the foot. Painted decoration in red, green and yellow overglaze enamels on the interior: a lotus flower and leaves outlined in red on a green ground; bordered by thin red lines and a wider band of red on which are painted rows of yellow dots.

Published: Wirgin, "Sung Ceramic Designs," pl. 56:f.

A very similar bowl is in the collection of the Gemeentemuseum, The Hague (Beatrice Jansen, *Chinese Ceramiek,* Haags Gemeentemusuem, 1976, pl. 116).

Lotuses painted in a style closely resembling that on the Chicago bowl appear on the walls of the Chin tomb found at Li-ts'un-kou, Ch'ang-chih in Shansi (see Fig. 80).

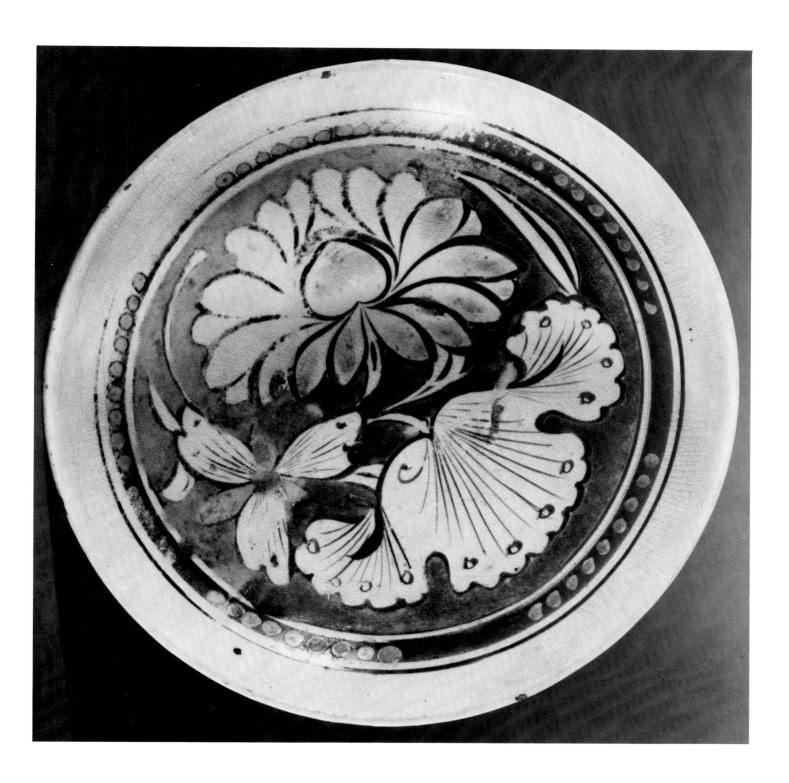

Plate 107
Ewer
Group 19
Five Dynasties Period, 10th century
H. 8 in. (20.3 cm.)
Collection of Hans and Gretel Popper, San Francisco

Ewer with ovoid body, short wide neck and flattened everted mouth rim; a thick double-strand handle on the shoulder opposite a short ribbed spout, and two small double loops between them; low flaring foot and flat base. Buff stoneware with white slip and light brown glaze stopping unevenly above the foot. Rouletted design of small dots in close horizontal rows around the body. Spout repaired.

Published: d'Argencé, *The Hans Popper Collection of Oriental Art*, (San Francisco, 1973), pl. 61.

Ewers like the one in the Popper collection and the one in the collection of Dr. Singer (see Pl. 108) make up one of the two sub-groups of Group 19, the wares with brown glaze over white slip. They appear to have been manufactured only in the tenth century, while the wares of the second sub-group were made in the twelfth century.

A ewer similar in shape and decoration to the example in the Popper collection is in the Staatliche Museum in Berlin (*Musum für Ostasiatische Kunst*, Berlin, Berlin-Dahlem, 1970, pl. 54). It, too has a widely everted mouth but no small double loops on the shoulder. A piece with squatter rounded body and trumpet-shaped neck is in the Victoria and Albert Museum (Oriental Ceramic Society, "The Ceramic Art of China," pl. 27, no. 39). The body is impressed with a design resembling woven matting, rows of small, oblique, cross-hatched lines made, also, by a roulette. A sherd, covered with brownish yellow glaze and decorated in the same manner was found at a kiln site in Chia-hsien (*WW*, 1965, no. 9, p. 32, fig. 1:5). Sherds with both types of rouletted patterns, the dots and the crosshatched lines, were found at the site of Ch'ing-ho-hsien (Nils Palmgren, *Sung Sherds*, Stockholm 1949, p. 285).

In shape, these ewers with the rounded body and widely everted mouth are similar to ewers of Huang-tao ware, the black-glazed ware known to have been made, also in Chia-hsien, during the T'ang Dynasty.

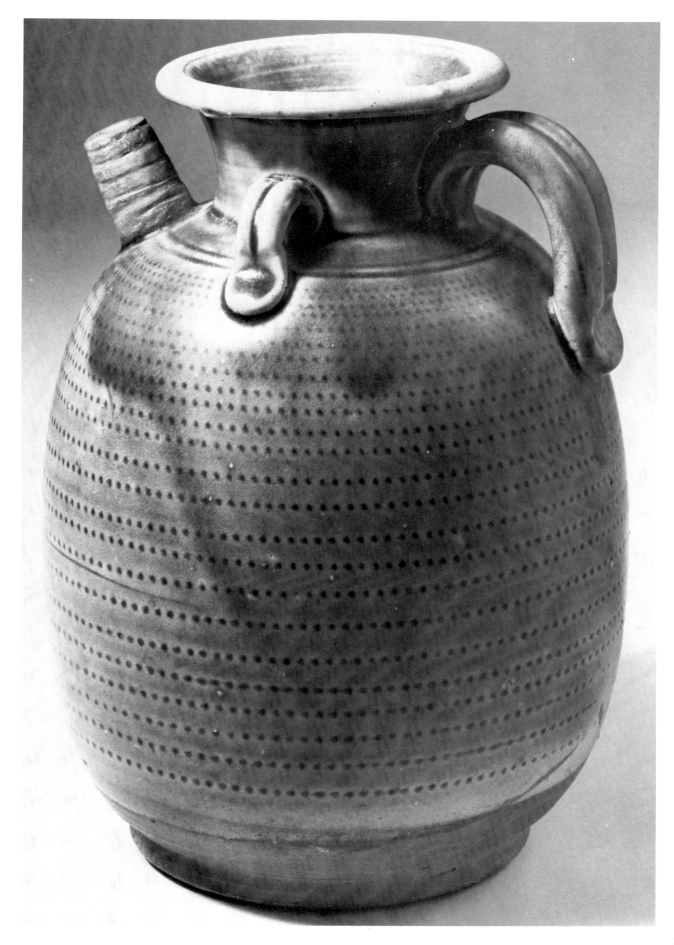

239

Plate 108
Ewer
Group 19
Five Dynasties Period, 10th century
H. 6-5/16 in. (16.0 cm.)
D. 4-5/16 in. (11.0 cm.)
Collection of Dr. Paul Singer

Ewer with ovoid body, straight-sided neck widening toward the slightly everted mouth rim; a thick double-strand handle on the shoulder opposite a short ribbed spout, and two small double loops between them; wide flat base. Buff stoneware covered with white slip and olive brown glaze stopping well short of the base. Rouletted design of oblique, crosshatched lines resembling woven matting in horizontal rows around the body.

Not previously published.

A slightly smaller piece of the same shape is also in the collection of Dr. Singer. Other ewers with straight-sided neck and slightly everted mouth rim but more elongated body can be seen in the Royal Ontario Museum (Mino, *Pre-Sung Dynasty Chinese Stonewares in the Royal Ontario Museum,* Toronto, 1974, p. 68), the Museum für Ostasiatische Kunst, Köln, and the Buffalo Museum of Science (Hochstadter, "Early Chinese Ceramics," pl. 30). While the ewers of more rounded shape show an affinity with Huang-tao ewers of the T'ang Dynasty (see Pl. 107), the more nearly cylindrical, taller ewers closely resemble Tz'u-chou type ewers of Group 1 (see Pl. 1) and Group 2 in their shape. Thus it would appear that the taller ewers are of slightly later date.

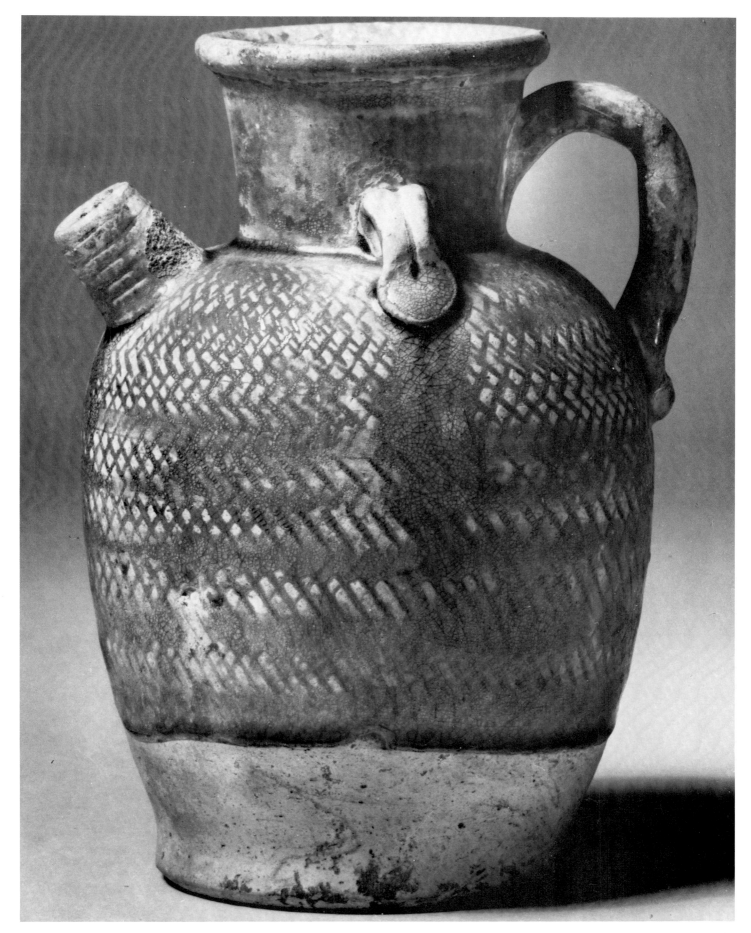

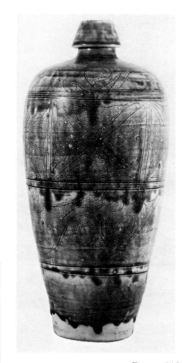

Figure 310

Plate 109
Mei-p'ing
Group 19
Chin Dynasty, 12th century
H. 16-7/8 in. (42.7 cm.)
Kyusei Hakone Art Museum

Vase with elongated ovoid body, high flattened shoulder, small neck and conical mouth; recessed flat base. Buff stoneware covered with white slip and brown glaze. Incised decoration in three horizontal bands around the body: floral scrolls in the upper and lower bands, leaf patterns in the middle; double horizontal lines below each band. Mouth repaired, not original.

Published: Watanabe, *Shina tojiki shi*, pl. 34; and Hasebe, *Jishuyo,* p. 17.

Brown-glazed wares of the second sub-group are decorated with incised patterns, sometimes in combination with combed and ring-stamped backgrounds. Vessels of this sub-group include *mei-p'ing* with a conical mouth like the example in the Hakone Art Museum, small jars and bowls.

The *mei-p'ing* are decorated with a variety of motifs. One, in the Staatliche Museum, Berlin, has a band of large quatrefoils between two bands of leaf scrolls around the body, all on a ground of difusely stamped 'fish-roe' (Fig. 310; *Museum für Ostasiatische Kunst,* Berlin-Dahlem, 1970, pl. 63). Another, in the Aso collection, Japan, has large 'interlocking cash' and floral designs in three horizontal bands, all on a vertically striated ground (Fig. 311; *Sekai toji zenshu,* vol. 10, 1955, pl. 115). A *mei-p'ing* with a meander band around the shoulder, a band of large leaves around the middle and overlapping petals around the base is in the Victoria and Albert Museum (Honey, *The Ceramic Art of China and Other Countries of the Far East,* pl. 65). All of these pieces, including the Hakone *mei-p'ing*, are of very similar shape and can be considered roughly contemporary. The glaze, lying on the white slip, tends to have a streaky appearance and varies in color from yellowish brown to dark brown.

The only example of a jar with brown glaze is a small covered *kuan* in the Tokyo National Museum that has incised decoration of upright leaves and overlapping petals in three horizontal bands (Fig. 312; *Kizo Hirota,* pl. 73).

A few bowls are known that are covered with a light brown glaze over rather deeply incised floral designs executed with a minimal number of fluid, curving lines. One example of this type was found at a kiln site in Yao-chou, T'ung-ch'uan-hsien, Shensi Province (Fig. 313; *Chugoku nisen-nen no bi,* pl. 51). Very similar bowls can be seen in Japanese collections, one in the Tazawa collection (Fig. 314; Hasebe, *Jishuyo,* pls. 78 and 79) and one in another private collection (*Sekai toji zenshu,* vol. 10, 1955, pl. 114).

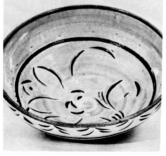

Figure 311

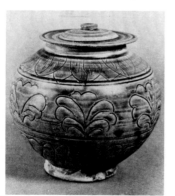

Figure 312

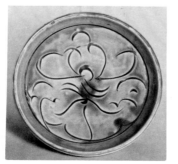

Figure 313

Figure 314

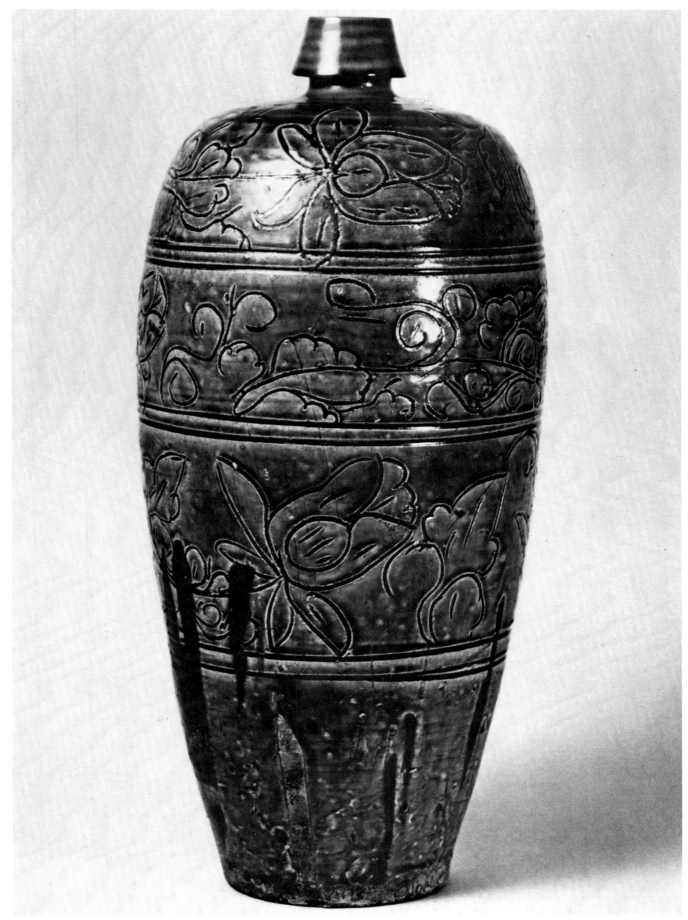

Appendices

Appendix A—LIST OF DATED MATERIALS

1071 A.D.

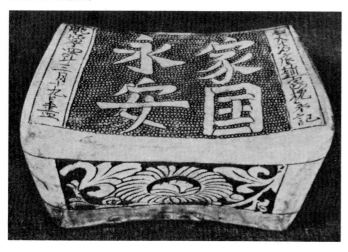

1071 A.D.
Seventh year of Hsi-ning
Pillow, British Museum. Hobson, *A Guide to the Pottery and Porcelain of the Far East,* (London, British Museum, 1924), p. 31, fig. 36. (see Pl. 23)

1105 A.D.

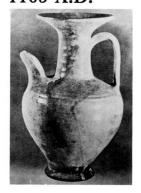

1105 A.D.
Fourth year of Ch'ung-ning
Ewer, Cleveland Museum of Art. *FECB*, vol. XI, nos. 1-2 (March-June, 1957), Pl. 11:a and b. (see Pl. 5)

1112 A.D.

1112 A.D.
Second year of Cheng-ho
Dish, Calmann Collection, Paris. Riddell, *Dated Chinese Antiquities: 600-1650,* p. 55, fig. 27.

1119 A.D.

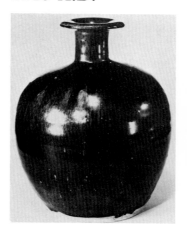

1119 A.D.
First year of Hsüan-ho
Truncated mei-p'ing, Idemitsu Art Gallery. Koyama, *Chugoku toji,* (Tokyo, 1970), Pl. 41.

1137 A.D.

1137 A.D.
Seventh year of Shao-hsing
Pillow, Umezawa Kinen-kan. Hasebe, *Jishuyo,* (Tokyo, 1974), p. 118, fig. 53.

1156 A.D.

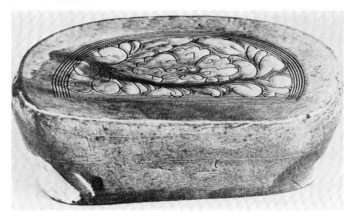

1156 A.D.
First year of Cheng-lung
Pillow, Tokyo National Museum. *Tokyo National Museum Catalogues: Chinese Ceramics,* (Tokyo, 1965), Pl. 299.

1162 A.D.

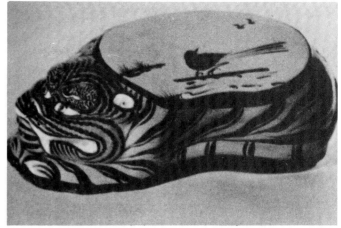

1162 A.D.
Second year of Ta-ting
Tiger Shaped Pillow, Shanghai Museum. *KK,* 1979, no. 5, Pl. 9:1.

1178 A.D.

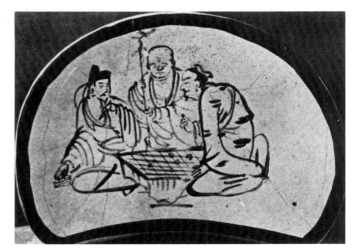

1178 A.D.
Eighteenth year of Ta-ting
Pillow, Philadelphia Museum of Art. *Archives of the Chinese Art Society of America,* no. XI (1957), p. 76. (see Pl. 55)

1185 A.D.

1185 A.D.
Twenty-fifth year of Ta-ting
Pillow, S. Lee Collection, Tokyo. Riddell, *Dated Chinese Antiquities: 600-1650,* (London, 1979), p. 72, fig. 46.

1200 A.D.

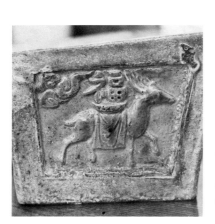

*Tokyo National Museum
dated 1200*

1200 A.D.
Fifth year of Ch'eng-an
Pillow, Tokyo National Museum. *Tokyo National Museum Catalogues: Chinese Ceramics,* Pl. 324.

1201 A.D. *(a)* 1201 A.D. *(b)*

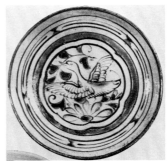

1201 A.D.
First year of T'ai-ho
a) **Bowl,** Tokyo National Museum. *Kokka,* no. 378 (1922) (see Pl. 105)
b) **Bowl,** Ataka Collection, Hasebe, *Jishuyo,* Pl. 85.

1210 A.D.

1210 A.D.
Second year of Ta-an
Jar. *KK,* 1979, no. 5, Pl. 9:5.

1230 A.D.

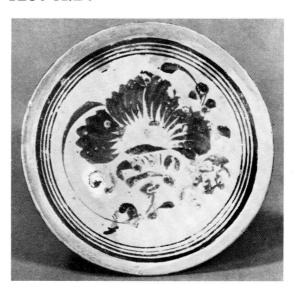

1230 A.D.
Seventh year of Cheng-ta
Bowl, Tokyo National Museum. Hasebe, *Jishuyo,* p. 103, fig. 31.

1251 A.D.

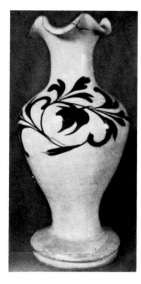

1251 A.D.
Eleventh year of Ch'un-yu
Vase, University of Sussex. Sullivan, *Chinese Ceramics, Bronzes and Jades in the Collection of Sir Alan and Lady Barlow,* (London, 1963), Pl. 62a.

1269 A.D.

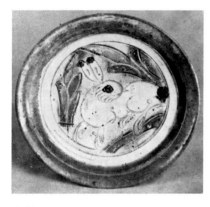

1269 A.D.
Sixth year of Chih-yüan
Dish, Tokyo National Museum. *Tokyo National Museum Catalogues: Chinese Ceramics,* Pl. 303.

1279 A.D.

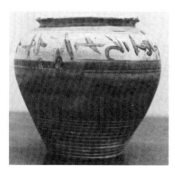

1279 A.D.
Sixteenth year of Chih-yüan
Kuan, British Museum, Registration no. 1935 10-15 5.

1303 A.D.

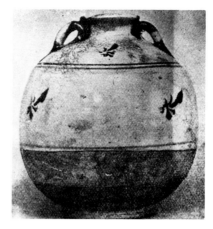

1303 A.D.
Seventh year of Ta-te
Jar with two handles, British Museum. Hobson, *A Guide to the Pottery and Porcelain of the Far East,* (London, 1924), p. 32, fig. 37.

1305 A.D.

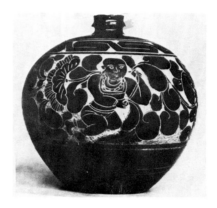

1305 A.D.
Ninth year of Ta-te
Jar with small mouth, British Museum. Lee and Ho, *Chinese Art Under the Mongols: The Yuan Dynasty,* (Cleveland, 1968), Pl. 56.

1314-20 A.D.

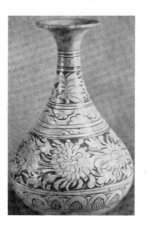

1314-20 A.D.
The Yen-yu period
Bottle, Japanese private collection. Hasebe, *Jishuyo* p. 97, fig. 20.

1336 A.D.

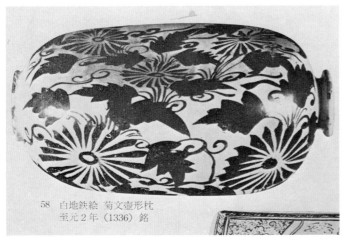

58 白地鉄絵 菊文壺形枕
至元2年 (1336) 銘

1336 A.D.
Second year of Chih-yüan
Pillow, Museum of Fine Arts, Boston. *FECB,* vol. VII, no. (September 1955), Pl. 34, no. 45. (see Pl. 56)

1351 A.D.

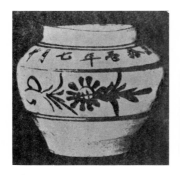

1351 A.D.
Eleventh year of Chih-cheng
Kuan, in China. *Chugoku Eirakukyu hekiga-ten,* (Tokyo, 1963), no pag.

1353 A.D.

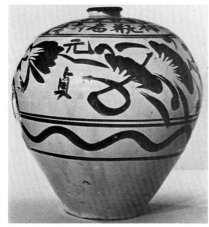

1353 A.D.
Thirteenth year of Chih-cheng
Jar with small mouth, Buffalo Museum of Science, Registration no. C 17069 (see Pl. 63)

1397 A.D.

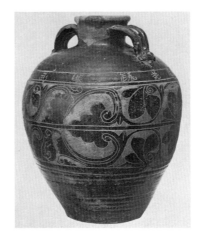

1397 A.D.
Thirtieth year of Hung-wu
Jar with two handles, Field Museum, Chicago, Registration no. 127240

1446 A.D.

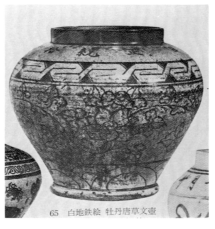

65 白地鉄絵 牡丹唐草文壺

1446 A.D.
Eleventh year of Cheng-t'ung
Kuan, British Museum. Hasebe, *Jishuyo,* p. 124, fig. 65.

1506-1521 A.D.

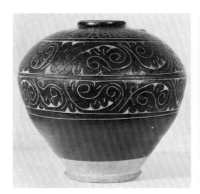

1506-1521 A.D.
The Cheng-te period
Jar, Museum für Ostasiatishe Kunst, Berlin—Dahlem, Registration no. 1969-13.

1540 A.D.

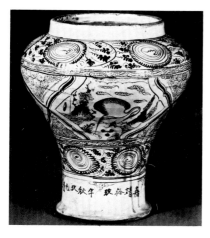

1540 A.D.
Nineteenth year of Chia-ching
Kuan, Herbert F. Johnson Museum of Art, Cornell University,
Registration no. 74.88.1. (see Pl. 84)

1547 A.D.

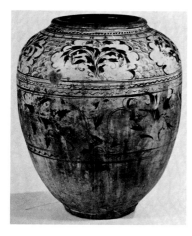

1547 A.D.
Twenty-sixth year of Chia-ching
Kuan (Large Jar), Newark Museum. *The Newark Museum Quarterly,*
(Summer/Fall, 1977), p. 38, Pl. 36.

1571 A.D.

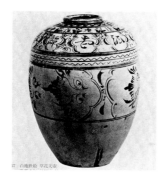

1571 A.D.
Fifth year of Lung-ch'ing
Kuan (Large Jar), Royal Ontario Museum, Toronto. *The Arts of the
Ming Dynasty,* (Detroit, 1952), Pl. 208. (see Pl. 85)

1573 A.D.

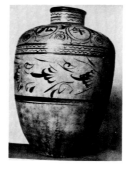

1573 A.D.
First year of Wan-li
Kuan (Large Jar), F. Brandt Collection, Berlin. Otto Kümmel,
Chinesesche Kunst, (Berlin, 1930), Pl. 116.

1573-1620 A.D.

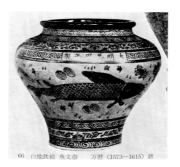

66　白地鉄絵　魚文壺　　万暦 (1573—1615) 銘

1573-1620 A.D.
The Wan-li period
Kuan, British Museum. Hasebe, *Jishuyo,* p. 124, fig. 66.

1600 A.D.

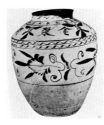

1660 A.D.
Seventeenth year of Shun-chih
Kuan (Large Jar), Japanese private Collection. Hasebe, *Jishuyo,* p. 125,
fig. 68.

1748 A.D.

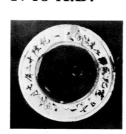 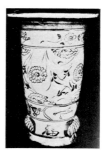

1748 A.D.
Thirteenth year of Ch'ien-lung
Jar, Nakao Collection, Japan. *Toji,* vol. 5, no. 3 (August, 1933), Pl. 9.

Appendix B—Chart of Tz'u-chou Type Kilns

Key:

Type of Ware
1. White
2. White with green splashes
3. White with black decoration
4. White with incised and/or combed decoration
5. White sgraffiato ware
6. Black glaze
7. Black glaze with sgraffiato decoration
8. Yellow-brown glaze
9. Green glaze
10. Green glaze with black decoration
11. Green glaze with incised decoration
12. Three color glaze
13. Enamel overglaze painting
14. Turquoise glaze
15. Incised decoration of fish-roe ground
16. Chün glaze
17. Celadon
18. Ying-ch'ing

Shape
A. Bowl
B. Plate
C. Basin
D. Cup
E. Cup stand
F. Jar
G. Ewer
H. *Tsun* vase
I. *Mei-p'ing*
J. Pillow
K. Box with cover
L. Bottle
M. Lamp stand
N. Incense burner

Abbreviations
KK: K'ao-ku T'ung-hsün, called K'ao-ku from 1959
KKPWYYK: Ku-kung Po-wu-yüan Yüan-k'an, Peking
WW: Wen-wu Ts'an-k'ao Tzu-liao, called Wen-wu from 1959

Kiln-site	Period of Activity	Type	Body Color	Shape	Reference
Hopei Province *Tz'u-hsien* Yeh-tzu-chen	11th-14th	1.2.3.4.5.	grey	A.B.C.	WW, 1952/2, p. 58. WW, 1964/8, pp. 42-3. KKPWYYK, 1960/2, p. 107. WW, 1952/2, pp. 58-9. KKPWYYK, 1960/2, p. 107.
P'eng-ch'eng-chen	15th-20th	1.3.6.	grey		
Han-tan-shih Kuan-t'ai-chen	11th-14th	1.2.3.4.5.6. 7.8.9.10.11. 12.15.	grey	A.B.F.G.J.K.	WW, 1952/2, pp. 57-8. WW, 1959/6, pp. 58-61. KKPWYYK, 1960/2, p. 108. Kuang-Ming Jih-Pao, Peking, Dec. 18th, 1962. WW, 1964/8, pp. 37-42.
Tung-ai-k'ou	11th-14th	1.3.	grey	A.B.F.J.	WW, 1964/8, pp. 44-46.
Honan Province *An-yang-shih* Hsi-shan-ying	10th-14th	2.6.16.			WW, 1952/2, p. 57. KKPWYYK, 1960/2, p. 108. WW, 1965/9, p. 45.
T'ien-hsi-chen	10th-13th	1.6.16.			WW, 1952/2, p. 57. KKPWYYK, 1960/2, p. 108. WW, 1965/9, p. 45.
Hui-hsien Yen-ts'un	10th-13th	1.2.3.6.8.	mud grey	A.B.F.G.K.	WW, 1965/11, pp. 35-39.
Miao-yüan-kang	10th-13th	1.2.3.6.8.	grey	A.B.G.	WW, 1965/11, pp. 39-41.
Yang-i-tang	10th-13th	1.6.	grey	A.B.	WW, 1965/11, pp. 41-2.
Tsai-p'o	10th-13th	1.6.8.	grey	A.B.	WW, 1965/11, p. 42.
Tang-yin-hsien Ho-pi-chi	10th	1.2.6.8.		A.B.F.G.L.	WW, 1964/8, pp. 3-5.
Ho-pi-chi	11th-14th	1.2.3.4.5.6. 8.12.13.16	sandy light yellow	A.B.C.D.F.H. I.J.K.L.M.N.	WW, 1956/7, pp. 36-7. WW, 1957/10, p. 57. WW, 1964/8, pp. 5-12. KKPWYYK, 1960/2, pp. 109-110.
Hsiu-wu-hsien *Tang-yang-*yü	11th-13th	1.2.3.4.5.6. 9.12.16.	buff	B.F.J.K.L.	Karlbeck, "Notes on the Wares from the Chiao Tso Potteries," *Ethnos, vol.* 8/3, 1943, pp. 81-95. WW, 1952/2, p. 56. WW, 1954/4, pp. 44-7. KKPWYYK, 1960/2, pp. 110-111. WW, 1965/9, Pls. 5: 7-15, p. 36.

Kiln-site	Period of Activity	Type	Body Color	Shape	Reference
Mi-hsien					
Hsi-kuan	10th-12th	1.2.4.6.8. 15.	grey	A.B.F.G.J.K. L.	*WW*, 1964/2, pp. 54-8. *WW*, 1964/3, pp. 47-51.
Yao-kou	10th-13th	1.3.6.8.	grey	A.B.F.G.L.	*WW*, 1964/2, pp. 58-9.
Teng-feng-hsien					
Ch'ü-ho	10th-13th	1.2.3.4.5.6. 12.13.15.	grey	A.B.D.F.G.J. K.L.	*WW*, 1964/2, pp. 59-62. *WW*, 1964/3, pp. 51-55 and 45.
Yü-hsien					
Shen-hou-chen Group					
Liu-chia-men	11th-14th	3.	yellow	A.B.F.K.	*WW*, 1964/8, p. 28.
Liu-chia-kou	11th-14th	3.	light-black	A.	*WW*, 1964/8, p. 28.
Shan-pai-yü (Miao-chia-men)	11th-14th	1.3.		A.B.C.F.	*WW*, 1964/8, p. 28.
Shan-pai-yü (Chang-chuang)	11th-14th	3.	coarse-white	A.	*WW*, 1964/8, p. 29.
Hsia-pai-yü (Lung-k'uei'ti)	11th-14th	3.	grey	A.B.	*WW*, 1964/8, p. 29.
Pa-ts'un	11th-15th	1.2.3.4.6.9. 12.13.14.	grey-white	A.B.F.H.J.K.L.	*WW*, 1951/2, pp. 55-6. *WW*, 1964/8, pp. 31-6. *KKPWYYK*, 1960/2, pp. 112 and 115.
Chün-t'ai (Pa-kua-tung)	13th-14th	3.16.17.18.		A.B.C.D.E.F. K.L.M.N.	*WW*, 1975/6, pp. 57-61.
Chia-hsien					
Hei-hu-tung	13th-14th	1.2.4.6.8.		A.F.L.	*WW*, 1965/9, pp. 31-2.
Huang-tao	9th-10th	1.3.		A.B.C.L.M.	*WW*, 1965/9, pp. 36 and 46.
Pao-feng-hsien					
Ch'ing-lung-ssu	11th-13th	1.3.4.6.8.9. 12.17.			*WW*, 1951/2, p. 52. *KKPWYYK*, 1960/2, p. 112.
Lu-shan-hsien					
Tuan-tien	11th-13th	1.2.3.4.6.			*WW*, 1951/2, p. 52. *KKPWYYK*, 1960/2, p. 112
Hsin-an-hsien					
T'an-tzu-kou Shih-shu-ling	12th-14th	1.3.6.13.16.		A.B.F.L.M.	*WW*, 1974/12, pp. 74-81.
Shanshi Province *T'ai-yüan-shih*					
Meng-chia-ching (Yüu-tz'u ware)	11th-14th	1.3.4.6.8. 17.	buff	A.B.J.K.	*WW*, 1964/9, pp. 46-51.
Chieh-hsiu-hsien					
Hung-shan-chen	11th-13th	1.3.4.5.6. 17.	white	A.B.C.F.	*WW*, 1958/10, pp. 36-7.
Kao-p'ing-hsien					
Pa-i-chen	12th-14th	1.12.13.			*WW*, 1965/9, p. 45.
Yang-ch'ü an-shih					
P'ing-ting	11th-14th	1.6.			*WW*, 1965/9, p. 45.
Shenshi Province *T'ung-chuan-shih*					
Huang-pao-chen	9th-10th	1.6.8.	light-grey	A.B.F.K.	*Shensi T'ung-Ch'uan Yao-Chou-Yao*, Peking, 1965, pp. 13-18. *Ibid*, pp. 18-46.
	11th-14th	1.3.6.8.17.	light-grey	A.B.D.E.F. G.L.M.N.	
Yü-hua	9th-14th	1.3.6.17.	buff	A.B.C.D.F. J.M.	*WW*, 1980/1, pp. 63-67.
An-len	12th-14th	1.6.17.		A.B.C.F.	*WW*, 1980/1, pp. 65-67.
Shantung Province *Te-hsien*					
Te-chou	12th-14th	1.13	reddish		Koyama, *Chugoku toji*, Tokyo, 1970, p. 71.
Tzu-po-shih	10th-14th	1.3.4.6.7.	white, grey and buff	A.B.D.E.F.G. I.K.L.M.	*WW*, 1978/6, pp. 46-58.
Anhui Province *Hsiao-hsien*					
Pai-t'u-chen	9th-13th	1.3.8.	light yellow	A.B.F.G.L.	*KK*, 1962/3, pp. 134-138. *KK*, 1963/11, pp. 662-667.

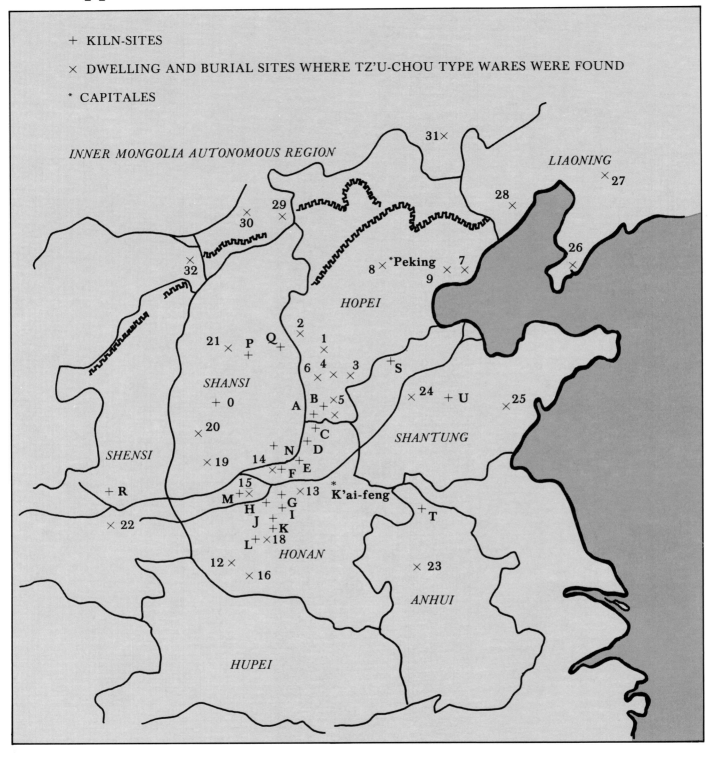

Appendix—C MAP

+ KILN-SITES

× DWELLING AND BURIAL SITES WHERE TZ'U-CHOU TYPE WARES WERE FOUND

* CAPITALES

INNER MONGOLIA AUTONOMOUS REGION

31×

LIAONING

×27

30× 29× 28×

32× 8× *Peking 7× 26×
9×

HOPEI

2×
21× P Q+ 1×
+ 4× *S
6× × 3× +
SHANSI × ×24 +U
+ O A B+ ×5 *SHANTUNG* ×25
×20 +C
× N +D
×19 14 + F E
+ × +
15 13× *K'ai-feng
+R M +×
×22 H + G +I
J +K
L +18
12× *HONAN* +T
16× ×23

ANHUI

SHENSI

HUPEI

Ocean

Regions

Kiln-sites

A. Tz'u-hsien 磁縣
B. Han-tan-shih 邯鄲市
C. An-yang-shih 安陽市
D. T'ang-yin-hsien 湯陰縣
E. Hui-hsien 輝縣
F. Hsiu-wu-hsien 修武縣
G. Mi-hsien 宓縣

H. Teng-feng-hsien 登封縣
I. Yü-hsien 禹縣
J. Chia-hsien 郟縣
K. Pao-feng-hsien 寶豐縣
L. Lu-shan-hsien 魯山縣
M. Hsin-an-hsien 新安縣
N. Kao-p'ing-hsien 高平縣

O. Chieh-hsiu-hsien 介休縣
P. T'ai-yüan-shih 太原市
Q. Yang-ch'üan-shih 陽泉市
R. T'ung-ch'üan-shih 銅川市
S. Te-hsien 德縣
T. Hsiao-hsien 蕭縣
U. Tzu-po-shih 淄博市

Dwelling And Burial Sites Where Tz'u-chou Type Wares Were Found

Hopei Province

1. Chao-hsien — WW, 1978, no. 6, pp. 95-96.
2. Ching-hsing-hsien — KKHP, 1962, no. 2, pp. 31-73. (see Figs. 64, 67 and 68)
3. Ch'ing-ho-hsien — Palmgren, *Sung Sherds,* (see Fig. 58)
4. Chü-lu-hsien — Li Hsiang-ch'i and Chang Hou-huang, *Chu-lu Sung-ch'i ts'ung-lu,* (see Figs. 6 and 8) *Ho-pei ti-i po-wu-yuan pan-yueh-k'an,* see Figs. 62, 71, 101 and 117)
5. Ch'ü-chou-hsien — WW, 1960, no. 3, p. 90. (see Fig. 254)
6. Hsing-t'ai-hsien — KK, 1959, no. 7, p. 369. (see Fig. 124) KK, 1961, no. 3, p. 174. (see Figs. 133, 135 and 138)
7. Lo-t'ing-hsien — *Hsin Chung-kuo ch'u-t'u wen-wu,* Pl. 196. (see Fig. 238)
8. Peking — KK, 1972, no. 6, pp. 2-11. (see Fig. 190) KK, 1972, no. 6, pp. 32-34. (see Figs. 189, 228, 251 and 270) KK, 1973, no. 5, pp. 279-285. (see Figs. 239 and 269)
9. T'ang-shan-hsien — KK, 1958, no. 3, pp. 10-14. (see Fig. 219)
10. Tz'u-hsien — KK, 1978, no. 6, pp. 388-399. (see Fig. 240)

Honan Province

11. An-yang-shih — WW, 1956, no. 8, p. 74. (see Fig. 149)
12. Chen-p'ing-hsien — *Chuka jinmin kyowakoku shitsudo bunbutsu ten,* Nagoya, 1977, Pl. 92. (see Fig. 195)
13. Cheng-chou — WW, 1958, no. 5, pp. 52-54. (see Fig. 7)
14. Chiao-tso-shih — WW, 1979, no. 8, pp. 1-16.
15. Loyang — KK, 1960, no. 10, p. 12. (see Fig. 290)
16. Nan-yang-hsien — WW, 1960, no. 5, p. 87 (see Fig. 175)
17. T'ang-yin-hsien — *Hsin Chung-kuo ch'u-t'u wen-wu,* Pl. 174. (see Fig. 274)
18. Yü-hsien — *WW*, 1954, no. 9, Pls. 62 and 63. (see Fig. 142) *WW*, 1964, no. 8, pp. 27-36. (see Figs. 198 and 206)

Shansi Province

19. Hou-ma — KK, 1961, no. 12, pp. 682-683.
20. Hsiang-fen-hsien — WW, 1979, no. 8, pp. 18-25.
21. T'ai-yüan — KK, 1955, no. 4, pp. 57-58. (see Fig. 203) KK, 1963, no. 5, pp. 250-256. KK, 1963, no. 5, pp. 259-263. KK, 1965, no. 1, pp. 25-30. (see Fig. 279)

Shensi Province

22. Sian — WW, 1956, no. 1, pp. 32-35. (see Fig. 289) WW, 1958, no. 6, pp. 57-61. (see Fig. 145)

Anhui Province

23. Feng-t'ai-hsien — WW, 1965, no. 10, pp. 46-56. (see Fig. 281)

Shantung Province

24. Chi-nan — *Shan-tung wen-wu hsuan-chi*, Pl. 244 (see Fig. 227)
25. Chu-ch'eng-hsien — *Shan-tung wen-wu hsuan-chi*, Pl. 236 (see Fig. 216)

Liaoning Province

26. Chin-hsien — KK, 1966, no. 2, pp. 96-111. (see Fig. 229)
27. Liao-yang-hsien — *Hsin Chung-kuo ch'u-t'u wen-wu,* Pl. 190, (see Fig. 218)
28. Sui-chung-hsien — KK, 1960, no. 2, pp. 43-443.

Inner Mongolia Autonomous Region

29. Ch'ai-yu-ch'ien-ch'i — *Nei-meng-ku ch'u-t'u wen-wu hsuan-chi,* Pl. 169. (see Fig. 87)
30. Chin-ning-lu — WW, 1961, no. 9, pp. 52-57. WW, 1979, no. 8, pp. 32-39.
31. Ch'ih-feng-shih — *Nei-meng-ku ch'u-t'u wen-wu hsuan-chi,* Pl. 168. (see Fig. 226)
32. Yü-lin — WW, 1976, no. 12, pp. 73-82. (see Fig. 167)

Index

Alexander Collection
Pl. 22
Anyang 安陽
p. 9
d'Argencé, R.
Pl. 7, 38, 66, 80, 92, 107
Art Gallery of Greater Victoria, Canada
Pl. 29
Art Institute of Chicago
see Chicago
Asano Collection 淺野
Pl. 16
Ashmolean Museum
see Oxford
Asian Art Museum
see San Francisco
Aso Collection 麻生
Pl. 109
Ataka Collection 安宅
Pl. 105
Ayers
Pl. 16, 43, 86, 67, 82
Barlow Collection
see University of Sussex
basin
Pl. 86
Berlin, Staatliche Museum
Pl. 54, 107, 109
Beurdeley, M.
Pl. 46
Boston, Museum of Fine Arts
Pl. 9, 12, 13, 14 17, 31, 44, 47, 54, 56, 71, 99, 104
bottle, n.c.
Pl. 74, 75, 76, 101
Boulay, A. du
Pl. 60
bowl
Pl. 12, 35, 37, 43, 64, 65, 105, 106
Bristol City Art Gallery
Pl. 1, 4, 6, 27, 42, 68
British Museum
see London
Brooklyn Museum
Pl. 49
Brundage Collection
Pl. 7
Buddhist Ceremony
Pl. 24
Buffalo Museum of Science
Pl. 2, 13, 60, 63, 90, 100, 102, 108
Burrell Collection, Camphill Museum
see Glasgow

Cambridge, Fitzwilliam Museum
Pl. 26, 35, 82, 105
Ch'a-yu-ch'ien-ch'i, Inner Mongolia 察古前旗
Pl. 36
Chai-kou-ts'un near T'ai-yuan 寨溝村, 太原
Pl. 96
Chai-li-ts'un, Hsin-feng-hsien, Shansi Province 寨里村, 新絳縣
Pl. 62
Ch'ang-chih, Shansi 長治, 山西
Pl. 42
Chang-chia-tsao 張家造
Pl. 46, 49, 51, 53, 54, 57, 58, 59, 60
Chang-chia-chen 張家枕
Pl. 46
Chang-chin chia tsao 張進家造
Pl. 50
Chang R. 漳河
Pl. 46; p. 13
Chang Hou-Huang 張厚璜
Pl. 6, 7, 31
Ch'ang-ming chen 長命枕
Pl. 31
Chang Neng-ch'en 張能臣
p. 13
Chang-te-fu 彰德府
Pl. 60; p. 9
Chao family 趙
Pl. 23
Chao Kuang-fu 趙光輔
Pl. 24
Chao-ts'ai li-shih 招財利市
Pl. 82
Ch'en-chia-chuang 陳家庄
Pl. 83
Ch'en-chia-ts'un 陳家村
p. 12
Ch'en-p'ing-hsien, Honan Province 鎮平縣, 河南省
Pl. 74
Ch'en Wan-li 陳萬里
Pl. 9, 22, 27, 46, 49, 51, 53, 54, 69, 70, 71, 100; p. 9, 11, 12
Ch'eng Che, 程哲
p. 11
Chi-nan, Shangtung 濟南, 山東省
Pl. 83
Chia-ching, 嘉靖
p. 11
Chia-hsien 郟縣
Pl. 107; p. 10
Chia-kuo yung-an 家國永安
Pl. 23
Chiao-tso, Hsiu-wu-hsien, Honan Province, 焦作, 修武縣, 河南
p. 9

Chicago, Art Institute of
Pl. 14, 20, 22, 24, 25, 50, 58, 64, 72, 76, 82, 85, 92, 106
Chicago, Field Museum of Natural History
Pl. 5, 6, 25, 31, 35, 41, 82
Chien An-lu　建安廬
Pl. 60
Chieh-hsiu-hsien　介休縣
p. 12
Ch'ien-lung　乾隆
p. 12
Ch'ih-hsi-ts'un, Ch'u-chiang, near Sian　沈西村　曲江, 西安
Pl. 102
Chih-cheng　至正
Pl. 63
Chin Dynasty
Pl. 27, 34, 37, 38, 43, 46, 47-55, 57, 58, 59, 63, 65, 66, 67, 69-72, 74,
75, 77-81, 88, 89, 90, 92, 95, 96, 97, 99, 100-106, 109
Chin Dynasty tomb
Pl. 27, 34, 98
Ching-ching tao-sheng　清淨道生
Pl. 40
Ch'ing-ho-hsien, Hopei　清河縣
Pl. 26, 107; p. 12
Ch'ing-ku mai chiu　清沽美酒
Pl. 68
Ch'ing-lung-ssu, Pao-feng-hsien　青龍寺, 寶豐縣
Pl. 100
Ch'ing-pai　青白
Pl. 3, 18
Chiu-hsiao-shih　酒小史
p. 13
Chiu-se ts'ai-ch'i　酒色財气
Pl. 82
Chiu-ming-chi　酒名記
p. 13
Chu-ch'eng-hsien, Shantung　諸城縣, 山東
Pl. 82
Ch'u-chou-hsien, Hopei　曲周縣
Pl. 91
Ch'ü-ho-yao, Teng-feng-hsien　曲河窯, 登封縣
Pl. 6, 9, 12, 14, 100, 105
Chü-lu-hsien　鉅鹿縣
Pl. 4, 6, 7, 22, 24, 28, 31, 33, 40, 43-46; p. 9, 13
Chu-lu-k'o-ts'un, Chien-p'ing-hsien　碌碌科村, 建平縣
Pl. 9
Chu-lu Sung-ch'i tsung-lu　鉅鹿宋器叢錄
p. 10, 13
Ch'u-t'ou-lang, Chih-feng-shih, Inner Mongolia　初頭郎, 赤峯市
Pl. 83
Chu Yen　朱琰
p. 11
Ch'un-yu　淳祐
Pl. 77
Ch'ung-ning　崇寧
Pl. 5
Cincinnati Art Museum
Pl. 101
Clark, Mrs.
Pl. 35, 105
Cleveland Museum of Art
Pl. 5, 10, 11, 13, 22, 24, 38, 52, 70, 93, 96, 99
Cornell University, Herbert F. Johnson Museum of Art
Pl. 6, 84, 99
covered jar
Pl. 66, 67
Cox, W.
Pl. 30, 33, 43, 44, 72, 93
Cunliffe Collection
Pl. 17
Daitoku-ji Temple, Kyoto
Pl. 58
Detroit Art Institute
Pl. 64
dish
Pl. 34
Dreyfus, R.
Pl. 74, 99

Eskanazi, G.
Pl. 9
ewer
Pl. 5, 10, 11, 22, 107, 108
Falk, Mr. and Mrs. M.
Pl. 37, 59, 81, 99
Feng-ch'u fa-chiu　鳳翱法酒
p. 13
Feng hua hsüeh yüeh　風花雪月
Pl. 82, 97
Feng Hsien-ming　馮先銘
Pl. 105; p. 9
Feng-t'ai, Anhui　鳳台, 安徽
Pl. 97
Feng-t'ien National Museum　奉天國立博物館
Pl. 73, 86
Fernald, H.,
Pl. 20, 21, 31, 32, 47, 51
Field Museum of Natural History
see Chicago
Fitzwilliam Museum
see Cambridge
Five Dynasties Period
Pl. 1, 2, 107, 108
Fogg Art Museum
Pl. 12, 34, 48, 61, 66, 68, 95, 97, 99
Freer Gallery of Art
see Washington, D.C.
Fu　福
Pl. 23, 46, 100
Fu-yü-hsien, Chi-lin Province　扶余縣 吉林省
Pl. 27
Fu-yüan Wang-chia tsao　滏源王家造
Pl. 60, 62
Gemeente Museum, Hague
Pl. 84, 106
Glasgow, Burrell Collection, Camphill Museum
Pl. 84, 95
Goepper, R.
Pl. 6, 33, 36, 52, 54, 60
Gray, B.
Pl. 94
Guimet, Musee
see Paris
Gyllensuard, B.
Pl. 60
Hakutsuru Museum　白鶴
Pl. 42
Hamburg, Museum für Kunst und Gewerbe
Pl. 5, 81, 82
Han-tan-hsien, Honan　邯鄲縣
Pl. 15, 24, 34, 49, 91
Hasebe, G.　長谷部樂爾
Pl. 3, 6, 8, 9, 10, 11, 12, 13, 14, 15, 16, 21, 22, 23, 27, 29, 34, 35, 36,
38, 40-44, 56, 57, 73, 78, 85, 87, 92, 94, 105, 109; p. 9, 10
Harrisson, T.
Pl. 91
Heeramaneck, N.
Pl. 57
Herzman, S.
Pl. 64, 66, 82
Hetherington, A. L.
Pl. 68
Historical Museum of Korea
see Pyongyang
Hobson, R.
Pl. 22, 23, 32, 40, 82, 94; p. 9
Hochstadter, W.
Pl. 2, 13, 90, 100, 102, 108
Ho-lin-ko-erh　和林格爾
Pl. 9
Ho-pi-chi, T'ang-yin-hsien　鶴壁集, 湯陰縣
Pl. 2, 34, 74, 82, 86, 92, 93, 105 (see also T'ang-yen hsien)
Hollis, H.
Pl. 11, 13, 70, 93
Honan　河南
Pl. 15, 27

Honey, W.
Pl. 80, 99, 109
Honolulu Academy of Art
Pl. 53, 60
Hopei 河北
Pl. 27
Hou-ying fang, Peking 后英房
Pl. 73, 82
Hoyt
Pl. 71
Hsi Hsi-chung collection, Peking
Pl. 95
Hsi-kuan-yao, Mi-hsien 西關窯 密縣
Pl. 6, 16, 17
Hsi-ning 熙寧
Pl. 23
Hsi-t'ao Hu-t'ung, Peking 西絛胡同 北京
Pl. 86
Hsi-yüan 至元
Pl. 56
Hsiang-chou 相州
p. 13
Hsiang-ti chang-chia tsao, Ai-shan-chen yung-gung 相地張家造 艾山鎮用功
Pl. 60
Hsiang-kuei 香桂
p. 13
Hsiao, citizen 蕭
Pl. 3
Hsieh Chao-chih 謝肇淛
p. 11
Hsien-feng 咸豐
p. 12
Hsing-t'ai 邢台
Pl. 46, 51, 52
Hsiu-wu-hsien 修武縣
Pl. 27, 36, 39
Hsüan-te 宣德
p. 11
Hsüan-wu, Peking 宣武, 北京
Pl. 82
Hu-kuang-i-yuan 胡廣義園
Pl. 76
Hua-p'ing Liu-chia tsao 花瓶劉家造
Pl. 42
Hua-t'a-ts'un, T'ai-yuan 華塔村, 太原
Pl. 76
Huai-chou 懷州
p. 13
Huang-tao ware 黄道窯
Pl. 107, 108
Hui-fa-ch'eng, Chi-lin Province 輝發城, 吉林省
Pl. 99
Hui-tsung, Emperor 徽宗
Pl. 16, 46, 57
Hung-chih 弘治
p. 12
Hung-hua man-yüan 紅花滿院
Pl. 72
Hung-shan-chen 洪山鎮
p. 12
Idemitsu Art Gallery
see Tokyo
I-ch'eng 宜城
p. 13
I-hsien, Liaoning Province 義縣, 遼寧省
Pl. 3
incense burner
Pl. 24, 25, 98
Indianapolis Museum of Art
Pl. 4, 9, 19, 25, 32, 71, 96, 101
Jacobson, K.
Pl. 39
Jen T'ao 仁韜
p. 12
Jen-ho-kuan 仁和館
Pl. 82
jar
(see also large jar), Pl. 44, 45, 63, 79, 80, 81

Kansas City, William Rockhill Nelson Gallery-Atkins Museum of Fine Arts
Pl. 6, 18, 42, 43, 68, 75, 88
Karlbeck,
Pl. 0; p. 9
Kato, H. 加藤土師萌
Pl. 73
Kempe Collection
Pl. 7
Kikusui Museum 掬粹巧美館
Pl. 42
Kiseleu, S. V.
Pl. 82
Knapp, J.
Pl. 98
Ko-ku yao-lun 格古要論
p. 9, 10, 11
Kobayashi, T. 小林太一郎
Pl. 13, 37
Köln, Museum für-Ostasiatische Kunst
Pl. 6, 23, 26, 33, 36, 60, 64, 108
Köln, Siegal collection
Pl. 23, 64, 108
Koryo Period
Pl. 24
Koyama, F. 小山富士夫
Pl. 1, 5, 13, 23, 32, 42, 70, 80, 94, 105
Ku-yao-chi-k'ao 古窯器攷
p. 11
Ku Hsiang Chang-chia tsao 古相張家造
Pl. 60, 61
Kuan 鑵
Pl. 83, 84, 91, 93
Kuan-t'ai 觀台
Pl. 6, 15, 24-27, 31, 34-36, 39, 41, 42, 43, 45, 63, 64, 66, 73, 87, 89, 94, 100; p. 10
Kuan-t'an-ch'ang 官鐔廠
p. 11
Kulturen Museum, Lung
Pl. 60
Kuwayama, G.
Pl. 30, 57
Kyoto National Museum 京都國立博物館
Pl. 39
Kyusei Hakone Art Museum 浚世箱根美術館
Pl. 87, 109
Lady Wen Chi 文姬
see Wen Chi
Lan P'u, 藍浦
p. 11
large jar
(see also jar), Pl. 85
Lee George,
Pl. 78
Lee, G. J.,
Pl. 12, 55
Lee, Sammy,
Pl. 6, 11, 93
Lee, Sherman E.,
Pl. 5, 13, 38, 42, 46
Lee, S. E. and Ho, W. K.,
Pl. 56, 63, 74, 99
Legaza, I. L.,
Pl. 82, 83, 92, 93
Lesser, J.,
Pl. 78
Li An-chung, 李安忠
Pl. 16
Li Hsiang-ch'i, 李詳蓉
Pl. 6, 7, 31; p. 10, 14
Li Ming-chi 李名記
Pl. 56
Li Po 李白
Pl. 82
Li-ts'un-kou, Ch'ang-chih, Shansi Province 李村溝, 長治, 山西
Pl. 34, 69, 74, 98, 106
Liang-hsiang-chen, Peking 良鄉鎮
Pl. 73, 83, 91

Liang T'ung-chu 梁同書
p. 11
Liao Dynasty
Pl. 8, 9, 27
Liao tomb
Pl. 3, 9, 15, 27
Liao-yang-hsien, Liaoning Province 遼陽縣
Pl. 82
Lien-tsu 連子
Pl. 21
Liu-li-ts'un 琉璃村
p. 11
Lo-han Hall 羅漢堂
p. 13
Lo-t'ing, Hopei 樂亭,河北
Pl. 86
lobed jar
Pl. 6
Loehr, M.
Pl. 81
London, The British Museum
Pl. 2, 7, 10, 16, 17, 19, 23, 31, 32, 39, 40, 43, 44, 60, 63, 67, 82, 86, 94, 105
London, Percival David Foundation
Pl. 82
London, School of Oriental and African Studies, University of London
Pl. 25
London, Victoria and Albert Museum
Pl. 2, 5, 8, 9, 21, 42, 44, 70, 92, 98, 99, 102, 105, 107, 109
Loo, C. T.
Pl. 12
Los Angeles County Museum of Art
Pl. 30, 57, 93
Lowe Art Museum, The University of Miami
Pl. 79, 99
Loyang 洛陽
Pl. 100
Lu 祿
Pl. 21
Lu 鹿
Pl. 21
Lu-shan-hsien 魯山縣
Pl. 27
Lü-shan Museum, Liaoning Province 旅順博物館
Pl. 28, 30
Lü-ta, Liaoning Province 旅大
Pl. 83
Lung-ch'ing 隆慶
Pl. 85
Malaysia, Art Museum at the University of
Pl. 46
Malcolm, M.
Pl. 83
Marcove, R.
Pl. 60, 62
Marshall, F.
Pl. 60
Matsuda Collection 松田
Pl. 10
Matsuoka Museum 松岡美術館
see Tokyo
Mayer, F.
Pl. 25, 38
Mayuyama, J. 繭山順吉
Pl. 13
Medley, M.
Pl. 63, 77, 85, 92, 105; p. 9
Mei-p'ing
Pl. 3, 4, 18, 22, 27, 33, 39, 40, 43, 68-73, 93, 94, 99, 109
Menasce Collection, G. de
Pl. 64
Metropolitan Museum of Art
see New York
Meng-chia-ching 孟家井
p. 12
Mi-hsien 宓縣
Pl. 15, 16, 17, 18, 22, 27, 30, 36; p. 9

Miao-yen 妙巖
p. 13
Ming Dynasty
Pl. 23, 84, 85, 99
Ming-hui-tien 明會典
p. 11
Ming Shih 明史
p. 11
Minneapolis Museum of Art
Pl. 9
Mino, Y.
Pl. 9, 15-17, 19-24, 26, 27, 32, 46, 108
Mishima, Sano Museum 三島佐野美術館
Pl. 16, 89
Mizuno, S. 水野清一
Pl. 28
Montreal Museum of Fine Arts
Pl. 46
Mu-ch'i 牧谿
Pl. 58
Munich, Staatliches Museum für Volkerkunde
Pl. 81, 82
Museum für Kunst and Gewerbe
see Hamburg
Museum of Art of the Rhode Island School of Design
see Rhode Island
Museum of Far Eastern Antiquities
see Stockholm
Naito Gyoho 内藤堯實
Pl. 20, 21
Nanking 南京
Pl. 3, 18
Nan-kuan 南關
p. 11
Nan-kuan-wai, Cheng-chou 南關外 鄭州
Pl. 6
Nei-fu 内府
Pl. 73
Newark Museum
Pl. 85
Nezu Museum 根津美術館
see Tokyo
New York, Metropolitan Museum of Art
Pl. 33, 43, 44, 53, 65, 103, 104
Northern Sung dynasty
Pl. 2-33, 35, 36, 39-45, 94
Okayama Museum of Art, Japan, 岡山美術館
Pl. 15, 16, 18, 19
Okuda, S. 奥田誠一
Pl. 20, 47, 63, 78, 105
Oriental Ceramic Society
Pl. 66
Oxford, Ashmolean Museum
Pl. 16, 23, 31, 64, 86
Pa-i-chen, Kao-p'ing-hsien, Shansi Province 八義,高平縣,山西省
Pl. 105
Pa-ts'un 朴村
Pl. 47, 64, 69, 75, 77-79, 100, 105
Paine, R.
Pl. 17, 19, 47, 48, 54, 56, 61, 97
Palace Museum
see Peking
Palmgren, N.
Pl. 26, 95, 107
Pao-feng-hsien 寶豐縣
Pl. 27
Paris, Musee Cernuschi
Pl. 10, 91
Paris, Musee Guimet
Pl. 10, 14, 71
Parke-Bernet Galleries, New York
Pl. 23, 81
Peat, W.
Pl. 4, 9, 71
Pechere, P.
Pl. 66
Pei-fang min-chien tz'u-ch'i 北方民間瓷器
p. 9, 10, 11

Pei-yu-kou, Wen-shui-hsien, Shansi Province　北峪口,文水縣,山西省
 Pl. 98
Peking, National Historical Museum
Peking, Palace Museum
 Pl. 15, 18, 19, 68, 76, 99
P'eng-ch'eng　彭城
 p. 10, 11
peony jars
 Pl. 7
Peters, Mrs.
 Pl. 92
Philadelphia Museum of Art
 Pl. 55, 60, 62, 72, 100
Photographic Archives of the School of Oriental and African Studies,
 University of London
 Pl. 10, 25
Pi-yang　沁陽
 p. 13
Pieh-kai-shan, near Anyang　鳖盖山,安陽
 Pl. 57
pillow
 Pl. 14-17, 19-21, 23, 28-32, 36, 38, 40, 41, 46-62, 92, 97 100, 102-104
Plumber, J.
 Pl. 11, 13, 38, 52, 93
Po Chü-i　白居易
Po-lin　伯林
Po-ling-kung　百重公
Popper, H. and G.
 Pl. 89, 107
Proctor, P.
 Pl. 51, 85
Pyongyang, Historical Museum of Korea
 Pl. 24
Rhode Island School of Design, Museum of Art of the
 Pl. 61
Riddell, S.
 Pl. 6, 23, 55, 56, 85
Riviere
 Pl. 10, 11, 39, 70, 101, 102
Royal Ontario Museum
 see Toronto
Royal Scottish Museum
 Pl. 60
Sackler Collections
 Pl. 28, 31, 37, 76, 82, 83
Saint Louis Art Museum
 Pl. 27, 53
San Francisco, Asian Art Museum
 Pl. 38, 60, 66, 80, 91, 92
San-Ming-ssu　三明寺
 p. 13
Sano Museum　佐野美術館
 see Mishima
Sanpo-do Collection　三方堂
 Pl. 75
Sarawak Malaysia
 Pl. 91
Sato, Ryuzo　佐藤隆三
 Pl. 78
Seattle Art Museum
 Pl. 60, 77
Seikado Collection　静嘉堂
 see Tokyo
Shanghai Museum　上海美術館
 Pl. 21, 36, 78, 92
Shen-yang, Liaoning Province　瀋陽
 Pl. 73
Shih-ch'iao-tung　石橋東
 p. 11
Shih-chuang, Hopei　柿庄
 Pl. 28, 29
Shih-huo-chih　食貨志
 p. 11
Shih-li-miaó, Nan-yang　十里廟,南陽
 Pl. 64
Sian　西安
 Pl. 54

Sickman
 Pl. 7, 42
Siegel Collection
 see Koln
Singer, P.
 Pl. 1, 26, 45, 65, 82, 107, 108
Siren, O.
 Pl. 16, 46, 57, 58
Six-spouted jar
 Pl. 26
Small-mouthed jar
 Pl. 82
Sotheby and Co.
 Pl. 35
Spelman, R.
 Pl. 59
Springfield, Museum of Fine Arts
 Pl. 1
Staatliche Museum
 see Berlin
Staatliche Museum für Volkerkunde
 see Munich
Stockholm, Museum of Far Eastern Antiquities
 Pl. 26
Sullivan
 Pl. 7
Sung
 Pl. 26
Sung Dynasty
 Pl. 16, 100
Sung Po-jen　宋伯仁
 p. 13
Sung Tomb, Shih-chuang, Ching-hsing-hsien, Hopei Province　柿庄,井陘縣,河北省
 Pl. 28, 29
Sung Tomb, Sian
 Pl. 21
Sullivan, M.
 Pl. 76
Sussex, University of, Barlow Collection
 Pl. 7, 64, 76, 77
Swallow, R. W.
 p. 9
Swann, P.
 Pl. 46, 31
Sweden, King of
 Pl. 103
Szekeres, J.
 Pl. 67
Ta-chung-hsiang-fu　大中祥符
 p. 12
Ta-kuan　大觀
 p. 12
Ta-ting　大定
 Pl. 55
Ta-tu, Peking　大都
 Pl. 93
Ta-t'ung, Shansi　大同
 Pl. 57, 75
Ta-ying-tzu-ts'un, Ch'ih-feng-hsien, Liaoning Province　大营子村,赤峰
 Pl. 9
Taipei, National Palace Museum　台北,故宫博物院
 Pl. 23, 57
T'ai-yüan Museum, Shansi　太原
 Pl. 28
T'ang Dynasty
 Pl. 2, 15, 108
T'ang-yang-yü, p. 12, Honan Province　當陽峪,河南省
 Pl. 36, 100
T'ang-yin-hsien　湯陰縣
 Pl. 74, 86, 94
T'ao-shuo　陶說
 p. 11
Tazawa, Y Collection Tokyo　田沢担
 Pl. 8, 109
Te　德
 Pl. 23
Te-chou, Te-hsien, Shantung Province　德州,德縣
 Pl. 105

258

Te-ying-hou　偲應侯
　　p. 12
Teng-feng-hsien, Honan　登封縣
　　Pl. 1, 9, 12, 14, 15, 16, 17, 18, 19, 22, 23, 27, 33, 36
Tientsin Museum　天津艺術館
　　p. 9, 13
Ting-hsien, Hopei Province　定縣
　　Pl. 8, 15
Ting ware
　　Pl. 1
Tokyo, Idemitsu Art Gallery　出光美術館
　　Pl. 1, 41, 65, 87, 91, 94, 100, 105
Tokyo, Matsuoka Museum
　　Pl. 74
Tokyo National Museum　東京國立博物館
　　Pl. 3, 5, 10, 11, 27, 32, 34, 35, 38, 42, 52, 54, 57, 65, 73, 74, 82, 87, 92,
　　101, 102, 104, 105, 109; p. 9
Tokyo, Nezu Museum
　　Pl. 16
Tokyo, Seikado Collection
　　Pl. 41
Toronto, Royal Ontario Museum
　　Pl. 5, 10, 20, 21, 31, 32, 35, 46, 47, 51, 69, 78, 85, 92, 97, 100, 108
Tou, high-footed bowl
　　Pl. 2
T'ou-ho shui-k'u, T'ang-shan, in Hopei　陡河水庫　唐山，河北省
　　Pl. 82
Towakai　陶和会
　　Pl. 10, 46
Trans-Baikal, Siberia
　　Pl. 82
Trubner, H.
　　Pl. 7, 53
truncated Mei-p'ing
　　Pl. 9, 87, 88, 89
Tseng, H. C.
　　Pl. 31
Tsiang, K.
　　Pl. 9, 32
tsun-shaped vase
　　Pl. 42, 43, 77, 78
Ts'ao Chao　曹昭
　　p. 10, 11
T'u-ch'eng-tzu, Ho-lin-ko-erh, Inner Mongolia　土城子，和林格爾
　　Pl. 8, 15
Tung,　董
　　p. 13
Tung-ai-k'ou　東艾口
　　Pl. 46, 49, 51, 64, 66, 87, 90, 95; p. 10
Tung-ch'eng, Peking　東城，北京
　　Pl. 93
Tz'u,　瓷　磁
Tz'u-ch'i　磁器
Tz'u-chou　磁州
　　Pl. 44, 49, 64, 66, 87, 94; p. 9, 10, 11
Tz'u-hsien　磁縣
　　Pl. 46, 60, 86; p. 9
Umezawa Collection　梅沢記念館
　　Pl. 12, 57
University of Michigan Museum of Art
　　Pl. 65
Valenstein, S.
　　Pl. 33, 103
vase
　　Pl. 8, 9, 13, 90, 95, 96
de Vasselot, J.
　　Pl. 8
Victoria and Albert Museum
　　see London
Wan-li　萬歷
　　Pl. 85
Wang　王

Wang-shih Shou-ming　王氏壽明
　　Pl. 62
Wang, Chao-chün　王昭君
　　Pl. 60
Wang man feng　王滿峯
　　Pl. 63
Wang Shih-pao　王世寶
　　Pl. 63
Washington, D.C., Freer Gallery of Art
　　Pl. 9, 98, 101
Watanabe　渡辺
　　Pl. 109
Wei-chi　圍其
　　Pl. 55
Wei na　維那
　　Pl. 63
Wen Chi　文姬
　　Pl. 60
Whitfield, R.
　　Pl. 60, 61, 89
Wirgin, J.
　　Pl. 10, 11, 13, 14, 15, 17, 19, 20, 21, 22, 23, 27, 38, 40, 42, 43, 46, 51,
　　70, 89, 94; p. 9
Worcester Art Museum
　　Pl. 39
Wu Chung　武忠
　　p. 12
Wu-tsa-tsu　五雜俎
　　p. 11
Yale University Art Gallery
　　Pl. 12, 46, 78
Yamato Bunkakan　大和文華館
　　Pl. 10, 14, 39, 105
Yao-ch'i-shuo　窯器說
　　p. 11
Yao-chou, T'ung-ch'uan-hsien, Shensi Province　耀州銅川縣，陝西
　　Pl. 109
Yao-chou-chih　耀州志
　　p. 12
Yao-Chün　耀郡
　　p. 12
Yeh-tzu-chen　冶子鎮
　　Pl. 46
Yeh-tzu-ts'un　冶子村
　　p. 10
Yen-te-yuan　閻德源
　　Pl. 75, 101
Yen-ts'un, Hui-hsien　沿村，輝縣
　　Pl. 2
Yen-yu　延祐
　　Pl. 36
Yi-yang-hsien-chih, Honan　宜陽縣志
　　p. 12
Yi, Royal House of, Seol
　　Pl. 39
Yin-kuang　銀光
　　p. 13
Yin-liu-chai shuo-tz'u　飲流齋說瓷
　　p. 11
*Ying-ch'ing　影青
　　p. 9
Yü-hsien, Honan Province　禹縣
　　Pl. 47, 48, 52, 54, 64, 65, 68, 69, 75, 77, 78, 79, 99
Yü-hsien-chih, Honan　禹縣志
Yü-lin, Inner Mongolia　楡林
　　Pl. 63
Yüan Dynasty
　　Pl. 36, 56, 60, 62, 63, 73, 76, 82, 83, 86, 91, 98
Yüan-shen　源神
　　p. 12
Yüan chen　元貞
　　p. 63

Bibliography

Abbreviations

BMFEA Bulletin of the Museum of Far Eastern
 Antiquities, Stockholm
FECB Far Eastern Ceramic Bulletin
KK K'ao-ku t'ung-hsün, called K'ao-ku from 1959
KKHP K'ao-ku hsüeh-pao
TOCS Transactions of the Oriental Ceramic Society
WW Wen-wu ts'an-k'ao tzu-liao, called Wen-wu from
 1959

Anon., "Chü-lu Sung-tai ku-ch'eng fa-chüeh chi lüeh (Excavation Report from Sung Dynasty City at Chü-lu), in *Kuo-li li-shi po-wu-kuan ts'ung-k'an*, vol. 1, no. 1 (1926), pp. 1-8

Araki Toshikazu tr., *So Gen keizai-shi* (Economic History of Sung and Yüan Dynasties), Tokyo, Seikatsusha, 1941

d'Argencé, René-Yvon Lefebvre, *Chinese Ceramics in the Avery Brundage Collection*, San Francisco, 1967

—————— , *The Hans Popper Collection of Oriental Art*, Tokyo, Kodansha International, 1973

The Arts of the Ming Dynasty, Detroit, The Detroit Institute of Arts, 1952

Ayers, John, "Some Characteristic Wares of the Yüan Dynasty," *TOCS*, (1954-55), pp. 69-86

—————— , *The Seligman Collection of Oriental Art: Chinese and Korean Pottery and Porcelain*, vol. II, London, 1964

—————— , *The Baur Collection Chinese Ceramics*, vol. I, Geneva, 1968

Bachofer, L. "Characteristics of T'ang and Sung Pottery," *The Burlington Magazine*, vol. XV (1934), pp. 72-76

Beurdely, Cécile F. Michel, *La Cearamique Chinoese*, Swisse, 1974

Boston Museum of Fine Arts, *The Charles B. Hoyt Collection*, Memorial Catalogue, Boston, 1952

Bushell, S. W., *Description of Chinese Pottery and Porcelain:* being a translation of the T'ao-shuo, Oxford, 1910

Cahill, J., *The Art of Southern Sung China*, New York, Asia House, 1962

Catalogue of the Sunglin Collection of Chinese Art and Archaeology, Peking, New York, Herbert J. Devine Galleries, 1930

Chang T'ing-yü (1672-1755) comp., *Ming-shih* (Ming History), 1739 edition, 332 vols.

Cheng Chen-to, *Wei-ta ti i-shu ch'uan-t'ung tu-lu* (The Great Heritage of Chinese Art), Shanghai, 1955

Ch'en Wan-li, *T'ao-chen* (Ceramic Pillows), Peking, 1954

—————— , *Sung-tai pei-fang min-chien tz'u-ch'i* (Northern People's of the Sung Dynasty), Peking, 1955

—————— , *Hsien-tai t'ao-tz'u kung-i* (The Technology of Modern Ceramics), Peking, 1957

—————— , and Feng Hsien-ming, "Ku-kung po-wu-yüan shih-nien-lai tuei ku-yao-chih ti t'iao-ch'a" (Investigations of Ancient Kiln Sites in Last Ten Years Sponsored by the Ku-kung Museum), *Ku-kung po-wu-yuan-k'an*, vol. 2 (1960), pp. 104-126

Chiang Hsüan-i, *Chi-chou-yao* (Chi-chou Ware), Peking, 1958

Chiang Ta-chien comp., *Chang-te-fu-chih* (Gazetteer of Chang-te-fu), 32 vols, 1787 edition

Chien An-lu, *Hsin-ch'uan-hsiang San-kuo-shih p'ing-hua*, produced during chih-chih reign (1321-1323), Peking, 1940 edition

Chinese Art, exhibition catalogue, Venezia, 1954

Chinese Ceramics, exhibition catalogue, The Brooklyn Museum, New York, 1944

Chinese Ceramics, catalogue of a loan exhibition, Los Angeles County Museum, 1952, by Henry Trubner

Chinese Stonewares and Porcelains, the Burrell Collection, Glasgow, Glasgow Art Gallery, 1963

Chōsen Sōtokufu, *Chosen koseki zufu* (Korean Antiquities Illustrated), 15 vols, Seoul, 1926

Chü Ch'ing-yüan, *T'ang Sung kuan ssu kung-yeh* (Public and Private Industry in the T'ang and Sung Dynasties), 1934

Chugoku nisen-nen no bi (China's Beauty of 2000 Years), exhibition of ceramics and rubbed copies of inscriptions in Sian, Tokyo, 1965

Chugoku Eirakukyu hekiga-ten (Exhibition of the Wall Painting from Yung-lo-kung, China), Tokyo, 1963

Chuka jinmin kyowakoku shitsudo bunbutsu-ten (Archaeological Treasures Excavated in the People's Republic of China), Tokyo and Kyoto, 1973

Chung-kuo ku wen-wu (Chinese Ancient Artifacts), Peking, 1962

Cox, W., *The Book of Pottery and Porcelain,* 2 vols, New York, 1945

Dexel, T., *Die Formen chinesischer Keramik,* Tübingen, 1955

Feng Hsien-ming, "San-shih-nien lai wo-kuo tao-tz'u k'ao-ku ti shou-huo 30 (Archeological finds of ceramics in China in last 30 years), *Ku-kung po-wu-yuan yuan-k'an,* vol. 1 (1980), pp. 3-27, and 50.

Fernald, H., "Chinese Mortuary Pillows in the Royal Ontario Museum of Archaeology," *FECB,* vol. IV, no. 1 (March 1952), pp. 1-14

Fu Chen-lun, *Chung-kuo tz'u-chi shih-lueh* (Brief History of Chinese Ceramics), Peking, 1955

Geopper, R, *Kunst und Kunsthandwerk Ostasiens,* München, Keysershe Verlagsbuchhandlung, 1968

————, et al., *Form und Farbe: Chinesische Bronzen und Fruh-Keramik,* Köln, 1972

Gray, B, *Early Chinese Pottery and Porcelain,* London, Faber and Faber, 1953

Gyllensvärd, Bo, *Chinese Ceramics in the Carl Kempe Collection, Stockholm, 1964*

————, Kinesiskt Porslin, Västeras, IGA-Förbaget, 1966

Hasebe Gakuji, "Shiro to kuro no kaichō Sō-ji no ichi danmen" (Black Against White and White Against Black—One Aspect of Sung Ceramics), *Museum,* no. 121 (April 1961), pp. 16-18

————, "Kanan no Tōfuyō" (Teng-feng Ware in Honan province), *Tosetsu,* no. 135 (1964), pp. 119-127

————, "Chūgoku tōjishi ni okeru nisan no mondai (A Few Problems in the History of Chinese Ceramics), *Museum,* no. 174 (September 1965), pp. 8-13

————, *So no Jishuyo* (Tz'u-chou Ware of the Sung Dynasty), in Tōki zenshū, vol. 13, Tokyo, Heibonsha, 1966 (revised)

————, "Ju seiki no Chūgoku tōji "(Chinese Ceramics of the Tenth Century), in *Tokyo kokuritsu hakubutsu-kan Kiyo,* vol. 3 (1967), pp. 177-242

————, "Hokusō zenki no Jishūyō ni tsuite" (On Tz'u-chou ware of Early Northern Sung Dynasty), in *Toyo toji,* vol. 1 (1973-74), pp. 21-34

————, *Jishuyo* (Tz'u-chou Ware), in Tōji taikei, vol. 39, Tokyo, Heibonsha, 1974

————, "Jishuyo. Honan temmoku (Tz'u-chou and Honan temmoku)" in *Sekai toji zenshu,* vol. 12, (Tokyo, 1977), Shogakukan, pp. 230-247

Hempel, Rose, *Tausend Jahre chinesiche Keramik aus Privatbesitz,* Hamburg, Museum für Kunst und Gewerbe, 1974

Hethrington, A. L., *The Early Ceramic Wares of China,* London, Benn Brothers, 1922

————, *Chinese Ceramic Glazes,* Cambridge, 1937

Hibino Takeo, "Tō So jidai no ni-san no jiyō" (A Few Ceramic Kilns in the T'ang and Sung Dynasties), in *Ritsumeikan bungaku,* no. 24 (1954), pp. 26-35

Hobson, R. L., "On Some Potteries in Kiangsu and Anhwei," *TOCS,* 1924-25, pp. 25-29

————, *The George Eumorfopoilos Collection: Catalogue of the Chinese, Corean and Persian Pottery and Porcelain,* vol. III, London, 1925

————, "Chinese Porcelain Fragments from Aidhab, and Some Bashpa Inscriptions," *TOCS,* 1926-27, pp. 19-21

————, Rackham and King, *Chinese Ceramics in Private Collections,* London, Halton and Truscott Smith, 1931

Hochstadter, W, "Early Chinese Ceramics in the Buffalo Museum Science," in *Hobbies,* the Magazine of the Buffalo Museum of Science, vol. 26, no. 5 (June 1946), pp. 101-147

Hollis, Howard, "More Sung Dynasty Stoneware," *The Bulletin of the Cleveland Museum of Art,* (January 1949), pp. 13-14

————, "Chinese Stoneware of the Yüan Dynasty," *The Bulletin of the Cleveland Museum of Art,* (March 1949), pp. 35-36

Honey, W. B., *The Ceramics Art of China and Other Countries of the Far East,* London, 1945

Ho-pei-sheng Wen-hua-chü wen-wu ku-tso-tui, "Fa-chüeh Kuan-t'ai Sung Yüan min-chien tz'u-yao ti shou-huo" (Excavation on the People's Ware from Sung and Yüan Dynasties at Kuan-t'ai), in *Guangming ribao,* Peking, 18th of December, 1962, no. pag.

Ho-pei ti-i po-wu-yuan pan-yueh-k'an, in 1931

Hou Te-feng, "Ho-nan Hsiu-wu-hsien mei-t'ien ti-chih" (Geology of Hsiu-wu Coal Field, Honan Province), in *Ti-chih hui-pao* (Geological Bulletin), vol. 15 (December 1930), pp. 13-24

————, "Ho-pei-sheng Tz'u-hsien nien-t'u kuang ti-chih k'uang-yeh chi yao-yeh" (The Clay Deposits and Porcelain Industry of Peng-cheng-chen in Tz'u-hsien), in *Ti-chih hui-pao,* vol. 17 (October 1931), pp. 43-82

Hsin Chung-kuo ch'u-t'u wen-wu (Historical Relics Unearthed in New China), Peking, 1972

Hsin Chung-kuo ti k'ao-ku shou-huo (Archaeological Finds from New China), Peking, 1962

Hu Ying-Ch'üan, *Chung-kuo mei-kung* (Chinese coal-mines), Shanghai, 1935

Ikeda Shizuo, "Hokusō ni okeru suiun no hatatsu" (Development of Water Transportation in the Northern Sung Dynasty), *Toa keizai kenkyu,* vol. 23, no. 4 (1939)

Irie Yoshitaka, "Sōdai shimin-seikatsu no ichi sokumen" (A Profile of the Civil Life in the Sung Dynasty), *Toyoshi kenkyu,* vol. 11, no. 4 (1949)

Ishibashi Shirō ed., *Wa Kan shu bunken ruiju* (Classification of Documented Japanese and Chinese Wines), Tokyo, Ibunsha, 1936

Jakobsen, Kristian, "Notes on Chinese Ceramics," in *Worcester Art Museum Annual,* vol. VII (1959), pp. 25-42

Jansen, Beatrice, *Chinese Ceramick,* Haags Gremeentemuseum, 1976

KK, 1955, no. 4, pp. 57-58. Chieh T'ing-ch'i, Chieh Hsi-kung and Yang Mo-kung, "T'ai-yüan-shih chiao ku-mu, ku-ssu miao i-chih ch'ing-li chien-pao" (Brief Report of an old Temple Site in the Outskirt of T'ai-yüan)

KK, 1959, no. 7, p. 369. T'ang Yüan-ming, "Ho-pei Hsing-t'ai fa-hsien Sung-mu ho yeh-t'ieh i-chih" (Discovery of Sung tomb and Iron Smelt Site at Hsing-t'ai, Hopei Province)

KK, 1960, no. 2, pp. 15-24. Feng Yung-ch'ien, "Liao-ning-sheng Chien-p'ing, Hsin-min ti san-tso Liao-mu" (Three Liao Tombs in Chien-p'ing, Hsin-min, Liaoning Province)

KK, 1960, no, 2, pp. 41-42. Wang Tseng-hsin, "Liao-ning Hsin-min-hsien Ch'ien-tang-p'u Chin Yüan i-chih" (Chin and Yüan Ruin Sites at Ch'ien-tang-p'u, Liaoning Province)

KK, 1960, no. 2, pp. 43-44. Wang Tseng-hsin, "Liao-ning Sui-chung-hsien Ch'eng-hou-ts'un Chin Yüan i-chin" (Chin and Yüan Ruin Sites at Ch'eng-hou-ts'un, Sui-chung-hsien in Liaoning Province)

KK, 1960, no. 10, p. 12. Feng Cheng-tse, "Lo-yang Chien-pin Yang-shao, Yin wen-hua i-chin ho Sung-mu ch'ing-li" (Study on Yang-shao and Yin Cultural Sites and Sung Tomb at Chien-pin, Loyang)

KK, 1961, no. 3, pp. 136-138 and 141. Feng Wen-hai, "Shan-hsi Wen-hsui Pei-yü-kou i-tso ku-mu" (A Old Tomb at Pei-yü-kou, Wen-hsui, Shansi Province)

KK, 1961, no. 3, p. 174. T'ang Yün-ming, "Ho-pei Hsing-t'ai ch'ing-li ti Sung-mu" (Study on Sung Tomb at Hsing-t'ai, Hopei province)

KK, 1961, no. 12, pp. 682-683. Yang Fu-tou, "Shan-hsi Hou-ma Chin-mu fa-chüeh chien-pao" (Brief Report on Excavation of the Chin Tomb at Hou-ma in Shansi Province)

KK, 1963, no. 5, pp. 250-256. Chieh Hsi-kung, "T'ai-yüan Hsiao-ching-yü Sung, Ming-mu ti-t-tz'u fa-chüeh-chi" (A Record of the First Excavation of Sung and Ming Tomb)

KK, 1963, no. 5, pp. 259-263. Tai Tsun-te, "T'ai-yüan Hsiao-ching-yü Sung-mu ti-erh-tz'u fa-chüeh-chi" (A Record of the Second Excavation of Sung Tomb)

KK, 1963, no. 6, pp. 343 and 339. Li Wei-jan, "Nan-ching Chung-hua-men wai Sung-mu" (The Sung Tomb on the Outside of Chung-hua-men in Nanking)

KK, 1963, no. 11, pp. 618-619. K'ung Yüan, "Chi-lin-sheng Fu-yü-hsien ti i-tso Liao Chin mu" (A Liao and Chin Tomb at Fu-yü-hsien, Chi-lin Province)

KK, 1963, no. 11, pp. 662-667. Hu Yüeh-ch'ien "An-hui Hsiao-hsien Pai-t'u-yao" (Pai-t'u Ware at Hsiao-hsien in Anhui Province)

KK, 1965, no. 1, pp. 25-30. Tai Tsun-te, "Shan-hsi T'ai-yüan chiao-ch'ü Sung, Chin, Yüan-tai chuan-mu" (Sung, Chin and Yüan Tile Tomb from Outskirts of T'ai-yüan, Shansi Province)

KK, 1965, no. 7, pp. 352-356. Wang Hsiu-sheng, "Shan-hsi Chang-chih Li-ts'un-kou pi-hua-mu ch'ing-li" (Report on the Wall Painting Tomb from Li-ts'un-kou, Ch'ang-chih, Shansi Province)

KK, 1965, no. 8, pp. 394-412. Ho-pei-sheng Wen-hua-chü Wen-wu Kung-tso-tui, "Ho-pei Ch'ü-yang-hsien Chien-tz'u-ts'un Ting-yao i-chih tiao-ch'a yü shih-chüeh" (A Test Excavation and Investigation of Ting Ware Kiln Site at Chien-tz'u-ts'un, Ch'ü-yang-hsien, Hopei Province)

KK, 1966, no. 1, pp. 33-35. Li Feng-shan, "Shan-hsi Hsin-chiang Chai-li-ts'un Yüan-mu" (Yüan Tomb at Chai-li-ts'un, Hsin-chiang in Shansi Province)

KK, 1966, no. 2, pp. 96-111. Hsü Ming-kang, "Liu-ta-shih fa-hsien Chin Yüan shih-ch'i wen-wu" (The Discovery of the Chin and Yüan Periods Artifacts at Liu-ta City in Liaoning Province)

KK, 1972, no. 6, pp. 2-11. Chung-kuo K'o-hsüeh-yüan K'ao-ku Yen-chiu-so, Peking-shih Wen-wu Kuan-li-ch'u and Yüan Ta-tu K'ao-ku-tui, "Pei-ching Hou-ying-fang Yüan-tai chü-chu i-chih" (The Yüan Dynasty Remains at Hou-ying-fang in Peking)

KK, 1972, no. 6, pp. 32-34. Tien Ching-tung, "Pei-ching Liang-ch'ing fa-chien ti i-ch'u Yüan-tai chiao-tsang" (Yüan Strage House from Liang-ch'ing in Peking)

KK, 1973, no. 5, pp. 279-285. Chung-kuo K'o-hsüeh-yüan K'ao-ku Yen-chiu-so, Peking-shih Wen-wu Kuan-li-ch'u and Yüan Ta-tu K'ao-ku-tui, "Pei-ching Hsi-t'ao-hu-t'ung ho Hou-t'ao-yuan ti Yüan-tai chü-chu i-chih" (The Yüan Dynasty Remains at Hsi-t'ao-hu-t'ung and Hou-t'ao-yuan in Peking)

KK, 1978, no. 6, pp. 388-399 and Pls 6-7. Tz'u-hsien Wen-hua-kuan "Ho-pei Tz'u-hsien Nan-k'ai-ho-ts'un mu-ch'uan fa-chüeh chien-pao" (Excavation of Yüan Dynasty Shipwrecks at Nan K'ai-ho-ts'un in Tz'u-hsien, Hopei)

KK, 1979, no. 5, pp. 461-471, Chao Kuang-lin and Chang Ning, Chin-t'ai tz'u-ch'i ti ch'u-pu t'an-so (First stage of investigation on Chin Ceramics)

KKHP, 1954, no. 8, pp. 163-202. Li Wen-hsin, "I-hsien Ch'ing-ho-men Liao-mu fa-chüeh pao-kao" (A Report on a Liao Tomb Excavated at Ch'ing-ho-men, I-hsien, Liaoning Province)

KKHP, 1956, no. 3, pp. 1-26. Cheng Shao-tsung, "Ch'ih-feng-hsien Ta-ying-tzu Liao-mu fa-chüeh pao-kao" (Report on Liao Tombs Excavated at Ta-ying-tzu, Ch'ih-feng-hsien)

KKHP, 1962, no. 2, pp. 31-73. Ho-pei-sheng Wen-hua-ch'ü Wen-wu Kung-tso-tui, "Ho-pei Ching-hsing-hsien Shih-chuang Sung-mu fa-chüeh pao-kao" (Excavations of the Sung Tombs at Shih-chuang, Ching-hsing County)

Karlbeck, Orvar, "Notes on the Wares from the Chiao Tso Potteres," in *Ethnos*, vol. 8, no. 3 (July-September 1943), pp. 81-95

————, "Notes on the Wares from the Chiao Tso Potteres," in *FECB*, vol. IV, no. 4 (1952), pp. 9-14

Katō Hajime, *Shina Mansen no togyo o mite* (A View of the Pottery Industry in China, Manchuria and Korea), Nagoya 1930

Kawai Unosuke, "Shu toshite shiro-geshō no kōsatsu" (Study on White Slip), in *Toji*, vol. V, no. 3 (August 1933), pp. 35-39

Kawakami Kōichi, *So-dai no keizai seikatsu* (Economic Life of the Sung Dynasty), Tokyo, Yoshikawa Kōbunkan, 1952

Kiangsi-sheng ch'ing-kung-yeh-t'ing Ching-te-chen t'ao-tz'u yen-chiu-so, *Chung-kuo ti tz'u-ch'i* (Chinese Ceramics), Peking, 1963

Kindai Bijutsukan, *Chugoku So-dai tochin ten mokuroku* (The Exhibition Catalogue of Ceramic Pillows in the Sung Dynasty), Kamakura, November 10—December 15, 1963, by Hasebe Gakuji

Kiselev, S. V, et al., *Drevne Monglskie Goroda*, Moscow, 1965

Kizo Hirota Matsushige korekushon mokuroku (Catalogue of Hirota Matsushige Gift), Tokyo, Tokyo National Museum, 1973

Kobayashi Taiichirō, *Shina toji zusetsu* (Illustrated Chinese Ceramics), Kyoto, Yamamoto Kōshu Shashin Seigei-bu, 1940

————, "Tanabata to Makōra" (A Research of Tanabata and Mo-hou-lo), in *Shina bukyo shigaku*, vol. IV, no. 3 (November 1940), pp. 1-34, and vol. IV, no. 4 (January 1941), pp. 30-53

Komori Shinobu, "Jishu-tōki no hatatsu dōtei to sono kachi" (The Development and Significance of Tz'u-chou Ware), in *Ato*, Ta-lien, vol. 4, no. 1 (1926), pp. 1-6

————, "Jisūyōzatsukō" (Brief Study of Tz'u-chou Ware), in *Toji*, vol. V, no. 3 (August 1933), pp. 20-29

————, *Shina ko toji-ki* (Old Chinese Ceramics), Kyoto, Kantō-shō Hakubutsukan, 1934

Komura toshio, "Sō-ji to sono jidai" (Sung Ceramics and Their Era), in *Towa keizai kenkyu*, vol. 24, no. 4 (1940), pp. 39-53, and vol. 24, no. 5 (1940), pp. 74-93

Koyama Fujio, "Jishū koyō ni tsuite" (Note on Old Tz'u-chou Ware), in *Toji*, vol. V, no. 3 (August 1933), pp. 50-61

————, "Jishūyō ni tsuite" (Note on Tz'u-chou Ware), in *Bijutsu ᐟkyū*, Tokyo, no. 134 (1944), pp. 18-35

————, "Kyoroku no kyūshi" (*Chü-lu-hsien Site*), in *Gasetsu*, no. 65 (1942), pp. 325-335

————, *So-ji* (Sung Ceramics), Tokyo, Jurakusha, 1944

————, "Hokusō no Shūbuyō" (Hsiu-wu Ware in the Northern Sung Dynasty), in *Bijutsu Kenkyu*, no. 161 (1951), pp. 1-19

————, "Sō-dai no Egorai to Sō-akae" (Egorai, Black-designed Wares and Sō-akae, Over-Glazed Wares of the Sung Dynasty, in *Sekai toji zenshu*, vol. 10, Tokyo, 1955, pp. 224-238

————, *Meito Hakusen* (Chinese Ceramics, one Hundred Master-Pieces from Collections in Japan, England, France and America), Tokyo, Nihon Keizai Shinbun-sha, 1960

————, *Chugoku toji* (Chinese Ceramics), Tokyo, Idemitsu Art Gallery, 1970

————, *So* (Sung Ceramics), in *Toki koza*, vol. 6, Tokyo, Yuzankaku, 1971

Ku-kung po-wu-yüan ts'ang tz'u hsüan-chi (Selected Ceramics Collection in the Palace Museum, Peking), Peking, 1962

Kümmel, Otto, *Chinesishe Kunst*, Berlin, Bruno Cassirer Verlag, 1930

Kuwayama, G, *Chinese Ceramics: The Heeramaneck Collection*, Los Angeles, Los Angeles County Museum of Art, 1974

Kyōto kokuritsu hakubutsu-kan, *To So no to chin* (Ceramic Pillows in the T'ang and Sung Dynasties), exhibition catalogue, Kyōto, Kyōto National Museum, October 6—November 23, 1970, by Fujioka Ryoichi and Kawahara Takehiko

Kobayashi Morihiro, "Sō-dai no kōshō to sono soshiki" (A Study of Kung-chiang of the Sung Dynasty Together with its Organization), in *Tohogaku*, no. 33 (January 1967), pp. 1-14

Lee, Jean Gordon, "A Dated Tz'u-chou Pillow," in *Archives of the Chinese Art Society of America*, vol. XI (1957), pp. 76-77

Lee, Sherman, "Two Basement Excavations, a Twelfth Century Bargain and a Gift," in *FECB*, vol. IX, nos. 1-2 (1957), pp. 41-43

————, and Ho Wai-kam, *Chinese Art Under Mongols: The Yüan Dynasty (1279-1368)*, Cleveland, Cleveland Museum of Art, 1968

————, "A Northern Sung Shape?", *FECB*, vol. II, no. 5 (Sept. 1950), pp. 94-99.

————, The Colors of Ink, New York, Asia House, 1974

Legeza, I, *Malcolm Macdonald Collection of Chinese Ceramics*, London, Oxford Press, 1972

Liao-ning-sheng Po-wu-kuan, *Liao-tz'u-shuan-chi* (Selected Liao Ceramics), Peking, 1962

Li Hsiang-ch'i and Chang Hou-huang, *Chü-lu Sung-ch'i ts'ung-lu* (Catalogue of Sung Artifacts from Chü-lu), Tientsin, 1923

Loehr, Max, *Chinese Art: Symbols and Images*, Wellesley College, Wellesley, Mass., 1967

Li Tung-yang (1447-1516) comp., *Ta Ming hui-tien* (The State Regulations of the Ming Dynasty), 1509 edition, 228 vols.

Lovell, Hin-cheung, "Notes on Chü-lu-hsien," *Oriental Art*, vol. XVI, no. 3 (Autumn 1970), pp. 259-261

Medley, Margaret, *Yüan Porcelain and Stoneware*, London, Faber and Faber, 1974

————, *The Chinese Potter: A Practical History of Chinese Ceramics*, New York, Charles Scribner's Sons, 1976

Mikami Tsugio, *Sō-ji to Sō-dai tōji* (Sung Pottery and Porcelain), *Kobijutsu*, no. 9 (1965), pp. 41-56

————, *Toji no Michi* (Ceramics Road), Chūōkōron, 1969

Mino, Yutaka, and Wilson, Patricia, *An Index to Chinese Ceramic Kiln Sites from the Six Dynasties to the Present*, Toronto, Royal Ontario Museum, 1973

Mino, Yutaka, *Ceramics in the Liao Dynasty: North and South of the Great Wall*, New York, China Institute of America, 1973

————, *Pre-Sung Dynasty Chinese Stonewares in the Royal Ontario Museum*, Toronto, Royal Ontario Museum, 1974

————, "Tz'u-chou type ware decorated with incised patterns on a stamped "fish-roe" ground," *Archives of Asian Art*, vol. XXXII (1979), pp. 55-71

————, and Katherine Tsiang, "Chinese Art in the Indianapolis Museum of Art," *Apollo*, Vol. CVIII, no. 199, pp. 156-163

————, *The Development of Tz'u-chou Type Wares*, Ph.D. dissertation, Harvard University, 1977

Miyazaki Ichisada, "Sō-dai ni okeru sekitan to tetsu (Coal and Iron in the Sung Dynasty), in *Tohogaku*, no. 13 (1957), pp. 1-28

Mizuno Seiichi and Hibino Takeo, *Sansei koseki-shi* (Report on Antiquities Found in Shansi Province), Kyōto, Kyōto Daigaku Jinmon Kagaku Kenkyūjo, 1956

Murakami Masana, "Kusado Senken-chō shitsudo no tōji" (Notes on the Potteries Found at Sengen-chō, Kusado, Hiroshima), in *Tosetsu*, no. 141 (December 1964) and no. 150 (September 1965)

Musée Guimet, *Collection Michel Calmann*, Paris, Ministere d'etat, Affaires Culturelles Reunion des Musée Nationaux, 1969

Museum Für Ostasiatishe Kunst Berlin, Berlin-Dahlem. 1970

Nagase Mamoru, "Hokusō no jisui jigyō" (The Work of River Training in the Northern Sung Dynasty), in *Sodai shakai keizai-shi kenkyu*, Tokyo, Fumaido, 1960, pp. 139-196

Naitō Tadashi, *Kotoji no kagaku* (The Science of Old Ceramics), Tokyo, Yūzankaku, 1972

Nakajima Kenryō, "Jishū gyōman-roku" (My Travels to Tz'u-chou District), in *Toji*, vol. IV, no. 2 (August 1932), pp. 35-50

Nakao Manzō, "Jishūyō-ki gaisetsu" (Outline of Tz'u-chou Ware), in *Toji*, vol. V, no. 3 (August 1933), pp. 1-14

Nanami Toshisada, "Sō-to Benkyō no hanka" (The Golden Period of the Sung Capital Pien-ching), in *Rekishi to chiri*, vol. 10, no. 5 (1922), pp. 36-51

Nei-Meng-ku ch'u-t'u wen-wu hsuan-chi (Selected Pieces from the Inner Mongolian Autonomous Region), Peking, 1963

Oriental Ceramic Society, *Ting, Ying-ch'ing and Tz'u-chou Wares*, London, 1949

_____ , *The Arts of the Sung Dynasty*, London, 1960

_____ , The Ceramic Art of China, *TOCS*, vol. 38 (1969-71)

Okuda Seiichi, "Sō-yo akae wan nitsuite" (Note on a Enamel Glaze Bowl of the Sung Dynasty), in *Kokka*, no. 378 (1922), pp. 161-164

_____ , ed., *Toyo toji shusei* (Collection of Oriental Ceramics), 5 vols, Tokyo, Tsujimoto Shashin Kōgeisha, 1925

Ozaki Atsumori, "Jishūyō manshitsu" (Note on Tz'u-chou Ware), in *Toji*, vol. V, no. 3 (August 1933), pp. 15-20

_____ , *Mindai no toji* (Ceramics of the Ming Dynasty), Tokyo, Yūzankaku, 1942

_____ , *So Gen no toji* (Ceramics of the Sung and Yüan Dynasties), in *Toki koza*, vol. 24, Tokyo, Yūzankaku, 1937

Paine, Robert, "Chinese Ceramic Pillows from Collection in Boston and Vicinity," *FECB*, vol. VII, no. 3 (September 1955)

Palmgren, Nils, "Kontakt med Keramiska gudalder Sung," in *Nordlig Sung-Keramik*, Stockholm, 1949, pp. 10-17

_____ , *Sung Sherds*, Stockholm, 1963

Pope, John, *Fourteenth Century Blue and White: A Group of Chinese Porcelains in the Topkapu Sarayi Mūzesi, Istanbul*, Washington, Freer Gallery of Art, 1952

_____ , *Chinese Porcelains from the Ardebil Shrine*, Washington, Freer Gallery of Art, 1956

_____ , and Lawton, T, *The Freer Gallery of Art*, vol. 1, Tokyo, Kodansha, 1972

The Raymond A Bidwell Collection of Chinese Bronzes and Ceramics, Springfield, Museum of Fine Art, 1965

Reitz, S. C. Bosh, *Catalogue of an Exhibition of Early Chinese Pottery and Sculpture*, New York, The Metropolitan Museum, 1916

Riddell, Sheila, *Dated Chinese Antiquities: 600-1650*, London, Faber and Faber, 1979

Rivière, Henri, *La Ceramique dans l'Art d'Extrême-Orient*, Paris, 1923

Royal Scottish Museum, *Chinese Pottery and Porcelain*, Edinburgh, 1955

Rücker-Embden, Oscar, *Chinesische Fruhkeramik*, Leipzig, Verlag Von Karl W. Hiesemann, 1922

Ryojun hakubutsu-kan, *Koko zuroku* (Selected Specimens of the Archaeological Collections in the Lü-shun Museum), Ryojun, 1935

Sakurai Ichirō, "Jishūyō mita mama no ki" (Report on the Scene of Tz'u-chou Kiln), in *Ato*, Ta-lien, vol. 4, no. 1 (1926), pp. 30-32

Schmidt, Robert, *Chinesische Keramik*, Frankfurt, Frankfurter Verlags-Anstalt, 1924

Sekai bijutsu zenshu (Series of World Arts), vol. 16 (China: Sung and Yüan), Tokyo, Kadokawa Shoten, 1965

Sekai toji zenshu (Catalogue of World Ceramics), vol. 10 (Sung and Liao), Tokyo, Kawade Shobo, 1955, and vol. 11 (Yüan and Ming), 1956

Sekai toji zenshu (Sung Dynasty), vol. 12, Tokyo, Shogakukan, 1977

Shan-hsi-sheng k'ao-ku yen-chiu-so *Shan-hsi T'ung-ch'uan Yao-chou-yao* (Yao-chou Ware of T'ung-ch'uan, Shensi Province), Peking, 1965

Shan-tung-sheng wen-wu kuan-li-so and Shan-tung-sheng Po-wu-kuan, *Shan-tung wen-wu hsüan-chi* (Selected Items Excavated in Shantung Province), Peking, 1959

Shiba Yoshinobu, *So-dai shogyo-shi kenkyu* (Commercial Activities During the Sung Dynasty), Tokyo, Kazama Shobo, 1968

Shih Hiao-yen, et al., *Chinese Art in the Royal Ontario Museum*, Toronto, Royal Ontario Museum, 1972

Shirae, Shinzo and Cox, Warren, "A Group of Sung Tz'u-chou Pillow," *Oriental Art*, vol. II, no. 2 (Autumn 1949), pp. 69-74

Sirén, Osvald, *Chinese Painting, Leading Masters and Principles*, 7 vols, New York and London, The Ronald Press Company, 1956-8

So no toji (Ceramics of the Sung Dynasty), Umezawa Kinenkan, vol. 5, 1969.

So Gen no bijutsu (Art of Sung and Yüan Dynasties), Osaka, Osaka Shiritsu Bijutsu-kan, 1978

Sogabe Shizuo, *Kaifu to Koshu* (K'ai-feng and Hang-chou), Tokyo, Toyamabō, 1942

Stein, Aurel, *Inner Most Asia*, vol. III, Oxford, Clarendon Press, 1928

Sullivan, Michael, *An Introduction to Chinese Art*, London, Berkeley and Los Angeles, 1961

_____ , *Chinese Ceramics Bronzes and Jades in the Collection of Sir Alen and Lady Barlow*, London, Faber and Faber, 1963

Sun Chien-ch'u, "Ho-nan Yü-hsien Mi-hsien mei-t'ien ti-chih "(Geology of the Yü-hsien and Mi-hsien Coal Field, Honan Province), in *Ti-chih Hui-pao* (Geological Bulletin), vol. 24 (September 1934), pp. 1-32

Sun Kuang-sheng and Shao Ta-yeh comp., *Yu-chou-chih*, 14 vols, 1747 edition

Sung-tai min-chien t'ao-tz'u wen-yang (Popular Pottery Designs in the Sung Dynasty), Shanghai, 1959

Su Pai, *Pai-sha Sung-mu* (Sung Tomb at Pai-sha in Honan Province), Peking, 1957

T'ao Tsung-i (Ming Dynasty) comp., *Shuo fu*, 100 vols., 1927 edition (Shanghai)

Tokyo kokuritsu hakubutsu-kan zuhan mokuroku: Chugoku kotoji hen (Illustrated Catalogues of Tokyo National Museum, Chinese Ceramics), Tokyo, 1965

To So meito-ten (Exhibition of the Masterpieces of Chinese Ceramics in the T'ang and Sung Dynasties), Tokyo, 1964

Tōwakai, *Soji tenkan zufu* (Illustrated Exhibition Catalogue of Sung Ceramics), Tokyo, Ōtsuka Kogeisha, 1929

Trubner, H, "Tz'u-chou and Honan Temmoku," in *Artibus Asiae*, vol. 15, no. 1 (1952), pp. 151-162

Tsang Li-ho et al., *Chung-kuo ku-chin ti-ming ta-tzu-tien* (Chinese Geographical Dictionary), Taipei, Tai-wan Shang-wu Yin-shu-kuan, 1966 (second edition)

Tseng Hsien-ch'i and Dart, Robert, *The Charles B. Hoyt Collection in the Museum of Fine Arts: Boston*, vol. II, Boston, Museum of Fine Arts, 1972

Ueda Kyosuke, "Jishūyō ni tsuite" (Tz'u-chou Ware), in *Ato*, vol. 4, no. 4 (1926), pp. 7-13

_____ , *Shina toji no jidai-teki kenkyu* (A Chronological Study of Chinese Ceramics), Osaka, Osakaya, 1929

_____ , *shina toji zatsudan* (Talk on Chinese Ceramics), Tokyo, 1930

Vasselt, J. J. Marquet, *La Ceramique Chinoise*, Paris, 1922

Visser, H. F. E., *Asiatic Art: In Private Collections of Holland and Belgium*, New York, The Beechurat Press, 1948

Watanabe Soshū, *Shina tojiki shi* (History of Chinese Ceramics), Tokyo, Seikokan, 1939

Wen-hua ta-ko-ming ch'u-chien ch'u-t'u wen-wu (Relics Unearthed During the Great Cultural Revolution), Peking, 1972

WW, 1952, no. 2, pp. 56-62. Ch'en Wan-li, "Tiao-ch'a p'ing-yüan Hopei erh-sheng ku-tai yao-chih pao-kao" (Report on the Old Kiln Sites Investigated in Hopei and Honan Provinces)

WW, 1954, no. 4, pp. 44-47. Ch'en Wan-li, "T'an Tang-yang-yü-yao" (Talk on Tang-yang-yü Kiln)

WW, 1955, no. 9, pp. 148-150. Li I-yu, "Shan-hsi T'ien-chen-hsien Hsia-chia-kou fa-hsien Liao-Chin shih-tai chü-chu i-chih i-ch'u" (A Discovery of Liao and Chin Dwelling Site at Hsia-chia-kou, T'ien-chen-hsien in Shansi Province)

WW, 1956, no. 1, pp. 32-35. Shan-hsi-sheng wen-wu kuan-li wei-yüan-hui, "Hsi-an Yü-hsien-men wai Yüan-tai chuan-mu ch'ing-li chien-pao" (Brief Report on the Yüan Tile Tomb at Yü-hsien-men, Shian)

WW, 1956, no. 7, pp. 36-37. Yang Pao-shun, "T'ang-yin-hsien Ho-pi-chi ku-tz'u-yao i-chih" (Old Ceramic Kiln Site at Ho-pi-chi in T'ang-yin-hsien)

WW, 1956, no. 8, p. 74. Chou Tao, "Honan An-yang-shih chiao-ch'ü Sung-mu fa-hsien tz'u-chen" (Ceramic Pillow from Sung Tomb on the Outskirts of Anyang City in Honan Province)

WW, 1958, no. 5, pp. 52-54. An Chin-hui, "Cheng-chou Nankuan-wai Pei Sung chuan-hsih-mu" (Northern Sung Tile Tomb at Nan-kuan-wai, Cheng-chou)

WW, 1958, no. 5, p. 72. Wang Yü-p'ing, "I-meng-chün Wang-ch'i fa-hsien hei-yu k'o-hua-p'ing (Black Glaze Vase with Carved Decoration Found at Wang-ch'i, I-meng-chün)

WW, 1958, no. 6, pp. 57-61. Wang Yü-ch'ing and Hang Te-chou, "Hsi-an Ch'ü-chiang Chih-hsi-ts'un Yüan-mu ch'ing-li chien-pao" (Brief Report on a Yüan Tomb at Chih-hsi-ts'un, Ch'ü-chiang Near in Sian)

WW, 1958, no. 10, pp. 36-37. Wu Lien-ch'eng, "Shan-hsi Chieh-hsiu Hung-shan-chen Sung-tai tz'u-chih chieh-shao" (Introduced on the Ceramic Kiln Site of Sung Dynasty at Hung-shan-chen, Chieh-hsiu, Shansi Province)

WW, 1959, no. 6, pp. 58-61. Ho-pei-sheng wen-hua-chü wen-wu kung-tso-tui, "Kuan-t'ai-yao-chih fa-chüeh pao-kao" (Excavation Report on Kuan-t'ai Kiln Sites)

WW, 1960, no. 3, p. 90. Li Te-yün, "Ch'ü-chou-hsien Tung-feng-ch'ü fa-hsien Sung-tai i-chih" (The Discovery of Sung Dynasty Sites at Tung-feng-ch'ü in Ch'ü-chou-hsien)

WW, 1960, no. 5, p. 87. Kuo Chien-pang, "Nan-yang-shih Shih-li-miao ch'ing-li Sung-mu i-tso" (One Sung Tomb at Shih-li-miao, Nan-yang City in Honan Province)

WW, 1961, no. 9, pp. 30-33. Li I-yu, "Ho-lin-ko-erh-hsien T'u-ch'eng-tzu ku-mu fa-chüeh chien-chieh" (An Introduction to the Excavation of an Old Tomb in T'u-ch'eng-tzu, Ho-lin-ko-erh-hsien)

WW, 1961, no. 9, pp. 52-57. Chang Yü, "Yüan-tai Chi-ning-lu i-chih ch'ing-li-chi "(Report on the Yüan Site at Chi-ning-lu)

WW, 1962, no. 10, pp. 34-46. Chieh T'ing-ch'i, "Shan-hsi-sheng Ta-t'ung-shih Yüan-tai Feng Tao-chen, Wang Ch'ing mu ch'ing-li chien-pao" (Brief Report on Excavation of Yüan Dynasty Tombs of Feng Tao-chen and Wang ch'ing at Ta-t'ung in Shansi Province)

WW, 1964, no. 2, pp. 54-62. Ho-nan-sheng wen-hua-chü wen-wu kung-tso tui, "Ho-nan-sheng Mi-hsien Teng-feng T'ang Sung Yao-chih tiao-ch'a chien-pao" (Brief Investigation of T'ang and Sung Kiln Sites at Mi-hsien and Teng-feng in Honan Province)

WW, 1964, no. 3, pp. 47-55. Feng Hsien-ming, "Ho-nan Mi-hsien, Teng-feng T'ang Sung ku-yao-chih tiao-ch'a" (Investigation on T'ang and Sung Old Kiln Sites at Mi-hsien and Teng-feng in Honan Province)

WW, 1964, no. 8, pp. 1-14. Ho-nan-sheng wen-hua-chü wen-wu kung-tso-tui, "Ho-nan-sheng Ho-pi-chi tz'u-yao i-chih fa-chüeh chien-pao" (Excavations of the Remains of an Ancient Porcelain Kiln at Ho-pi-chi, Honan Province)

WW, 1964, no. 8, pp. 27-36. Yeh Che-min, "Ho-nan-sheng Yü-hsien ku-yao-chih tiao-ch'a chi-lüeh" (Reconnaissances of Ancient Kiln Sites at Yü-hsien, Honan Province)

WW, 1964, no. 8, pp. 37-56. Li Hui-ping, "Tz'u-chou-yao i-chih tiao-ch'a" (Reconnaissances of the Remains of Tz'u-chou Ware Kiln Sites at City of Han-tan and Tz'u-hsien, Hopei Province)

WW, 1964, no. 9, pp. 46-51. Yang Chih-ying, "Meng-chia-ching tz'u-yao i-chih (The Ceramic Kiln Site at Meng-chia-ching)

WW, 1965, no. 9, pp. 26-56. Feng Hsien-min, "Hsin Chung-kuo t'ao-tz'u k'ao-ku ti chu-yao chou-huo" (Important Chinese Ceramic Finds from New China)

WW, 1965, no. 10, pp. 46-56. Ko Chih-kung, "An-hui Feng-t'ai 'Lien ch'eng' i-chih nei fa-chien i-p'i T'ang-Yüan shih-tai ti wen-wu" (Relics of the T'ang through the Yüan Dynasties Found on the Site of Lien Ch'eng at Feng-t'ai, Anhui Province)

WW, 1965, no. 11, pp. 35-43. Ho-nan-sheng Wen-hua-chü Wen-wu Kung-tso-tui, "Ho-nan Hui-hsien Ku-yao chih tiao-ch'a chien-pao" (Brief Investigation of Ancient Kiln Sites at Hui-hsien, Honan Province)

WW, 1966, no. 1, pp. 51-52. Chu Chien-yüan and Hei Kuang, "Hsi-an nan-chia ch'u-t'u i-p'i yin-ting" (Silver Ingots unearthed in the Outskirts of Sian)

WW, 1972, no. 8, pp. 39-48. Ting-hsien po-wu-kuan, "Ho-pei Ting-hsien fa-hsien liang-tso Sung-tai T'a-chi" (Two Pagoda Foundations of the Sung Period Discovered at Ting-hsien in Hopei Province)

WW, 1972, no. 10, pp. 63-66. Chin Ko, "Mi-hsien Pei-Sung t'a-chi chung ti san-ts'ai liu-li-t'a ho ch'i-t'a wen-wu" (Three-color Lead Glaze Pagodas and Other Artifacts Unearthed in the Foundation of the Northern Sung Pagoda in Mi-hsien)

WW, 1973, no. 7, pp. 20-29. Feng Hsien-ming, "Wo-kuo t'ao-tz'u fa-chan-chung ti chi-ko wen-t'i" (Some Problems Concerning the Development of Chinese Ceramics)

WW, 1974, no. 12, pp. 74-81. Ho-nan-sheng po-wu-kuan, Hsin-an-hsien wen-hua-kuan, Chiao Ch'ing-yün and Wang Tien-chang, "Ho-nan-sheng Hsin-an-hsien ku-tz'u-yao i-chih t'iao-ch'a" (Investigation of the Old Ceramic Kiln Site at Hsin-an-hsien in Honan Province)

WW, 1975, no. 6, pp. 57-63. Ho-nan-sheng Po-wu-kuan, and Chao Ch'ing-yün, "Ho-nan Yü-hsien Chün-t'ai yao-chi ti fa-chüeh" (Excavation on chün-t'ai Kiln Sites at Yü-hsien, Honan Province)

WW, 1976, no. 2, pp. 73-82. Li Tso-chi, "Sui T'ang Sheng-chou Yü-lin-ch'eng ti fa-chien" (Reconnaissance of the Site of the Sui-T'ang City of Sheng-chou at Yü-lin County, Shensi Province)

WW, 1977, no. 4, pp. 40-49. Hei-lung-chiang-sheng wen-wu k'ao-ku kung-tso-tui, "Hei-lung-chiang p'an Sui-pin Chung-hsing ku-ch'eng ho Chin-t'ai mu-ch'ün" (The Ancient City of Chung-shing and Chin Tombs in Sui-pin County by the Hei-lung River)

WW, 1978, no. 6, pp. 46-58 and 87. Shan-tung Tzu-po tao-tz'u-shih pien-hsieh-tsu, "Shan-tung Tzu-po-shih Tzu-ch'uan-ch'ü Tz'u-ts'un ku-yao-chih shih-chüeh chien-pao" (Group in Charge of Studying the History of Tzu-po Ceramics: A Report on the Excavation of the Site of an Ancient Porcelain Kiln at Tzu-ts'un Village in Tzu-ch'uan District of the City of Tzu-po, Shantung)

WW, 1978, no. 6, pp. 95-96. Chiao-hsien wen-wu po-kuan-so and Li-Jui so "Ho-pei-sheng Chiao-hsien Sung-ts'un Sung, Yüan mu ch'u-t'u ti chi-chien wen-wu," (Several Artifacts from Sung and Yüan Tombs at Sung-ts'un, Chiao-hsien in Hopei Province)

WW, 1979, no. 8, pp. 1-16. Honan-sheng po-wu-kuan and Chiao-tso-shih-wu-kuan "Ho-nan Chiao-tso Chin-mu Fa-chüeh chien-pao (Brief Excavation Report on the Chin Tomb at Chiao-tso, Honan Province)

WW, 1979, no. 8, pp. 18-25. Lin-fen-ti-ch'ü Ting-ts'un wen-hua kuo-tso-chan and T'ao Fu-hai, "Shan-hsi Hsiang-fen-hsien Nan-tung Chin-mu ch'ing-li chien-pao (Brief Report on the Chin Tomb at Nan-tung, Hsiang-fen-hsien in Shansi Province)

WW, 1979, no. 8, pp. 32-36. P'an Hsing-yin, "Yüan Chi-ning-lu ku-ch'eng ch'u-t'u ti chiao-tsang ssu-chih-wu chi ch'i-t'a (Silk Cloth and Other Objects Found at the Site of the ancient city of Chi-ning-lu of the Yüan Dynasty)

WW, 1980, no. 1, pp. 63-67, T'ung-ch'uan-shih, Hsün-i-hsien wen-hua-kuan Shen-hsi-sheng wen-kuan-hui "Shen-hsi Hsin Fa-haien liang-ch'u ku-tz'u-yao i-chih" (New Finds two kiln sites in Shensi Province)

Willetts, W, *Foundations of Chinese Art*, London, 1965

Whitfield, R, "Tz'u-chou Pillows with Painted Decoration" in *Chinese Painting and The Decorative Style*, A Colloquies on Art and Archaeology in Asia no. 5, London, Percival David Foundation of Chinese Art, School of Oriental and African Studies, University of London, June 23-25, 1975, pp. 74-94

Wirgin, Jan, "Sung Ceramic Designs," in *BMFEA*, no. 42 (1970)

————, "Sung Ceramic Designs and Their Relation to Painting," in *Chinese Painting and The Decorative Style*, A Colloquies on Art and Archaeology in Asia no. 5, London, Percival David Foundation of Chinese Art, School of Oriental and African Studies, University of London, June 23-25, 1975, pp. 22-38

Wu Mu-shun (1772-1832) comp., *An-yang-hsien-chih*, 28 vols., 1819 edition

Yabe Yoshiaki, "Ryō no ryōiki kara shitsudo shita tōji no tenkai" (Development of the Ceramics Excavated from the Liao Territory), in *Toyo toji*, vol. 2 (1973-74), pp. 21-44

Yabunouchi Kiyoshi ed., *So Gen jidai no kagaku gijutsu-shi*, (The History of Science and Technology in the Sung and Yüan Dynasties), Kyōto, Kyōto Diagaku Jinmon Kagaku Kenkyudo, 1967

Yeh Lin-chin, *Ku-chih chung-wai t'ao-tz'u hui-pien* (Selected Ceramics, Ancient and Modern), Peking, 1934

Yonaiyama Keiō, "Jishūyō ron" (Notes on Tz'u-chou Ware), *Tosetsu*, no. 108 (1962), pp. 34-40, and *Tosetsu*, no. 109 (1962), pp. 36-40.

Zusetsu sekai bunkashi taikei (Illustrated Series of World Cultural History), vol. 17 (China III: Sung), Tokyo, Kadokawa Shoten, 1959